T0191950

Advances in 21st Century Human Settlements

Indexed by SCOPUS

This Series focuses on the entire spectrum of human settlements – from rural to urban, in different regions of the world, with questions such as: What factors cause and guide the process of change in human settlements from rural to urban in character, from hamlets and villages to towns, cities and megacities? Is this process different across time and space, how and why? Is there a future for rural life? Is it possible or not to have industrial development in rural settlements, and how? Why does 'urban shrinkage' occur? Are the rural areas urbanizing or is that urban areas are undergoing 'ruralisation' (in form of underserviced slums)? What are the challenges faced by 'mega urban regions', and how they can be/are being addressed? What drives economic dynamism in human settlements? Is the urban-based economic growth paradigm the only answer to the quest for sustainable development, or is there an urgent need to balance between economic growth on one hand and ecosystem restoration and conservation on the other – for the future sustainability of human habitats? How and what new technology is helping to achieve sustainable development in human settlements? What sort of changes in the current planning, management and governance of human settlements are needed to face the changing environment including the climate and increasing disaster risks? What is the uniqueness of the new 'socio-cultural spaces' that emerge in human settlements, and how they change over time? As rural settlements become urban, are the new 'urban spaces' resulting in the loss of rural life and 'socio-cultural spaces'? What is leading the preservation of rural 'socio-cultural spaces' within the urbanizing world, and how? What is the emerging nature of the rural-urban interface, and what factors influence it? What are the emerging perspectives that help understand the human-environment-culture complex through the study of human settlements and the related ecosystems, and how do they transform our understanding of cultural landscapes and 'waterscapes' in the 21st Century? What else is and/or likely to be new vis-à-vis human settlements – now and in the future? The Series, therefore, welcomes contributions with fresh cognitive perspectives to understand the new and emerging realities of the 21st Century human settlements. Such perspectives will include a multidisciplinary analysis, constituting of the demographic, spatio-economic, environmental, technological, and planning, management and governance lenses.

If you are interested in submitting a proposal for this series, please contact the Series Editor, or the Publishing Editor:
Bharat Dahiya (bharatdahiya@gmail.com) or
Loyola D'Silva (loyola.dsilva@springer.com)

Anjali Krishan Sharma

Traditional Urbanism Response to Climate Change

Walled City of Jaipur

 Springer

Anjali Krishan Sharma
School of Architecture, Planning
and Design
DIT University
Dehradun, Uttarakhand, India

ISSN 2198-2546 ISSN 2198-2554 (electronic)
Advances in 21st Century Human Settlements
ISBN 978-981-19-4091-0 ISBN 978-981-19-4089-7 (eBook)
https://doi.org/10.1007/978-981-19-4089-7

This Springer imprint is published by the registered company Springer Nature Singapore Pte Ltd.
The registered company address is: 152 Beach Road, #21-01/04 Gateway East, Singapore 189721,
Singapore

To PUNCHTATVA the five elements of nature
FIRE, AIR, WATER, EARTH & SPACE

Foreword by Dennis Rodwell

Climate change is one of the foremost challenges of our age. This, alongside appreciation that planet earth has finite material resources and limits to its carrying capacity in the face of continuing over-exploitation of its environmental capital—the global stock of natural resources and environmental assets.

Much attention is focused on natural resources that remain in the ground. Tables are regularly published that disclose the reserves of the most commonly exploited resources and their current rates of exploitation and projected expiration dates. These are periodically updated as extraction rates vary and new discoveries are made.

Little attention is paid to the environmental capital that has already been invested in our cities—their embodied materials and energy represented by existing buildings and urban infrastructures. Esteem for these exploited resources represents a substantive potential contribution to reducing the depletion of non-renewable material and energy resources as well as limiting greenhouse gas emissions. Notwithstanding, they are not currently incorporated into the international and national agreements, directives and scientific methodologies applied to the agenda of anthropogenic global warming. These focus on the energy consumption of buildings, infrastructures and transportation in use, not in construction or manufacturing. At the same time, there is a need to render the existing building stock and infrastructure in cities more ecologically efficient.

A holistic, systems-based understanding of traditional urbanism, in all its time-honored resource-efficient adaptability, resilience to functional and lifestyle changes, respect for socio-cultural inheritance and continuity and accordance with the best principles of sustainable city design including the prioritization of passive systems over technology dependent interventions, is an essential contribution to addressing one of the principal challenges of our time.

Adopting the World Heritage City of Jaipur as its case example, this book marks an important contribution to today's foremost debate.

Scotland, UK
August 2021

Dennis Rodwell
Architect-Planner

Foreword by Francesco Bandarin

In 2016, the United Nations gathered in Quito, Ecuador on the occasion of HABITAT III, the third world conference on urban development, an event organized every twenty years to assess the urbanization trends and their impacts on life on the planet. While the previous two conferences (Vancouver,1976 and Istanbul, 1996) focused primarily on issues related to the management of urban processes (urban slum upgrading, urban infrastructure development, land consumption, etc.), Habitat III focused on what is going to be the greatest challenge for humanity in the twenty-first century: the urbanization of most of the population of the planet, and its impacts on the quality of life, on economic development and, most of all, on the environment, considering the alarming progress of climate change. In 2019, at the C40 World Mayors Summit in Copenhagen, the UN Secretary-General António Guterres stated that the climate battle 'will largely be won or lost in cities', pointing to the major role that cities play in energy consumption and emissions of greenhouse gasses. It is clear, therefore, that the widespread urban and metropolitan development process currently underway, that will raise the urbanization rate of the earth to 70 % by the year 2050, is a major challenge not only at the local scale, but also at the global scene. Has this challenge been fully addressed by urban management processes in the different regions of the world? There are unfortunately many reasons to doubt it, as the rapid and large-scale urbanization continue to be dominated by industrial development processes focused on short-term economic and technical results. Should countries effectively fulfill the commitments taken with the UNFCCC 2015 Paris Agreement on reduction of energy consumption and emissions, the urbanization patterns followed so far will have to be substantially reshaped.

This is the theme of the reflection offered by this book.

By revisiting the key elements of traditional urbanism, in a quest for solutions to the present urban development challenge, Anjali Krishan Sharma puts on stage the critical issues humanity is facing in what has already been called the 'urban' century. As mass urbanization is a relatively recent phenomenon, historic cities constitute a relatively small part of the world's urban complex. Indeed, a complete survey on the historic urban environment conducted by UNESCO on the occasion of the Habitat III Conference, and published in 2016 in the 'Culture: Urban Future' global Report,

clearly shows that historic cities represent a small percentage, varying between 1 and 2 %, of the total urbanized surface of most countries. While their economic role is far bigger than that, reaching in some cases even 10% of employment and national product, historic cities remain a small component of large scale metropolitan hubs. Their symbolic power, however, is a dominant feature in all countries of the world, where traditional settlements, their monuments, public spaces, urban fabric and cultural life is celebrated with pride and becomes often the symbol of national identity, as proven by the extraordinary success of this 'category' of heritage in the World Heritage List, where historic cities represent over 30% of the total number of sites inscribed.

Traditional urbanism, as argued extensively in this book, has been largely overlooked in the course of the twentieth century, dominated by the paradigms of modernist architecture and urban planning, and by industrialized—and often alienating—urban development programs. The rich experience offered by traditional urbanism and architecture in the design of energy efficient buildings, more adapted to local climatic conditions than the concrete-steel-and-glass building technologies of modern times, as well as the ability of defining multiple-use spaces and functionally flexible structures, has been -if not completely- largely sidelined. Fortunately, since the 1960's a great interest, at national and local level, for the conservation of historic areas has gained ground, first in developed countries and later in many other parts of the world where, as the survey conducted within the UNESCO 2016 Report clearly shows, historical urban traditions have remained strong. The impact of this conservation effort was significant, and probably we can we can still enjoy the quality of traditional urban spaces and learn from the past urban processes thanks to the successes of the urban conservation movement in Europe, Latin America, Asia and to a lesser extent, in North America. Furthermore, interest for vernacular urban models and architecture remained alive in many parts of the world, emblematically represented by the works of some architects of international renown, such as Hassan Fathi, or by the built forms that have been called 'architecture without architects' by Bernard Rudofsky in 1964. Why is the lesson of traditional urban forms relevant in addressing today's urban challenges? An issue of primary importance, as shown in this book, is linked to energy consumption, as energy for the production, operation and maintenance of a traditional urban fabric is significantly lower than energy needed to produce a modern urban structure. This depends largely on the choice of construction materials, often based on local geology or produced with low energy inputs, such as earthen or stone architecture, and on a great refinement of building design processes.

The high degree of functionality achieved by traditional structures originates in very long building traditions, sometimes thousands of years old, and in the continuous experimentation of methods to provide comfort in climatic conditions that could vary from the harsh environments of the African or Asian deserts to the cold summers and winters of the sub-arctic countries. It is not surprising therefore to see today a re-evaluation of earthen architecture techniques, like in the large apartment blocks the Pritzker Prize winner architect Wang Shu is currently building in Paris. Another factor that enhances the energy effectiveness of traditional urbanism is its compact fabric,

today promoted as an alternative to the urbanization models that prevailed in the past century, largely -albeit not uniquely- based on low density sprawled settlements. A compact city allows energy savings not only because of its form and a reduced land consumption, but also because urban services can be delivered at much lower energy cost, from transportation, to utilities and commodities distribution. In the past two centuries, compact cities have been developed in all climatic conditions, making available to us a variety of urban and building typologies, regulations, planning tools and operational models, that can be used to address the climate challenges of the present and future.

Traditional urbanism, furthermore, provides other direct and indirect benefits, that have been praised by contemporary designers, as it allows to generate human-scale urban spaces that improve the quality of life of the inhabitants and facilitate social integration and cohesion to an extent far greater than what is allowed by dispersed urbanization patterns. Urban design principles inspired by traditions have been at the core of the interest of UNESCO for the conservation of the historic environment, culminating in the important Recommendation on the Historic Urban landscape of 2011, a text that not only promotes the principles of urban conservation, but points also to the directions that contemporary urban planning should take to ensure quality of life and sustainability. This includes a full understanding of the historical layers that compose the city, a comprehensive integration of the natural environment in the planning process, the valuing of local urban traditions and traditional management practices. While a once-fit-all approach is certainly not recommended to face the present and future challenges, we can learn from the traditional city many important lessons that can guide planners, citizens, politicians and investors in defining a sustainable urban future.

Geneva, Switzerland Francesco Bandarin

Francesco Bandarin has been Director of the UNESCO World Heritage Centre (2000–2010) and UNESCO Assistant Director-General for Culture (2010–2018). He is currently Advisor to ICCROM, the Aga Khan Trust for Culture and the Smithsonian Centre for Cultural Heritage.

Foreword by Deo Prasad

Traditional urbanism has evolved over a long period with different influencing factors around form, spaces, community, society and culture among others. Over long periods now issues such as restoration, conservation and appropriateness in today's world have been questioned. A number of factors in recent times have brought attention to the debate on future cities and the relevance of traditional urbanism:

Massive urban population growth has been a major factor in influencing growth both in typologies and scale and this has had consequences on planning and urban design—the 'density versus sprawl' debate.

Climate change and urban microclimates including mitigation and adaptation—this is among the key influencing factors now as we experience extreme events such as much higher urban temperatures than prevailing which can be attributed to design and planning decisions. Mitigation measures such as cool roofs; urban vegetation, water bodies; special surfaces and materials are all emerging and may influence planning decisions. The importance of health, well being and livability are key outcomes of planning as we navigate the future together with carbon and sustainability.

Move toward net zero carbon for cities is now high on priority and the discussions at the COP#26 in Glasgow will further reiterate the importance of tackling carbon and drive us toward regenerative design and planning where we add to the amenity and not just draw from it. Influence of technologies is only going to increase and the features of the 'smart and data led' city of the future is an evolving reality. This can tie together all other aspects being noted here.

Resilience has now also come to the forefront, as we realize not only climate related resilience as evidenced in floods, fires, cyclones responses but spread of diseases. Covid19 has shown the broader planning paradigm may be under challenge. Push toward public transport, large venues and gatherings are being linked to disease spread.

So how do we navigate these layers of concerns and this takes us to looking at how traditional urbanism worked. There are many lessons to be learned and case stories such as Jaipur and the Walled City reveal time lasting aspects. The least carbon impact development is one that exists—zero development or with minimum improvements is closest to net zero carbon. This book is well focused and within three

key chapters articulates a refocus from simply a conservation-based improvement to a more holistic one that ensures elements of all the above to deliver a future where such traditional projects remain highly relevant.

Scientia Professor Deo Prasad AO
FTSE
UNSW Sydney
Sydney, NSW, Australia

Foreword by P. S. N. Rao

India is a land of traditions. This is a land of ancient culture, which evolved as a response to experimentation and experience over centuries. This led to depth of understanding and a sophisticated expression in variegated forms. Whether it is language, music, food, clothing, sculpture or building, India has a past that is unsurpassed by any other civilization anywhere in the world. The harsh climate of North India demanded a suitable response in building for comfortable living. This had to be articulated in the locally available materials and construction technologies of the times. Further, buildings had to respond to the functional requirements of the day. Constructing individual buildings, streets, neighborhoods' and the city thus became an aggregation and led to a way of life called urbanism. Today when we see urbanism and the urban construct of our ancient settlements, we see a summation of several factors, which are climate responsive. This book is an exploration of these. Initially the book discusses the concept of traditional urbanism and then moves on to climate change responses. It looks at the case of the city of Jaipur in detail and seeks for a future based on continuation and adaptation of traditional practices for the future where climate change becomes extremely significant. This book, based on a doctoral dissertation, is a welcome addition to the literature in architecture and town planning on Indian cities.

<div style="text-align:right">

P. S. N. Rao
Director, School of Planning and Architecture
Chairman, All India T&CP Board, AICTE, Government of India
Member, Central Zoo Authority, MoEFCC, Government of India
Member, Advisory Council, DDA, New Delhi
Member, Expert Appraisal Committee, MoEFCC, Government of India
Member, National Wetlands Committee, MoEFCC, Government of India
Member, DPCC Board, Government of NCT of Delhi
Independent Director, Ujjain Smart City Limited
Member, General Council, National Board of Accreditation (NBA)
Chairman, DUAC, Ministry of H&UA, Government of India (2014–2021)

</div>

Chairman, Delhi Regional Chapter, Institute of Town Planners-India (2018–2020, 2021–2022)

Delhi, India

Foreword by Matthias Ripp

Cities, we live, this is where we work, live, love, research, raise our children and celebrate our lives. Cities also are a matrix of complex systems with sub-systems within (like traffic grids) and designs and frameworks. Within these Frameworks and live grids is the domain of people and objects. A sum of all these moving parts is a city in its real essence. Different parts link in ways that a change somewhere affects the large spectrum. Classical Research studies single parts or has a sector approach, for example, the material aspects of monuments. These studies conducted by scholars make for in-depth work, but a broader view can demonstrate how the conglomerates of million systems live inter connect.

Urban transformation is as an emerging discipline to focus; another one is a collection of theories and methods under the umbrella term of 'Urbanism'. The approach of this book is to understand the different subsystems of cities in the viewpoint Urbanism, that examines a defined number of phenomena, like culture, heritage, urban planning, side by side explores how to respond to urban and global challenges. One of the most pressing subject of climate change; on which a large section of the book is devoted to. The building sector makes is a large global emitter, and is therefore a significant field for change and transformation.

Heritage needs to be understood as a system, it also impacts and attempts to prevent global challenges like climate change which is best understood in a systemic approach taking into account natural, cultural, social and economic realities in the backdrop of local communities. While doing so, the author examines Traditional Urbanism practices in architectural designing and assesses their potential transfer to cities of the future. This approach is filling a gap in the growing field of scientific research at the crossing point of climate change. Prevention and conceptual approaches like resilience often are focused either on singular risks and their prevention. Technical solutions through are not ambitious enough in trying to take into account the complexity of the situation at hand. In such discussions, the prevalent narrative still is that heritage is the object that is to be preserved and often thus is perceived as an obstacle for interventions designed to respond to effects of Urban Transformation. The City of Jaipur serves here as an Example, where the specific

local principles and strategies are examined on the level of urban planning and architectural design of the building stock. The idea of this book explores what can we learn from heritage to make our cities more resilient by examining the specific qualities of traditional urbanism and how they can be transferred.

We need more research approaches like this one to expound the notion that heritage has undiscovered qualities that can be used as a resource for resilience. This new understanding and narrative can motivate and integrate local communities in local resilience strategies and plans, because heritage is a strong-also often emotionally accessible—focal point for the identification and social and psychological well-being for local communities. Heritage is often connected to 'feeling at home' and associated with positive and negative feelings of important events in the lives of local communities. To use it more as a resource and factor for resilience is therefore a smart and promising road to travel. Strong point of this book lay therefore not only in the elaborated and descriptive Examples of Traditional Urbanism but on a more principle level shedding light how heritage can be activated and even transferred as a resource for urban resilience.

Regensburg, Germany Matthias Ripp
July 2021

Preface

Climate change is in a state of emergency. The challenge of climate change with ground realities of nations with varying capacities is compelling us to look for solutions as the way forward. Mankind has cracked the best of technology and upgrading regularly but the dissemination of the same; neither exists nor resources available; a limitation that is putting the world on a back foot.

Capitalism drove the global economy and became the key driver for growth largely tapping on both natural and human resource capacities of nations irrespective of their state of economy or development. Considering only a selected few-initiated anthropocene, the impact has been borne by mankind at large. The dynamic between anthropocene and geo-political rests with small groups that are driven by capitalism. In this equation the toll on the environment began to emerge as central concern. Parallely the global economy caused the evolution of the global community with dollar as the common denominator that valued all the regional and ethnic diversities. This approach of the global economy to equate global community as numbers proved futile with cultural nuances inherent to the global social capital and the paradigm shift from economy-driven society to socio-culturally driven economy, something that existed when civilizations evolved virtually completing this loop. The symbiotic relationship of man and nature that existed for centuries got jeopardized with capitalism, soon enough to realize with frequent natural disasters. However isolated attempts by few developed nations have managed to accomplish but on the global canvas made only a marginal difference.

Cities are becoming important like never before with the majority of the world population to be living in urban areas and thus it's imperative to understand the tradition of urbanism. Tracing the narrative of urbanization, Traditional Urbanism emerges as being consistent that responded to changes from geo-political, social, cultural, infrastructure services to technological in the recent past. The strength of traditional urbanisms is much more than cultural heritage and thus limiting it to a special area for the tourism sector may be a skewed outlook. Among the numerous dimensions the built morphology of traditional urbanism that was climatic responsive typology, is a huge resource. Traditional urbanism had a holistic approach and operated as a system of systems and thus only a comprehensive approach enables one

to view, understand and appreciate in correct perspective. The standard interventions in these cities have been for retrofitting, adaptive reuse or part interventions among others that celebrated the rich architectural heritage. While the need to look beyond and decipher the underlying design and planning principles that responded to their respective climate and solutions that were designed, which evolved over time and fine tuned such were low on carbon footprint utilizing minimum energy. Each of the traditional urbanism typologies demonstrates the application of laws from science with deep understandings of climate, existing natural features of the site where the city was built. Typically built with nature, lifestyles in sync with available natural resources and typically across all scales of the city from layout of the city to urban design scale to detailing of the buildings. Moreover these cities are vibrant, lively with a strong sense of identity something that the hegemony of the global cities lacks.

I belong to a generation that drank tap water while growing up; hailing from a developing nation has witnessed scientific innovations, infrastructure services to communication and information technology. Therefore fairly sensitized for change especially frequency of change that is crucial. The transformations observed, understood, adapted and developing thresholds for more in future is challenging. Having been a mute observer to the global events one felt the need to contribute with my niche wisdom. This book is my input with four decades of professional exposure, awareness and learning that I firmly believe that nations with their rich traditions could add to knowledge base and regional perspectives.

The book has three sections as traditional urbanism, climate change and demonstrated with a case example of the walled city of Jaipur. My doctoral research focused on tracing the sustainability of walled city of Jaipur for about three centuries and with World heritage site status I felt the need to share the learning's at a global platform.

Shimla, India Anjali Krishan Sharma

Contents

Local Terminology Used

Sawai JaiSingh	Name of the king who patronized building of walled city of Jaipur; prefix Sawai means 1.25 metaphor for someone is more than one
Vastupurusha mandala	is a sacred model of Planning from ancient Indian texts of architecture
Chowkri	Indian nomenclature for a block that was used in case of walled city of Jaipur
Chauper	Indian nomenclature for intersection of primary streets that was used in case of walled city of Jaipur
Chattri	a domical roofed structure with four columns that is open on all sides
Jal- Mahal	man made water body developed on the northern part of the walled city, Jal means water in hindi
Amanisha	name of a perennial stream that ran on the western side of the city
Dharbhavati	name of rivulet that use to flow on the east of the city
Haveli	is a large courtyard residence with many rooms
Nahargarh, Talkatora, Santosh nagar, Moti katla, Galtaji and Kishanpole	names of villages that existed on the site of walled city prior to the building of Jaipur
Sanganer	place on the periphery of Jaipur known for Textile block printing
Mirzapur	a place in state of Uttar pradesh known for Carpet and brassware handicrafts
Seesham, Neem, Pipal	local names of trees seesham for timber while others for medicinal vales

lpcd	litres per capita per day
Ramchanderji-chowkri	name of one the Chowkri
Chajjas	Indian term for sun shading projections over windows
Araish	is a top coat that has two base layers in lime
Khamira	is a lime wash
Kund	is a man made water body small ones for houses while large ones for the city- these structures are elaborate with architectural heritage
Stucco	is lime mortar with sand and aggregate often used for mouldings, ornamentation and finishing
Jalli/ Jallis	perforated screens made in stone used for fenestrations often instead of windows
Rs	refers to Indian currency rupee [INR]
Vaid & Hakims	are Medical practioners former practices Ayurveda while later ones practice Unani and Tibeti

List of Figures

Chapter 1
Traditional Urbanism

1.1 Introduction

Cities are about people and their experiences with spaces with their natural surroundings through culture, lifestyles, norms and practices stemming from social, economic and environment. With civilization's communities evolved those nurtured the cities for collective memories from building of spaces to place making; was the very essence of urbanism at large. With cities becoming magnets for economy the same was reflected in the city's fabric and with this shift from social capitol to financial capitol the urbanism got redefined and resulted in global cities with varying connotations from mega cities to global cities smart cities when stimulated by infrastructure facilities and the cities started consuming people. This financial model of global cities resulted in stable developing economies; those at one hand diluted the geographical boundaries for people having access to these cities enriching diversity while at the same time having access to their natural resources as well and the concept of developing and developed nations' was in place, with economy as the common denominator to determine the two factions and continuing. Economy and technology essentially explores various dimensions and addresses that for the benefit of mankind and typically do not make a distinction for geographical location or time line; their response is standard be it old, contemporary, new or proposed. However, the disparity of varying economies jeopardizes social justice benefits unevenly, as profits for a certain section with meeting the needs for the rest and resources drawn from our only planet earth.

Civilizations began from Asia followed by Europe and the rest of the world while the technological innovations propelled the financial models and interestingly that began from Europe. With technology and infrastructure strength their economies flourished and the limits to growth expanded to the globe and global cities. It may be noteworthy that the ancient civilizations contained their growth for their context and enriched with innovation's that were strongly indigenous for optimum utilization of natural resources and the knowledge valued such. In the discourse of developing and

developing economies' pricing were the baseline and the value of things overlooked evident in the global database of GDP, per capita and others. This gap had a universal consequence for climate change for our planet. These contextual cities enjoy rich tradition and cultural heritage with a strong set of values as well. However, globally the heritage is recognized, documented and valued and designated as world heritage sites, cities and others. Ironically the general perceptions that the World Heritage sites including historic cities have to face the challenges of preparing and adapting to climate change have inherent limitations; as the threshold of thermal comfort, energy efficiency is quantified as per global standards. The heritage building stock is strongly contextual and was used by the local communities thus their thresholds' of thermal comfort stemmed from their lifestyles, norms and practices therefore relative. The same has been validated through the scientific studies wherein energy use is determinant by the social behavior often culturally driven as well. With urbanization the global norms are significant and arriving at a range for thermal comfort and energy use shall prove to be compatible; rather than assigning them absolute values. Furthermore these traditional building stock to be dovetailed with the mainstream development planning instead of isolating them as special areas. Such a distinction segregates them from the additional developments, as each city grows with its set of layers of developments; as all the layers co-exist and deliver such at the city level and the people while using the built environs do not distinguish them then as architects, planners to view them separately may be a limited viewpoint. The strength of traditional historic cities lies within themselves and the contemporary development's need to weave the fragile fabric such. Next the culture's in these cities are managed by communities more a spontaneous, innovative, natural response to resources resulting in lifestyles, thus to ensure continuity of cultural heritage the framework needs to be facilitated when the additions occur to the existing traditional cities, that is flexible to respond to the changing needs of the communities over time line. Such a response to nurture the cultural heritage through the mixed land use and the scale of built spaces timely adapted and reused manages the cultural heritage in its natural course of growth rather than monitored. In fact concepts like regenerative, revitalization on the core areas too need to be facilitated as often the core areas are viewed for local handicrafts and rich architectural detailing and spaces that is responsible for the ambience that are typically preserved such with planning initiatives to conserve the areas to be convincingly supported by traditional heritage.

1.2 Urbanism with an Inheritance

Urbanism has come a long way since the civilizations' came up. The early settlements typically mushroomed next to the sources of water bodies especially rivers and later with time, along the trade routes for which the settlements grew across various geographies that widened the context from water edge to hills, plains, coastal, desserts

for varying climatic conditions. Such an array of contexts shaped up the respective urbanism. Population that continued to live in such places nurtured an association with that space and cultures evolved such. Each of the cultures got nurtured further for the respective context evolving into rich tradition, unique for the specific context. Such a system of urbanism prevailed for centuries reaching its pinnacles quite evident in the medieval cities followed with globalization; wherein political and global economy had a paradigm shift that accelerated with automobile, technology and information technology and the urbanism from a traditional context thus got contained as traditional urbanism.

Urbanism is a continued way of life that through timeline recognized as tradition for the local community to be perceived as their identity. Typically characterized with rich architectural heritage but the strong cultural heritage surly dovetailed with that typical way of life. When that way of life got passed for generations on ends up being tradition for the said community touched upon all aspects of life from economy, social, local environment translated such in the built environs with time. This whole narrative has evolved and become more multifaceted including transformations of all. Within this realm the traditional urbanism needs to be comprehended in perspective of traditions of urbanism. Further the strength of such cultural heritage needs to be looked upon and be linked along with all the dimensions of traditional urbanism. Based on the local traditions that have shaped up and continuing, some translated strongly in the built environs while some transformed to richer and complex, while others responding limiting it to their regions at large. Typical perception to outline traditional urbanism does not do justice to define the term; it needs to be laid out meticulously arrived at in a pragmatic way. Beginning with the discourses on urbanization at large graduating to cultural dimension embedded within the narrative of local lifestyles; driven by geographies and the drivers of change of globalization on to the contemporary urban areas. Urbanization has transformed the face of the world more so at the turn of the millennium. Globalization triggered global economy wherein the local geographical context has and is going through a major transformation, widening the canvas across nations and oceans; the attributes becoming more complex and challenging i.e. both natural and man made resources and their related parameters initiate impacts leading to domino effect affecting our planet earth. Further the scale and nature of paradigm shift varies across nations and continents that make the situation more challenging.

The traditions, nurtured a symbiotic relationship between the users and the spaces and often they were typical for the respective context. Such physical manifestation of culture's created urbanism that over time grew in to a tradition. With these traditional communities urbanism grew, expanded and evolved with time underpinned by religion for the set of contextual resources. The traditional communities are culturally rich through the social processes that give them their unique disposition. But globalization draws parallel to the traditional culture's lifestyles as the driver of tradition communities was the traditional culture whilst that of global communities is global culture driven by technology and information sector that scaled up global economy and thereby accelerated urbanization across the world. This brought about a major change in all aspects of life more profound in cities. Globalization initiated a growth

pattern in urban areas that was standard and uniform across all context's when urbanization occurred next to traditional urbanism; the natural process of osmosis failed to permeate in the traditional tissue and therefore the two set exists parallel such. Thus the urban typology initiated due to globalization continued to expand and growth occurred adjacent and beyond the edge of traditional urbanism and has survived the impacts of globalization. The impact of globalization began with the existing stock of urbanism and based on the strength of the local and regional economies the typologies were developed and growth happened. This growth was a paradigm shift and at an unprecedented rate that proved to be unsustainable, evident with the rising natural disasters.

The discourse on traditional heritage has come a long way from a set of buildings to cities, to precincts and continuing survived the impact of globalization and these in the whole debate of conservation of heritage parallel to the expanding urbanization sustainability emerged as important and thus the rich heritage translated as tradition needed to be placed in the contemporary development processes; as the nature of development are different it proved to be challenging and an opportunity as well continuing till date. The two sets of developments are characteristically inhabited by two sets of communities, the traditional one house the local culturally rich communities while the other one is global in nature with diversities of all kinds. This difference is phenomenal in many ways and impacts the spatial utilization and thereby urbanism as well. The heritage studies have proven that the traditions established by the culturally rich communities are key that shaped up the urban typology while the globalization triggered anthropogenic interventions have become frequent and equally diverse bringing in major transformations in the built environments for typology, grain and texture at large. Whereas irrespective of the process of globalization, the culturally rich communities continued with their socio-economic activities in traditional built environments, over centuries these traditional communities responded to the changes and the changes were rationally filtered through the socio-religious and cultural framework and embedded within and adapted but the globalization triggered a paradigm shift, virtually erasing the mother tissue that traditional urbanism stood for centuries.

The global economy patronized by capitalism is gradually diluting the local communities towards a standard global society that has a way of life, which often grows beyond the regional contexts, and bringing in their respective cultures on table in a form that is individualistic rather than community oriented. However technology enables the global society to look in addition to the landscapes of traditional lifestyles, giving one innovative opportunities to explore contemporary needs of globalization through culture and bio-diversity to connect with the traditional urbanism. Thus traditional urbanism is a way of life touching upon all aspects of life forms on the earth disciplined with the contextual environmental framework that are mapped as cultural heritage for mankind. Significant is to register the difference between cultures and traditional cultures as they have stood the test of time and continuing parallel to global culture with an identity of their own. With globalization migration continued that impacted globally, adding diversity of color, caste, creed ethnic groups and others and the cultural diversity that added heterogeneity to the social capital of the cities.

Whilst at the traditional urbanism end cultural heritage, the way of life has been recognized and accepted to be an integral part of cities traditional urbanism. The consistency of way of life is largely attributed to the various dimensions of culturally rich communities. With urbanization and increase in migration the traditional communities continued to be the core for the culturally rich heritage.

In essence the traditional urbanism observes the culturally rich lifestyles to the minutest of detail for optimum resource consumption essentially to, vouching for low carbon lifestyles. As when they developed there was no electricity thus maximum use of daylight was integral, to spaces both open and covered; use of passive systems resorted to for thermal comfort virtually reducing the energy consumption and cities basically pedestrianized that inculcated low carbon living. As attributes of culture and lifestyles are qualitative the changes with time were small for the limits of contextual framework and when migration from immediate hinterland came through the framework expanded to regional and that too proved to be resilient. This transition from the contextual to regional was broadly in the same geographical genetics thus the transition was nominal and changes gradually most of them imbibed by the traditional communities. These various layers in history are legible in the built morphology of any traditional urbanism. The depiction is evident across all scales of built environments from a building to group of buildings to city level for the traditional urbanism that are centuries and few old dating back to almost thousand years. The distribution of such urbanism across the globe is concentrated in Asia and Europe; of which the ones in Europe are relatively popular tourist destinations basically because of good infrastructure facilities supported by climate as well. It's surely worthwhile to note that culturally rich precincts fall back on the traditional lifestyles to be recognized for their rational approach and identities and understanding urbanism for its traditional strength, the legacy of inheritance needs to be mapped such. The value of heritage for a context is integral for any archetypal traditional urbanism that needs to be recognized within the global broadening of values through text and charter's but nurtured by the local community at large. As the recognition shall be mapped contextually to weight them on a standard global scale may not possible, also not appropriate as well for example the thresholds drafted by the global standards needs to reviewed for people as the thresholds are culturally ruled despite the said ethnic groups being a part of the global societies. Thus value of heritage is inherent for urbanism and older the inheritance richer is the value of inheritance and greater the role to be played for contribution to urbanism.

> Traditional architecture and urbanism is not an ideology, religion, or transcendental system. It cannot save lost souls or give meaning to empty lives. It is part of technology rather than style; it is a body of knowledge and know-how allowing us to build practically, aesthetically, socially, and economically satisfying cities and structures in the most diverse climatic, cultural, and economic situations. [1]

Cities on earth are currently faced with the eco-politics and large-scale spatial development is the global way forward and to be under the hammer of new climate regime the humanity is at a point of no return. At one hand we have high-end condominiums with state of art technology and innovation at its best, with ghost town

cities, to large section of people that are home less. The universal vision to address the Social and resources as equitable for sustainability is both complex and cumbersome to rule this disparity in spatial disposition. In the whole debate people are the common denominator and thus inheritance by generations is the key. Studies have validated that in tradition social connotation is central and as societies are culturally driven get translated in built environment and stabilized. When the process was gradual which is its merit as well and is core for cities. The world today is at the cross roads with technology at its best, requires reshaping the future—developing critical perspectives on future material legacies and new heritage paradigms for a post-Anthropogenic earth. It is unanimously accepted that sustainability of the planet is most vulnerable with ample validation just reinforces the gravity of the issue.

The term tradition is perceived as legacy something from the past to be revered upon, something that the next generation be aware off for its continuity, knowledge and cultural connotation as that helps one to connect with one's roots. But with globalization the creative fields have often limited the active participation with tradition for contextual while the global is universal wherein history for traditional identity for both tangible and intangible heritage is conserved for heritage of built environs to acknowledge the historical layer for tourism and related interests. Perceptions are restricting and myth for binding of such rich knowledge. The wider canvas of tradition enables one to analyze the cultural landscape, wherein a set of locally available resources from nature or manmade nurtured by the local population, those gets fine tuned with time for their optimum potential, aesthetics and information for utilization for lives of the local communities of that region, that eventually gets translated as traditional cultures. Typically a culture has its own framework wherein the contextually available resources are the drivers for development of science of tradition and that with time evolves to have an identity of its own. Traditional knowledge driven by culture contains an evolutionary value of progress in the history.

Tradition at large is reflected in all aspects of life i.e. enveloped in physical spaces translated over time to be known as identity of that place for the activities that they initiated, cultivated and perpetuate. Such translations occur across all scales of built environs from layout of the cities to the individual buildings to large public spaces, streets to personal courtyards, terraces and balconies: both vertically and horizontally. One may logically conclude that the traditional cultural knowledge has been integral to development and more holistic in nature. Significant observation in the processes was the pace of change. Irrespective of drivers of change each transformation when recognized was translated and impacted to result as part of tradition, triggered by the limitation or abundance of resources, the application was for optimum utilization as per the need of the local communities addressed. As the scale was limited to the region or local, thus the change too was restricted and commensurate to the contextual scale therefore absorbed by the local population; meeting the need of the communities and often for migrant population as well. Largely these transformations were integral to the processes of lifestyles and cultures, an inherent balance with the contextual ecology and therefore sustained. Typically the traditional urbanism proved to be nuclei for growth and expansion for urbanization across the globe except for the industrial towns that had specific purpose; establishes the significance

of the traditional urbanism at the global level. The stage of human society post industrialization with the onset of capitalism brought in 'surplus' on the table, at production stage, thus for the demand and supply to be at par the delivery end had to be mobilized for which the vulnerable communities with easy access were prey and the capitalists earned more and possessed more in terms of resources. The traditional existing balanced equation of systems got pumped in with more resources and these surplus resources affected the local homogenous community with an imbalance got set in with few possessing these resources and thereby power as well. This shift of the local community to a capitalist few, initiated social transformation for change of scale from local to regional even national in some cases. This transition directly affected the towns to cities to metropolis. Next the Industrial revolution coupled with the scientific innovations in eighteen century took roots and the potential thus offered by technology pushed the capitalist society to facilitate their agenda of power, narrowing it down to a limited few that controlled the resources continuing till date. The paradox of these two stages changed the scale drastically and the inherent balance that existed was unable to absorb the said transitions and impacted the equilibrium that had continued for centuries on. In the whole narrative of urbanism under going major transformations the cultural heritage too had a paradigm shift but the core strength of the cultural heritage that is centuries old continued for its merit, identity standing parallel to the globalization. Typically people and the local cultures acknowledged and carried forward through creative arts and design for their respective identities evident in the hegemony of globalization. Interestingly a closer look at the global culture/society is essentially an amalgamation of a set of local culture's. Further each of the global cities has a typical amorphous culture of both old, new and changing that influences the set of cultures across the continent, nations. In such a scenario people from various countries that migrated to various continents for numerous reasons, have huge presence acknowledged even in global cultures; just validates the core identity of traditional culture and often these traditional urbanism are their adobe.

This critical stage can only be addressed by an integrated approach across all systems and scales structured and shall enable one to arrive at a specific approach that shall be sustainable at this point in time for the framework within which each of the typical urbanism sustains and thrives. The narrative of Industrial Revolution coupled with scientific innovations and technological advancements that got layered with the natural systems and Anthropogenic, as traditions in time line were trans-lated as cultures across the globe. Interestingly the technology has shrunk the world and making it accessible for all, this in some ways have diluted the timeline layers and subjected them to the world for their respective worth. Mankind has perceived history in layers and accepted it as a process of evolution and progress with time. While the cultures that have sustained in their right have under gone a transformation in the recent past. When the latter shift of the local economies to regional, national and global economies; occurred that had a related impact on resources and ecology at large leading to environmental decay continuing till date, the need of greed, to consumption syndrome started consuming resources to cities, regions for its social values, norms and beliefs and altering culture's, our heritage and its continuity. The

relationship between production and consumption by people jeopardized the neces-
sary balance. People are essentially, communities interlaced with cultures that gets
shaped up with centuries on and translated such in our cities and towns; with public
spaces their loud examples i.e. streets, blocks, neighborhoods', large public spaces
and others. With this paradigm shift in economy has impacted the social conno-
tation substantially and interestingly the built environs have been testimony to the
transitions and have responded accordingly.

1.3 Traditional Lifestyles Nurtures Urbanism

Urbanism is a way of life that can be traced through tradition of urbanism since
Indus valley civilization shaped up by the local geography that can be summed up
by the geo-genetically framework within which urbanism was nurtured over time.
As the operative framework was limited to the locally available set of resources with
indigenous technology; the vocabulary that emerged was archetypal and ended being
the identity of the place. The spatial characteristics were translated in the building
typology, urban tissue and built morphology that contributed for place making. With
trade the said framework widened and an exposure to other cultures added further
dimensions to local understandings, the process was gradual and the changes layered
to the local culture were interpreted in the built spaces that became inherent to
the socio-cultural strength of the local community. Such a completion of the loop
proved to be significant for the sustainability of the traditional culture of the city.
Until the medieval period these contextual cities reached pinnacle for their respective
cultures strongly woven with the social tissue, which was displayed as an extension
of socio-economic connotation and despite the growth and expansion, the circular
loop was complete and often flexible for the timely changes if any. The eighteenth
century period enriched the contextual threads and the purity of contextual styles
thus enriched and bloomed. But with industrial revolution, driven by capitalism and
underpinned by technology outlined the global geo-genetically framework for the
world. However industrial revolution and automobile mode of transportation enlarged
the scale manifold and revised the scale of cities to megacities and during the said
transition architects and planners felt constrained with the traditional framework of
development and sought for freedom of expression to be innovative that led to devi-
ation from the typical traditional urbanism. With cities expanding the framework
of contextual extended to regional and eventually to global framework. Urbanisms
adapted, changed, transformed for each hierarchy of the framework and in the process
the symbiotic relationship of the three pillars of sustainability was jeopardized. As the
global contemporary approach deviated from the Traditional Urbanism but interest-
ingly was unable to alter the core socio-cultural strength of the local and that emerged
as the key strength of traditional urbanism such, while the economic indicator being
global had a paradigm shift from traditional urbanism and decisions related to the
global economy impacted the environments drastically. However progress, growth

and development are inherent for people but the pace and nature has grown geometrically with global economy whereas parallelly the traditional urbanism continued its growth governed by the contextual framework. The response of each of the traditional urbanism varied for geographies, nations and regions determined by their respective local economies while the global economy diluted the geographical boundaries to economy driven through virtual zones that panned across the nations. This transition of geo-genetically to eco-genetically framework was possible only due to information technology that transformed the workspaces big time. Also as the eco-genetical framework spread across the globe making the time zones redundant and thus the global economy galloped twenty-four seven and escalated the nature and pace of development irrespective of geographies. With globalization the nations at varying stages of development had to respond to the global norms and standards; the global hegemony became largely visible nice and loud in our major cities. Developed nations with stronger economies expanded for their assets of cultural heritage for tourism sector at the global level that addressed the supposedly smart global city vocabulary whilst the traditional urbanism adequately conserved and retrofitted for tourism i.e. countries in Europe. Where as the developing economies were faced with duality to keep pace with developing economy and meet the vocabulary of global hegemony in all respects. The global economy in place now for almost half a century now when compared with the contextual and regional economies; they continued to sustain at their pace in sink with the local population that has been gradually transformed due to migration from immediate hinterland, to national and often across nations and continents too. With such a backdrop and process of development each of individual cases proved to be sustainable in their own right. Incidentally the traditional urbanism is continuing basically for *economic reasons* either for global economy rather dominant for the developed nations while with local economies continuing for the developing nations thriving essentially because of their *strong socio-cultural strength*, i.e. cities in the Asian sub-continent. An inherent balance that is sustainable; is the very concept for human ecology and Traditional urbanism.

The three pillars of sustainability when mutually complemented maintained an inherent balance that proved to be sustainable. But with globalisation, economy riding high, impacted environment and reducing the social to be rather incidental. Dominance of the two E's economy and environment over the 'social' could not sustain and an imbalance emerged evident in the current scenario. About two decades ago Sustainable Cities program by UN was implemented, as feedback of sustainability indicators among the others culture was highlighted as key social issue, which was never featured in the first set of sustainability indicators for SCP-sustainable cities program. Although the global economy operated in various contexts but the output was largely guided by the work culture of the social context and that further reinforced the cultural connotation. Capitalism drove the global economy for profits, further the work culture's delivered at varying hierarchies with the uniform global economy structure that continued its impact on the environment, ignoring the social often perceived as human resource that is a part of the equation of global economy, operated regionally. This jeopardized the pillars of sustainability, soon enough the

impacts were visible as natural disasters world over especially with environmentally sensitive regions—hills and coastal, resulting in augmented climate change establishing strong need to retain the necessary balance. But as the pace of impact and nature of the respective pillars varies to bring back the equilibrium is a tall order between tangible and intangible, quantitative over qualitative, monetary over cultural and so on and so forth; for which only an inter-disciplinary approach wherein attributes of each pillar has a specific and significant role to contribute, irrespective of their quantum of input especially for monetary gains (Fig. 1.1).

The three pillars of sustainability that got re-defined to the equation of the two E's with the social to be more quantitative rather than qualitative and that has lead to the global climate change concern and has become inevitable to re-establish the equation from eco-environmental to socio-economic for the environment. Currently the social, economic and science are at varying levels and is altering the development and urbanism across the world that is a challenge leading to climate change. In the current scenario with high rate of urbanization to be sustainable inline with contextual environmental framework is emerging as key for sustainability and within that realm, ascertains the significance of traditional urbanism that have thrived for centuries on. In view of the said situation, it is imperative to understand the merits of traditional

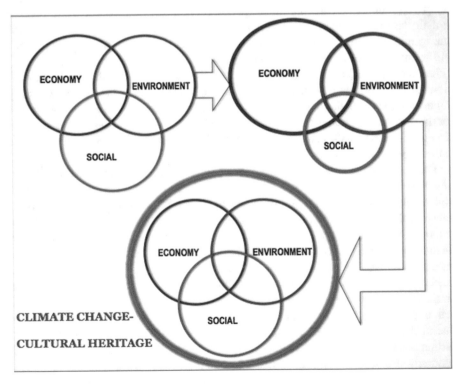

Fig. 1.1 Paradigm shift in pillars of sustainability (Author)

Urbanism of the various contexts and their translation in the built morphology its relevance in contemporary development processes.

Typically for urbanism the threads of continuity are picked up as they are appraised with time and emerges as one of the best practices and recognize the pace with which we need to proceed to yield the best results. The pace of development is the key as the three pillars of sustainability have their own respective evolutionary processes. With the nature of three pillars so diverse thus the pace, scope and dynamics too vary as environmental needs to be consumed at the rate less than its regeneration; while economy be need based over pure profits whereas the social to be more evolutionary layered with rationale thinking honoring the harmony and well being for the local communities; continuing especially from the traditional communities reinforcing their roots. The social pillar evolves gradually and is strongly contextual; whereas economy has undergone a paradigm shift from local to global and socialist to capitalist underpinned by technology having ignored the value systems sometimes even the spiritual religious beliefs of the local cultural heritage has enumerated transitions in social dimensions making it more complex and multi pronged. Further the canvas of context got revised from regional to national and global that had direct bearing on the environmental framework. The positioning of social and economic in the global ecological framework is both challenging and unique at especially this time in the history of mankind. As the solutions to address need to be across all scales rooted in lifestyles of the people and in this whole narrative cultural heritage has emerged as common continuing thread. In the discourse of sustainability with the social aspect to be revitalised as, the key pillar of sustainability, culture emerges as a significant determinant for Traditional urbanism also endorsed by academia think tank and validated such by the related professional forums.

In the current environmental conditions it is significant to be sustainable especially with rapid urbanisation at global level. With current rate of consumption and production augmented by global economy and vice versa reinforced by technology escalated the scale that drastically impacted the rate of growth and nature of development across the geographical boundaries. This paradigm shift accelerated the consumption of resources for greater production for economies to rise and with the demand and supply theory in place for global economy national markets had to be identified for which the developing nations proved to be a soft target. Principally going by social equity, all natural resources are common to the world at large and their significance of sustainability needs to be recognised by all was scarified for global economy whereas stronger economies with sound financial standing at their disposal started taking up initiatives to mitigate the impacts of climate change. While the countries with poor economies experienced the dual impacts one of their developing economies and their limited resources to address the climate change. This inequality fast-tracked the climate change that it is has become the foremost concern globally for the mankind.

As per UN by 2050, 70% of the world population shall be living in cities and thus Urbanism shall play a key role for humanity in near future. The recent past has witnessed one of the fast pace of urbanisation ever in the history. Global economy is largely responsible for this rate of urbanisation and concentration of population

needs to be facilitated for global lifestyles that are taking a tool on resources, leading to environmental degradation, which is posing challenges in all sectors of life. Next urbanisation across the nations with fluctuating economies, are at varying stages of development state of technology. Further as technology is fine-tuning constantly the developed economies has quick to respond whilst the poor and developing economies have a dual setback one of technology and level of technology; this state of affairs takes tool on the resources making the environmental decay even grave with impacts for our only planet earth. With global economy and global cities the traditional framework just enlarged manifold making it a complex web of inter-disciplinary with multifaceted information that is frequently changing responding to the global economy pressures. In this equation of economy and resources the socio-cultural connotation got reduced to matter of fact, as it could not be calculated in the said mathematics, soon to be recognised and thus featured as pillar of sustainability.

1.4 Cultural Heritage Base of Urbanism

It is universally acknowledged that 'culture' is a driver of Urbanism. Culture is a living system and evolves with time with the responses of the communities. Cultures when nurtured created traditions; and traditions that evolved with time demonstrated a symbiotic relationship emerging as traditional culture heritage. It's interesting to observe how a set of local population growing into local communities resulted in rich traditional communities. Processes took centuries to get recognised but the global economies impacted the local communities and when the pace of changes became more frequent it created a gap and in some cases even loss of cultural layers. Social issue related to culture is invariably a gradual process and with time each of the small changes affect and based on the rationale of the local communities integrated within the larger framework of culture to act as one or discarded as redundant when the changes are frequent or irrelevant a shift occurs and a drastic move quite legible in the cultural matrix that often disrupts the continuity of the act of culture. Thus culture is the key determinant to regulate the way of life that regulates the space utilisation for the related activities and thereby urbanism.

As put forth by Rapoport urbanism can thrive only within healthy regional structure that initiated the dialogue about cultural variety in architecture throughout the world, pointing to the way housing form may be a fusion of influences that include local climate and construction techniques as well as the subtleties of regionally distinct cultures continuing with the same narrative. People contribute for cities and communities build Urbanism and the key distinction between the two being the culture. Typically all societies have a culture of their own be it the contemporary global societies or traditional ones. Ironically the basic difference is that traditional cultures are continuing to contribute for the global culture and not vice versa; with migration when people move cultures too move or shift. It may logical to conclude that based on the migration patterns the respective global cultures emerge. As cultures

govern the lifestyles and resources and as that has direct repercussions on space util-
isation and energy use that is significant from sustainability viewpoint. Culture has
been a consistent until but with industrial revolution and more so at the turn of millen-
nium there has been a paradigm shift in the nature of culture itself, making it more
dynamic and transient. When cultures are strong the communities are richer; but
with changing nature of culture the communities are giving way to a set of people
context whose is revised to national and global. Despite the transient nature of culture
at large, the local traditional cultures serve as baseline and the deviations from the
said baselines juxtaposed with other cultures to amalgamate for the global city's
culture. Further the symbiotic relationship amongst the various cultures within the
larger realm of contextual cultures is the key determine for the urbanisation of that
city. Based on the inherent resilient nature of the communities the acceptability of
changes came about and also the extent of changes. The direct relationship between
the global society and its culture in place is exposed to vulnerability of all kinds
thus dynamic fast changing and relatively less stable when compared to traditional
cultures; consistent the culture stable are the communities and thus resilient. Often
the traditional communities are more resilient to changes and also retained their core
strength and even practices; where as the urban population with all the diversities are
more prone to drastic changes or in other words more in line with the global cultures.
At the same time the global cultures too fall back on the traditional ones as a gesture
to connecting to roots or to validate themselves or to break the hegemony of the
global culture to relate to heritage. All such expressions get reflected in the activities
and spaces syntax. In the recent past with changes happening are frequent making
cultures more vulnerable and so the socio-economic attributes that directly impact
the urbanism. The direct impact of cultures on to the built environs and cities typi-
fied such; conventionally the cities with rich traditional built heritage have a robust
display of culture at large. The concern duly recognised by the professionals and their
significance in planning in these urban areas has been addressed both at regional and
international level i.e. historic urban landscapes recognising with their own defini-
tions with parallel efforts as: new urban agenda, traditional environmental knowledge
and similar initiatives accepted that traditional urbanism as enhancing liveability,
health and well being among others. While Historic urban landscapes includes both
cultural and natural values and attributes to include broader urban context for the
respective geographical setting. Layering of cultural values translated as thresholds
and juxtaposition for other aspects—values-social-physical, when translated can be
read through timeline, is the core strength of the culture as it has the inherent value
to be legible, observed and perceived to be read as cultural heritage mapped in urban
morphology through lifestyles.

Traditional Culture and Urban Heritage have a symbiotic relationship translated
such in the cities. With fast pace of urbanization, diversity is becoming increas-
ingly important for cities to be resilient and thereby sustainable. Diversities of all
kinds from social to economic are translated in built environs. Each of the cities
nurtures a typical framework that's inherent for its growth and development and the
framework is specific. The framework is a resultant of deliberate equation between
socio-culture and economy for the geo-political context. Further the urban societies

are constantly transforming due to migration are exposed to various cultures, norms, values, practices and mind-sets. Characteristically each of the traditional urban areas a have a core social capital that is resilient with varying thresholds to selectively accept the migrant cultures and diversities. More over each of the diversities layered largely attempts to adapt them to be in line with the core social capital; initially for their survival and the need for acceptance for practical purposes and that over time often translates as one more aspect of the wider social canvas shaping up as heritage for the city. Typically for each of the social capital, norms values and heritage defines the core strength of people. In the broader realm of culture, the continuing thread is heritage and therefore the key binding aspect as well. However much one may look upon the process of development as linear but with local dynamics in place, gives it a unique disposition as each city patronizing it's own culture; quite evident in its distinctive position among the global cities of the world today. It may be observed where ever the heritage has been recognized and acknowledged in the urban fabric as deliberate punctuation that forms the landmarks' at strategic locations of the city and stand apart for their own strength. Such an approach reflected in the cities has archetypal aesthetics ensuring identities in the hegemony of globalizing world. Global Cities essentially characterized by multiple cultures, have to deal with the dichotomy of local, indigenous ontologies at the same time. Such negotiations invariably are distinct for each city, governed by its social capital and geo-political will.

Urban Cultures that are strongly depicted in common open spaces are a loud expression of culture translated such in urbanism vocabulary as public spaces and public squares. They are the platform for events of cultural activities like festivities and practices of various cultures with global ones rather profound. Mostly in the global cities the contextual framework takes precedence over the other diversities, for example in Tokyo the Japanese cultural heritage is predominant while other cultures co-existing. Thus in the broader terms the resultant heritage of the metropolis evolves as a composite but city specific reins, parallel may be drawn for London, Paris, New York and Sydney among others. Although each of these global cities enjoys a status of world-class mega city but the lineage of heritage gives each one their distinct identity as well that is their strength of the urban cultural heritage. The hegemony of globalization that it's dictating all aspects of lives including how people entertain themselves at individual and community level; in such a realm the heritage connotation emerges as a silver bullet for the city, i.e. the typical entrance gateways of the traditional cities has given way to airports/railway statins/roads all public spaces basically contemporary structures are the forum, wherein the global festivities are celebrated nice and loud; some of the pertinent events being beginning of new year varies from January to April across culture's quite evident in public spaces and institutions, Olympics and others. Worthwhile observation is that the typical culture of the city is exhibited, underpinned with technology redefining the scale and ostentatious of it for people to indulge in the heritage as urban culture. This just validates the strength of the contextual culture that nestles within the traditional built environs and layered with global culture's that is well cemented in the contemporary spaces both built and open includes other diversities resulting in a unique tapestry

for the city. The traditional urbanism proves to be the seed for the urban heritage that needs to understood and perceived exclusively for the respective context, as aspects may be common for all cities but the expressions are unique and specific that uphold the identity of the city over the global hegemony. The new paradigm for sustainable development for the world is tradition and cultural Heritage.

It is universally acknowledged that 'culture' is a driver of Urbanism. Culture is a living system and evolves with time with the responses of the communities. Cultures when nurtured created traditions; and traditions that evolved with time demonstrated a symbiotic relationship emerging as traditional culture heritage. It's interesting to observe how a set of local population growing into local communities resulted in rich traditional communities. Processes took centuries to get recognised but the global economies impacted the local communities and when the pace of changes became more frequent it created a gap and in some cases even loss of cultural layers. Social issue related to culture is invariably a gradual process and with time each of the small changes affect and based on the rationale of the local communities integrated within the larger framework of culture to act as one or discarded as redundant when the changes are frequent or irrelevant a shift occurs and a drastic move quite legible in the cultural matrix that often disrupts the continuity of the act of culture. Thus culture is the key determinant to regulate the way of life that regulates the space utilisation for the related activities and thereby urbanism.

As put forth by Rapoport, urbanism can thrive only within healthy regional structure that initiated the dialogue about cultural variety in architecture throughout the world, pointing to the way housing form may be a fusion of influences that include local climate and construction techniques as well as the subtleties of regionally distinct cultures continuing with the same narrative. People contribute for cities and communities build Urbanism and the key distinction between the two being the culture. Typically all societies have a culture of their own be it the contemporary global societies or traditional ones. Ironically the basic difference is that traditional cultures are continuing to contribute for the global culture and not vice versa; with migration when people move cultures too move or shift. It may logical to conclude that based on the migration patterns the respective global cultures emerge. As cultures govern the lifestyles and resources and as that has direct repercussions on space utilisation and energy use that is significant from sustainability viewpoint. Culture has been a consistent until but with industrial revolution and more so at the turn of millennium there has been a paradigm shift in the nature of culture itself, making it more dynamic and transient. When cultures are strong the communities are richer; but with changing nature of culture the communities are giving way to a set of people context whose is revised to national and global. Despite the transient nature of culture at large, the local traditional cultures serve as baseline and the deviations from the said baselines juxtaposed with other cultures to amalgamate for the global city's culture. Further the symbiotic relationship amongst the various cultures within the larger realm of contextual cultures is the key determine for the urbanisation of that city. Based on the inherent resilient nature of the communities the acceptability of changes came about and also the extent of changes. The direct relationship between the global society and its culture in place is exposed to vulnerability of all kinds

thus dynamic fast changing and relatively less stable when compared to traditional cultures; consistent the culture stable are the communities and thus resilient. Often the traditional communities are more resilient to changes and also retained their core strength and even practices; where as the urban population with all the diversities are more prone to drastic changes or in other words more in line with the global cultures. At the same time the global cultures too fall back on the traditional ones as a gesture to connecting to roots or to validate themselves or to break the hegemony of the global culture to relate to heritage. All such expressions get reflected in the activities and spaces syntax. In the recent past with changes happening are frequent making cultures more vulnerable and so the socio-economic attributes that directly impact the urbanism. The direct impact of cultures on to the built environs and cities typified such; conventionally the cities with rich traditional built heritage have a robust display of culture at large. The concern duly recognised by the professionals and their significance in planning in these urban areas has been addressed both at regional and international level i.e. historic urban landscapes recognising with their own definitions with parallel efforts as: new urban agenda, traditional environmental knowledge and similar initiatives accepted that traditional urbanism as enhancing liveability, health and well being among others. While Historic urban landscapes includes both cultural and natural values and attributes to include broader urban context for the respective geographical setting. Layering of cultural values translated as thresholds and juxtaposition for other aspects—values-social-physical, when translated can be read through timeline, is the core strength of the culture as it has the inherent value to be legible, observed and perceived to be read as cultural heritage mapped in urban morphology through lifestyles.

1.5 Culture a Negotiator of Spatial Planning

Culture is the intangible key negotiator of spatial planning as it determines the utilisation of spaces across all scales from public to private. The earliest rich cultures initiated and nurtured in Europe and Asia and later spread to the rest of the countries. Social, one of the key pillars of sustainability has been central for traditional urbanism; typically the traditional lifestyles governed all aspects of lives from food, clothing to traditional values, practices for consumption of resources including kinship abled for gender connotation, underpinned by religion were innate part of the local community, fostered by vernacular education system to evolve as Cultural heritage duly translated such in built spaces and more pronounced in public spaces in streets and squares. The sensitivity of cultural heritage translated for norms and practices by the people was executed across all hierarchies of built spaces within homes for families and clan, within streets for the neighbourhood while in public open spaces for gathering of people of the city. This symbiotic relationship was strongly contextual and patronised by governance and Institutions and facilitated by framework-legislation. System of systems' added up for the wisdom of knowledge for generations on for the respective context and is insightful for the consumption

pattern, Indigenous Technology outlined by traditional lifestyles. Lifestyles driven by culture and vice versa decided the utilisation of spaces conventional families nurtured a strong bond amongst the clan for the residential neighbourhoods while activities housed in streets and public squares established the harmony amongst people and communities of the city.

In history culture was nurtured by social connotation driven by geo-political boundaries whereas currently global economy is driving political decisions; with geographies and social incidental. Typical cultures thrived with a symbiotic relationship with the socio-economic context; timely adapted to the political scenarios prevalent i.e. during the medieval period fortification was inherent for security reasons irrespective of the context, for which quite often the natural features like rivers, landform etc., were exploited, a logical and rational decision to economize on the building materials, construction costs and minimum alteration to the natural landform and the list continues, the significant is the approach. Such a systematic approach can be observed in traditional urbanism; from planning to building detailing and this consistency vouches for a comprehensive and holistic methodology that was in place. Accessibility and entrances have always been significant in all cultures and their translations in urbanism are evident in the built forms too. Many a times the entrance gateways were celebrated to highlight the status of the city and if there were more than one gates then the hierarchy determined the scale, level of detailing, orientation and so on. More often the gates oriented towards rising sun had cultural significance and the main entrances for kings/nobles, guest visitors etc. Further entrances signify beginning's thus important in its own right, a cultural connotation that is depicted within disparate contexts. Thus each of the traditional urbanism exhibits sensitivity, while may vary for the weightage given to an aspect over other normally contextual driven or ruled by the religion too in some cases. Interestingly irrespective of the cultures the key concerns of social are similar while their translation in norms and practices often governed by the context. Key milestones of life cycle i.e. birth, death, marriages and others established the harmony amongst the communities. Clan that bonded and continues to be equally important in global communities as well with practices modified just reinforces the cultural connotation. The traditional cultures facilitated the liberty of personal expression within the contextual framework and often the individuals those were high up in the social ladder due to position or being rich did go over board for resource consumption defined by the individual aesthetic sensibility as well was exclusive, but ensured the continuity thread of culture at large. The main observation for the said understanding is that the set of principles ensured everyone's presence recognized confirming the necessary harmony amongst the clan, community and the city. The personal and public spaces that housed the set of cultural activities were the key backdrop, contributing equally for the practices. But in the recent past the set of events are perceived as culture rather than the intent and this shallow perception leads to skewed sensitivity of traditional cultures. At the same time we also have case examples wherein these personal and public spaces have responded for the needs of the changing times for example with modes of transportation from horses giving way to automobile and occasionally these public spaces celebrate their glorified events occasionally; now for tourism sector that makes it

superficial to be imbibed as culture but rather a cultural product that may be traded. Negotiations of public open spaces for tourism celebrates the spirit and makes it a holistic experience are often limited in their own way. The debate is beyond the connect of activities and the spaces but planning principles, scale, proportions, and symbolic connotations to detailing could prove to be of relevance even today as the times when urbanism took roots they lacked infrastructure like electricity, water and means of travel was pedestrian which restricted the growth of the urban centres' was largely low carbon living and thus sustainable. Although in parts' some of the solutions, as fundamentals continue to be common and thus may be relevant even today i.e. passive systems and principles of thermal comfort are worth introspection among others. Therefor it may be logical to conclude the strength of Cultural Heritage for Climate change.

The cultural heritage is in transformation today and with a pluralistic approach in theory and practice of conservation doing justice to it in a changing world, is to consider as part of a worldwide cultural, environmental, economic and social policy [2]. Although social and culture are two sides of the same coin but culture governs the three pillars of sustainability. The key contribution of cultural heritage is of resources' from production systems and related energy use to consumption pattern by the local community. The geographical context proves to be an opportunity within a limitation. Figure 1.2 demonstrates the how the contextual framework contains the pillars of sustainability with cultural heritage as the fourth pillar, while the overlap of the related issues outlines the scope and inter dependence amongst each one with sustainability at the central core of it. This deliberate balance is typical for each of the traditional urbanism; as each of the geographical context vary the dynamics of the balance too is unique reflected such in the built environment, also illustrates the potential of the new paradigm in bringing together cultural policies and politics.

The set of local resources defined indigenous solutions and local technologies, which were specific, evolved by the wisdom of knowledge, that over generations shaped up as traditional knowledge. As the contextual framework limits the consumption of natural resource and further the same carried forward for production processes as well results in archetypal products' that are unique for the contextual. Such an approach lends identity too that is cultural specific which hard to get marginalized in the hegemony of global scenario. This understanding between environment and economy governed by the geo-politics and technology both have been changing frequently especially in the recent past and thus affects sustainability. Next although relationship between environments and social when nurtured over time shaped up as culture often continued as norms and practices but policy decisions by the local governance intervened for profits to enrich the economy were not necessarily sustainable. The impact of global economy affected the balancing act of three pillars of sustainability social was adequately aligned with the economies of local resources, as it existed in the traditional practices. However in the initial phases the numbers were quantified but the desired sustainability was disturbed and cultural heritage the key connotation of social emerged as the fourth pillar. The cultural framework determined the behavior pattern of the local community outlined as norms. Such behavior pattern were/ are often dovetailed with religion to ensure the continuity as practices

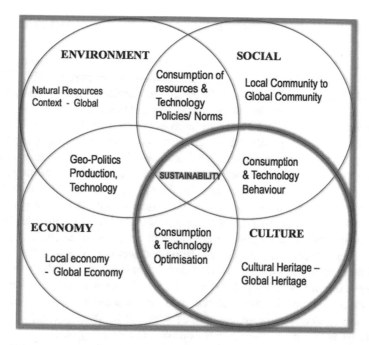

Fig. 1.2 Culture heritage and sustainable development (Author)

that are inherent to the cultural heritage. The rationale of practices continued for generations on with timely fine-tuned as well, displaying the resilient character of the core local community, the social capital. Habitually the DNA of the people too was typical for each of the local communities and with that came in the threshold and their abilities to develop indigenous technologies, develop production processes, consumption of resources' to the standards of thermal comfort level too and all these shaped up their lifestyles and are directly proportionate to the energy consumption, that was low carbon living and thus sustainable.

Addressing the challenge of aligning efforts and advancing new thinking with cultural mode of production; in the pursuit of a true globalization with harmony and moderation, a study of Kanazawa, Japan, focused on the operationalization of local distinctiveness through a new 'global yet varied' social and production system model (Sasaki, 2007). From a sustainable city perspective, decisive factors are: (a) unique character and specialties, based on a city's traditions and culture; (b) creativity and the ability to adjust to new circumstances; and (c) cooperation between residents and the local government. The paradigm of culture and sustainable development entails silver bullets widening the scope and width of what we currently understand by cultural policies. Committee on Culture of United Cities and Local Governments in an attempt to visualize the new components of cultural policies developed a 'new cultural policy profile', which included the current 'inner core of cultural policies' and added the new components that emerged that culture is related to sustainable development [3].

1.6 Phronesis of Traditional Urbanism for Climate Change

The quintessentially question for the Cities on earth for climate change a judgment of the geo-politics and design of spatial development to face the new climate regime lead to addition of culture as fourth dimension to reinforce sustainability. The two degree limit was taken up by nations included as strategies in planning policies and implemented such also assessed through scientific, meta studies, analyzed and evidence based outcomes integrated to fine tuning the strategies completing the loop for them to be sustainable, stable and growing economies are in a position to complete the loop but the poor and developing economies due to lack of research and resources are limited and struggling to complete the loop. Nevertheless, the challenges are diverse; the solutions too need to be specific within the framework of geopolitical for one to deliver; where such infrastructure and resources are available. However the cultural dimension often underpinned by religion is an added challenge, as it is more prevalent where social capitol is strong and therefore impacts. To recognize cultural heritage in the grammar of traditional urbanism through the geo-political strategies and developmental policies for climate change is significant. The global agenda needs to be translated at regional level implemented at geo-contextual, level assessed through scientific research studies with and feedback revised polices and strategies for improved performance to complete the loop (Fig. 1.3).

The universal acceptance of cultural heritage is significant as social pillar of sustainability for climate change as the system of social stratification in traditional urbanism varied from color/caste/creed/ethnicity and others that decided the hierarchy within the community and thereby access to resources. The aspects of traditional lifestyles echo the hierarchy for norms and practices as well i.e. higher up the hierarchy elaborate are the practices' that are directly related to resource consumption and for the notion of connecting to the roots each of the generations had a

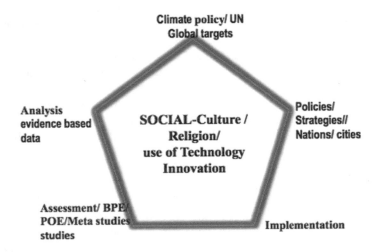

Fig. 1.3 Pentagon loop of Climate change (Author)

tendency to carry forward the traditional practices and the rationale often ignored. The drivers of globalization are nurturing the rationale approach whereas the traditional communities timely reviewed the relevance for respective standpoint and often the translation of norms and practices redefined in creative and innovative manner keeping sustainability in mind and thereby attended climate change until the recent past. With information technology the global society has standardized the life styles for example if illustrated for food the top twenty super foods are in demand irrespective of the DNA, regions and contexts while the traditional foods were climate specific, season specific, occasion specific all related to the natural cycles of production and availability. While the global norms are jeopardizing the traditional foods and increasing the demands of such foods that has increased carbon footprint; often energy intensive for production and transportation costs so as to be accessible for global community to be patronized such. Parallels can be drawn for others aspects likewise for food and such a mindset with deviation from tradition for namesake is accelerating the impacts on environment. Thus the rationale and systematic approach of traditional communities need to be put in the forefront for their merit, strength and relevance over vogue. The hands on practical indigenous knowledge passed on for generations is truly a wisdom of knowledge that is contextual praxis that is gaining awareness basically due to tourism sector (Fig. 1.4).

Typically the traditional urbanism advocates socio-economic pursuits that are essentially climate responsive reflected such in their norms of lifestyles. Research studies have confirmed that with passive systems in place are effective and enhances the building performance and reducing the gap with respect to the global norms and thus the energy demand reduced substantially and that too is a help to reduce the carbon emissions. Our historic building stock is a huge repository that demonstrates traditional practices that achieved thermal comfort and low carbon living thereby to minimize energy demand. Engaging with traditional knowledge, one may be much closer to achieving our climate goals for the built environment. Also with adaptive reuse the component of embodied energy shall reduced substantially as embodied carbon in construction accounts for 11% for GHG emissions [4].

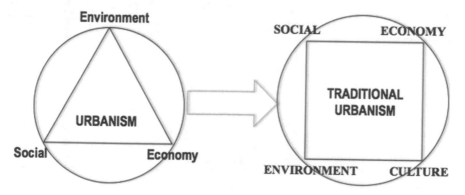

Fig. 1.4 Sustainability redefined with culture for traditional urbanism (Author)

The living traditional cities for centuries on responded to the parameters added from time to time i.e. migration, services to technological innovations. Conventionally each one integrated with the local community for re-densification, addition and alterations for the traditional lifestyles. The infrastructure facilities and technology provided for flexibility of working hours that increased the energy demand and continuing although modernized with technically equipped work culture helped while transportation of handicrafts added carbon emissions; largely driven by geo-political decisions that outlined the hours and standards increased the energy demand and as transportation enabled expansion with no limits impacted environment all the more (Fig. 1.5).

Deviation from the traditional systems is one of the significant aspects of globalization. As the global economies flourished the production spiraled and intensified the consumption beyond rationale. The mass production and mass consumption is in contrast with the traditionally crafted products that were limited; rich with detailing and being contextual enjoy their uniqueness and interestingly the markets valuing their worth such. However, as each of the traditional cultural heritages is apart of the system and the implications of production consumption and markets had an inherent regulatory system. But the spiraled demand escalated the energy demand and related resources, and technology contributed to microclimate proportionately. With climate change on high priority the technological developments frequently focused to improve efficiency however the up gradation such was often not translated such at ground zero with costs involved and often the negotiations of larger interest of global economies over looked the regional contextual initiatives to be abreast and mitigate for the said impacts often got sidelined. Therefore going back to the fundamentals wherein the production, consumption and tradeoff may be worthwhile for a relook. The global economy largely focused on financial model that

Fig. 1.5 Dimensions of traditional urbanism (Author)

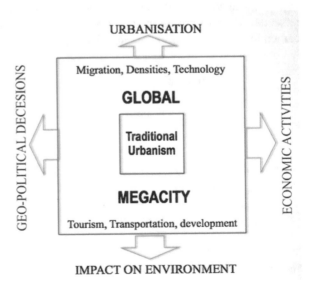

was guided by numbers and lacked the social qualitative aspects considering out of the seventeen SDG majority of them have strong social connotations. Talks of circular economy within the realm of global economies and its impacts for regenerative economy, and other regional and local initiatives echo the system of systems the traditional urbanism vouched for, which delivered. Broadly the narrative refereed to the paradigm shift and the relevance of age-old traditional systems and a rational approach for a system's perspective: linking eco-cultural sectors, technologies and consumption patterns; as fundamental of culture is beyond diversities of any kind be it caste creed, ethnicity and diversity of any type but transcends for the needs of he people for the time zone and thus may prove to be the unifying thread to address the issue globally with same language. The decisions of global financial model implemented uniformly in nature irrespective the geographies and contexts have escalated the climate change issue. Such an approach affects the environmental, economic and social but if addressed through cultures for each of the geographies that patronizes a specific culture and that can contribute for the balancing of the pillars of sustainability. Noteworthy is that each of the local culture's response was specific and tailor made for the context to yield the universal target to be sustainable. For example technology is for mankind but decision needs to be in place based on the geographical context; as for developing and poor economies labor intensive production systems may be logical to bring in necessary social equity and facilitate capacity building while the use of artificial intelligence through apps among the stable and developed economies may be appropriate. Typically the global economy addressed the production systems as uniform, irrespective of the context in the name of maintaining standards that needs re-consideration as the input for the state of nations varies. Globalization driven by economy has been the sole determinant for decision-making across all platforms beginning with economic activities facilitated through geo-political and governance and cutting across the contextual framework to regional and national level. As identified earlier we have two sets of traditional heritage cities as static and living irrespective of state of economies the thrust was uniform across the world. Typically the former ones are loud examples for tourism and impacts are directly related to preserving and conservation of the buildings, precincts' or zone and to cater to the needs of all activities of the tourism sector; the scale of intervention was arrived by the status of the heritage and the target population likely to visit. Carrying forward the said narrative the challenges may be summed up for each one respectively.

Having accepted the universal strength of Traditional cultural heritage; the classification and categorisation from regional to national to global level needs to be acknowledged distinctly. The traditional heritage may be recognized by the scale and typologies i.e. if the building is a religious structure then the responses are specific essentially based on the social norms of the local communities. Typically the streets leading the site characterised by the practices and related products retailed such while the accommodation facilities may facilitate for economic strata accordingly. Whereas in case of a UNESCO world heritage site the accommodation is likely to be for all sections of the society from high end to dormitories. Thus based on the facilities to be provided the visual connect and proximity are key for which the built

texture or grain often gets altered and in such a process if a layer in history may lead to permanent loss of typology, rich architectural style and planning principles may also be sacrificed. When facilities for tourism sector are attended sometimes the infrastructure facilities retrofitted such that may not be efficient due to financial limitations and further with regular technology upgraded the necessary changes may not be reflected such adding to energy demand. These processes have an impact on the spaces especially open spaces that impacts the visual character and experience of the traditional ambience; elaborate the facilities complex is the detailing. To feed these economic activities the work force required might encourage migrant population to make spaces available for accommodations, eateries and retail the individual ownership that brings about a change, which may be a permanent change. Conventionally the ownership is limited to the traditional community, which is matter of pride, identity with a sense of belonging rather than the monetary value. Thus very often the real estate prices of the properties in the traditional cities are very high and neither available nor accessible as the properties limited and invariably required the social approval from the local community; a cultural connotation abided by most. Broad observation suggests that gentrification in the living traditional cities were as the core population were resourceful and aware, encouraged technology that helped energy efficiency. Ironically culture in traditional urbanism has become a product an intangible heritage for tourism sector that added for the local economy. However the traditional food, artefacts are products for retail, frequently upgraded with technological innovations that have its own strength from creativity perspective. Also good infrastructure in place encouraged tourists; the scale got enhanced and the local economy flourished; and that encouraged further expansion of the facilities both in scale and nature as well. The process had substantial impact on energy use and impact for climate change.

The transition of local community occurs regularly with migrant population attracted due to economic opportunities and re-densification that adds to the growth of population. The rate and scale of change in the social composition depends on the nature of migrants, education, awareness and other issue when the rate of change is gradual the transitions gets embedded within the local community over centuries and generations on but the essence of social capital of traditional urbanism is that all these diversities get imbibed within the core strength of the local community. This is largely due to the resilient characteristic of the local community and thus to gauge the climate change and energy the traditional conservative behaviour often aligned for energy efficiency. The spheres of change at the regional scale have opportunity of technology to be responded and acceptance reflected as behaviour change by the local community including mitigation and adaptation as well. The narrative sums up, as the strength of the social capital to that is most pronounced in traditional urbanism thus intervention of any kind needs to be contextually aligned with it to yield desired results for climate change i.e., approach including the social dimension of (historic) cities and the involvement of the local community in the decision-making for any intervention be constructed to propose measures and alternative scenarios to monitor the impact of urban development on the traditional built fabric including the social one [5].

With urbanization the traditional urbanism expanded beyond the city walls to it's immediate periphery. Each intervention from within to the edge or immediate peripheries had interdisciplinary issues. The foremost was the scale of development; the new construction adds much more carbon dioxide due to building materials, construction technology, services, energy use and transport. Technology escalated the scale and gave options for thermal comfort using air conditioning that consumed high energy that got fine-tuned with time for energy efficiency through technology, research, development and transportation facilitated the urbanization at the cost of energy. However efficient the transportation systems may be but when the fundamentals deviated such growth at an unprecedented scale proved to be a threat. Real estate sector triggered the model of development that was based on as a business model with buildings products of high value with high-energy use versus the core traditional precincts' buildings Kyo Machiya, courtyard houses, and traditional mixed land-use residences among others. The scale of traditional urbanism was of walk able cities ruled out modes of transportation that had energy use. Such an approach limited the scale of the traditional urbanism and facilitated migrant population through re-densification that lead to compact cities. The pressures of global economy lead to the growth of the city to extend beyond the city walls or boundaries coupled with the nature of development that deviated from the traditional urbanism and was typically high on energy use. The worth of the walk able cities as new urbanism for the lessons learned has the potential be duplicated i.e., use of the passive systems for heating costs in Europe and cooling costs in Asia and Arab nations, among others. Research studies demonstrate that densities are directly related to energy use and the built morphology and the contextual geographies and climate determines building typologies to be either compact or sparse. Compact cities are characterized with low-rise high-density typology and accessible within ideal walking distance contributes for low carbon living. There exists evidence of strong correlation between energy consumption and urban density; according to some studies each doubling of average density is associated with a decrease in per-household vehicle use of 20–40% and the corresponding decline in emissions. A study of GHG emissions in Toronto 8 concluded that as the distance from the central core increases, the share of automobile emissions begins to dominate the total [6]. Among the developing economies there exists a range for modes of transportation i.e. manually pulled rickshaws, two wheelers, automobiles, buses etc. with this hybrid modes co-existing the speed of the traffic is slow by default reduces the accidents risks but time taken for each trip is relatively longer and relatively low on energy too. However within the traditional urbanism the mode of transportation the fastest is walking or by manually pulled rickshaw's that does not need any fuel and thus environmental friendly provide job opportunities. Often such a model is duplicated among residential condominium outside the core area of the city, its interesting to note that when the people commute within traditional cities their response to the modes of transportation is likewise irrespective of their place of residence either within or outside the traditional city; this demonstrates the cultural mindset of adapting to facilities as available and largely managing with what one has. Such an approach is socially engaging and culturally reinforced the slow pace of movement enables the commuter to look around, visually

participate with the built environs' and connect with the streets at large; an experience that reinforces the identity and sense of belonging and despite being a tourist conducts as an extended part of the local community. Thus when it comes to climate change communities' matters for de-carbonization and related climatic issues.

Typically traditional urbanism exist either as stand-alone or as core of mega cities and interestingly most of the global mega cities have a traditional core i.e. London, Paris, Tokyo, Beijing, New York and so on. Although contextually governed the state of economy and governance respond to the transformations that impacted the energy use, carbon emissions and climate change. Strategies and approach need to articulate the specificities to address wisdom of knowledge that exists, well demonstrated in the traditional urbanism. To make a difference at the ground zero the impact of Global transformations for climate change is a matrix with four pillars of sustainability contextually implemented, reducing the gap between policies and Building Performance Evaluation, Post Occupancy Evaluation and other such related research and meta studies. Parallely one does come across isolated sustainable residential condominiums though with gentrification biases that exhibits traditional urbanism principles. Pragmatic understanding of Traditional Urbanism for climate change triggered by globalization that impacted the world and cultured hegemony that side lined the diversities including the strength of traditional urbanism. The traditional precincts are part of the cities so the policies of city as laboratories maybe uniform for its cultural heritage well nestled within the contextual framework. Wisdom of knowledge in traditional urbanism contributes for sustainability: Social—in transition, evolving and diversifying; economy—paradigm shift from traditional to global; environment—economy driven with set of contextual resources' and lived in such. The fourth one cultural that tied up the three dimensions and all these dimensions' of sustainability housed in spatial framework of built morphology of Traditional Urbanism—set of planning principles, systems and designs that stands for efficient and flexible utilization of space, an identity within this realm of symbiotic relationship between man and nature. Passive systems analyses the parameters of the heritage houses to explore the impact on the human thermal comfort and energy consumption compared with the typical modern houses shows how these houses depend on passive design to control solar gains, and decrease heating and cooling loads keeping a good level of thermal comfort inside [7].

Global economy initiated financial model for sustenance and developmental of traditional urbanism especially through tourism sector with additional, alterations and interventions at various scales. When such an approach is in place for living historic cities then the thrust needs to be rather inclusive prioritizing the local community their economic activities dovetailed with tourism sector as additional; or else the thrust is more on conservation virtually freezing the cultural heritage. Considering in traditional urbanism cultural heritage is living, evolving, growing and responding to time therefore a robust and potent resource and with preservation may prove to be skewed exercise's as the room to evolve, grow and fine tuning may get shelved such. As put forth by Archaeologist and heritage professional Graham Fairclough that the obsession with physical conservation became so embedded in twentieth century mentalities; it is almost as if one is not allowed to be interested in the past

without wanting to keep or restore, the remains of the past, which seem to exist only to be preserved. The wide range of how the past is used by society has been reduced to the literal act of preserving its fabric [8]. Thus the strength of traditional urbanism is much more than the rich visual architecture but for the synergy between environmental concerns and sustainable living aptly demonstrated through its built environs that is ready reckoner for nature of development for future cities; narrative summed up by NHS. What National Health Services does is life saving as it is the largest health sector organisation in UK. But what the arts and social activities do is life enhancing. "Yet these places museums, galleries, historic buildings] can help with recovery from the current crisis by bringing benefits to national mental wellbeing with relaxing, peaceful, unpressured but stimulating environments" [9]. "The social benefits of heritage range from increased social cohesion and a greater sense of identity to improved wellbeing and better learning and skills outcomes." Heritage is unique in providing a sense of community cohesion, an opportunity for reflection, and an understanding of place. Heritage helps individuals who would otherwise be at risk of exclusion from mainstream society by teaching them new skills. These skills stay with participants long into the future.

References

1. Salingaros N, Krier L (2001) The future of cities: The absurdity of modernism. Available on https://www.planetizen.com/node/32
2. Petzet M (2009) Conservation politics in a changing world. International Principles of Preservation, Monuments and Sites XX, Berlin
3. Duxbury N, Cullen C, Pascual J (2012) Cultural policy and governance in a new metropolitan age. The Cultures and Globalization Series, Vol. 5, Sage, London
4. Gambardella. Carmine Le Vie Dei Mercanti International forum. http://www.leviedeimercant i.it/
5. Historic Urban Landscape Report of the Second Consultation on its Implementation by Member States (2019) UNESCO World Heritage Centre
6. Burgess's Earnest; the City (1925)
7. Calthorpe P (2011) Urbanism in the age of climate change. Island Press, Washington, DC. ISBN 978-1-59726-720-5
8. Historic Urban Landscape workshop methodology project by EU (2018). https://www.clicpr oject.eu/historic-urban-landscape-workshop-methodology/
9. World Bank Report (2001)

Chapter 2
Epistemology of Traditional Urbanism

2.1 Introduction

One of the popular school of thought on traditional cultures appeared around the conceptual idea of recognition of cities or settlements as an organism with a life of it's own drawing from its immediate natural resources for their growth and sustenance over time, richer the tradition robust was the growth while the narrative of tradition drew from both natural and manmade resources through socio-cultural framework. Rich cultures are a result of years of nurturing of the traditional communities that manifested as ecosystem having systems of systems, which was holistic and often inter-disciplinary in nature, that resulted for their typical identities. Further the traditional urbanism can be seen in the physical manifestation of the city a resultant of numerous layers that were depicted and translated, often timely responding to the needs of the local communities for their contextual framework. Thus the built spaces prove to be resilient to respond to the changing needs. Flexibility has been inherent for the living traditional cities for centuries on and the strength of the urbanism thus reinforced, profound example are the public spaces quite often they are the visual image of the traditional cities often acknowledged as the identity of the place. With such a perception when traditional urbanism is deciphered the mapping of various layers are evident both for natural as well as manmade.

Birth of any traditional urbanism began with the selection of site, the location where the city was to be built. Typically the earlier ones were located next to perennial source of water and gradually mushroomed along the trade routes a prominent example is that of the silk route. Next the mode of transportation decided the number of towns or cities to be spaced with political and security being key concern thus walled cities. Conventionally the natural landform i.e. hills, hilly outcrops, water bodies, thick forests and other natural features exploited to aid the site selection for the city and further layout planning executed based on the geographical and the socio-cultural context. Climate chiefly determined the typology of the built morphology as daylight had to optimized for efficiency and thermal comfort for the ease of livability

A. K. Sharma, *Traditional Urbanism Response to Climate Change*,
Advances in 21st Century Human Settlements,
https://doi.org/10.1007/978-981-19-4089-7_2

of the city. The mode of transportation was pedestrian and carts driven by animals for goods thus the scale got determined. Each of the traditional urbanism is walk able from one end to another whereas the location of the immediate town at a distance that could be covered by the mode of transportation available then. The arrangement saw birth of settlements and towns following similar models of which some grew into noticeable examples of traditional urbanism.

The walled city with fortifications, gates had limited access, that ensured safety and security; a prime concern then for the inhabitants was further reinforced by the natural landform exploited proved to a logical approach. Thus entrance gateways of traditional cities were strategically placed in the layout plan and often celebrated as well a kind of prelude to the city within. The gateways displayed rich architectural detailing, grandeur and ostentatious in scale and detailing were an expression of rich cultures'. The layout of the entrance gateways with fortifications contributed for the visual image of that city i.e. the fort wall inter spaced with natural hilly outcrop/ forests and also structural system punctuated with bastions' for viewpoint adds for the skyline and silhouette of the city and relates with the identity of the traditional urbanism as well. The geo-contextual aspects were key determinants for 'where' the city to be laid out with while 'how' was governed by sacred planning texts and what to be decided by socio-political, the prime locations in the layout plan was the privilege of kings, nobles, priests followed by the social hierarchy reflected in the layout of the city. Allocation of the social groups gave added security to the kings in the Centre or at a high-elevated location. The social hierarchy under pinned by religion governed the layout of the city with main public spaces and street patterns for their scale and areas to provide for community activities and social interactions; were arrived at for the cultural activities determined by resources facilitated by the geographical location. The street patterns sub-divided the fortified cities in blocks wherein the social hierarchy was super imposed with the central block being the safest allocated for governance, administration, religious structures with key administration offices and key public space as well and the layout to buildings continued. With such a layout in place, land use was assigned to the blocks as social connotation was the key so the logical planning approach was mixed land use to limit the residence and work; habitually similar activities got concentrated within neighborhoods'/ condominiums that gave them opportunity to share the infrastructure if any with peer learning for value addition as well strongly reflected among the local handicrafts. Interesting observation is that they lived in harmony and with a healthy spirit rather than competitors. The system of street pattern was largely determined by climate and movement of sun; as the streets were basically pedestrian circulation had to be thermally comfortable by layout of the buildings i.e. the hot climate main or primary streets oriented at east west axis as they were shaded during the day except late evenings while secondary streets relatively shorter were oriented north south, sometimes covered or semi covered corridors or fully covered as in case of the famous gold souks in Marrakech, with *Traboules* in Lyon, France. The street patterns were laid out so as to provide comfort during the daylight, protect from harsh winds, dust and other natures' aspects that denied thermal comfort were key determinant of the typology of the traditional urbanism. With growth prospects in

cities migration occurred from immediate rural areas and urbanization occurred at another level with transformations, re-densification of the mixed land use residential blocks and interestingly the built morphology transformed for additional densities retaining the grain and texture of the city at large. With technological innovations infrastructure facilities were super imposed on the existing urbanism that was a necessary evil and a challenge as well as the existing built environs' were not planned such but even the transformations due to services were laid out amicability and delivered too.

Traditional cities have also been layered with transformations due to political decisions, social changes, economic growth, regional connotations including super imposition of infrastructure facilities i.e. electricity, individual water supply connection to technology interventions in the recent past. Layering the urbanism responded for flexibility to accommodate and it facilitated the users. But super imposing the network for electricity and water supply altered the visual aspect of the place, a concern that affected the Imageability of the urbanism character that got aggravated with information technology as well. The impact was inherent too beyond the visual as it brought about a paradigm shift in consumption patterns of the local communities due to gentrification and tourism sector that revised the thresholds of comfort. With electricity available 24×7 the working hours got extended and more production and economic base expanded to regional level and gradually to international level with information technology faculties. Demand for electricity increased for heating and cooling spaces as the diversity of the users grew from regional to national and trans boundaries.

Technology is for the mankind but the global economy seems to have inversed the relationship and impact is omnipresent. In this narrative, significant is the placement of lessons learned from traditional urbanism those that are relevant, even today. To achieve sustainability and completing the loop needs to be self-sustaining, the way it did for the contextual framework of traditional urbanism. Thus the contextual framework of urbanism that got translated to global now needs to be tailored such that the respective traditional urbanism with the global connotations modified to facilitate the contextual rather than the other way around as it is occurred in the recent past, one is aware of global standards that are implemented need not be the norm. In this respect the time tested traditional urbanism that embody the essence of socio-cultural that accepts and rejects the technology with impacts well recorded in numerous scientific papers for energy issues are a testimony to revisit them. The way culture has emerged as key for sustainable development, parallel the role of local economies in the global economy is a strong pointer that traditional urbanism has to offer. Although the nations with poor or developing economies count on the existing continuing traditional economic activities and continuing such but with global economic activities patronized by political, will enlarged the scale that does not fit within the contextual framework rather creates a scenario of surplus. Despite the pressures of globalization the traditional urbanism has survived, thrived and stand tall for their merit for tourism sector today but the other dimensions of traditional urbanism are also getting recognition i.e. regenerative economy and traditional environmental knowledge a

huge resource not adequately documented and each ne studied at regional level, few shared at national and discussed at intervention level that needs attention as for the same geo-climate zone the solutions may prove peer learning surely an asset for the world.

2.2 Selected Theories of Traditional Urbanism

Typically each of the traditional urbanism is rooted to ancient scriptures especially Asian and Europe, in addition to their strong respective contexual framework. While some of the contemporary school of thoughts on planning often refer to few dimensions of traditional urbanism in one way or the other i.e. migration, urbanisation and technology while security is a major issue resultant due to imbalance of social cultures largely driven by capatilist economy and natural resources, oil being the foremost often lacks the sensitivity of the roots. While walking through the narrow lanes of Carcassonne in France, Fez in Morocco, Isfahan in Persia, Banaras in India, one feels that one is in an ambience that touches one very deeply. It is another space, another place. But our present day worldview prevents one from taking such an experience seriously. Today the worldview has reduced human being to molecules moving randomly in space; City as a reflection of the human body.

References of many of the ancient traditional literature on historic cities on Islam, Hinduism, Chinese, Christianity and other traditions draws on conjectures i.e. the human body parallel to a city with its socio-political functions. Book by Ibn "Arabi" celebrated Andalusian mystic, refers to divine governance of the human kingdom and indicates its content as 'how to green the city or kingdom of human state, whose functions are compared to that of the body. Rasa"il ("Treatsis") written thousands of years ago in Basra and Baghdad by "The Brethren of beauty" contains a whole section on how the body is like a city. (Al-tadbirat al-ilahiyyah fi islah al-mamlakat al-insaniyyah) It is the body that is understood traditionally, which means the locus of the confluence of the physical, the psychological, the emotive and the intellectual, and the spiritual, which is not to be confused with the psychological. The Kabah in the heart of the city centre corresponds to the human heart. The space of the cathedral symbolizes in the form of cross the body of Christ. In Ming Tang in classical China; three-dimensional magic squares dominated the numerical symbolism, symbolized the marriage between the Heaven and the Earth with emperor being the bridge between the two representing precisely the function of man in his universal aspect. ChuangTzu (fourth century BCE) conceptually describes the general principle of consequentialism (gravity & impact) moderated by Teleology and Deontology (intends as a check against excessive altruism). Also spoke of 'rights of animals' or obligations to nature, talk of morality; justice, righteousness, benevolence......have lost their way to live naturally and act spontaneously, flexibly and intuitively. Further in ancient Indian texts concern on environment protection is found in Kautilya's 'ARTHSHASTRA', it was *Dharma* of each individual in the society to protect nature. In 'RIG Veda' that Universe consists of five basic elements Earth, Air, Water, Fire and

Ether (Space). People worshiped natural elements: SUN, AIR, WATER and LAND in various cultures dating back from Greek and Roman empires. Such recognition and acknowledgement lead to protection and preservation of the environment. Ancient India acknowledged the proximity of mankind with nature; especially since the Vedic period. The text's continues that nobody will destroy vegetation and nobody shall kill animals [maintaining biodiversity], versus of 'ARTHV Veda' chants: 'what of there I dig out, let that quickly grow over, let me not hit thy vital, or thy heart … 'Meaning one can take only so much as one can put it back [key principle of sustainability], while versus from 'Manusmirti' mentions optimum use of resources of nature and so on. Hinduism considers nature as the abode of God therefore peepal, neem, bard, tulsi etc. worshiped and never cut; relating animals as vehicles to Gods i.e. tiger, garuda rat etc. Similar ideologies are depicted in Buddhism and Jainism that propagates non-violence, minimum destruction of natural resources: simple living minimum needs (minimum consumption of energy). While Muslims and Christians consider water as sacred and pure. Thus this strongly establishes the roots of the traditions wherein the response to natural resources and to have lifestyles that honour the contextual and explains why the traditional cities thrived for centuries on and were sustainable [1].

Early nineteenth century on urban school of thoughts—the Chicago School model suggested that cities grow steadily outward from the urban core or central business district that surrounding zone as workspaces followed by residences in hierarchy of affluence which over time got redefined in line with the transition in value systems. While the New York school suggested that most economically productive districts and the most desirable residential areas are concentrated in and around the city's dense center while growth along the periphery is less patterned i.e., typical for Asian cities. Pattern of growth for the cities has been typical across the world irrespective of origin of the school of thought. Further the streets were recognized as key public spaces in addition to large spaces like squares, streets intersections of streets and others. The dynamics of these social spaces contributed largely to the urban character of the cities as public spaces. It's these very public spaces nurtured local cultures that evolved as tradition with time. And continuation of such practices that ensured participation of generations on ensured harmony amongst them for their respective identity. Parallel Geddes school of thought for cities as 'organic' in nature; highlighted the spontaneous response of people for utilisation of spaces both public and personal. Both set of spaces responded to the timely needs of the people often transforming the spaces, vouching for the resilient and organic nature of the city to grow with time; each of the transformations can be deciphered as layers of history and even be mapped. Translation of spatial analysis is insightful to understand engagement of social identities conventionally more profound in public spaces. Therefore largely the public spaces are created, participated and managed by the people only. Largely granular character of the cities an urban design connotation exhibited such, emerges as a key indicator for urbanism of cities.

Designated principles of urbanism derived from fundamentals of urban design are insightful for a comprehensive understanding to establish the planning principles vouching for anthropogenic of traditional urbanism at large. The foremost are

by Royal Institute of British Architects (1970) advocated that major characteristic is the arrangement of the physical objects and human activities which make up the environment; a concern for the relationship of new development to existing city form as much as to the social, political and economic demands and resources available for the space it's relationships of elements. Reinforcing the significance for a clear definition Pittas (1980) suggested seven parameters as: enabling rather than authorship—emphasizes on the limit to growth with a sense of ownership; relative rather than absolute design products—strongly conforms to the contextual specificities; uncertain time frame-as each of the cities are at varying thresholds for both the pace and nature of development are governed by typical set of issues; a different point of entry than architecture- recognizing the social sciences aspect for habitation; a concern with the space between buildings—acknowledging the open over covered spaces as they are key for social interactions and activities; a concern with the three dimensional rather than two dimensional—its all about spaces at large across all hierarchies and scale and principally public activity—establishing the *nuclei of the city*. Further adapting to the changing needs of the global cultures in parts or whole that is occurring and continuing, Araabi (2016) summed up as concise of urban design theories: subjects, objects and knowledge by are three theories and over timeline observed as layers in urban design approaches are as theory about subjects i.e. from principles of spatial aspects from architecture of buildings, urban design to planning of cities across all scales over its historical layers for flexibility, and image for comprehensive view space mapping for place making; and about knowledge deriving from both spatial and social processes [2].

Traditions largely are deep rooted with nature and all natural elements so much so that its virtually a spiritual connect with the natural elements: Sun, water, air, land-earth and all the living beings with mankind as one the traces are evident in most of the established civilizations. An approach shaped up the attitude to build is accepting the resources with sense of borrowing from nature for growth and sustenance along with other living beings as well. This sense of surrendering enables to connect with nature more as a reverence, an expression of art and architecture continued as cultural heritage. But with global economy and technology aiding the said sentiment got shelved for numbers and growth too had a paradigm shift wherein the cultural heritage was ignored. Each of the traditions evolved out of the response to the set of natural resources of the context.

The narrative of traditional urbanism has established that it is a huge reserve of lifestyles and cultural heritage however the thrust has been limited to heritage, historic precincts for its rich architectural planning, detailing at large. While there is a plethora of aspects that traditional urbanism offers from addressing the pillars of sustainability for its contextual framework translated in the built environs governed through legislation that was dovetailed within the socio-cultural aspects of the local communities. With tourism sector high on the agenda for traditional cities is often limited for the visual image limited to building facades to be acknowledge traditional buildings, precincts to be preserved and conserved. Whereas the under laying planning principles, the rationale of decisions, the optimum use of locally available resources the indigenous traditional knowledge base of local communities touching

on all aspects of lifestyles is a huge resource typically neither continued nor documented except for the world heritage sites. Unfortunately such resource that exists across the world are neither listed and invariably lack the documentation often limited to the nations who have limited resources to do so and mapped at the global level, that gives only a skewed mapping at large i.e. Europe has largest number of traditional historic cities well documented for the global map, a pride and a resource for the world.

Typically traditional urbanism is not taken up as a dimension of mainstream development and thus the developments are often parallel rather focused with heritage agenda thus lacks the overall development planning at large among professionals from other disciplines, Geographers, Sociologists, economists, environmentalists and others; where each of the disciplines has a perception that has narrow outlook for the respective discipline as the key base while the rest inter-related but all the relationships among the disciplines occur within the built environs with ample intensity. The built environ is a physical manifestation of each of these disciplines reflected and woven such in the urban fabric resulting in unique tapestry with an identity; The ones that are mapped and recorded are in the public domain and often recognized. Largely the prominent traditional heritage cities are acknowledged but there exists' a large repositories of culturally rich heritage cities, precincts', buildings that may not significant at the global level but enjoy attention for the local contexts and thus has potential to contribute. However they may lack for some aspects but negating them in our planning is surly a major loss especially at local and regional level where in traditional urbanism is significant. Also intent needs to go beyond the generic recommendations and guidelines be comprehensive and tailor made solution for the contextual approach dovetailed with mainstream development planning policies/ strategies/ approaches; rather than being parallel it may be worthwhile to be competitive as the way forward is collaboration and put forward a united front.

Tracing the key response foremost is UNESCO who has played a pioneering and historic normative role in proclaiming, since 1954 through Conventions, Recommendations and Declarations, a comprehensive international legal framework for cultural heritage. Hague Convention- for the Protection of Cultural Property; Convention on the Means of Prohibiting and Preventing the Illicit Import, Export and Transfer of Ownership of Cultural Property (1970); Convention concerning the Protection of the World Cultural and Natural Heritage (1972) wherein the traditional notion of group of buildings as announced originally by the UNESCO World Heritage Convention is not sufficient to protect their characteristics and qualities against fragmentation, degeneration and, eventually, loss of significance. Parallel the narrative on sustainability too was initiated by Club of Rome'72 wherein an inter-disciplinary group of professionals raised the concern referring to the limitation of resources and the connect between demand supply, production and consumption and this discourse got narrowed down to the local level. In 1990 approaches introduced to the nation of regional cities viz. Transit Oriented Development that reinforced the economic agenda virtually diluting the limits with seamless growth while New Urbanism acknowledging the traditional urbanism. The most critically issue for growth and development in Traditional Urbanism is largely of decisions due by geopolitical and

societies; overriding the social capital. UN Conference on Environment and Development through Agenda 21 (1992) was implemented for local governments participation worldwide, alongside sustainability key issue of social development, women and habitat cities debated upon. In UNESCO's World commission on Culture and Development published a report "Our cultural Diversity": report argues convincingly that the prevalent model of development based solely on the yardstick of economic growth is outmoded. That model ignores both the environmental consequences and cultural dimension of development. The report concludes that, above all, cultural diversity is here to stay. It is a manifestation of the limitless creativity of the human spirit. Its aesthetic value can unfold in multiple ways and stimulate the production and marketing of new and unique products. Finally, cultural diversity is a reservoir of knowledge and experience of social and environmental interactions that can form improved sustainable approaches to using natural resources and protecting built heritage. While in Europe, the 1975 campaign that gave rise to "European charter of the architectural heritage" identified the fact that structure of historic center's is conducive to a harmonious social balance and that by offering the right conditions for the development of a range of activities of such old towns.

The entire discourse compiled in 1996 UNESCO Report of the World Commission on Culture and Development, and the same year the standard UN sustainability indicators were implemented across the globe to gauge sustainability of the cities and one of the significant feedbacks was to include culture as an indicator. Thus in the next cycle in 2001 culture was duly incorporated with all its aspects from built heritage to intangible as well. This was further reinforced by Vienna memorandum (2005) Convention on the Protection and Promotion of the Diversity of Cultural Expressions that got shaped up as draft (2010) for HUL and concluded in 2011 with New Urban agenda UN –Habitat-III bottoms up approach to be relevant at local level. And debate on conservation, cultural heritage to sustainable development fine-tuned to HUL (2016). Among the foremost global initiatives for traditional urbanism the holistic approach to view Historic Urban Landscapes wherein all aspects of development can be argued from social, economic, cultural heritage and all related for example: gender inequality often refereed in HUL can also be interpreted as order in a rigid framework and the sub-aspects of taking cognisance for women's perspective, their consent, their participation and thereby positioning gender for climate change is direct as they are largely responsible for resource consumption, food, energy, health and well being, utilisation of spaces, negotiations for mitigation, technology, behaviour and culture contribution to industry. Understanding HUL for its set of systems knowing each aspect for its sensitivity, relevance, continuity and potential to deliver for current development.

The conservation aspect of traditional urbanism dealt at global platform has formally been documented through its large body of texts and narrative resulting as UNESCO HUL recommendation (2011), include, the UNISDR Sendai Framework, with the Ten Essentials for Resilient Cities and the UN 2030 Sustainable Development Goals; compiled by UNESCO a Global Report—Culture|Urban Future and the UN Habitat III adopted the New Urban Agenda. Further enriched with the Paris Agreement of the United Nations Framework Convention on Climate Change

and others. Summed up as the Globally Important Heritage Areas to be approached through bottoms up strategy with geo-cultural contexts innate for transformations. Identification of heritage is a typical issue for the status to be national or international, but such a take is standard for the tourism sector while traditional urbanism being a contextual outlined heritage significant at local level is as important may not be as celebrated as per the accepted norms of heritage. The formal structure to support the implementation of the HUL approach four categories of tools have been identified namely: civic engagement tools, knowledge and planning tools, regulatory systems, and financial tools; advised to adapt these tools to the local context and develop them during the process with the stakeholders' involvement [3].

This sequence of events wherein social pillar being the common denominator for sustainability and traditional urbanism, reinforced by culture emerged key for the progress and development of the urban areas. The traditional cities thrived for centuries on and continuing are a huge repository for all pillars of sustainability with a silver lining of their unique rich architectural heritage having universal value. As school of thoughts on urban planning, local initiatives often relevant at regional level as well for contextual and recognized at the global as world heritage sites. In 90's the notion of Critical regionalism cities by Kenneth Frampton, to Collage city by Colin Rowe echoes the dimensions of traditional urbanism and the contextual for respective geographies, appropriately addressed in 'New Urbanism'. This backdrop tabled various approaches for development activities in culturally rich traditional cities from insistence to be contemporary however in limited sense, recognizes cultural heritage as the wellspring of creativity but the contemporary nature of development banality is unstoppable. Responses for cultural heritage and HUL by UNSECO is conducted based on the geographical divisions of continents; considering economy plays a key role for decision making thus it makes sense to club nations with similar economic backdrops with similar state of development and resources to arrive at solutions through best practices is the way forward. Megacities resemble each come closer sharing the same idiom of glass façade buildings, high-rise buildings synonym for progress and symbol of economic development. Although the omnipresent hegemony does have heritage precincts continuing but their identities are superseded by the global architectural vocabulary. Interestingly the developed economies took to the said vocabulary quicker with the resources available to them to execute and develop a research database as well. While the nations with growing economies are developing gradually also most of the traditional cities are living heritage for them that have been undergoing transformations over time thus delivering in contemporary times as well, but the solutions are governed by factors over and above the contextual framework geo-political or global economy or technology driven and all these may not be sensitive to the socio-cultural connotation of the local community. It should not be assumed that developed nations with sound research and development to offer models that might not be necessarily relevant as the contexts are diverse. These transformations represent the new challenge for urbanism where growth and change need to be understood and managed.

There have been global awareness and initiatives for our cultural heritage exhibited in built environs as cities, precincts, buildings, zones etc. with approaches and

theories i.e. New Urbanism, Traditional environmental knowledge and others such responses. Additionally universal take of Historic Urban Landscapes that refers to conservation management, development plan; vouched for designating the heritage precincts as special areas kind of exclusive or delineated for specific intervention. European Charter of Architectural Heritage prophecies "The past as embodied in the architectural heritage provides a sort of environment indispensable for a balanced and complete life. It is a capital of irreplaceable spiritual, cultural, social, and economic value." A great proportion of the historic cities are located in the developing countries. They are constantly up against population pressure, crumbling infrastructure, and eroding economic base of the developing country; much at risk is the urban tissue of the historic city. The concept of culture in development does not view culture as an elite activity for the few but the essence of being for all [4].

In the traditional cultures gender and age were recognised to pass on the value's the hedonic model; qualitative in nature does not feature in the global community. Their contribution however small but is important and an integral part of the culture, very early in their upbringing the values for relationships both to nature and with clan, learning to give and take to be in harmony almost instilling a symbiotic bond at large. Such an up bringing is rooted for generations on in most of the cultures and that shapes up social capitol. Each of the cultures recognises the role of gender and as a matter of fact they are directly involved in resource utilisation at large; ironically the traditional roles are continuing despite women taking to work basically because of the tradition cultures ingrained, quite often it's a deliberate choice. This dimension is insightful to understand their responses to resources at large, more so when the communities are homogenous and it comes in handy largely for performance evaluation studies. Also intervention if any too is easier to put it across as the acceptability too is especially when the communities are homogenous. With globalisation the nature of community has embraced diversity and for it to get stabilised needs time although the process is accelerated through information technology, its interesting that the global communities bonded as the adaptability is faster almost in line with the generations in technology as well. With majority of the urbanisation occurring among the developing nations, and ironically there exists a large number of thriving traditional cultures gives one an opportunity to establish the baseline for thermal comfort and related resource consumption.

Although geographically climatic zones have been defined but the local communities across the same latitude often resort to varying solutions that are strongly contextually driven. It may be worthwhile to map them for their individuality and peer learning as well invariably such documentation are done either due to them marginalised or owing to their poor or developing economies.

2.3 Context Fundamental to Traditional Urbanism

Our planet earth has a range of natural habitats and each geographical zone characterized by a set of natural resources, among them water played a crucial since early settlements. Typically each of the towns and cities utilized the locally available resources, a limitation by default for ease, efficiency and pure logic. This rationale prevailed further for improvising for their indigenous technology that got fine-tuned over time. Thus the geo-genetically framework determined the contextual framework that shaped the built environs wherein the communities evolved their disparate cultures. The rational balance between urbanism and ecology was a deliberate equation for the said context that resulted in a disparate typology that demonstrated system of systems such. The context largely embodied built morphology which was recognized for their respective identities, that contributed for Imagebility in cases, where the built structures were robust and intricate that enriched the identities even more. The aesthetic expressions became a gauge to make a statement of their position and power. This interplay of culture dovetailed for respective context and recognized for demonstration their typology of built, architectural style and cultural heritage proved to be the signature. Although the initial settlements was closer to water but gradually got diversified for the availability of other natural resources for mineral's, flora, fauna and others basically when agriculture economy moved from small scale to industries as civilizations grew for processing of natural resources local technologies developed and those became an integral part of their lifestyles with overtime resulting as practices. Each of the geo-genetically developments was co-depended amongst them and flourished enhancing the scale. As a matter of fact the lifestyles that emerged were conditioned by the climate. With limitation of indigenous technology each context-developed solutions were logical, simple and ease of understanding for the people.

Irrespective of the geographies the comforts for human has the common baseline thus the responses were strongly reflected in the building typology. Most of the solutions were passive in nature using minimum energy but using fundamental scientific principles, validated in the recent past through various scientific studies, papers, research publications just reinforces the strength of the techniques and solutions that were in place long before across all scales of planning. The strength of planning principles of the urban areas to the detailing of the buildings the natural resources were used judiciously. The economy of earliest were based on agriculture with water as the key natural resource and for other basic needs the local resources were adapted to the production to consumption was limited to the local over time with trade the products got fined tuned enlarging the local to the regional while the mode of transportation proved to be a limitation and thus limited for the region and sustained. But the lifestyles got fine-tuned and so did the cultures as well. The contextual connotation prevailed for centuries on and governed the cultures' that was key for the traditions and traditional urbanism. Interesting is where the nature was barren the response of local cultures ended up using lots of colors with intricate detailing as carvings, ornamentations and others i.e. case of deserts. Whereas when the nature

beauty was high on aesthetic quotient then the lifestyles were simple and matter of fact i.e. hills and coastal areas. This deliberate balancing of context of natural to the built, integrated with lifestyles is the very essence of traditional urbanism.

Urbanism through the ages has demonstrated various forms of building typologies. Each of the typologies got shaped up by their geographies and locally available resources evolved with time that was underpinned by local economies. This pace of growth was gradual that determined the nature of development and progressed. The pace was typical for the respective geographies and thus the local cultures evolved that were fine-tuned with time. Orthodoxly this pace of urbanism was truly in sink with the social connotation as it emerged as an integral pillar of sustainability therefore the urbanism that evolved, got stabilized with time, inherent local cultures with vernacular vocabularies. It is significant to understand that these were socially determined economy translated into urbanism. The socio-economic relationship governed by the local resources nurtured the 'archetypal' dimension of their towns and cities. Each of the socio-economic setup shaped Urbanism that was specific for the respective geographies. and with time where economies flourished, population migrated from neighboring rural areas, increasing the densities, transforming the built morphology of the city. The traditional cities continued living for all kinds of transformations those occurred overtime just displayed the resilient strength of the built morphology. With varying geographies across the globe the nature of urbanism got shaped up with varying specificities and scales as well. Interestingly majority of traditional urbanism falling in the same climatic zones have a lot in common irrespective of their geographies, religion, and economies basically because of the socio-culturally heritage. Water has been one of the key determinants from planning of cities to dwelling units as well to be used in an optimum way, again examples can bee seen from aqueducts to water channels to personal ponds and wells: that evolved a typology of urbanism and son on so forth for other nature elements as well. Lifestyles nurtured cultures that sustained till the global urban vocabulary came on the horizon.

Urbanism thrives only in comprehensive healthy regional systems. The balancing act is significant where the built landscapes are in harmony with the regional framework. The local resources when understood for optimum utilization in a cyclic manner, an art by the local population resulted in a context to be established. And that with time nurtured the typology of urban structure to result as prototype for the respective context. The negotiations in architecture and urbanism are evident in urban layers in time; a key dimension of traditional urbanism that imbibed the timely changes rationally to enrich and made it more holistic or rather one may call it inclusive demonstrated by each of the traditional urbanism has been resilient to changes, demonstrating the rich traditional values on culturally rich urban life. The transitions in traditional cultures have been consistent even when the geo-genetically framework expanded to regional from context. Historically one has example of silk route that recognized the rich traditional across nations and traded as well. But as the global cultures are derived globally have limitation to deliver mainly because of scale of operations with many changes that were quite frequent. With traditional cultures both the scale and frequency were within the limits of the respective context

and that with industrial revolution and scientific innovations escalated the pace and the debate of global to local and Global arose.

The key lesson to be learned is that traditional urbanism isn't a page from history but continuation reflected in social behavior, norms and practices. Whereas the need to go back to its roots as growth and development is all about change but the requirement about completing the loop to be sustainable is a must as global economy disrupted the socio- cultural strength of the traditional communities; when people started moving out of these communities for global lifestyles and global benchmark of quality of life; a phenomenon only in the recent past; soon proved to be vulnerable for its short life i.e. mushrooming of china towns in other developed nations and other national diasporas ascertains the need to be connected to ones roots through their respective cultures. While on the other hand its an opportunity for other cultures to be made aware of traditional cultures encouraging a mutual respect and sensitivity. Although the traditional cultures were seeded contextually; their shear strength is immense as it brings people together and builds harmony and social, being one the key pillars of sustainability needs to perceived such. This just reinforces the nature's principle of growth that deeper the roots higher the trees grow parallel may be drawn for the roots of traditional cultures are so deep that not only they have been resilient to changes but has managed to respond to the global impact as well, sensitized the global communities of diversity with acknowledgement of disparate communities.

Of the key global initiatives to recognize cultural heritage Agenda 21 accepted culture as the fourth pillar while the strategic approach of the traditional urbanism is holistic and inclusive and that needs to recognized rather than establishing more dimensions to sustainability at large. The global culture is proving to be unsustainable with incidents of climate change the message is loud and clear. Its time we look upon the traditional urbanism as time tested with solutions at the local where ever applicable with a rational viewpoint. With rational as the global culture is here to stay and communities feel the need to connect with their roots as well thus a systematic sustainable approach is the way forward. Therefore traditional urbanism goes beyond a page in history for nostalgia and tourism the popular recognition now. They are huge repositories of traditional knowledge base with solutions that are low on energy. The negotiation between the urbanism language and the subcultures in conflict the baselines are not adhered to impacting high-energy use. The options offered by the indigenous solutions by thresholds and use of latest technology under pinned with research shall be insightful. Thus in such a realm the role of contextual traditional urbanism cannot be negotiated. To be aware, know and understand mapping of Traditional Urbanism across the globe is the way forward; for which initiative to document world historic cities are in place. Although the process is on but other than the cities there are local precincts', which exist, may not necessarily fall under the said framework, however their strength cannot be negated for the exhaustive repository.

To read a city one needs to observe the various layers in time line and with that logic to isolate tradition as distinct is a point of concern, thus quite often the urban development polices and strategies do not look upon it as mainstream dimension but only a layer from history. Each city is typical and therefore should have a contextual

approach for development beginning from policy through strategies to implementation within an inherent mechanism of review so as to complete the loop to make it sustainable: the way it was for traditional urbanism. The global economic operated with planet earth's environmental framework but operated locally. Considering the drivers of change for the global cities commit solutions that vary due to varying thresholds of development of each city. The chief being the economy as it determines the growth of the city by access to technology, research and development and infrastructure. The mapping of the traditional cities across the globe is also governed such i.e. Mogul and Colonial are relatively better mapped and acknowledged irrespective of their location; but traditional urbanism is a global resource and therefore needs to be mapped, understood, recognized and continued for its merit. When money is pumped in for selective recognition there are related impact as well on other aspects especially the social demographics have a tendency to get altered and that is a permanent change with selective reinforcing of certain layers that dilute or erase issues/ aspects i.e. for future generations only the well conserved shall get acknowledged (Figs. 2.1 and 2.2).

Closer examination of distribution of Traditional Urbanism across the globe has African the oldest with Asian followed by Arab states, Greece, Romans and European. Interestingly if placed in descending order for their economic strength. This inherent capacity reflects in the way each of the nation have protected and sensitively executed design interventions responding to the deteriorating physical infrastructure, retrofitting for energy consumption to tourism at large and have been mapped by international organization. It is evident from the map that Europe ranks highest and other continents to follow suggests that the process in on and once complete the mapping at the global shall prove to be a resource for the mankind. Heritage has universal values and should be prioritized for future generations. Each of the built environs is a typical solution of local, regional ecologies that is significant all the more especially in hegemony of the globalizing world. World Heritage Cities has listed 237 cities that represent a special set of urban centers. The original historic cores of WHC have become generally part of much larger urban agglomerations while characteristically they retain their cultural identities for social, environmental and largely economic as well for the contextual framework [5].

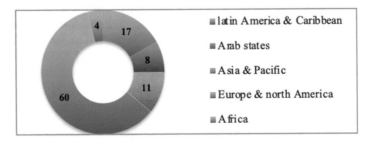

Fig. 2.1 World Heritage cities region wise [5]

Fig. 2.2 Distribution of World Historic sites [5]

Traditional cultures knew the various layers of reality material to spiritual plane; through a chain of references and analogies implied in the relationship between macrocosm and microcosm. Modern movement rejected the need thus natural fluidity between past and the future was blocked, stifling the creative communication between human beings and their cultural matrix and fragmenting their vision of the world. This perspective surly puts the historic cities of the world map as a volume of resource has a significant potential to contribute and to be acknowledged the world over.

The mapping of the traditional urbanism can be traced through traditional cultures as documented in the history. The prominent examples are of Nile, Indus valley basins, followed by cities in Europe, Middle East, Africa, and Asian continents. As industrial economy came into being with information technology and globalization the typologies of the cities had a paradigm shift to metropolitan cities to smart megacities of today and growing. This paradigm shift was significant for typologies, the urban grain, character and texture of urbanisms.

2.4 Economies of Traditional Heritage

Economy has been the basic premise within which each of the traditional urbanism was conceived, framed, evolved and developed. The basic approach starts with negotiations with the selection of site for its natural features, from landform to flora and fauna to selection of building materials and indigenous construction technology development for optimum use of natural resources in its pure form as once its deteriorated for its lifecycle gets absorbed in the nature to complete the lop and thereby sustainable. Next the same approach for processing of products be it handicrafts or

daily use. A collective response of the people resulted in culture that nurtured to be cultural heritage and traditional identity of the local community. New sense of currency gained within the society shall determine the nature of heritage that shall evolve the key strength of traditional urbanism is its economy that too is strongly contextual making it truly economic for the economy of the traditional urbanism. To achieve economy in economies of systems ranging from trade, commerce, tourism sector, building sector to behaviour pattern that are socially driven and culturally determined. Economy of traditional urbanism gets translated for all aspects both qualitative and quantitative that touch upon the SDG's. The most promising aspect of traditional urbanism is its inherent attitude to co-create innovative solutions for deep sustainable transitions and the emerging paradoxes in learning.

Value of heritage for economy in nations' GDP got prominence with the world heritage status tourism/heritage artefacts. The impact of world heritage sites extends to broader areas within cities and the urbaness of world heritage status brings in narrative of designation status; that enumerates the debate should one look upon the world heritage status in isolation as for all practical purposes it is an integral part of the larger whole of metropolitan city through economy due to its status along with local economic activities in the city and regional level as well. Along with the status that's is arrived from assessment viewpoint along with the defined framework delivered from management perspective brings in interventions that may not be in alignment with the Traditional Urbanism. The implications are challenging for a living heritage; as for the static one the narrative is focused only for the heritage status thus simpler to manage, as isolating the precincts and conserving them from tourism perspective is a single agenda with related development initiatives. Typically the related economic activities are often an extension of the traditional system of production with or without improvisations and use of technology. Products made with traditional fundamentals systems are appreciated more by the tourists'. For a living heritage traditional city intervention needs attentions across various hierarchies of development and scales [a] to ensure sustainability of the traditional city [b] intervention for tourism sector to be proportionate to the local economy [c] adaptive reuse strategies' for conservation of traditional urbanism [d] protect and recognise the cultural practices for the local community and not be a product for tourism and others for each one only a holistic experience of traditional urbanism is the key and thus all dimensions of traditional urbanism matters.

Global economy accelerated the pace of urbanization in the recent past with mass migration. However during the timeline of traditional urbanism the migration was limited basically from the adjacent and neighboring villages and hinterland; whereas the global economy encouraged migration across nations across continents and that added diversity of all kinds to the metropolis. The migrant population once distanced from their roots the traditional cultures, indigenous knowledge, connect with affiliated communities got diluted Simultaneously in cities diversities of all kinds was added that redefined the social connotation of metropolis. Typically each of the cities has a culture of their own and with migration there is layering of diversities of cultures bringing in a permanent change. However gradual the process may be but alteration does occur. Situation brings in paradigm shift in the context of the city

and significance of core culture gets altered and with these shifting the thresholds at large revised more in line with the global norms and standards and such base lines are a challenge. For example the thresholds of thermal comfort defined by the global communities supersedes those back home where the resource consumption was optimum. This shift from optimum to superfluous adds to the climate change and further when it happens in the context of developing economies where urbanization is highest just escalates the issue manifold.

Global economy accelerated both the nature and rate of transformations for the two sets of nations where traditional urbanism was conserved and the other one living. Currently irrespective of the state of economy the two distinct approaches are in place, as a strong and stable economy provides and facilitates for research and documentation and adequate resources for development and provision of infrastructure services. As economy is not depended on the traditional urbanism except for tourism the thrust if more for conservation; wherein the cultural heritage is revered upon in its pristine image and a top-down sensitive approach for governance proves to be successful. The loud examples are the high streets of London and temples inter spaced within the built fabric of Tokyo city stand tall amongst the contemporary modern planning and buildings as well among other such examples across the world. Whereas the case example of living heritage the layers of development in history can be deciphered irrespective of the causes that may range from political to social to economic or even environmental. When a layer is added such all aspects of sustainability are affected and therefore transformations in such context needs to be bottoms up, including all stake holders and participants. Considering each of the actors have a role to play but the public participation contribution is minimal due to the cultural setup such. The local community largely is opinionated and can be understood through their traditional norms and practices; a cultural heritage indicator extremely useful for the success of transformations at large. In fact both sets have something to offer and thus mutually complement each one too as the use of technology with precision is insightful and the best practices can be emulated. Also the resource allocation in some of the nations financing tools and instruments are allocated on the basis of per capita, that may be reviewed for the contextual worth at national and global level and budgets prioritized.

The traditional handicrafts gradually improvised to cater to the rising demand with use of technology, optimum use of resources and sometimes even responding to the fashion vocabulary of the markets, that was smart move but again the motifs, shape, colors, continued as original. In fact globalization gave boost to traditional products as the micro and macroeconomics were connected such. It is interesting to note that the diverse response of the global economy has related repercussions; while along side there are responses that moderate as well. Therefore it is important to keep in mind the global targets and then the trajectory to be taken up by each of the traditional urbanism be designed that may be similar but not identical.

Across the world urbanization economies and with that emerged the global vocabulary of development determining the nature of built environs standardized across the world diluting the local identities. Typically, where the regional economies that were flourishing in traditional urban Centre's through dialectical process of resolving

local issues for its contextual framework became the nuclei for the growth and new developments like IT hubs; industries mushroomed on the periphery of these urban areas. Further as the global economy diluted the time zones and delivered 24×7 that was super imposed on to local cultures the two continued to co-exist but had related repercussions. The traditional cultures when overlaid with the global cultures was and is a sensitive issue as it is impacting all aspects of the lives of the people; and thereby cities and urbanism. The architectural vocabulary of global culture is in stark contrast with the traditional cultural heritage. The developed economies the main heritage status structures conserved and preserved but frozen in timeline with few alterations to cater to tourism sector; while the lesser significant ones with adaptive reuse for tourism and needs of the local community. Whereas the developing economies due to limited resources responded to the changing needs of the local population and continuing. Thus the global architectural vocabulary had limited impact on this traditional urbanism as infrastructure facilities key to global architectural vocabulary was already in place adapted. As the changes were frequent and continuing, the local population was selective and thus only the required ones incorporated an selective approach was essentially a result of cultural approach to accept and let go off facilities available and accessible. The second faction exhibited the rationale approach that was evident in lifestyles. The traditional built typologies were resilient to respond for changes but technology added a dimension that altered the architectural vocabulary substantially in sync with the global built morphology with a paradigm shift from the existing building stock.

But currently the two sets of cultures perpetuate diverse urbanism and with economies supporting one and leaving the traditional to fend for themselves where the local economies are gradually diluting; and that is directly affecting the urban areas. The traditional urbanism strongly driven by culture is getting transformed although gradually. A gradual transition shall eventually transform the traditional culture for good although over a period of time but traditions however nominal shall be permanent. The dichotomy of development in traditional urbanism with global vocabulary often concluded as in harmony of contrast implying one super imposed on other. The concern is not so much about introduction of technology but the continuity of traditional urbanism in essence. Must in the name of development changes be layered on to a rich continuing culturally driven urbanism. Progress implies inherent critical evaluation of the implied change; its rational, its relevance and implementation. Apparently, technology is not labour intensive and where the population is large with poor economies resorting to labour intensive approach makes more sense, encourage social equity adding a personal touch to the process of production giving each one a uniqueness.

Currently the most critical issue for growth and development in traditional urbanism is governed by geo-political. As each of the traditional urbanism is a global resource therefore its collective responsibility of all and a collective prerogative with the local geopolitical responses are conserving, protecting and safeguarding the traditional cities. Also as they are the reserves of cultural heritage their continuity is important for sustainability. Traditional urbanism is beyond a conservation exercise and that acknowledges, recognises and grows with responding to changes with

time. Cultural values cannot be translated into economic ones; with cultural heritage recognised in 2030 agenda. It's interesting that the traditional urbanism irrespective of their location and state of economies are desired for real estate sector and often the availability of the property in precincts is limited and if at all can be bought by the local community clan; this ensures the continuity of the social capital not diluting as well. Further each of the property is priced very high especially among the living historic cities; as each one is unique. This equation puts a value to cultural heritage at large; as it were a commodity rather than imbibed, experienced and related to for all its attributes. This dynamic makes such built environments accessible to a limited few due to the buying power and thus development too gets restricted, exclusivity dilutes the intent of universality and more so do not benefit the local community in essence as it did in the past putting a question mark on the continuity.

Largely traditional urbanism needs to be recognized for more than the tourism sector; as a global resource and has the potential to contribute i.e.: quality of life, building typologies, choice of building materials and construction technologies to public streets i.e. high streets of England, bazaars of Asian to souk in Mediterranean cities to large congregation open spaces too. Considering these streets are characterized by rich urban design planning principles and typologies at large the responses need to be uniform as we value them for their universal resource but the regional geo-political decisions patronized by local economies often hamper the intent. It's interesting to observe that with high end vogue brands making their presence in these streets and have showrooms in such precincts, while in Asia the mall typology were built on the periphery of the cities but with high real estate values within the living heritage areas the edge of the city walls are being exploited: an opportunity for planners and architects to stitch the traditional tissue but interventions are in stark contrast and break the continuity which is inherent for any city.

Global economy facilitated anthropogenic activities across the world diluting the geographical boundaries and over riding local economies; such an approach often overlooks the best interest of the local communities for their capacities, limitations and skills not utilized to their optimum but thrust shifted for repetitive tasks that impacts their health and well being and gradually the traditional skills a permanent loss. With the debate of mass production for the world's global population may be argued with diversities of local production that is sufficient to deliver for the respective local community thus putting the mathematics together the world population may be delivered by an assorted set that is characterized by richness of local identities unlike the hegemony of the global mass production. Typically the traditional production systems fall under small and medium business thus ensure social equity unlike the global brands with few owners. This amalgamation of resources to a limited few has the potential to influence the decisions for their own vested interest, which invariably may not in the best interest of the mankind; quite evident with the frequent changes in the climate and natural disasters. When the scale is limited the participation with the production processes is more personalized and connect with nature is evident and the individual using or consuming the product such experiences the same sentiment. However with time, options to be innovative and creative were facilitated by technology that added value as well, recognizing the notion of progress. The entire

process of production and consumption patterns occurred in spaces with mixed land use implying the residence and work spaces under one roof may be varying floors depending on the geographical location from thermal comfort and maximum use of daylight being the key determinant. An arrangement ruled out travel from home to work, making the blocks lived in 24×7 assuring security and ruling out redundant spaces with limited use. Also the large industrial structures and large office spaces are not required and become dead spaces at non-working hours; such spaces are not there in any of the traditional heritage cities. Next these mixed land use neighbour-hoods' hadspaces that were essentially determined by the locally available material and indigenous structural systems thus the spans and scale are similar. Interestingly the social hierarchy is strongly reflected in the layout thus the strategic locations are allocated to the ones higher in the hierarchy, further rich detailing too is another typical characteristic of these spaces. i.e., if courtyard is standard for a conventional house then there could a series of courtyards may be norm for the bigger house and so on.

The mapping of traditional urbanism across the world suggests the huge resource available to mankind. However, the thrust for management of heritage cities in the twenty first century wherein the process of preservation has been limited to build-ings as heritage identified by experts rather than a multi layered understanding of the local communities and only such a holistic perception shall address sustain-ability. Although world heritage cities are built on the discourse on heritage as inter-disciplinary but limited to a privileged few with resources that gradually increased its canvas of perception from heritage to cultural heritage, preservation, to conservation to address for the context of traditional urbanism a rich tapestry with all hues and textures.

The social and economic activities are intertwined for most for the traditional urbanism. This symbiotic relationship was sustainable one for the nature of economic activities structured within the social stratification inherent based on caste, creed, ethnicity for tasks, more as structure rather than being judgmental. The structure has inherent strength that sustained as each of tasks for production was recognized and acknowledged. The vernacular education system was geared up to feed the respective tasks and strata. This deliberate approach for which the decision makers were the stake holders, which evolved with time and the acceptance of technology just proves to display their resilience nature to respond to changes. This interdependence was and is embedded within the contextual framework for the set of natural resources that governed the economic activities and determined the skills that the local community developed and evolved with time. Typically the dogmatic ideologies of contemporary economy has been credited for bringing in the paradigm shift in the post industrial era while the geo-political governance exploited economy wherein the social got sacrificed; more so when the scale for operation was the world thus impacts was collateral. Instead if the traditional synergies of social and economies continue with context revised for regional of global scale has the potential to deliver such that the balancing act of the three pillars of sustainability maintained.

The general tendency to value what we price and take for granted the nature's resources' neither traded in any markets nor not priced, these so-called ecosystem

services. Often the non recognition of nature in economic models of production and consumption a gap exists although attempts i.e. green deal, green economy, green architecture, green economy to specifics like carbon tax, environmental tax are in place but they bring attention to the issue more conceptually with intent only as the rise in natural disasters is unsettling. It's imperative for the mankind to pause and relook at the disruptive century and structure us from the numerical GDP growth to sustainable and well-being index, for which circular economy is being perpetuated. The entire discourse completes the loop to confirm to the time-tested solutions those have continued to evolve grow and nurture with the "scale", 'pace' and 'nature' of development being the key. The GDP and to be global superpower jeopardized the existing synergies of contextual system of systems of living with nature.

Urban structure as a set of organizational principles obeys the scientific rules and largely independent of regional geographies. This uniform modernist approach erased the traditional dependence on local tradition, climate, resources, and materials, something that was incidental and secondary. Urbanization is driving development globally and more pronounced among Asian nations at a fastest rate ever in the history. The developments driven by geo-political decisions to support the global economy that has a standard agenda of numbers related to GDP, per capita and others thus limited in it's approach. Irrespective of geographies and the socio-cultural connotation has impacted the dynamics, as neither they were accounted for in the numbers except for the workforce and largely their working conditions. Both the nature and production processes of workplaces have not been sustainable and reflected such in climate change at large. Tracing the history of urbanization the cities evolved with geographies as its basic premise for a community and that puts each of the urbanism are uniquely placed and thus the quantitative aspect of economy and its standard gauge cannot be implemented as universal. Regional contexts are politically divided rather than geographically divided; that adds an interesting dimension as for the same geographical location across the globe cities may be inhabited with diverse cultural communities because of their varying socio-economic set up shaping building typologies and built morphology that may not be similar. Future development in Asian countries need to develop enlightened with the indigenous forms of urbanization or maybe with a transformed extension of Traditional Urbanism as they shall have opportunities to address Climate Change in a more effective way.

2.5 Dimensions of Traditional Urbanism

The contextual framework of traditional urbanism safeguarded the necessary balance among the pillars of sustainability efficiently as it was a necessary for shear survival as well; translated in the spatial characteristics of the city. Cities are about people and when people get represented as communities the translation in built environs is evident as rich architectural heritage, such a symbiotic relationship has been the strength of traditional cities. However, the contextual framework when identical across same geographical location on the planet earth, the social connotations varied

in norms and practices specific for each of the traditional cities often similar but never identical making them unique for their identity. The key attributes of social structure that affected the built environments was family its composition, number of members, gender issues, ethnicity, caste, creed even the DNA as that drew their thresholds to deliver and indulge in activities at large i.e. ishfan etc.. Largely the economic activities and the social setup were interdependent; such an arrangement ensured they acted as one community; and when knowledge got passed for generations' on became a tradition that impacted numerous aspects further each aspect has a role to play, to enumerate one such with an example of gender connotation; addressed in the built spaces limiting their movement that was broadly accepted either due to religion or social segregation of caste, creed etc. The built spaces were inherently gender responsive and the intent was not about inequality but complementing relationship for the said culture. Whereas in contemporary approach women having equal access for all opportunities, resources, decision making has its own implications for awareness, education and cultured upbringing women were/are sensitive about the traditional contexts' and utilize the resources in an optimum manner which they pass it on to the next generation especially daughters as a cultural practice. Significant is that the women were and are largely responsible for social securities through lifestyles and cultures for both tangible and intangible resources. Traditional Urbanism offers opportunity to learn the continuing practices and through application of contextualizing lessons as best practices. The intent is to continue the said practices that have delivered for the contexts' and share as a universal resource as it is the need of the hour too. Often the narrative of women empowerment arises for limited communities only while religion plays an important role in defining the role of women and with globalization that is being reviewed with a critical rational thinking, which, denies women to be pro-active in contributing for development. It may be summed up that the role of women has been of traditionally conservative nature and that has an inherent mind-set to approach for optimum utilization of resources assured such with continuity of cultures. The global economies reigning and global lifestyles taking Centre stage the traditional role of women too took a paradigm shift and they took to work as co bread earner the rationality soon to be replaced with buying capacity and affordability; propelled by the global economy earn more spend more; and the traditional mind set got side-lined. Also for generations on relatively the girl child was raised to imbibe the cultural heritage, values and norms and that are deeply ingrained in their DNA and despite educational awareness and rational thinking it's quite profound and has potential to engage for climate change.

To understand the dimensions of traditional urbanism for the built fabric that acknowledges the strength of the socio-cultural communities and views the norms and practices in the light of rationale of decisions for the resources in time and accepted with sensitivity for the context. While the living Traditional urbanism has stood the test of the time strongly acknowledged and imbibed the changes of the development process transforming itself but retained the core strength intact as the spine ensuring continuity with grace and it's unique identity that stands tall that global hegemony lacks.

Typically, the wisdom of knowledge for each of the contextual environment is a huge source of information passed on for generations on and continuing. Therefore, this traditional knowledge base contains an evolutionary value in the history of progress, the value produced by the past generations is not commensurable to the value of time to re-establish and restore continuity to the regenerative space of it. This is the meaning of serious disasters of human heritage, which break the glue that binds the generations. Therefore, Architecture, Cities, Infrastructures and Landscape not only represent the form of time but all the disciplines that have contributed to and contribute to their characterization. Tradition therefore contains an evolutionary value in the history of progress [6].

The context as outlined puts forth the set of environmental resources both natural and manmade, that determines the economic activities possible and the physical disposition of the urbanism for it's spatial characteristics: beginning with the selection of site for the layout of the city from the macro level to the minutest detail of the fenestrations in a building. In this framework the social that is cultured by context underpinned by religion and typically for an identical geographical slice the social capitol is archetypal. Traditional disparate societies nurtured their cultural heritage evolving their own set of norms. The narrative of understanding the sustainability of traditional urbanism indicates establishing the pillars of sustainability for impact on climate change to arrive at the dimensions of traditional urbanism at large.

ECONOMIC: Both nature and economic activities governed by contextual natural resources beginning with agriculture and local handicrafts products with trade routes that each transit base developed for the day-to-day need-based products manufactured with the natural resources locally available; significant was that the symbiotic relationship between the economic activities and the natural resources. Local species and local biodiversity played a key role and quite often even the local food, lifestyles and handicrafts evolved with time for their creativity and innovation that resulted as the identity of the place. The symbiotic relationship between the environment and economy was executed through the local community, which continued and expanded in scale and duly upgraded with indigenous technology. The geographical economy grew to regional economy and with globalization both scale and nature of economy had a paradigm shift with global resources, global political powers and so on with mega cities as anchors to that facilitated. There is ample literature that has established that the vested interest of global economy for global natural resources irrespective of their availability as accessibility was politically governed. Therefore, the role of geo-politics on the global arena has shifted base from nations to set of nations. Ironically the grouping of nations is based on religion and social connotation and not so much on their economies. Contextually system of production was in line with local resources but the global economy supported with technology accelerated both scale and proportion of production and consumption that got facilitated by transportation, regionally, nationally and internationally, the transportation costs although initially was to facilitated and with volume came at the cost of environment, that got precipitated as main cause for natural disasters and environmental degradation. The role of technology has been for problem solving, easing out cumbersome tasks faster and quicker. Scientific innovations and technologies typically aided for improving

lifestyles but with global economy used technology at an unprecedented scale like the system of production and translated in system of consumption facilitated through information technology and social media.

UN initiated for Sustainable Development Goals for the world and the related impacts of the global economy. SDGs 9, 10, 11 and 12 related to economy refer to industry innovation and infrastructure; responsibility of consumption and production by the state and local authorities through incentive's to provide for economic, cultural, historical, and social values to be bridged. This ensured the canvas of economic factor to be enlarged for social, cultural heritage, values that are depicted in the built morphology for its selection of building materials, construction technology to the visual image and related aspects. An approach for economic aspect is similar for other pillars of sustainability as well for an integrated and more holistic approach that is inter-disciplinary may be summed up as inclusive approach that was inherent to traditional urbanism wherein the pillars of sustainability were not looked upon in silos rather enjoying a symbiotic relationship.

SOCIAL—Global societies are in a paradigm shift from the traditional local communities due to migration that introduced diversities of all kind and nature-bringing in a set of cultures that were not contextual that when facilitated by geo-political governance took a toll the environment for the outlined lifestyles and consumption patterns and other related shifts of gender connotation to standard education system super imposed over the vernacular education system, with various ethnicity underpinned by religion resulted in a urban population, an agglomerate of communities each one having potential in their own right but not necessarily in harmony amongst each other; for which the political decisions played a key role and issue like security emerged as the key. Comprehensive surveys and mapping by UNESCO recommendations on HUL shows an average 40% responded for decision-making processes for assessments on the human resources of the historic urban areas; with Arab states received 50% positive replies which was highest among all categories [6]. Considering the nations are strongly driven by religion that may be unifying factor for the one voice also these nations are financially stable rich with resources; that enables them to acknowledge the historic urban areas.

ENVIRONMENT: Geographies limits climatic zone and natural resources, scale and type of activities possible with the locally available and determined the local economies. But the global economy under pinned with political will executed through technology upgraded regularly. The socio-economic setup operated strictly within the contextual framework driven by political governance for the local geographical resources dictated the nature of agriculture, availability of raw materials and thus the production of goods using the indigenous technology that is largely dependent energy for which sun along with coal and oil the key sources; and limited availability at regional level indirectly controlled the usage. But with electricity on board virtually transformed the whole dynamics of work culture propelled with technological innovations and liberated the time zones as well.

Having discussed and debated the key issue of traditional urbanism as cultural heritage, social capital, economic activities that are geo-politically governed for the contextual environment framework. The pillars of sustainability are inherent for

climate change and rendered in built environs. The social and economic are intangible ones that govern the tangible environment both natural and manmade through built environs. To arrive at the key attributes of climate change for traditional urbanism and to work up a pragmatic way, the pillars of sustainability is an ideal starting point addressed by the SDG defined by the UN. Thus Traditional urbanism is a huge resource in all respects for a holistic living for the mankind and much more than just rich built heritage.

PHYSICAL: The physical attributes of traditional urbanism spans across all scales from selection of site to layout of the city, accessibility, system of streets and public open spaces down to mixed land-use condominium blocks that are characterized with rich architectural styles and detailing that is contextual; disparate for its identity. Historic cities conventionally had an FAR of two. The buildings not exceeding three to five floors, allowing well lit and humanely proportioned private open spaces and public spaces easily achieved the high density [7]. Typically the workspaces were part of their residences and the mixed land uses spaces designed as it nullified the travel to work and zero energy for circulation as people basically walked to the work and education places; validated through scientific studies on energy use by people for carbon emissions. Mixed land use ensured the streets to be vibrant 24×7 encouraging harmony and assuring security by default for the local community and the implications reflected as lifestyles. While the modern planning principles are based on zoning with disparate land uses as commercial, residential, offices, institutional and others; and with cities expanding due to urbanization; transportation became a necessary evil contributing for carbon emissions. Interestingly when studies were conducted for energy consumption from user's perspective the outcome had varying results that decoded back to the traditional lifestyles and behavior patterns culture emerged as a crucial issue with responses i.e. resistance to use daylight, selective use of technology, threshold norms of the community and a large body of scientific studies conducted for building performance evaluations, post occupancy evaluations validates too the same.

As per UNESCO report HUL project-based assessment about 70% accepted norm for both 'mechanism in place to assess the vulnerability of heritage attributes of urban areas to socio-economic pressures' and 'assessment of the vulnerability of attributes of urban areas to climate change' implied context specific, supported by few nations while for inclusion of heritage in impact assessment but as a part of environmental impact assessment framework and social impact assessment.

Summing up the key synergies between Traditional Urbanism and SDG [7] for climate change is as follows:

- Goal 3 Health and Well-being: thrust on physical health, mortality rate whereas metal health/state of mind/emotional quotient/connect with nature/connect with people in real world are inherent to Traditional Urbanism.
- Goal 4 Inclusive and Equitable quality education does not touch upon the wisdom of knowledge; awareness of contextual environments especially the local natural renewable resources that are inbuilt in upbringing of children; living with nature inclusive in the cultural education sometimes reinforced with religion or integral

part of norms and practices underpinned with indigenous technology. A deliberate upbringing focused more on gender, as they are largely responsible for managing day-to-day resources.

- Goal 5 Gender equality and women empowerment—focuses on access and right and are significant for living traditional heritage cities as women are in direct connect with natural resources except for financial and thus can contribute especially for bottoms up approach. Also they are empowered through cultural connotation of the respective community.
- Goal 6 Sustainable water and sanitation for all—quantity and quality of water related to government spending plan while its typically culturally driven with women having access and for utilising as well.
- Goal 7 Energy access to sustainable and affordable—as currently energy through renewable sources is technology driven thus nations with stable economies have been able to harness and through research and documentation making it affordable as well while for poor nations both renewable and non-renewable aspects of energy are a challenge and the passive systems of traditional buildings can prove to worthwhile option.
- Goal 8 Inclusive and sustainable economic growth—typically the traditional urbanism was based on the premise of socio-economic set up thus was inclusive and sustainable as well.
- Goal 9 Resilient infrastructure and Sustainable Industrialisation- data on GDP and per capita carbon emissions per unit of volume research for the said areas focus only on quantitative data where as qualitative data is equally significant and affects quantitative and inherent to traditional urbanism.
- Goal 10 reduce inequity—although the traditional societies were structured but had an inherent symbiotic relationship amongst them and that enabled the community to function in an organised manner with each one contributing and delivering collectively.
- Goal 11 make cities and Human settlements—the strong socio cultural aspect makes the cities Inclusive/safe/resilient/sustainable, that are rich for respective building typologies as well.
- Goal 12 Sustainable consumption and production patterns—the strong contextual approach of traditional cities for development, growth and sustenance limits the carbon footprint both for production and consumption and vouches for low carbon living.
- Goal 13 Urgent action to combat climate change and its impacts—with transformation the traditional ways of living have been deviated from and can be largely looked upon as best practices especially for residential sector.
- Goal 17 Strengthen global partnership—disseminating contextual success examples across same geographies is worthwhile to be explored.

Synergies among the UN pillars of sustainability for traditional urbanism for climate change as in Table 2.1.

Table 2.1 Dimensions of Traditional Urbanism

Pillars of sustainability for Traditional Urbanism	Contextual framework	Global impact affecting climate change
Social		
• Social structure: Demography, Ethnicity/caste/ creed, gender etc • Traditional lifestyles: food, clothing, energy-use, and Consumption patterns etc • Education system- Traditional/local • Cultural heritage- traditional norms and practices family values and clan • Religion • Local administration Institutional and governance, legislation • Security • Connecting with nature	• Culturally rich local community driven by religion governed the lifestyles with the locally available resources both man made and natural using indigenous technology • Maximum use of daylight • Wisdom of Traditional Environmental • Low Carbon living and energy efficiency • Traditional education system, in harmony with local community thus security • Living with nature/context	• Global Lifestyles: consumption pattern food, clothes, health • Global culture for education system, driven by technology • High Energy use and large carbon footprint for: transportation, thermal comfort • Safety over security • Geo-political decision-making • Depleting cultural heritage • Diluting social capitol • Migration adding diversity and revising core population
Economic		
• Local economy • Agro based and production of local handicrafts, transforming for mass production, Industrialisation	Local available resources/ materials, indigenous technology used • Regular innovation to respond to the rising demand of handicrafts	• Global economy, system of production • Geo-Political decision making • Depleting cultural heritage • Lack of regulation- for energy efficient
Environmetal		
Geographical location and climate	• Indoor and outdoor spaces symbiotic • Locally available natural resources, natural features land form, • Indigenous flora & fauna and climatic condition, source of water, • Strong connect with nature/biodiversity	• Geopolitical decisions, impacting societies/economies. environments/ • Global resources exploited irrespective of geographical boundaries, facilitated by technology

(continued)

Table 2.1 (continued)

Pillars of sustainability for Traditional Urbanism	Contextual framework	Global impact affecting climate change
Physical		
• Identifying site and location • Zoning Planning principles • Typologies, Built morphology • Mixed land use • Densities • Street patterns, • Public open spaces • Modes of transportation • Norms and legislation • Governance and developmental framework • Growth, Transformations, re-densification, adaptability, additions and alterations, etc • Re-building of structures • Safety	• Traditional planning principles and norms responding to local natural features and resources, • Compact development • Locally available materials and Indigenous construction Technology • Architectural style/aesthetics of the built environs, visual aspect, • Resource consumption, Energy use, • Impact of social behaviour for use of energy and space • Walkable cities • Overlay of Infrastructure facilities	• Geopolitical impact • Impact due to Nature and pace of Urbanisation, • Global lifestyles, Lack of social equity • Impact of modes of transportation • Up-scaling Infrastructure facilities, impact of technology • Transformations of cities, image and identity of the city • Impact of tourism sector

2.6 Conclusions

Each of the traditional urbanism across the globe has common indicators of context that determined the scale of the city largely walkable and often compact as well based on the climatic conditions. The global economy propelled urbanization that accelerated the rate of growth along with it emerged the global architectural vocabulary strongly underpinned by information technology and communications. The hegemony of globalization brought about a paradigm shift consolidated the world at large at the cost of diluting the boundaries from geographies' to political, social, cultural practices and norms at large. Prior to the global economy the local and regional economies although interdependent but each one had a distinct identity of its in the larger economic network. This paradigm shift is on across the globe in sync with the pace of development thus it's evident among the developed nations while in transition among the developing nations and yet to occur in few nations with poor economies. The later nations are largely concentrated in Asia and African continents; ironically it's these very continents that have a large repository of the traditional urbanisms' and to integrate them for expanding cities and fast rate of urbanization shall ensure continuity of the said urbanism and be sustainable as well.

References

1. Anjali Krishan S (2012) Sustainability of living Historic cities in India; case study walled city of Jaipur, doctoral study, School of Planning and Architecture, Delhi
2. Anjali Krishan S (2018) Contextual Urban design approaches'—sustainable built environments presented at International Conference for Sustainable Design of the Built Environment; 12–13 September 2018, London, UK. http://newton-sdbe.uk/conferences/sdbe-2018/
3. Pereira Roders (2018) Introducing the HUL approach, the six critical step, and the four tools before the round-table session of the HUL workshop held in Amsterdam: Historic urban landscape workshop methodology by Clic project by EU https://www.clicproject.eu/historic-urban-landscapeworkshop- methodology/
4. Mike Turner, Ana Roders, Françoise Ged (2011) HUL beyond the new urban agenda the implementation of the UNESCO historic urban landscape pdf [accessed on 16 dec 19]
5. UNESCO—The World Heritage Committee, having examined Documents WHC/19/43.COM/8B and WHC/19/43.COM/INF.8B1, inscribes Jaipur City, Rajasthan, India, on the World Heritage List on the basis of criteria (ii), (iv) and (vi)
6. Gambardella: Carmine Le Vie Dei Mercanti International forum http://www.leviedeimercant i.it/
7. http://sdgun.or/goals

Chapter 3
Axiology of Traditional Urbanism

3.1 Engaging Traditional Urbanism

The traditional urbanism across the globe may be broadly put in two sets the first one as where the economies are stable and sound with technology as well this set of traditional urbanism is well conserved and accessible for tourism industry for international tourists the success story includes cities of Europe and others. The historic precincts are a pride but frozen with time dating back to its respective timeline. Whereas the second set of traditional urbanism that are a part of developing or poor economies and thus lack technology and research input as well. Also as these cities had economies in place which continued therefore despite the city expanding the traditional core continued as central business district virtually the nuclei status for the city. With the status was the responsibility to deliver as well thus transformations occurred for which the core built morphology responded timely exhibiting the inherent resilient nature. As the built environs were altered, rebuild and updated with infrastructure facilities the spaces mange to deliver but even in the whole exercise to accommodate the rich contextual architectural character was retained as much as possible with layers of history to be perceived by the future generations too this was a significant contribution and that was largely due to the local community the social capital of the traditional urbanism. Further the traditional handicrafts too gradually were improvised to cater to the rising demand with use of technology, optimum use of resources and sometimes even responding to the fashion vocabulary of the markets, that was smart move but again the motifs, shape, colours continued as original. In fact globalisation gave boost to traditional products as the micro and macroeconomics were connected. It is interesting to note that the diverse responses of the global economy have related repercussions, while alongside there are responses that moderate as well. Therefore, it is important to keep in mind the global targets and then the trajectory to be taken up by each of the traditional urbanism be designed that may be similar but not identical.

© The Author(s), under exclusive license to Springer Nature Singapore Pte Ltd. 2022 59
A. K. Sharma, *Traditional Urbanism Response to Climate Change*,
Advances in 21st Century Human Settlements,
https://doi.org/10.1007/978-981-19-4089-7_3

Globalization has established global cities those have transformed from metropolis to smart mega cities strategically developed to be in line with the world at large. Interestingly each of top global cities has to a traditional urbanism as a part of them. Each city responded governed by their context for culture heritage with thrust varying either due to political, economic or traditional connotation parallel with global standards. Irrespective of the expression the contextual connotation is apparent and can be deciphered, when solutions are studied across same geographies that make it stimulating. In all the megacities the traditional urbanism is integrated in a systematic way administered and responses vary in case of Tokyo with economy that developed the fastest in Asian sub-continent have preserved the buildings and precincts with their respective location within the city planning and punctuations of stage i.e. Imperial palace in the city's fabric adds to the tapestry of the city, whilst the image of the city that is largely because of more recent prefectures with loud examples of global cultures i.e. Roping hills, Yokohama and others. In case of London the heritage precinct is the core nucleus a landmark, an identity for the city with city growing in all directions as well. i.e. Trafalgar square, oxford street, regent streets. In case of Paris the Haussmann plan is very much integral to the city the heritage precincts enjoy special recognition and are pride too. In case of global mega cities with developed and stable economies traditional urbanism is very well conserved as a resource for the mankind, thus often closer to its Imageability and other characteristics. The same are mapped such in the city as individual buildings/structures of entire precinct and the traditional areas are incidental for their existence and continuity. Whereas when the traditional urbanism is a part of mega city with developing economy and urbanizing fast the said urban area is largely transformed with few or limited areas conserved for their heritage and their edges merging with the peripheral urban precincts with varying responses based on its specific immediate context determined by the divers of development at large. Conventionally the said areas are the nuclei for the mega city, anchoring the urban metropolis.

However disparate the mapping of traditional urbanism may be for the context's, significant is their acknowledgement, deliberate decision of their continuity with vocabulary governed. Both the approaches have their strengths as the former more in line for the tourism sector has access and shall continue to enjoy for may generations largely in its pristine while the other case where the urbanism under goes transformation proves to be more resilient and sustainable as they respond to the need of the hour and despite the transformations the layers in history are evident speaks volumes as they are a living example for generations example of strength a profound core social capital. Such responses clearly enumerate the innate strength of context and thus need to understand closely for anthropocentrism. It may be worthwhile to know the drivers for decision making for the contexts that are transient and continuing.

Presently most of the medieval traditional cities enjoying the status of living cities, their strength lies in their ability to respond to changing times and stand by the local community. Although the measures of development have altered the urban character but the public open spaces have continued ascertaining their status quo. A utopian approach for the essence of spaces i.e. squares, markets, public spaces, waterfronts and others are premium for the cultural heritage in urbanism. Frequently

they house the events both traditional and contemporary as well, a deliberate attempt to dovetail the heritage for contemporary events, a precedence seen in Athens, Tokyo and others for a global event like Olympics and others. This deliberate polarisation of activities has resulted in enhancing the quality of these traditional public spaces for the socio-economic growth for the metropolis as a whole.

Majority of the traditional urbanism is positioned as nuclei for the mega city at large, that brings in three areas of concern the traditional urbanism by itself second one is the edge where the urban tissue is in direct contrast with the development that occurred later and that further based on the timeline of process of globalisation the impact is manifold and the third one being the current urban fabric. Although typically each city maybe mapped for its respective layers but the process through which the decisions would have impacted could vary drastically affecting the recognition and deletion of the respective layer; that may be significant in it's own right from planning perspective. A key determinant is mode of transportation that escalated the scale of growth and even the pace of development. Although automobile altered the utilisation of open spaces to a certain extent but the fact that each of the traditional cities are of pedestrianized scale; once acclaimed by cultural heritage for tourism sector the pristine glory got revived for quite a few. The association of space to place making is directly related to the perception of the city, as walking is a slow pace that enables one to view things closely, acknowledge details so as to appreciate them and gets etched in the memory; experiences go along way toward the health and well being of an individual.

Modes of transportation in the heritage cities are a challenge as the scale of the cities is essentially walk able thus the automobile and other modes of transportation may be restricted on the periphery and people encouraged to walk as the streets have normally thermally comfortable with covered passages and other design solutions. Also the slow pace enables the visitors to experience the traditional ambience and appreciate too, ensuring a holistic feel of the space and relate to the unique identity of the place; from space creation to place making. Traditional patterns of streets and squares are the optimal means of networking of public spaces are integral for such experiences.

In the large responses and reactions for globalisation, the role of traditional urbanism is integral for the growth and progress. Be it for economy reasons for tourism sector or as continuity of the cultural heritage, that indirectly impacts resources, consumption both natural and man-made transformed in usage of spaces. Typically, the scale of traditional urbanism are parallel irrespective of their geographies, they enjoy a special place in the urban planning but the responses and acknowledgement has been diverse based on if they are part of develop or developing economies. Currently the status of each of them is being governed by strength of local economies and often due to regional economy as well. As shared where economies are strong the development is geared for tourism and thus infrastructure developed to cater to the sector are prioritised i.e., accommodation facilities for all economic classes, facilitate food from traditional to global and so on till the leisure and entertainment. As traditional urbanism is the key tourism potential thus close proximity to the said sites and precincts of the core city is premium. This demand of

tourism sector has manifold inputs on the traditional urbanism i.e. dilution of social capital as the tourists are external to the core social communities as the space main impacts is on spaces as they are altered to cater to the needs of the tourists, while the transformations occurs in the built spaces; often the architectural character and rich detailed either fortified or not conserved due to limitation of budgets as comfort of tourist supersedes the other decisions and often in adaptive reuse projects as well. Challenging is the nature of intervention, sensitivity to the architectural vocabulary, acknowledging the planning principles and norms to redefining the thresholds of comfort for resources consumption. Whatever may be approach for development but the interventions need to be sensitive to context, meeting the needs of the people and respecting the environment to be sustainable.

Currently technology is in sync with the digital world as a milestone of progress surely brings in precession on table but with related costs however, technology is for the mankind and not vice versa. The decision to use technology needs to be contextualised wherein the socio-economic equation to be placed in correct perspective, nations with poor economies and limited resources and large population may settle for labour intensive production, construction technology may be logical. Although with labour intensive the precession may be limited but the trade off wherein the aspect of social equity and a personal touch to the product is indispensable. In fact, the same logic may prevail for infrastructure services as well resorting to contextual alternative systems for waste management for sewage, waste and garbage. When the alternative systems are environment friendly; not only they are sustainable and fosters connect with nature and geographical context at large.

3.2 Critical Issues of Traditional Urbanism

The key issues in Traditional urbanism core areas, their immediate periphery and adjacent areas are challenging and presence of such areas in close proximity too does have related repercussions. When development occurs it happens across all scales and thus cut across all issues especially the pillars of sustainability. For any development often the policy decisions/strategies, norms, standards, research and documentation to best practices needs to be observed. Only in the recent past UNESCO initiated the HUL framework but that needs to be adapted for the specific context and executed; as the role of cultural heritage is inherent to achieve results. Typically these areas were acknowledged as special zones for conservation, while the real estate sector speculating in areas tables an important dimension that invariably has political and economic bias, which may not be in the best interest of the traditional urbanism. Although through pillars of sustainability one has insight for the three aspects but in case of traditional urbanism only an inter-disciplinary approach as the strategy to develop them was in the past. Broadly the critical issues may be summarized as follows:

- The traditional urbanism as built heritage in the form of cities, precincts, or group of buildings or sometimes even a building typically are characterised with their rich architectural heritage reflected as building typologies, planning principles, system of fenestrations to hierarchy of spaces with narrowing down to rich detailing as well. Further the open spaces too an equally significant role in contributing to the said character at large; from the large public open spaces, the street patterns to their personal open spaces as well exhibits as their identity and Imageability at the global arena. With tourism on rise the requirements that need to facilitate the same follow global lifestyles norms and standards which are high on energy and spaces and to accommodate them the traditional urbanism is being altered in parts and such changes even if in parts affects the whole as the traditional urbanism acts as one. Although the pressure to cater to tourism is in place but needs to handle in a sensitive manner specific to the context the solutions be arrived at that acknowledge the traditional urbanism at large, which is the magnet for the said activity. For example, be it high streets in European context, to souks in Middle Eastern countries to bazaars in Asian nations are unique and contribute to the identity of the city at large.
- Archetypally the scale of traditional urbanism is limited thus often fall under walkable cities; as the circulation was essentially pedestrianized and other modes of transportation limited to horses and carts driven by animals. The structure of built morphology in traditional urbanism is such with aristocracy/administration with wider circulation spaces and the mixed land use neighbourhoods with streets that are thermally comfortable and the street sections often designed such. In cases where the heritage is catering for tourism sector only the streets deliver for the mono function while the urbanism where the local communities are living and the tourism requirements are in place the same street is expected to handle the circulation of two very diverse natures. Interestingly in most of the case examples the two co-exist and the local people taking to two wheelers as they are easy to navigate through the narrow streets and the personal open spaces especially the courtyards used for parking displays flexible use of space with time.
- Each of the traditional urbanism developed with economic activities hat was indigenous delivered through mixed land use neighbourhoods. With advent of electricity, technology and communication facilities there was a paradigm shift; that had many impacts from review the their work cultures, to urbanisation and global pressures introducing new economic paradigms that were universal in nature and thus in case of traditional urbanism the old economic continued with a technology upgrade along with contemporary economic activities as well; and this amalgamation when done in the existing traditional fabric proved to be challenge.
- As most of the traditional urbanism have been in existence for centuries on in some cases implies need for *addition and alternations* to the existing built structures either due to their deteriorating conditions or to adapt to the revised functional needs of the people. Any addition to the existing structure requires careful examination of the state of the structure, building materials and construction technology used, which is often indigenous dating back to the timeline. Thus, the additions/alterations needs to be in harmony and sensitively executed and the

challenge is access to professional expertise, availability of materials and the craftsmen and each of the three is limited and often inaccessible too.

- With large reserve of built among traditional cities, over time transformations occurred and the spaces responded such but despite the paradigm shift and access to infrastructure facilities the inherent flexibility of spaces continued to deliver through *adaptive reuse*; that enabled to revitalise the cities, reduce for carbon footprint of new construction otherwise, connecting with the lineage with the ambience that nurtured cultural heritage and roots. It's a challenge to address adaptive reuse, as the proposed function needs to be woven with the existing fabric of traditional urbanism.

- *Rebuilding activity* for the structures that are in dilapidated conditions for which in addition to the above mentioned the key challenge if that is design of the building as with available services and technology enables the architects and planners to explore more with umpteen possibilities but the challenge is the anchor the imagination for the respective site and be strongly contextual; more so for a public building and the impact is substantial. The crucial aspect is to ensure that the layer of history not erased that in future when the layers of development are legible and roots traceable; which was and is the strength of traditional urbanism.

- Energy efficiency of heritage buildings is an issue with large existing building stock and access to energy a concern through all nations. as each of the traditional heritage buildings were constructed centuries back and some altered and added on for more space resorted to building materials and constructions technology then. With layering of infrastructure facilities to cater to contemporary functions the energy use is a concern. With global initiatives to reduce, retrofit and refurbishing such structures is proving to be challenge as each context is disparate and thus the solutions too need to be case specific. For example, the use of PV cells on terraces and roofs is not feasible due to the visual connotation of the buildings or skyline etc. as use of renewable energy sources is the need of the hour but issues as mentioned and often the logistics of installing within the existing constructions is a challenge.

- *Infrastructure* services from water supply, electricity, waste disposal, solid waste management to telecommunications to security were super imposed on the existing built morphology over a period of time; thus they are neither co-ordinated nor organised. Also the norms and standards of thermal comfort introduced are parallel to the existing ones and sometimes even create conflicting situation and that isn't healthy for the harmony of the local community.

- The *core social capital* is the key strength of the traditional urbanism. The local community are the custodians of cultural heritage and that executed in the traditional built environs by them is a complete statement. Thus, any attempt to look upon an aspect in isolation doesn't work be it tangible or intangible cultural aspects. Often the sustenance of cultural heritage is at stake, which is an important resource for the mankind to be cherished by the future generations and proves to be vital for tourism sector as well as in contemporary economic activity.

- The *continuity* of the local community is the key thread that ties up many aspects as one. Over a period of time the spatial constraint, accessibility of services,

provision for car parking, and a family growing with pressure on land increasing has been constant. Often some of the family members move out to be a part of global lifestyles with rest continuing to stay; that assures the local community in place. But when the entire families move out to be replaced with migrant population to move that have multiple impacts beginning with dilution of the core community to altering spaces to suit their requirements that adapts to their lifestyles that may not be in alignment with the core community. Sometimes over a period of time even the migrant population merge with the locals with local cultures modifies sometimes enriching them or may bring in minor changes as well that over a period of time becomes permanent in nature to be an integral part of the cultural heritage. While tracing the layers of traditional urbanism the mapping of the cultural practices are evident in the spaces both public and their houses.

- The concept of economy reflected in built morphology the most crucial being mixed land use with low rise high density [LRHD] making the city compact, dense, reducing the travel time making the walled cities and other factors as well. Typically, these cities are dense and over the years with additions and alterations increasing densities too. Most of these cities were ground plus one floor those expanded to four storied structures. Retaining the open spaces from internal courtyards to entrances porches to streets and was never built on, although the nature of use, timely responded to the needs of the local community. The densely populated neighbourhood bounded the community through cultural practices and norms. Framework evolved typologies of buildings with optimum densities but not over crowding. There existed a strong symbiotic relationship between the practices and spaces both built and open that extends to the aesthetics of the space as well for scale, proportion and inter-relationships. Evolution perspectives enable indecision of local community in nature, where nature is understood as cultural diversities. The whole matrix of development resulted in archetypal vocabulary specific to the context and in the name of progress driven by economy the said matrix was overlooked and super imposed with an alien vocabulary that never got integrated with the existing one, considering that was the essence of traditional urbanism. When sensibility prevails the large body of work is at stake i.e., connect with nature, practices that are high on energy, issue of safety translated for security and so on.

The traditional urbanism in contemporary planning approaches are designated as special areas/zones and accounted in contemporary planning approaches with heritage zones delineated for the master planning. It's dichotomy as the economic activities initiated in this core heritage zone are continued with addition of industries over time and even the social fabric is kind of extension of the core with migrant population living the global lifestyles. Whereas in planning the contemporary built morphology is parallel to the existing heritage texture. The state of economy and the nations the traditional urbanism hails is insightful for the approach one needs to have in place as its developmental framework. The developed nations have adequate resources to safeguard the traditional urbanism a resource for the city, nation and

world at large; to be cherished by the tourism sector and invariably well equipped to cater to home and international tourists. While the traditional urbanism located in nations with poor and developing economies often lack in professional expertise as well and the key challenging aspect is that these zones are living traditional heritage thus intervention if any has to cater to the continuity of the ongoing activities and address the tourism sector as well. Further the tourism sector addressed in a static and living traditional heritage has its own issues as in the former one the tourism sector is to be facilitated whereas in the latter one both local community and the tourism sector needs to be attended; and when the state of economies are at developing stage the tourism sector is given priority over the local community which may have immediate returns but in long run at the cost of traditional heritage and that proves to be a permanent loss. Next facilitating accommodation for the tourism sector the issue of global standards come in for host of concerns from spaces the sizes, proportions to thermal comfort etc. and normally they are not in alignment with the characteristics of traditional urbanism and alterations are done to the traditional fabric to meet the needs of the tourists; and such intervention is a permanent alteration to the cultural heritage at large as each of the spaces are backdrop for host of activities those contribute for the traditional norms and practices and any change affects the activities.

Largely the perception by the professionals for traditional urbanism is that with physical conservation which is strongly embedded in twentieth century mentalities that often their understanding of the the past and its larger or rather holistic meaning is skewed and limited to which bits of it to protect and keep. It is almost as if one is not allowed to be interested in the past without wanting to keep or restore the remains of the past, which seem to exist *only to be preserved*. The wide range of how past is to be used by society has been reduced to the literal act of preserving its fabric [1]. Conservation of cultural heritage, too, means to accept and testify of on-going change, not to prevent it. In other words both natural and cultural heritage are dynamic manifestation of change over time, not its victim. In order to connect, what is done to heritage in the contemporary world, with the benefits of heritage for future and creative transformations over time [2]. Given the heritage is about people, not about monuments conservation must always be informed by the question of what we want the heritage to do in, and to, society in order to benefit specific people in present and future generations [3].

With globalisation came in global standards as well that established the baselines for thermal comfort among others. Such an understanding created a dichotomy in the traditional urbanism wherein passive systems were prevalent and the local communities well adapted to certain baselines. When energy is a huge concern, it may be worthwhile to question the said baseline for global mapping; as already mentioned that the threshold of thermal comfort for the various communities across the globe varies and standardising in advance for the developing economies may not be relevant especially with climate change issues i.e., rise in temperatures continuing, natural disasters too on he rise and others.

Technology is contributing largely for all aspects of our lives from services, social, to lifestyles and more. Further technology upgraded over time has impacted the spatial requirements, as every square inch of space is a premium as these cities are compact

and dense, therefore the implications are significant. Next with technology innovations continuing its hard to arrest the solutions and timely intervention is required for optimum utilisation of spaces. Technology is a necessary evil of our lives today. The role of indigenous technology has been for problem solving, easing out cumbersome and repeated tasks quicker. While the scientific innovations and technologies typically aided to improve often upgrade the lifestyles at large and continuing. The global economy used technology to escalate the production and to even the consumption end information technology used. This increased use of technology for both production and consumption end and global lifestyles was underpinned with energy use, which had issue of emissions too. Thus, technology may have eased our lifestyles but the related costs of energy have been substantial. Global economy and technology have a direct relationship both growing at a fast pace with a related cost of energy with as a direct fall out of climate change but ironically, it is the technology that is addressing the concern of climate change as well.

Additionally planning parameters i.e., mixed land use that ruled out the travel time form work to residence revised with modern planning principles have proposed concepts like small office home office, a translation for quality of life, health and well being. The traditional urbanism conceptually has a lot of merit and despite transformations the essence of the design aspect has the potential to be continued; mixed land use one of them. Cultural heritage as the fourth dimension of sustainability directly impacts the three pillars; the environmental for access to resource's, economy for consumption and production processes while integral to social. All attributes of social are governed such, from social composition and its sub aspects like social cohesion and others. The social may be interpreted as diversity in societies due to colour/creed/caste/others based on the context/continents/state of economies etc.

Social diversity existed in traditional communities and each one enjoyed a symbiotic relationship for the tasks conducted; although the relationship continues but symbiotic nature is replaced with number's and so on. The set of aspects vary in weightage for each of the context that exhibits the rational innovation by a community rather than high profit efficient solutions. Despite repeated re-densification in the core areas the quality of life is largely consistent, seldom used as ambience for tourism sector. The morphology of these areas especially the public spaces play a significant role both for activities and connecting to roots at large. The adaptability of the public spaces to deliver over time for activities to technology driven infrastructure loaded.

Of the large number of traditional urbanism, the selected ones as world heritage sites are officially recognised as global heritage resource that has its advantages and related issues as well. The advantage of global awareness for its presence on the tourism map, However, when the world heritage site is living then the world heritage framework may not necessarily in alignment with the contextual framework and may crest conflicting situation; a challenge for any development initiatives. This implies that there is an inherent cap to the number of visitors that makes the experience rich and rare to be cherished for a long time. But one the traditional Urbanism is declared as World Heritage site then the challenge becomes manifold and to cater to the demand the experience cannot be diluted as each one has equal right to the heritage

that is universal global asset. Next the real estate enjoys a high value and the built spaces with related detailing adding value and often, for the tourism sector copies are made wherein the physical spaces are built but lack the soul or the very essence of it for which they stand for. Culture cannot be looked upon as a product/commodity for tourism sector instead culture needs to be observed, perceived and imbibed in the framework that nurtured it as much as possible; only the associated values shall be appreciated and may lead to the continuity and thereby regeneration if at all. Invariability innovation has been integral for tourism purposes for each of the cultures as each one is distinct and unique. This clearly suggests that people have graduated from recognising monuments/buildings to precinct level for continuity and holistic experience.

3.3 Traditional Urbanism in Timeline

Science of urbanity can be traced through science of evolution through the ages of human habitats. For a holistic understanding of human habitats is inter-disciplinary knowledge from sociology, geographers, philosophers, biologists, economists and related professional knowledge that is insightful for the built typologies and can be deciphered through public spaces, system of street network that was essentially the public open spaces further the nature of governance, political situation and within timeline the urbanism evolved. For administration cities: the commercial street with key institutional buildings strategically located being the main spine of the city with residences laid out governed by the local geographies. With time the contour of sociology added necessary dimensions of urbanism and gave it its individuality as fine-tuning. The layout of street patterns is often organic in nature following the natural slopes and features; whereas on a plain and flat site grid—iron pattern was opted for but often negotiated for planning texts and cultures too significant role i.e. for communities that are introvert invariability characterised by cul-de-sac or had dead ends for security or cultural practices for gender discrimination and others etc. Next, the basic street graduated to hierarchy of streets; with individual buildings punctuating the streets in a strategic location further accentuating the individuality even more. The wisdom of knowledge with the local population coupled with their sensitivity for the regional resources reinforced their distinctiveness with transformations demonstrated for as varying typologies from settlements, walled cities and compact cities to smart metropolitan global cities. Thus interesting to observe the translation of local geographical typologies across the globe as unique and that truly demonstrates the strength of urbanism across the various scales of urbanism.

Tracing the key milestones on urbanism with reference to traditional city is the, Chicago school one of the earliest that focused on urban sociology and vouched for mapping of cultures and its impact on growth of a city through urban institutions, delinquency associated with physical deterioration and high migrant population [4]. The concentric layout vouched for a certain order and systems prevalent then, but the key elements continued to be the streets, activities in the streets and related issues.

The main representation of urbanism was observed through its streets, public spaces, institutional buildings and layout of the city through the qualitative aspects of the streets that housed a range of activities for all age groups. This linear open space essentially a circulation area acted as veins and arteries for the city; the flexibility of space to house the range of activities was a significant aspect that contributed to the quality of life of that urban area reinforced by designers and planners. With layers of history in traditional urbanism; cultures' evolved and sustained adding value to the urban area and city and that over a period of time resulted in identity of that place. Often the concentration of activities and people in cities have environmental advantages achieved due to optimum usage limited to local resources. The towns and cities were compact and provided for seamless pedestrianized movement of public and adaptable to change with other modes of transportation with time. The public spaces, institutions and human scale in its buildings and neighborhoods when enriched with large public participation reinforced the identity of any place. An ensemble of urban form that responded to the needs of the people over a period of time translated into rich traditional urbanism with each generation leaving it are blueprint and adding respective dimensions with time.

The scale of development was essentially guided by the local available resources thus the pace of development was gradual that was consistent for decades on until the industrial revolution. With global economy global inter urban networks have emerged for large-scale production and consumption of goods, services and technology. The contextual geographies are being superseded by the global resources irrespective of their origin are proving to be as a boon for the global economy. With capitalism ruling the global economy, the nations politics are becoming a necessary evil and advantage taken for eco-political. A shift became the key detriment for strategies and policy decisions at national and regional level. Strong economies established developed nations while the developing nations in the process were vulnerable and for growth were at the receiving end, for markets and under-pinning service sector. A back-drop and eco-politics of Infrastructural urbanism impacted nature of urbanization world over more so for traditional urbanism; irrespective of its local geographies and social connotations. An overlay of infrastructure with technology getting upgraded frequently is proving to be challenge for the developing and poor nations. In the stage of transition, the time-tested value of Urbanism shall be a worth exploring for its recognized and shifting perceptions needs immediate attention at all levels. Further with automobile of transportation has escalated the scale of urbanization have cities expanding exponentially i.e., as transit-oriented development the urbanization has assumed new scales. Next the towns are urbanizing fastest as compared to the metropolitan cities thus a strong or reason to monitor the nature of development in such cities. The backdrop characterized the urban grain and the traditional urban tissue got transformed with new typologies driven by eco-political climate for setting up for manufacturing in aspiring and developing nations. Next major driver that intensified the global economy is technology especially information technology that brought in a paradigm shift in the work cultures and scaled up. The nine to five working stretched to twenty-four seven setting in global cultures with domino effect and affecting all aspects of life. Thus, global economy paved the path for global

cities, mega cities to smart megacities and similar in essence they defined the global urbanism that catered for the global communities. Rapid rise of natural disasters across the planet the highest ever in the history of mankind is a resultant of rapid urbanization governed by global connotation started taking toll on environment and with environmental deterioration continuing at a geometrical rate climate change has emerged as the prime focus.

The contextual framework for traditional urbanism was localized; essentially characterized by walk able communities and largely depended on daylight and indigenous systems often by default were low on energy and thus circular in nature that completed the loop but limited to context and with over time the circle expanded at the city and regional level making it open ended and contributing for environmental degradation evident with frequent natural disasters on the rise. The concern was more about a different type of urbanism that was super imposed on a contextual one wherein related aspects were superseded. Change is surly a sign of growth and scale an indicator of progress but both the pace and nature got overlooked with rapid urbanization leading to the current state of unsustainability. During the process of development, transformations occurred and translated in both open and covered spaces. Typically, each global economy decision pushed the process of urbanization even more. There were two responses to traditional urbanism on the growth of the city with traditional urbanism as core as expanding and mushrooming of new cities those delivered for industrial, automobile, and service sector to information technology as per the need of globalization. The new cities were dealt with planning theories often innovative with efficiency, delivery of products as the key with other aspects treated as facilitators including the residential sector; considering housing has a strong social-cultural that was integral in the traditional urbanism planning process. The organic planning of traditional urbanism gave way to structured orthogonal planning; the scale of the streets was translated as boulevards and wider streets to accommodate cars and so on and thus the nature of urbanization had a paradigm shift for social, textures, detailing, quality of space, visual character for both tangible and intangible. The traditional urbanism was planned with principles rooted from the respective cultures of their contexts, while the unifying factors across the planet for such urbanism is judicious use of natural resources from daylight to landform to locally available building materials.

When Urbanism grew at the regional level the diversity got added, enlarging the scope to multi–disciplinary in nature. The diversity of geographies, climate, context, social-caste, creed, ethnicity, cultural connotations, religious dimension, and others even narrowing it down to the DNA as well; as that determined the thresholds for the local communities that in turn impacted the environment and resource consumption for their respective economies. This relationship matrix grew into a web of aspects orienting the developments such. With urbanization the homogenous traditional community gave way to a social composition that comprised of all kinds of diversity that contoured urban sociology, layered over time that cuts across geographies and establishes itself clearly depicts the inherent strength over political and economic arenas. But each of cultures retains their identity in the cosmopolitan society and displayed through their festivities, food habits and clothing habits that

can be rooted to their traditional urbanism. Each of the communities co-exists and lives together in metropolises. Key observation here is that each of these communities nurtures and sustains their cultures and the basic premise of any culture's rationale is, use of resources that ensures continuity and only gradual changes are imbibed as transformations and any kind of paradigm shift disrupts the continuity as the changes are not gradual, also with the diverse nature of the parameter as well. For the urban expansion to be sustainable this is both logical and proves beneficial too.

Typically, planning norms are in place in developed nations while among the developing nations often they are drafted explicitly but the contextual sensitivity in inherent to their approach. In the recent past with development in the traditional urban areas are being governed by tourism sector as foremost option to mobilize resources for the said areas. More often based on the heritage value at the global level the related infrastructure is placed or upgraded, often underpinned with technology. i.e. most of the world heritage sites irrespective of their geographical location are addressed. Although the traditional heritage buildings and precincts are addressed for tourism for which provision of electricity is necessary for thermal comfort, illumination, to sue information technology and others. All these are overlaid on the existing historic urban landscapes for the sites and to provide accommodation and access that requires changes in the tissue of the traditional fabric. Further the changes for the site are invariably done with sensitivity and care as the heritage value is at stake but for the rest in the development quite often lacks sensitivity thus the context at large gets altered as the traditional heritage and the context wherein its placed have a strong symbiotic relationship thus development of any kind needs to be recognized, well researched and only a deliberate approach rationally arrived at as inter-disciplinary in nature shall prove to be all inclusive.

Development in Traditional Urbanism is not unilateral but a matrix that is socially and culturally ingrained makes it complex and challenging at the same time. The nature of development in traditional cities was geographically confined, socially governed, politically executed and culturally continued. Further social governed the economic structure and thereby the resources too while the political patronage nurtured the cultures. As social dimension is qualitative and was pivotal for growth thus the nature of development too was gradual. To this backdrop religion contributed in a way big way and maintained the necessary balance to sustain the cultures, its growth and continuity responding to timely changes as well. This resilient nature enabled local community to participate and be involved in decision making as well. Till the time the equilibrium in the framework continued the development in traditional urbanism can be understood in layers and that is the key strength of the urbanism. This stage of traditional urbanism in history is longer and typically spans for centuries on. With industrial revolution the said equilibrium was re-defined and global economy overtook the local economy thereby reducing the contribution of social and related aspect culture. This new equation was super imposed on the existing equilibrium and there was a paradigm shift. And this new equation transformed virtually all aspects of traditional urbanism. Although the initial transformations got imbibed with the local cultures for dimensions of traditional fabric of the city, till the fenestration details; such a transformation across all scales explains

the paradigm shift. In the name of development and progress may not prove to be a positive indicator, except when coupled with rationale response to contextual environment at large. When this equation took cognizance of resources that were accessible at the regional and global level then the national boundaries got diluted and the political stakes took a standpoint in line for the global economy. A shift is proving to be unidirectional and with the fast pace of global economy. The transitions when are within the limits of the social framework, irrespective of its scale were imbibed, honoring the core values. But with globalization both the framework and the scale of transformation including the nature and pace all re-defined for good. With majority of global impacts still in progress there is still hope to bring in the necessary equilibrium.

The typology of urbanism that is culturally driven was strongly depicted both in the overall texture of the city and the public squares, large open spaces in the city Centre as the core; whereas the mixed land use blocks for work and residences that exhibited resilience to accommodate the migrants and gentrification through generations as well. The standard design approaches through the times touch upon the various dimensions of traditional urbanism in parts of whole. The various development typologies perceived as traditional, historic, regionalism to modernism, post-modernism have added to dimensions of contextual framework. Only a comprehensive understanding has enumerated the paradigm shift from contextual socio-economic to regional environmental issues, to globalization and related anthropogenic, underpinned by technology for subjects, knowledge and global urbanization issues may be amicability summed up with agenda 21, the charter's and protocols to HUL initiative and continuing just establishes the worth of dimensions of traditional urbanism. Nara charter with focus on contextual framework describes Culture is a very powerful tool to bring the mankind together on the same page as it's above caste, creed, religion and other diversities, its largely humane part of mother nature thus thrives. Each of the traditional urbanism is a global resource therefore it's a collective responsibility of all. But the local geopolitical responses are conserving, protecting and safeguarding the traditional cities. Also as they are the reserves of cultural heritage their continuity needs to be sustainable. Each of the development introduced varying kind of transformations adding diversity to the nature of developments just authenticating the globe's urban future. With the type of urbanism the need to confront climate change the built morphology, environmental foot print, social opportunities surface as the key [5].

It's noteworthy that conventional sustainability is looked upon as completing the loop but at the global due to paradigm shift in scale it has graduated to helical. Therefore, its imperative to recognize cultural heritage and the role played by it and thus needs to map for all its dimensions from various perspectives, as only then one shall understand in a holistic manner to carry it forward effectively. Next as the cost of cultural heritage is essentially a negotiation between the qualitative and the quantitative and thus equating a cost in economic terms over the social costs that is complex to gauge. Ironically as anything to do with the culture is largely social and people centric for them to change is constant, while in the recent past the change has been frequent and drastic as well unlike in the past where it was

gradual. Going by the nature of the aspect, anything that has social connotation means dealing with the human psychology, which is delicate and sensitive at the same time subject to geographies, context, framework of political/environment and economic conditions. If we intend to regenerate the cultural heritage the trajectory needs to be similar but not identical, to the way it has got nurtured such studying the indicators related to cultural heritage i.e. social, cohesion may be interpreted as compatibility of diversities in societies of color/caste/creed/ethnicity/any others that are based on context/continents/state of economies etc., the integration of these aspects in each of the culture's is distinct and unique. The strength of the cultural heritage cannot be limited for tourism sector instead needs to be observed, perceived and imbibed in the framework that nurtured for the wider canvas and only the associated values once appreciated may ensure the continuity and thereby regeneration may happen in true sense. The significance is reinforced more so as the contemporary modernist estates and campuses are artificial prolongation of unsuccessful experiments of social and architectural collectivism. The theoretical models are ready, but in their application for cultural connotation are slow. Regarding the connection between preservation and sustainable development viewpoint that historic cities are not static objects to be appreciated for their rich architectural history, but as living organic spaces that are occupied and appropriated by local communities as an integral part of the process of recognizing community's identity and sense of belonging and said social dynamics of historic cities impacts the local sustainable policies at large.

3.4 Transformation in Traditional Urbanism

As cities flourished the densities steadily increased with time and the tradition built morphology adapted timely as these cities grew from re-densification to layering of electricity, individual water supply connections, communications faculties—mobility, telephones, Internet and others that never existed at the time when these cities were designed. These aspects were limited to the context over timeline the traditional urbanism got super imposed with infrastructure facilities and facilitated with technology. With economy expanding its base exposures to other cultures the aesthetic sensibilities of the people also fine-tuned and that endorsed through politics of governance they were imbibed within the local cultures making them even more typical. Transformations occurred in the cities with increase in densities having a related impact on infrastructure facilities and transportation being the key issue; that added the dimensions: of automobile and communication technology bringing paradigm shift in growth and development of the city's expansion especially on the immediate periphery and within. Largely wherever the traditional cites have grown they have continued to be the nuclei for the mega city and retained their identity for the global city. With migration, re-densification occurred in these core cities while public spaces have continued to deliver for activities, such flexibility continues to be the key strength. The transformations in the traditional core occurred parallel to the contemporary global developments. The capitalist driven global economy impacted

the social capitol that resisted the change. Often traces of traditional urbanism can be seen and that connects to the nuclei in some ways sometimes an extension of traditional urbanism or even as deliberate design initiative. Growth of urbanism at the regional level continued till the medieval period followed by the era of industrial revolution, scientific inventions and information technology being the recent one. Each of the changes was neither gradual nor contextual; with an idiosyncrasy of the global urbanism took over all aspects of lives for the mankind. All the changes and shifts occurred in the shortest time span in the history for the lives on the planet earth and these short-term gains have accentuated the nature of urbanism although research in technology that aided to optimize, often at the cost of marginalizing humans.

The contextual framework nurtured a sense of consistency with pace of development that cultivated urbanism, which imbibed the social connotation timely balancing the environment and economy. When social aspect got marginalized with economy over-riding the environment, the context got nullified and the development tended to be helical almost unidirectional. Each of the traditional sustainable tissue needs to be woven to the global city fabric. At the outset, it appears to be utopian but the global city governed by global economy has top down approach and that has shown its results whereas the bottoms up approach wherein the contextual is central dovetailed with the cultural heritage has proven its merit. For our basic needs at this moment in history it is fundamental to shape the sustainable future and in this respect in short traditional Urbanism as the foundation vouches for a low carbon future, surely an option worth exploring.

The traditional urbanism of walled city of Jaipur witnessed a unique gentrification from the conventional local community to accepting migrants when suburbs were in vogue but this phenomenon was nation specific. Typically among the Asian cities the core local community continued despite all odds defying the gentrification and upholding the pride of the cultural heritage. Automobile mode of transportation impacted urbanism like none other; it virtually brought about a paradigm shift in urban planning. Escalated the scale of the urban areas from pedestrianized compact cities to mega cities to urban agglomerates to transit oriented developments that stretched across few hundred miles. Further the train networks too shrunk the nations across the world and the distinction between rural and urban got diluted bringing the two at par aided by technology the quality of life was consistent. But this rural–urban gap continued among nations with developing and poor economies and in these nations the two urbanisms were parallel and continued. In the former backdrop the traditional urbanism has been recognised in the planning process for its cultural heritage strength thus enjoys its distinct position and well structured for global tourism sector. Where among the developing economies the traditional urbanism not only survived apparently thrived with the key strength being the socio-cultural heritage and environmental decay has been across the globe and poor economies could not contribute actively; thus of the key pillars of sustainability the balancing act pivoted around social with culture as inherent. However limited may have been the balancing act and based on the each case the sustenance varied. This observation clearly highlights the role played by the traditional heritage and living historic cities' context and the response of traditional urbanism. Further between the two scenarios

where the conservation is at its best is being supported by tourism sector with the traditional urbanism static except catering to the global tourism therefore if any are reflected as adaptive reuse for contemporary needs of tourism sector. Whereas in the second situation the traditional urbanism continued to cater to the local community responding to their timely needs, responding to the growth and layering of infrastructure, technology to upgrade the lives of the core local community and apparently adding value to their local products as well. Also the key public open spaces nurtures activities and events related to the cultural practices and norms, when recreated for tourism sector are rather frozen while when participated by the community reinforces the heritage strength that goes deep down in the history as continuing, validates the reference to context in totality.

Globalization has triggered for half the world's population to be living in cities in near future. In the process the people who manage to migrate to the developed nations with stable and growing economies irrespective of their origin and the gap exists with developing nations with poor economies. The disparity of economies and access to natural resources emerged a major concern for governance and securities. This pace of urbanization is ensuring concentration of people from diverse culture's that has triggered issue of security amongst others and that is advocating people of identical or similar cultures to congregate together for a common ground of ethnicity, caste creed and others aspects. One may observe the complexity of deviation from the context framework to global has huge environmental impact's that both sensitive and multi-disciplinary too.

The traditional urbanism connotation in contemporary development reflected in standard global vocabulary but housing varying communities. However, the hegemony of global vocabulary re-defined the built environs largely for visual aesthetic especially for glass façade buildings that was more a statement by architects and designers to break free from the traditional contextual framework and that was emulated by all nations aspiring to be clubbed with as developed nation where the said architectural vocabulary germinated. These visual images overlooked everything from issues to context's only to be incidental. This robust architectural expression of glass façade buildings executed irrespective of geographies adversely impacted the environment. As the countries where they originated logically wanted more of daylight to come in for office buildings and keep the buildings warm due to the trapped heat. Whereas when they were duplicated in countries where there was abundance of sunlight and the large glass fenestrations let in excessive daylight and heat as well; for which air-conditioners had to be installed for thermal comfort that had multiple impacts from disproportionate use of energy to creation of urban heat island—an impact of global hegemony Parallely the traditional built spaces were thermally comfortable, low on energy, rich in architectural detailing, having a scale of the work spaces that was neither imposing nor formal. Thus deviation to be aligned with global architectural vocabulary is now being relooked at especially in Asian countries where the pace of urbanization is fastest and majority of the construction is yet to happen thus timely intervention is much needed, as the situation is alarming. In the recent past numerous initiatives have been taken up by research sector including scientific studies to quantify and develop mitigation strategies i.e., meta studies and research

on building performance evaluation, post occupancy evaluation, user friendly technologies and umpteen seminars, conferences, summits and workshops with one of the significant outcome validated is the role of 'culture'. The cultural roots basically determine behavior pattern that governs the consumption of resources proven. This just reinforces the fact that despite economic pressures the social connotation is significant and the same is time tested wherein social capitol nurtured by cultural heritage has been responsible for sustainability of traditional urbanism that is low on resource consumption. The learning from traditional urbanism translated such for pillars of sustainability for the built environments may be looked upon as best practices for the respective geographies.

With urbanization over timeline various dimensions of traditional urbanism have been exposed to the changes and transformations that occurred due to political and socio-economic reasons until the global economy took over that expanded the contextual framework to global one. Conceptually in history the east got civilized first followed by the west while the milestone of globalization by the west influencing the east and continuing. However, the narrative on sustainability has recognized the regionalism and some of the contexts are attempting to complete the loop from local to global to now local again through transformations. The contextual typologies that mushroomed regionally enjoyed disparate identities in the mapping of globalization. The global economy accelerated the growth and development across the globe and while the nations with stable and rich economies had the necessary resources thus were sensitive of their traditional urbanism and addressed for tourism in a structured manner. Deliberate approach has proved to be a resource for the world i.e., middle and European countries are success stories among others. Next the growth and expansion of cities was deliberate planning addressed access provided for through various modes of transportation.

While for the nations with developing and poor economies traditional urbanism continued to be the core and transformations occurred over time to respond to changing needs and sometimes were done at the cost of structural transformations of the rich traditional urbanism. With the pressures of urbanization, the core city started growing on its periphery and expanding further, that the core city ended up as a small percentage of the contemporary metropolitan city but enjoys being the nuclei of the city at large. This approach had inherent dichotomy of traditional urbanism that enjoyed a pedestrian scale compact development with mixed land use with public spaces and streets making them homogenous and with automobile mode of transportation the growth of the traditional cores expanded geometrically with modern planning principles, norms, practices and standards in place that was in stark contrast with existing distinct identities. This distinctive approach to traditional urbanism for the two set of nations resulted in well preserved heritage in developed nations and as a living heritage in the developing economies with transformation in the built morphology and building typologies.

The role of younger generation is significant as the future custodians their participation is crucial for continuity of cultural heritage and development and transformations. Typically, in case of living heritage the local communities ensure the sensitivity as a part of upbringing with events reinforcing despite the contemporary lifestyles;

as it enables them to connect with their roots, that instills in them sense of belonging which is an important part of their emotional quotient. With this backdrop wherever required the cultural heritage may be an inherent part of education system dovetailed to be part of their persona as lifestyles. Grooming the younger generation shall ensure cultural heritage be integral to their approach to do things and shall contribute for sustainability at large.

3.5 Traditional Urbanism Culture Matters for Future Cities

Cities of the future have been cloned with the hegemony of the global vocabulary wherein the urban fabric is occasionally punctuated with the traditional connotation more so in the intangible aspects. Conventionally the tangible and intangible in traditional urbanism were bonded through 'contextual' cultural heritage and thus the traditional is a holistic experience; unlike the global although the equation continues but with the world as context it may take centuries on for it to be a holistic experience and shall be complex web of numerous issues and may not happen as well. Also the cities of the future are exposed to frequent changes and with the time gap reduced the transformations often do not get registered as a layer in history of events; as while mapping of a city each of the layers add to the strength of the place. The layers of each city get amalgamated with time to result for the cultural of the city; wherein the cultural heritage is just another layer but the resilient one that permeates through other layers and often passes on the hue through each one. The intensity with which each of the layers permeates demonstrates its inherent strength. In such understanding of the city the cultural heritage emerges as the key layer, even when the physical display of the heritage precincts may be limited but is evident in the socio-cultural connotation and that is reflected in the resilience of the city. Thus, traditional urbanism is inherent to most of the global mega cities i.e., London, Tokyo, Shanghai, Sao Paulo, Beijing, Delhi and so on.

Numbers for production and consumption for products, to all aspects to lifestyle down to the leisure activities, drive the global economy that is defining the global paradigms for future cities. The large-scale production of products brought in uniformity compared to the limited production of similar looking products; that made each product exclusive that brought in a personal touch kind of non-anonymity, which was different from the standard products. Further due to limited production and processes involved was limited to the set of resources within the context. defined scope was environment friendly a strong aspect of traditional urbanism.

The key takeaway learning is living with nature meant honoring the natural elements for their optimum use that their rate for renewability is more than the consumption kind of completing the loop for their regional context. Such a take has direct impact on the rate and system of production, directly related to the economic activities rather than concentrated distributed uniformly so as to make largely each

oneself sufficient; while the rate and quantum of consumption be limited through condoning the lifestyles from food, clothing, standards of thermal comfort and other related resources consumption like water and so on. The opulent global norms are proving to be redundant and the traditional ones more meaningful better aligned for carbon emissions and climate change. Although global megacities are required to follow the global norms but they house only a marginal population compared to country's total population, whereas the small and medium cities house majority of the population and they have the opportunity to follow best practice of traditional urbanism.

The challenge is co-existence of traditional and global be it living heritage or just architecturally rich precincts. The unprecedented pace of urbanization, highest in the recent has escalated the growth of cities exponentially. The age-old traditional tissue gave way to disparate developments that is in stark contrast with the traditional urbanism and the anthropogenic impacted each of the disparate urbanisms and the affect was direct and indirect that has cumulative effect. i.e., mode of transportations, the compact cities were essentially walk able that was eco-friendly, healthy lifestyle no additional space required for parking but now with two and four wheelers in place, all the three aspects are effected. As the growth of the city was driven by modern planning principles thus the modes of transportation became more and more pertinent for navigation within the cities. With such a dichotomy the impacts are felt uniformly, while the traditional urbanism pockets emerge as isolated sustainable pockets placed in developments that are governed by contemporary planning.

Heritage and conservation are predominant themes in discussion of cultural identity and preservation such an approach reduces it to a skewed outlook of a limited few from conservation backdrop whereas it needs to be part of the mainstream planning processes wherein cultural heritage and sustainability are the one of the key attributes in global urbanisation process. In fact, the current parallel approach by a set of professionals attempting to address the agenda for their respective issues has not been able to deliver and more pressing issues emerging foremost being the climate change. Cultural heritage that responds to the changing realities of the time is relevant as that only contributes to the society while the frozen dialect is more a romantic perception and miles away from the ground realties. The need and pressure for continuity of cultures in the name of heritage and that the global culture's is a void of some kind. Anything that is perpetuated by people is culture and to judge the same is a big question. The fact that the contextual cultures events make their presence felt during sometime in the year has risen the awareness of the rich local at large and that has invoked sensitivity for sure while their acceptance is redundant but their understanding is surly helping people to predict their perceptions and behavior and gradually the inter dependence amongst them is now a large part of the global culture and the biases redundant. However much the global cultures are handy to address the key issues like climate change but surely are underpinned by the traditional cultures. The global cultures over time shall emerge as culture with outstanding universal values (OUV) in which cultural heritage shall play a key role that shall respond to time and evolve with its own vocabulary this is binding the mega cities even today and shall continue to anchor in future as well may be with a transformed form.

The traditional urbanism has witnessed a unique gentrification from the conventional local community to accepting migrants when suburbs were in vogue but this phenomenon was/is contextual specific, as typically among the living traditional heritage cities, the core local community continued despite all odds defying the gentrification and upholding the pride of cultural heritage. The Traditional urbanism is perceived as resource of cultural heritage and needs conservation an approach for intervention in such areas or even in the overall master plan developments exercises these areas delineated. Its been established that cultural values cannot be equated for economic equations and in the name of growth for tourism sector transformation in urban areas driven by tourism for economic and built environ sector.

Mapping cultural indicator recognized for development thrust through cultural practices can be insightful to target long term indicator of SDG for the contextual fragile ecosystems both man made and natural as they are prone to hazards. In order to facilitate the implementation of the HUL approach has a six-step action plan aspects related to climate change is: Mapping resources: natural, cultural, and human-mapping Cultural Heritage resource is a challenge as it's a qualitative aspect that lacks formal structure thus mapping and reaching a census for its values and narrowing it down to its related attributes shall be unique for each case and thus to assess their vulnerability to change and development too is extremely relative for the urban development framework. Although the HUL suggests prioritizing actions for conservation and development but for each case the local partnerships and management frameworks shall be specific.

Additionally, the same needs to be dovetailed with the mainstream development and not to approach as a niche. The contemporary approach towards SDGs and urban planning concerns have a tendency to focus on things and niche areas. The intent was to fine tune at large but in the process the large picture is getting diminished. Therefore, the three pillars of sustainability (Social, Economy and Environment) are getting re-established. The narrative on sustainability started with environmental decay with environmentalists taking the lead and more vocal with social and economy as well but nature, GHG and related to climate change. As conscious professionals, social sciences putting forth their concerns while economists too rising to the concern to acknowledge that all need to act together to yield the desired result. Although the broad-based debate of inter-disciplinary occurred but in the larger narrative disparate discipline took precedence for sustainable development and large text available is insightful of it. For example, in case of social issue, culture is being established as key but that is largely inherent to socio-economic; it becomes imperative to perceive culture in the socio-economic context and analyze. Such an approach needs to be in place for all issues at large; this brings us back to the placing of traditional urbanism in contextual connotation.

The traditional living urban heritage areas have been the true drivers for development responding to the changing economic activities. Considering all global cities are a vector of global economy and are the main culprit for carbon emissions leading to climate change across the world; adequately validated through scientific studies as well. Most of the global cities have a backdrop of traditional urbanism whose presence in evident both in planning and contributing for the image of the city at

large. However much the modernist movement attempted to establish itself but was always up against the traditional from getting defined as deviation form the tradition as reference to architectural vocabulary. The strength of traditional urbanism lies in its all dimensions of urbanism as enumerated in the previous section and therefore it may be logical to carry forward the dimensions of traditional urbanism rationally along with the needs of the contemporary societies; fundamentally through cultural heritage. London a known for its global status exhibits its cultural heritage through Christmas celebrations to New Year parade, to the high streets that are housed in rich traditional buildings. Demonstration of cultural heritage is standard across the global cities of the world and often-traditional urbanism is deep rooted making them disparate. Also there is not a single contemporary global city that does not recognize any or all dimensions of traditional urbanism; this just establishes that the traditional urbanism is more than history and connected to the lives of the people. Often, we come across contemporary global cities that are not inhabited, as they are build for tailor made societies while the cities that breathe, live and grow are for all they way lives co-exist in nature. There exists a strong symbiotic relationship between the traditional urbanism and the contemporary developments completed over time. When the urbanism is based on traditional cultures the continuity of it is evident in some form or the other and that often ends up being the OUV for the place (Fig. 3.1).

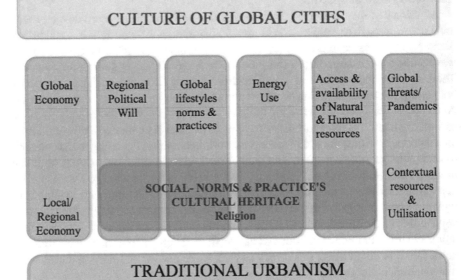

Fig. 3.1 Culture of global cities [Author]

Typically for the living traditional urbanism had inherent social equity through the structure's balance of diversities mutually accepted by the people that resulted in the local community with the governance at the helm that had a strong symbiotic relationship with the social capital. When these cities grew re-densification occurred within the structured hierarchy and addressed by the local administration.

Thus, there was an order in which the urbanization occurred and dovetailed in the traditional urbanism. Whereas when the heritage precincts are used mainly by tourism sector then the dynamics of urbanization are aligned more with the key economic activities of the city and has related implications on integration of cultural heritage to the city; that includes all dimensions of urbanism for example the issue of security in the recent past is a growing concern something that in the traditional urbanism was taken care as the local community was the social capital that was in harmony and only when the conflict of interest exists that security proves to be threat. Thus to trace a basic issue of security to cultural heritage of the local community that demonstrated their resilience to respond to the migrant population and urbanization as re-densification is key for traditional urbanism that matters.

Densities and cities are synonym in contemporary cities while in traditional urbanism the response to densities was for building typologies essentially responding to climate conditions i.e., from compact development for arid climate, sparse development is case of coastal and humid climatic conditions and so on. Further the correlation between demographic pressure and building typology of high-rise buildings is a myth that addresses the numbers but at the cost-of-living environments. Conventionally in traditional urbanization process encouraged migration that was typically clubbed with the economic activities while their social status is parallel, and the settlement pattern is guided by the social status and not by the tasks conducted. This inherent dichotomy gets reflected in the nature and type of settlements of these populations; wherein their respective cultural connotation virtually guided their lifestyles responding to the new context. Significant observations is that it's the cultural heritage connecting them to their roots and adapting to the new context demonstrates the resilience nature that embraces changes as well. Further the resource and space utilization is largely governed by their social behavior, a thread that often connects to the traditional urbanism. However, each of the precincts houses typical communities based on the diversity of ethnicity, religion of economic class as the social cohesiveness exists because of their basic premise of being grouped and the cultures play an important role reflected such in the built morphology. This deliberate inter dependence of built spaces and culture are exposed to technology and global lifestyles and standards often observe a selective perception and imbibed within the existing cultures' at large. In the name of progress these socially disruptive technologies when interacts with the cultures' the norms and practices of traditional urbanism are evident in their social behavior validated through building performance evaluations', energy efficiency and others. Often the approach is on the conservative side as the contextual approaches instills in them for optimum utilization of resources; although the approach may not be identical but similar among various communities as the global mega cities encourages migration from all contexts. Next irrespective of the economic section of the society the migrant population be their cultural connotation

continues however modified it may be but the very essence exists and is a strong pointer for energy use and climate change at large.

The city constitutes largely for residences and housing while the public and institutional buildings only a fraction of the city; but the key consumer of energy and carbon emissions. This stark deviation came about with modern planning approach of land use and zoning unlike in traditional urbanism mixed land use was the norm that had inherent advantage of multiple use of the same space ensuring maximum utilization of spaces that was safe and thus security was not an issue. While the assorted land use segregated the land parcels to be used only for specific purposes invariably high of energy use to meet the global norms. This has been a major shift with walled city gateways giving way to airports and railway stations standardized the entry the global cities in contrast to the single entry through the gate that defined the transition however at the airports the presence of cultural practices is deliberate as a gesture to welcome to the city; therefore be it gateway or airport they are the key transition spaces and first introduction to the city and it's the cultural heritage that makes each of theses space unique and disparate; an impact of the traditional urbanism that matters and counts.

The large open space in any traditional heritage city had a pivotal role to bind the local community for their collective celebrations and practices of festivities; while open spaces in global cities are more than one partly because of the scale of the city as they are large thus decentralized, further the global society with its own segregation are associated with one of them classified such. The global society is divided based on economic stratification and that reflects both for access and utilization of spaces thus the city's population operates parallel unlike the traditional communities where the stratification is duly bonded due to interdependence mutually cementing the community and thus the practices are one and brings the local community evident as social capital of the traditional city the key strength pillar of sustainability. When the economic disparity exits the corresponding buying capacity varies and directly impacts the access and use of resources and often lacks the sensitivity for social equity. The segregation of society when translated in city planning as land uses we have workspaces turning redundant after office hours against the mixed land use in traditional urbanism where the multiple use of the space provided for flexible use of spaces.

Landmarks within traditional urbanism were public buildings ether next to the open space or at strategic location within the layout of the city and the structure's has social, religious or administration significance and accessible to all that instilled the sense of belonging among the people. In global cities landmarks are tall buildings: Roppongi hills, Skytree, Burj-Khlifa, Petronas tower to stadiums or structures like London eye and so on and all have limited access further reinforcing the divide in the society; for our cities to be inclusive in true sense these disparities need to be addressed, a lesson from traditional urbanism. The landmarks contribute for the skyline of the city that is unique for traditional cities due to their rich architectural style; while the global cities display a standard visual image. Thus diversity offered by the traditional urbanism has OUV strongly underpinned by the cultural heritage that demonstrates the culture nature journey. Further among the current interventions

in traditional Urbanisms' thrust for concepts and policies for protection of heritage sites- majority are for regeneration for which the challenges vary from living and static heritage sites but in both cases the learning's from traditional urbanism is of value. In case of the former one redevelopment is inevitable and needs to be aligned with contextual framework to acknowledge the historical developmental layers. The rebuilding in traditional urbanism has lived through reconstruction for renewal and revitalization of the built environs at large [5]. Any type of intervention in global cities for heritage is city specific for the set of resources available and that may not be limited to the traditional contextual framework and the traditional urbanism may get redefined but continues to ne an integral part of culture of the global city.

Cultural Heritage is the strength of traditional urbanism that vouches for low carbon emissions along with related implications on production and consumption to health and well being; the merit of traditional urbanism stands tall across the world. It is necessary to recognize and map the traditional cultures; to strategize for development for future at the earliest to revise the pace of activities to integrate for the core cultural values and advance within the contextual framework. The developed nations have the resources; know-how with a research base that can be tabled with the traditional environmental knowledge of context under pinned with traditional cultures is the way forward. We have many such examples in Europe and other countries to validate the same. As globalization is here to stay and galloping as well thus what is significant is rational approach logically arrived at to address climate change is the immediate issue.

The contemporary discourse on urbanism there are attempts for the traditional cities to be recognized for existing that acknowledged the changing needs of the community and understood the regional connotation within the global perspective that thrived such besides industrial, modern and postmodern cities. In this debate culture has been central beginning with recognition of cultural diversity giving each city its distinction and a closer understanding of cultural heritage required a holistic awareness of its both natural and man made landscapes as historic urban landscapes. Identification under pinned with information technology virtually established the cultural tourism sector in the hegemony of global cultures. The contextual framework got expanded to culture based urban governance to yield sustainability.

The modern planning concepts essentially deviated from the traditional planning principles but the two continued their presence parallel just reinforces the inherent merit of traditional urbanism. Cities are basically about people, their responses to built environment and history shows that redundant gets deleted or modified to address the needs of the people. Each city can be read through its layers in history and the same when done for the global cities the strands of traditional urbanism are significant and crucial for the city; strongly dovetailed with the culture of the place making. These translations cannot be priced but have immense value for urbanism of the city; this is because of the shear strength of the traditions. The key attributes of design and planning principles of traditional urbanism that has the potential to contribute for climate change can be drawn across all scales of traditional built environment, from site layout to building's element details' from site selection-orientation, Street pattern, nodes of economic activities, public spaces, Landmarks/Imageability/heritage and

others. Numerous scientific studies validate that traditional urbanism has a strong connect with nature vouching for low carbon living and thus climate responsive as well. In the name of progress and growth the current pace of development reinforced with technology gave us options and the scale of cities expanded to megacities, transit oriented developments and others the relevance of traditional urbanisms is a wisdom that vital question, the need to escalate the scales? Having experienced the impacts; the trend is to conceptualize to be inline with the traditional urbanism principles often modified to cater to the contemporary specific needs and explored in the design, nature and scale of district and neighborhoods' with success. But such a piecemeal approach creates islands of sustainability while for the desired results' city as a whole nestling in the context needs to be sustainable at the regional level as well. As the cities are dense and spread across larger areas the scale of their impacts too gets enlarged at regional level beyond the contextual, however the fundamentals still hold merit. Other than the contextual framework the other crucial aspects of traditional urbanism in the global city's fabric are the edges and the periphery. There may be two interpretations for the city edge one the city walls' that defined the city limit but was resilient for re-densification as the periphery of the city was used for agriculture producing food for the city population; a lesson for introspection for our ever-expanding cities whereas traditional urbanism facilitated democratic base with accessibility for all but providing for basic amenities with physical infrastructure, health, low carbon living. The global cities are expanding seamlessly for which providing for infrastructure is both cumbersome and high on energy and the fundamental difference between the traditional and contemporary urbanism is of 'scale'. It may be worthwhile to relook at the scale of our mega cities although technology aids them to be smart but at the cost of energy, it may be logical to review our planning policies and norms to decentralized rather than concentrating on few megacities' thereby assuring social equity and may reduce slums especially in Asian cities are a challenge. Under the categorization of urban areas the expansion of boundaries of urban areas based on historic urban landscape survey the highest rate is from Asian and Pacific states where economies arte developing along with economic activities of the core of traditional cities.

Other valuable lessons that may be learned and are relevant for global urbanism are rate and pace of transformations retaining the core merit of the typologies. In traditional setup such changes were determined by the socio-cultural context; an inherent mechanism rather than through legislation, executed through general consensus that addressed the public participation and sense of belonging. Often one observes that that culture governs the behavior patterns among communities that may be detrimental to design decisions, energy consumption and sometimes even for transformations, something that is culturally driven and socially accepted in traditional urbanism.

Transformations when socially driven as in case of traditional urbanism is intrinsically culturally driven they can be determined and evaluated rather precisely. The definition of "Social science, which is generally regarded as including psychology, sociology, anthropology, economics and political science, consists of the disciplined and systematic study of society and its institutions, and of how and why people

behave as they do, both as individuals and in groups within society." clearly enumer-
ates the relationship of economy, culture and anthropogenic at large that was the
key strength for traditional cultures. However, in the recent past the decisions have
been politically and financially driven and thus the gap between design intent and
user behavior exists; a premise that may be considered in contemporary planning
and architectural projects. An approach assures an inbuilt resilience for the city, the
public and semi-public spaces are loud examples when society reclaims them they
have universal access while exploited for financial gains may be for tourism sector
has limited use for a privileged few reflects a skewed understanding for a city.

Thus, role of traditional urbanism is pivotal for any global city that renders its
identity and pride at large something the neo global cities built with glass façade
blocks irrespective of the geographical, social, cultural context. The living urban
historic landscape heritage needs to be an integral to planning beyond to be conserved
at city level. Need to respond to the changing needs of the time to make it sustainable
while individual buildings may be conserved for their heritage value.

3.6 Urbanizing Traditions and Traditional Urbanism

Urbanism that is created by people for nature of a place, which sustained as practices,
was shaped up as tradition with time. The Sun being the key source of energy and
life in nature, the approach was innovative and creative for the geographical context
thus exclusive. Urbanism is about people, places and practices that result in built
environs for nature embedded in culture'. Tracing traditions of urbanism and the
cities that urbanized the traditions lead to archetypal architecturally rich environs.
The traditional practices outlined the planning principles, norms down to execution
of built spaces that nurtured the lifestyles for maximum utilization of spaces, which
were flexible to adapt to the changing needs of the people over time. In the name of
progress and development mankind driven by global economy aided by technology
with a universal approach, overlooked the regional and local contexts; that resulted
in environmental crisis leading to climate emergency. Globally economy encouraged
the universal development that focused on built spaces rather mathematically with
limited attention to tradition as an informed way to live. With the technology and
awareness, the professionals were quick to follow the global baselines essentially to
align for their contextual framework to belong to the global community. The Climate
Colonialism thresholds that are fundamental for the research studies, structured, the
responses to climate change are limited to nations that are conscientious and have
outlined a trajectory for future. With nations at varying stages of growth and devel-
opment to aspire for such absolute baseline lacks the understanding of anthropocene.
Climate change is a global phenomenon the road may needs to be robust to accom-
modate all. The global economy has proven that the key drivers of development in all
societies vary, as we often come across ghost towns and abandoned condominiums
in most of the countries. The societies with traditional cultures have their thresholds
of thermal comfort and resource consumption and therefore the baselines varies and

not necessarily in alignment with the global. With climate change as a global threat time to relook at the nature and pace of urbanization. As majority of the world's population is to live in urban areas, the anthropocene is crucial. The need of the hour is to acknowledge the urbanizing traditions are inclusive at ground zero. Traditional practices that are place specific have a direct participation of people; a democratic approach with threads from traditional urbanism when assimilated regionally was the strength to be effective globally. In this realm the relevance of traditional practices that are accessible, easy to communicate, feasible to execute indigenously, locally acceptable to achieve the global targets.

Tracing the history of urbanization, the earliest well-planned cities existed in Asia followed by the rest of the world. The large repository of traditional urbanism is unique for disparate traditions, which urbanized through the times area as huge resource for passive systems that developed by the contextual socio-cultural setup. Urbanization occurred through the ages but the 'pace' and 'nature' was determined by the local ecosystem. Technology aided the communication and transport sector that escalated the pace and scale of urbanization bringing in a paradigm shift in the tradition of urbanization. This vocabulary of urbanization impacted the world with the hegemony of cities that super imposed a school of thought that was in stark deviation from the respective continuing traditions. The intent to deviate may be recognized as a response to time but to rewrite cities with a universal grammar has resulted in environmental impacts for nature and climate change. Our traditions of urbanization were resilient that imbibed timely transitions that were geo-specific over the existing traditional lifestyles to value urbanization valuing traditional urbanism are worth for continuity, connect with roots, rationale for decisions for growth among others that addressed climate change.

Globalization propelled large-scale urbanization that resulted in mega cities across the world but at strategic locations as global political power. The global approach is inclusive for economy for which it dilutes diversities of all kinds as universal, developed an urbanism with a vocabulary of it's own. The utopian intent of one world one planet, the outcome proved to be rather veneer-deep in nature virtually parallel to the continuing regional contexts. Typically, urbanism absorbed the layers in history while the globalization lacked the roots to connect with people, economy is for people and not vice versa. The global economy largely focused on profits exploiting technology and human resources irrespective of geographical contexts' reducing them to mere location of latitude and longitude. The scale of operations was staggering for production and consumption and to deliver the same has contributed for the climate change. However, to achieve the Paris agreement action at local level is the way forward just reinforces the relevance of various geo-political social contexts with their respective traditional urbanism. Intriguingly, each of the global cities is abode of traditional urbanism along with layers of growth including global urbanism as well and each one legible and distinct in the city's fabric. The influence of each layer has permeated to stitch the fabric thus the texture varied. Each thriving city has its layers of history embedded in the urbanism, evident in public spaces, cultural practices etc. Each of the historical layers is about people, places and practices that

have been translated in spaces. The efficacy of these practices and systems are an asset of traditional urbanism that has proved their worth for reduced energy consumption and low carbon living.

Currently the global call of climate change is strategized amongst disciplinary debate; each one putting across precision with best of technologies and yet not there to achieving the target. The gaps are evident across the globe due to various reasons well known and the intent are being addressed in silos, although the narratives are being built for inter-disciplinary but gaps continuing. The anthropogenic activities in the recent past have accelerated climate change to climate emergency. The need to maneuver the urbanization is crucial with developing nations urbanization fastest with either poor or developing economies thus limited resources. The formal urban planning framework is structured for the contemporary ongoing planning parallel to focused planning strategies i.e., HUL and special urban areas delineate such. The main cause of climate change; irrespective of their geographies, state of economy, stage of growth, ethnicities and diversity of all kinds the way forward needs to be inclusive in every way. The thrusts on climate initiatives that are on are based on political standing, as the economies are in sync and often with state of art and technologies in place. This geo-political standpoint is skewed and even with the universal strategies in place their implementation to yield the desired results seems inadequate. Urbanization is universal for the globe and as it is about people and building communities an ideal starting point. The people are not numbers but to be perceived for their roots, origin, cultures' as that is key for their responses for all aspects from social, political, and environmental to economy. Although energy and resource consumption are directly related to climate change and carbon footprint but the other aspects contribute indirectly and are sizable component that is addressed by specific professionals for their respective niche areas. The narrative from traditional to contemporary has had a deviation from holistic to specific, from inclusive to exclusive, socio-culture to socio-economic, from local consumption to global consumption, from ethnicity to diversity, form identity to hegemony and so on. Globalization disrupted the continuity of urbanization processes with a paradigm shift to a universal, one that wasn't rooted either socially translated as numbers of human resource or for place making rather exploiting strategic geographical location. The statistical approach overlooked the continuing traditional backdrop of the people isolating them such and congregating them as population with diversities and managing them. Although sensitivity prevailed and talk of inclusivity for diversities of all kinds, issue of social equity, economic disparities occurred but this humanitarian concern picked up momentum with climate change as the need to be closer to ground reality became a necessity with climate change. The situation arose when the deviation for the continuing urbanization processes got disrupted and when the trend continued as the global pace of growth was that exponential and the situation became grave.

The modern planning concepts thrived on segregation of functions as residential, office, commercial, institutional, industrial and so on; introduced typologies that were high on energy, services and intensive technology input. The transition from mixed land use to functional segregation as global typology were owned and

operated by global multinationals companies that outlined thresholds for thermal comfort with respect to their geographical contexts by their own standards thus global norms got laid down. Nevertheless, the working population hailed from across the world for strategic geographical locations and urbanization occurred with global built morphology and global norms. When these cities were urbanized with such typologies it was taxing on the environments and carbon footprint rose with related climate change repercussions occurred. Globalization accelerated urbanization among developing countries so as to exploit for financial gains. The nations with poor economies were struggling with their thresholds of developments parallely commercial and office spaces were constructed to deliver for global work cultures and markets that proved to be unhealthy for the city. When these high-energy spaces were recognized for contributing for increased carbon footprint, adequate measures were taken for mitigation resulting is sustainable pockets within a city that was developing and ranked within the growth ladder and these developments although sustainable pockets within the city but proved to be unsustainable for the city as a whole. However, the MNC's provided for jobs to the local population but the political intent nurtured the sole agenda of economy of human resources, whereas the socio-cultural, environmental connotations were incidental and were isolated sustainable pockets in a city that shaped as unsustainable as a whole.

Multi-functional spaces, heterogeneous societies, compact urban form and diverse economic linkages including the climate responsive practices characterized each of the traditional urbanisms. Planning process was bottoms up in case of traditional urbanism while contemporary planning processes with data for optimum utilization of land and resources have a top-down approach considering opportunity exists as ready references of practices in traditional practices. Varying perceptions of real estate in traditional historic cities or precincts prevails of states either frozen or thriving with high almost inaccessible prices generally where continuity of traditional economic activities. The disciplinary debate on typologies has silver bullets for the urbanization process wherein the tradition of urbanization that has deep roots with local communities needs to be recognized, acknowledged in contemporary urbanization processes. Currently the traditional urbanism is revered upon for cultural heritage, historic landscapes and outlined as distinct urban area. The need is to integrate with mainstream development in the urbanization processes with modifications if so required for socially driven economic activities and not vice versa.

The strong presence of the core population impacted the decisions related to the walled city and continuing irrespective of their nature from political, administrative, institutional or any other. Thus, reading the mapping of the city, both natural and manmade layers are legible; depicts the cultural sensitivity of the core population that cares for people centric methodologies. Research study indicates that social sustainability of walled city of Jaipur is primarily responsible for the city to thrive and for accreditation as world heritage site. Of 1121 documented world heritage sites, 36 are in danger and of which a large number constitutes of old towns, city center core areas while 869 designated for culture and related to built of which there is large concentration in Europe followed by Africa, Asia and USA Historic center's/sites, stand alone precincts' and numbered traditional historic cities are designated of the

thirty cultural sites only from India two traditional cities are Ahmedabad [2018] and Jaipur [2019] and both are living historic cities with strong traditional and cultural heritage [6].

References

1. Ripp M, Rodwell D (2015) The geography of urban heritage december 2015. Hist Environ Polic Pract 6(3):240–276. https://doi.org/10.1080/17567505.2015.1100362
2. Holtorf C (2015) Conservation and heritage as future-making. Linnaeus University, Sweden. https://openarchive.icomos.org/id/eprint/1857/1/6_Holtorf.pdf
3. Loulanski T (2007) Revising the concept for cultural heritage: the argument for a functional approach. Published online by Cambridge University Press, 30 January 2007
4. Calthorpe P (2011) Urbanism in the age of climate change. Island Press, Washington, DC, ISBN 978-1-59726-720-5
5. Historic Urban Landscape workshop methodology project by EU (2018) https://www.clicproject.eu/historic-urban-landscape-workshop-methodology/
6. UNESCO—The World Heritage Committee, having examined documents WHC/19/43.COM/8B and WHC/19/43.COM/INF.8B1, inscribes Jaipur City, Rajasthan, India, on the World Heritage List on the basis of criteria (ii), (iv) and (vi)

Chapter 4
Engaging Traditional Urbanism for Climate Control

4.1 Climate Change and Contexts of Urbanisms

Globally, urbanization is at its peak the impact of Climate change is crucial for urban areas with influences rather profound for traditional heritage cities. The traditional cities as repositories of urbanism with an identity, enjoying disparate socio-cultural heritage placed in typical rich architectural style outlined with contextual planning principles and other related values too much to surmise to assess for impact of any kind. Contextual based approaches governed by the geo-political framework is typical in Asia i.e., 'Satoyama' concept in Japan; 'Hezar too' in Israeli among others. The impacts vary and are more pronounced especially in ecologically sensitive regions like the coastal and hilly areas; as these regions are facing natural disasters rather frequently. The impact of climate change on Traditional urbanism is multi-pronged; the governance in traditional urbanism virtually is in continuation of the existing irrespective of the formal structure in place as the social capitol has a strong presence for decision-making, whereas the urban agglomerate of the said city is driven by eco-political decisions patronizing the global economic interests.

Climate change has gained proportions' beyond the weather changes as it is impacting our livelihood systems with chemical and biological changes i.e. rising sea levels to food securities to quality of air with pollution crossing the political boundaries and reaching the earth's atmospheric layers an outcome of the way mankind has decided to live and continuing. Such is the footprint that life is at stake with loss of biodiversity with species already becoming extinct a price too much to surmise. The nature of natural resources puts the climate change at the global map and the international climate agenda requires inter-disciplinary approach on all levels; wherein the local governments have a bigger role to play for carbon emissions that has universal value. Despite the best of Information technology and scientific innovation that are constantly being upgraded globally and addressed such for climate change initiatives but the threat continues. In the fast-changing times wherein change is a constant and therefore the dimensions of this constant for climate change needs to be closely

A. K. Sharma, *Traditional Urbanism Response to Climate Change*,
Advances in 21st Century Human Settlements,
https://doi.org/10.1007/978-981-19-4089-7_4

monitored, studied, understood and a rationale way forward to be the need of the hour. Climate change in the near future shall reach a point of irreversibility and abrupt changes shall become the norm and recognized as national security by big nations just reinforces the concern. Many aspects of climate change and associated impacts will continue for centuries, even if anthropogenic emissions of greenhouse gases are stopped. The risks of abrupt or irreversible changes increase, as the magnitudes with temperatures are increasing [1]. Climate change is bringing more energy into the atmosphere influence on weather hazards, and the vulnerability of buildings and infrastructure to natural events as well. The development of preventative structures and regulation also have a major effect on the scale of registered losses; i.e. studies have revealed that the probability of severe flooding events in certain regions across the coastline has increased significantly compared with a world without climate change. Of 131 extreme events in different parts of the world investigated in peer-reviewed studies by one scientific journal, 68% revealed an influence of climate change on altered exceeds probabilities. IPCC report (2001) at the turn of the millennium emphasized, "Climate change decision-making is essentially a sequential process under general uncertainty. Decision making has to deal with uncertainties including the risk of nonlinear and/or irreversible changes, entails balancing the risks of either insufficient or excessive action, and involves careful consideration of the consequences (both environmental and economic), their likelihood, and society's attitude towards risk' [2]. Gap between intent and result is the key global challenge. IPCC outlining and UN-Habitat taking up initiatives through *Climate Action Studies* has been active in countries like Bangladesh, Colombia, Lao PDR, Rwanda Brazil, India, Indonesia and South Africa, supporting planning departments to define low-emission and adaptation needs and approaches.

In recent past, changes in climate have caused impacts on natural and human systems on all continents and across the oceans. Impacts due to climate change, irrespective of its multiple causes indicate the vulnerability of natural and human systems to changing climate. Cost of delay to address climate change is increasing manifold with each passing day; that needs immediate focus especially in cities, as they are largely responsible for carbon emissions for both small and long-term actions. Further due to resource constraint only a handful of nations are applying a "climate change lens" to the implementation of regional spatial or economic development policy framework often regional development policies are applied independent of national sectorial strategies to address climate change and such an inherent dichotomy; the contextually rich traditional urbanism are vulnerable.

Latest UN COP25 reports that an estimated USD 93 trillion worth of infrastructure will be built by 2030, over 70% of which will be built in urban areas. The buildings and construction sector alone accounts for over 20% of global greenhouse gases emissions. Buildings operations account for 23% of energy related CO_2 emissions globally, making them among the largest contributors to climate change. USA is one of the top contributors for carbon emissions despite stable and developed economy. Limiting climate change would require substantial and sustained reductions in greenhouse gas emissions, which, together with adaptation, can limit climate change risks [1]. Cumulative emissions of CO_2 largely determine global mean surface warming.

Projections of greenhouse gas emissions vary over a wide range, depending on both socio-economic development and climate polices [1].

Constructing the broader narrative of the global south particularly Asian countries were inhabited earliest and for centuries on celebrated civilizations' that went down in history, however with global economy these very countries are facing the highest rate of urbanization coupled with a global vocabulary of development that is contributing to climate change in multiple ways and continuing. The anthropogenic activities are influencing the development processes with GHG gases, carbon emissions among others rising are aggravating the continued carbon emission causing further warming with long-lasting changes, from increasing the likelihood of severe, pervasive and irreversible impacts for people and ecosystems. The events are direct repercussion of carbon footprint, environmental decay and others, however a closer understanding of the issue needs to be rather holistic as apparent in the earlier section. Broadly there may be two approaches to address the issue; one that addresses directly and other one that challenges the root cause, which is strongly woven in our anthropogenic influences. The implementation of two-degree limit needs to be implemented contextually with bottoms up approach and may be as percentage rather than absolute values i.e. as the data base available is essentially from nations with stable and developed economies and the thresholds have been arrived such; whereas the poor and developing economies are not there yet; at the said threshold. This gap that puts the nations developing economies on a back foot and with the scale and shear volume especially among Asian countries especially China and India even a marginal increase can jeopardize the said thresholds. Therefore, at whatever threshold of development each of regions may be; a generic reduction in percentage or stabilized at certain level may help to achieve the target; significant is the perception of the two-degree limit at global level and contribution by all nations. The lack of social equity it is established that the biggest risk is to the urban poor; people from nations who are the least responsible for the consequences of carbon pollution, are expected to be faced with severe impacts. In addition to being the victims of the climate crisis and also exposed to environmental repercussions of climate change. The regions directly impacting the renewable resources from social, technical and cultural standpoint for acceptance, awareness and implementation, thus climate change. Climate action is the game changer in virtually every country; city and community and therefore it may be appropriate to declare it as climate emergency for all lives on this planet. Initiatives by the countries to limit the global warming to less than two degrees brought most of the countries at a common political platform but due to varying thresholds of the various countries the required target is proving to be a tall order. It is evident that even when countries with strong economies and political will have had limited success with climate change. While poor economies are struggling even harder and lacking in latest technological inputs, the impacts get amplified for their stages of urbanization and development that economies need to attend.

Documenting the narrative of anthropogenic development through United Nations Development Program has summarized five types of human society that have spread worldwide as hunter-gatherer, agriculturalist, mercantile capitalist, industrial capitalist and followed by the consumer capitalist while the current; sixth type of society

requires both greater energy and improved ways, to communicate knowledge and manage information essentially intensified due to anthropogenic factors over time. However, each typology in chronological order is inversely proportionate to duration of time in history becoming more complex with each type. The initial three stages of societies cultivated a symbiotic relationship with geographical location and natural resources consumed but industrial revolution initiated drastic changes and impacted the operational framework of the societies virtually with a paradigm shift that resulted as the current one. The anthropogenic influences that intervened transformed landscapes driven through biological and natural systems related to the physical changes to our planet. In this realm the contextual traditional solutions demonstrated in traditional urbanism are worthwhile as best practices having sustained for centuries in some cases. The traditional urbanism is omnipresent among important global metropolitan cities; that reinforces their presence and significance.

Global lifestyles are predominant in urban areas and metropolitan cities where over half of the world's population is expected to reside by 2030 and is largely responsible for high energy use and carbon emissions leading to climate change now deduced as a socio-cultural issue endorsed by capitalist global agenda is in contrast to the sustainable traditional lifestyles. The global economy driven by capitalism focuses on financial models, that's quite diverse from social equity with related environmental costs, parallel to the existing local economies that were in sync with the social and regional environmental framework. Therefore, initiatives like circular economy, regenerative economy and others an attempt to acknowledge local cultures and focus to revive or continue with the traditional socio-economies has operational framework limited to traditional urbanism but needs to be carried at regional scale as well of else such piecemeal application may prove to be romantic only. The global lifestyles coupled with the high rate of urbanisation determining the nature of development are the root cause of climate change. The large concentration of people and greater densities infused microclimate changes resulting in increased energy consumption with high carbon emissions. The negotiation between the financial gains over the social construct underpinned by cultural issues happens to be typical for each geographies and regions and that is in sync with the global economy. The regional urbanism responded the local geographies for their respective traditional framework i.e., the soil characteristics—indigenous food production to usage of water and other natural resources for centuries and the traditional understanding of environment that addressed human comfort, safety, health and well-being. Typically, the microclimate focused on such cultural heritage and responses that were inherent to the traditional urbanism.

The large-scale urbanisation propelled due to globalisation; global societies emerging are assorted with kinds of diversities introduced due to migration across nations, continents and the world. The traditional social tissue was homogenous with its inherent stratification nuances whereas the global societies is grouping of diverse fragments of traditional social tissue that are geo-region specific thus though the social tissue is richer for its characteristics that contributes for urban densities with the population numbers equated such but the social tissue needs to be understood for their typology as communities for their respective cultures, each one contributing for

economies and typologies responding for resource consumption. Cultural matters are inherent to the lives of the people and therefore as development is directly related to quality of life ratified at Habitat-III by UNESCO; now recognized as a key component of strategic urban planning and instrumental for the New Urban Agenda and often as unanimously accepted the fourth dimension of sustainability.

The 19th General Assembly of ICOMOS (Resolution 19GA 2017/30) acknowledged the climate change agenda with narrative build through meta studies by the Scientific Council (SC) and Scientific Committees (ISCs) including the ISCs on Energy, Sustainability and Climate Change; recognized the role of cultural heritage solutions to climate change adaptation and heritage's potential to contribute to the global climate change regulatory built on the Scientific Council Symposium entitled "Cultural Heritage and Global Climate Change" (Pretoria; 2007). The World Heritage Committee (Krakow; 2017) stated that "growing evidence of climate impacts across World Heritage properties confirmed that urgent and rapid action was required and leadership by all countries is needed to secure the full implementation of the Paris Agreement that emphasized that cultural heritage is impacted by climate change and is a source of resilience for the local communities; that heritage sites as well as local communities' intangible heritage, knowledge and practices' that constituted an invaluable repository of information and strategies to address climate change, even while those resources are themselves at risk from climate impacts and that the value of cultural heritage-based solutions to climate change mitigation and adaptation are significant as the way forward.

Next the cultures and sub-cultures reflected such in broader and sub-communities are insightful for decision making across the scales from global to local. And therefore, the understanding of the world population as communities is crucial, as that needs to be acknowledged for its inclusive representation and contextual participation for sustainable development goals agenda. The 19th General Assembly of ICOMOS acknowledged the climate change agenda with narrative build through meta studies that recognized the role of cultural heritage solutions to climate change adaptation and heritage's potential to contribute to the global climate change built on the Scientific Council Symposium [3] and The World Heritage Committee [4] stated that all countries needed to secure the full implementation of the Paris Agreement that emphasized that cultural heritage is impacted by climate change and is a source of resilience for the local communities; that heritage sites as well as local communities' intangible heritage, knowledge and practices' that constituted an invaluable repository of information and strategies to address climate change, even while those resources are themselves at risk from climate impacts and that the value of cultural heritage-based solutions to climate change mitigation and adaptation are significant as the way forward. The Intergovernmental Panel on Climate Change comprehensive assessment have documented drastic impact of fossil fuel emissions especially since the turn of the century and that has affected the earth systems. Additionally impacts of urbanisation and globalisation, the GHG affecting the earth's atmosphere layers, polluting the air and deteriorating the quality resulting in rise in temperatures. The climate change is highlighted across all hierarchies from the GHG gases, depleting ozone layer, atmospheric layers, rising temperature to built environs to

existing building structures, heritage buildings including an intermediate scale that of streets, public open spaces, precincts and others. Each of the traditional urbanism has its own challenges as all the hierarchies are inter-connected and therefore only inter-disciplinary approach is the way forward as it includes cultural heritage beyond preservation, conservation of heritage management projects. Considering weathering, atmospheric changes, rising temperatures, aging and others taking a toll on traditional heritage, although fair amount of work has been done among the developed and stable economies and continuing with input for correction measures to adept to the global norms and standards. In the process of retrofitting and adapting the comprehensive and through understanding and documentation needs to be place of the existing structures that has layers of information addressing all dimensions of built environs for systems that are in place. Climate is primarily influenced by local features such as topography, land use to choice of materials and indigenous construction technology used in heritage structures'; whereas the planning principles, space syntax, fundamental theories from physics i.e. Bernoulli's theory (the movement of air is accelerated when the opening at the two ends vary in sizes) reflection, conductivity and the list goes on. While the individual cases explored through research papers, meta-studies and often limited for building or group of buildings whereas comprehensive study, understanding and documentation shall be insightful for all the dimensions of traditional urbanism at large.

Globalization has set standards of development among others for built environs i.e. architectural vocabulary of glass facade buildings that is omnipresent. This conventional notion of development has had a paradigm shift wherein the geo-political dynamics are in place with nation's boundaries diminishing and redefined for the potential for global mapping from the viewpoint of resources, governance and ownership. The key industries were bought and controlled, while the unexplored ones mapped; such has been the prime focus of global economy. Strategic investments in Asia and Africa nations the recent past for funding and operation thus are urbanizing rapidly. The global economy has pushed the geo-political issues as central for all nations especially among the developing nations. Currently China with its growing economy is aggressively investing in Africa especially along its coastline strategic for reinforcing its economy and political standing in the continent and as global power. However, the scenario is predominant such across other nations as well that has accelerated the urbanization with the standard global vocabulary. The building sector contributes to about 40% of carbon emissions shall be alarming. This pattern by the developers investing in nations for local interventions to facilitate the local economies often at the cost of environment impacting at global level is indeed a challenge. They provide job opportunities for the local population but salary structures lack the social equity globally and the numbers contributes for HDI are exploited for carbon trading. The operational logistics often not accounting for the social attributes like culture and geo-environmental framework thus the strong technological interventions end up as futile exercise for urbanization except for sheer financial gains. Climate change is intrinsic to sustainable development with such anthropogenic influences across the world has aggravated the situation and continuing creating urbanism that is mathematical and lacks aspects in a comprehensive manner.

Each of the traditional urbanism contributed through their respective way of life that sustained for centuries while the global lifestyles deviated from it in the name of progress. It is time to review the contemporary gauge of progress and larger meaning of development for the mankind today, more so for our planet mainly at the cost of continuity to the roots. At this point in history of mankind climate change has put forth the need to act as one rather than in silos with definitions like developing and developed and the related data that categorizes us. The need of the hour is bottoms up approach through contextual approaches that vary in strategies and actions but the focus is one that for our planet to be sustainable. However, economically strong Europe, Australia and others have been aggressive with their research and development to meet the targets but for the world as whole to rest of the nations with weak economies have a major role to play to achieve the global targets. Typically, in nature the time taken by a fruit to mature equates to for time for it to decay, drawing parallel the traditional cultures have and are continuing to sustain, while the global practices are proving to be un-sustainable evident in the current circumstances. However, the technology driven global awareness is making people to re-look at the traditional lifestyles that are healthy and time tested as well virtually completing the loop. Conceptually, it may be logical to build with the traditional environmental knowledge as that responded for changes over timeline while the nature of global changes are not in line with the trajectory of nature of development of traditional urbanism. The traditional urbanism is a huge resource for all aspects of life and the resources and are not limited to the region but because of communication technology, information accessible to all, either to draw from or to develop on it. The programmatic demand for a unity of ecological, social, economic and cultural goals have immense potential to explore innovative perspectives for planning of large-scale urbanization with urbanism principles that are strongly strengthened by traditional urbanism and recognizing the traditional urbanism as integral to the process.

The contemporary planning systems at the outset have a radical dissociation from rich traditions as something that is old and possibly not in line with the current norms. Such an approach wherein resigning from the local perspective in favor of the concepts that present the issue of traditional cultural heritage; the strength of the context was reinforced by Nara charter [5]. For centuries the symbiotic equation between traditional urbanism and climate change by local communities continued was rather an integral part of traditional urbanism. As the traditional urbanism has lived through centuries and has undergone transformations as well but in the recent past with global economy and to cater to the tourism sector the said equation got disrupted with the paradigm shift over gradual transformations as it followed the global norms irrespective of their geographies. The paradigm shift occurred through piecemeal interventions for global thermal comfort standards with ambience of local lifestyles; considering in traditional urbanism each aspect is a part of the said whole and any change for single aspect jeopardized the inherent balance for example for adaptive reuse when required in traditional urbanism for new uses and with available technology often the interventions were accompanied by norms to meet climate resilience and carbon emission standards. Similar strategy to be in place for timely layering of infrastructure services i.e. water, sewage and waste disposal, electrical

with recent addition of communication, Internet security measures. Having traced the mapping of traditional urbanism for its worth in contemporary global urbanization processes the key observation is the skewed perception of traditional urbanism for its rich built heritage cultural lifestyle for tourism sector; while the strength of traditional urbanism lies for a holistic, inclusive approach that has proved its worth by being sustainable through timeline; needs to be outlined in a pragmatic way to explore each of the dimensions as system of systems.

4.2 Traditional Urbanism Response for Climate Change

This climate change emergency has highlighted the geographical boundaries over political ones, to which the global economy further dilutes the national boundaries. In this realm the disparate identities of traditional urbanism although locally operated are a global resource; has the potential to contribute but the cultural identities make it challenging. As at one hand their significant typologies cannot be negated and at the other end, they are the roots of their identities in the hegemony of the globalizing world. Thus, in the light of fast pace of urbanization the tradition of urbanism needs to be extended, to inter-connected and be inter-dependent at the regional structure creating polycentric, truly a great urban place for the context of the world. Despite the diversities each of the traditional cities pride themselves for their specific typologies a signature of their respective geographies and contexts. The public open spaces brought the communities together at one point in time. These spaces a matter of pride and synonym to their identity i.e. theatre structures among others however now they are more an opportunity for tourism sector. Public open spaces have been integral to urbanism and with global consumer society it has been replaced by malls while other public buildings like museums, convention Centre's, and so on have limited accessibility which further defragments the urban fabric and are high on energy. Systematic, multi-sectorial strategic planning is required to exploit synergies between climate change and nature of development for the building typologies and the framework of urban policy goals with culture added as fourth pillar of sustainability strengthens it further. This has put substantial thrust on socio-technical environmental issues and large body of text exists of research globally. The present contexts and emerging from new circumstances, models and data due to cultural heritage sciences studies and engineering alongside natural and social sciences; demonstrate that investments for refurbishing of existing building enhances the carbon emissions. The role of technology is significant for building sector but the costs are for applications that are evolving regularly thus their time of application and assessment of performance is a challenge. Globalization is propelling development across the globe in all nations for the pace, nature and scales irrespective of its geo-politics. The new buildings stock has the potential to be built for net zero but needs to be substantial with adequate knowhow, resources, technology in place and that itself is a challenge for example: in Africa where maximum development is expected to have access to technology may be limited and may have a gap. In such scenario the respective traditional urbanism

emerges as an option that may be transformed, underpinned with technology to cater to contemporary requirements.

In order to achieve sustainability in the urban energy system, a profound rethinking of our infrastructure and information systems as well as urban planning principles is required. The critical issues of social and environmental justice to be addressed for high energy to net zero, the pointers are urban energy systems across the three key stages beginning with sources of production to distribution and concluding with consumption by the users. Whilst traditional lifestyles utilized maximum daylight thus the working hours were limited with rest of the time for social interactions, families and clan that lead to a balance for healthy living. Thus, maximizing the use of daylight reduced the production of energy for lighting and limiting working hours the energy demand was minimum with related carbon emissions virtually nil. Next is dissemination of energy through transmission grids, varies if from local or tapped from a distance the component of transmissions losses, systems, technology in place is significant and if across states the geo-political implications too exist. While the consumption of energy at user end is governed by the norms and thresholds of thermal comfort for the type of usage from domestic, offices, commercial to institutional. As for the public spaces the standards are global, unlike in traditional urbanism where such distinction is not present as its largely mixed land use with limited institutional; as offices retail and commercial land uses consumes maximum energy share that was ruled out in traditional urbanism. The users' are a homogenous group in case of traditional communities. Despite the best of technology the socio-technical dimension for energy use is a crucial determinant and with the cosmopolitan nature of the global mega city typically each of the condominium when occupied by a homogenous ethnic community the energy use is line with the traditional-cultural connotation. While in cases when an economically determinant faction then the energy use in the condominiums is often on a higher side owing to the global socio-cultural standards.

Globally cities are responding to climate change at all levels through politically driven policy formulations to local planning interventions as an inclusive approach by the professionals, government and non-government institutions, private organizations, knowledge partners to academia and research forums. It is evident that the anthropogenic interventions are root cause for the carbon emissions and climate change; as these interventions impacted all aspects for the disparate built morphologies of traditional urbanism. Among these the most vulnerable urban areas are the coastal and the hilly with increasing sea levels and melting ice and accelerated due to related anthropogenic is taking it's tool. Although with research and technology attempts are being made to mitigate energy demand that is universally accepted. This situation has been created with global thermal comfort norms and with help of innovations and with regular technology up gradation to even it. Parallel in existing building stock with large proportion of traditional urbanism sustainable urban solutions exist; although these are also being retrofitted for low energy consumption and low carbon emissions. A balanced approach to be in place to study and know for gains through investments for retrofit of existing buildings versus the gains for carbon emissions and monitor the new development for both scale and nature of development as the

current trends are impacting the Climate change relatively more than the existing. The cost of technology versus the application, as its evolving by the day and by the time application and large-scale production is underway for the impact to be assessed is an added challenge. With this backdrop traditional urbanism emerges as a success story validated as well through contemporary approach of circular economy; going back to the roots for socio-cultural completing the loop for urbanism by reconciling environmental performance and heritage significance, that has the proven potential to contribute for climate change.

With rising economy the cities started growing and urbanization occurred transforming the built morphology of the traditional urbanism. Financial growth largely numerical when layered with the qualitative aspects of socio-cultural connotations both in scale and nature of growth shaped up with gaps and voids impacting the traditional vocabulary of the built fabric. The consistency of the growth pattern that existed in the past had a paradigm shift underpinned with technology and globalization that deviated from the continuity of traditional. Impact on morphology due to various urbanization issues occurred due to technology, densities etc., that affected the microclimate and that resulted in high-energy consumption. The rise in energy consumption occurred due to ease of accessibility for energy, demand from tourism sector and development opportunities; that were an individual initiative often overlooking the larger intent and systems of the local community. The main drivers of change for the development were land use, density and open spaces with related support systems of infrastructure facilities. The term development for traditional urbanism stood for growth that was strongly socio-economic culturally driven and limited to the contextual resources. But with globalization, finances governed growth and expansion with resources irrespective of their origin. This paradigm shift in the name for growth the nature of development that re-defined land use and densities. This shift affected the continuity of climate responsive making it vulnerable even more with continued activities of globalization. Conventionally the spaces related to economic activities were proportionate to the local socio-cultural setup, but with capitalist global economy there was a steep rise in commercial and related office spaces and that coupled with migrant population of diverse ethnic groups revised the local community to cosmopolitan society with a bend for global lifestyles. Traditional urbanism nurtured an inherent balance of social setup while the global urbanization added diversity of nations, cultures among others and that coupled with increasing densities increased the energy demand, and consumption that contributed for climate change. When re-densification occurred, proved to be more than just numbers as in socio-cultural context that reinforced in building of local communities; while in case when driven by model of global economy the numbers directly impacted for climate change.

It is evident that for future forms of Urbanism in the age of Climate Change, Traditional Urbanism has a potential to contribute for sustainability. The built morphology of traditional urbanism across all scales of development have proven to be flexible and resilient and sustained such. Carbon reduction through sustainable urban form moving beyond GHG to socio-cultural, economy, environmental consequences has given professionals an opportunity to develop innovative approaches that has resulted

in emergence of a new design philosophy, a new development paradigm that recognizes most dimensions of traditional urbanism. The translation of the new paradigm has and is being explored across each scale from buildings to the city to confront for Climate change. The manner in which traditional urbanism is disparate for its geo-context thus the way forward for each city too needs to be tailor specific for its respective context. There is no "one-size-fits-all" framework for effective for cities across the globe, having accepted the regional finer attributes it may be appropriate to conclude that with the broader framework may be standard. Therefore, for successful co-ordination can be driven globally from the top by national or regional authorities, grow from the bottom up as local policy innovations provide models for regional or national action and may feature a hybrid of both approaches. Parallel climate mandates in national urban and regional policies in various countries for 'Green New Deal' has advanced local climate action. The research and development learning's of the developed nations shall be insightful and enable timely intervention for policy decisions that may be economical, cost-effective and save on energy and reduce carbon emissions i.e. the high rate of urbanization in global south, that needs to be done in a sustainable manner may include indigenous standards that can contribute for sustainability and thereby address climate change. To understand indigenous standards the practices, systems and solutions of traditional urbanism is the key. Additionally, the passive systems, building materials with indigenous construction technology coupled with behavior pattern by the local community demonstrates low consumption of energy and optimum use of resources. Derived from the narrative of DNA and traditional cultures the norms and thresholds of thermal comfort arrived at is a crucial gauge; typically governed by global standards often the old heritage structures are retrofitted such side-lining the said standards. Based on the geographical location the disparate typologies of traditional urbanism, responded to the changing times for various drivers of change and continuing, very often operating within limits for the local communities for centuries and when the tourism sector gained momentum with the global norms in place retrofitting became essential thereby rising the energy demand for the traditional urbanism even if limited to buildings, precincts; set the immediate built morphology too to revise their norms to global ones and this domino effect had multiple impact on energy requirements and related carbons emissions among others.

The globalisation triggered by economy; soon to acknowledge that people mattered and local communities are inherent. Considering the global models irrespective of varying geographies driven by geo-political intent did yield immediate profits. While sustenance became an concern with indigenous issues that were culturally driven, emerged as dampener and therefore in the recent past new and innovative ways of thinking about economics: An approach aligned with the latest understanding of how the universe and its living systems works', approach defined as the application of nature's laws and patterns of systemic health, self-organization, and self-renewal to the vitality of socio-economic systems; termed as regenerative economics. Drawing parallel with living historic traditional cities enables one to perceive things in perspective of its evolutionary processes and thus the seed of regenerative economies responding to the escalating and interconnected social, economic, and ecological

concerns that exists within a cultural context, is a hopeful way forward. And when the existing cultural context is traditional with its living cultural heritage reinforced by Birzet project: UCL Bartlett treated the existing cultural heritage context—with all its unseen social networks and habits—as the single most vital resource for designing sustainable communities. The local community groups nurtured something they have done for centuries as living growing and responding timely to changes and evolving thus each of the timeline layers that had their own inherent strength to adapt and add value such and as it deals with people, they created it nurtured it and even stood the test of time. In an increasingly urban world the global initiatives have a thrust to create new synergies between traditional practices and architecture, in which cities are hubs through the prisms of culture, heritage, urban planning and architecture carrying forward the synergies through. The HUL approach largely accepted by global states strengthened the relationship between historic urban areas and natural environment; strengthening sustainability and quality of life with Ecologically sensitive policies and practices; i.e. Arab states those are developing in an aggressive manner in building sector are addressing the said issue 100% followed by Eastern European states. Geo-political decision-making is the key determinant for the rest of the continents to address the said agenda, are relatively at varying levels for the relationship between historic urban areas and the natural environment addressed climate change [6].

The Barcelona Climate Action Plan 2018–2030 drafted the road map to combat for heritage; engaging heritage with Climate change engaging heritage and archaeology with climate policy, adaptation planning, community engagement, and to climate and migration solutions connecting Climate Change and Heritage (CCH) and the platform discussed ways to translate through research to inform decision making to monitor climate change for sustainable mitigation strategies and systems as well as trans-disciplinary examples of engaging with climate change from research design to outreach for cities and buildings. Of numerous initiatives taken up at global level for Cultural heritage, Heritage structures, historic precincts to traditional urbanism and climate change just states that the scale of climate risks with the framework needs to be rather robust, may be with case examples of same geographical climatic zone and the traditional best practices, systems, planning principles, planning norms is the way forward for climate change. To address the said narrative the Koppen's classification of climatic zones shall be insightful for climate change in a structured manner. The frequency of climate change events increasing by the day has put a pressure for immediate action and the traditional urbanism worth an introspection to look for time tested solutions. As most of the global cities have a core traditional city thus there is potential by the respective core city to contribute in defining role in shaping planning polices and strategies for the city and contribute at national level. The scale of economy and growth prospects of such urban centers' shall prove to be an opportunity to solving one of the key existential concerns of climate change. Globalization and global economy with its norms and standards a challenge but also has an opportunity readily available from the core city of traditional environmental knowledge, sensitized with cultural heritage, leveraging the same for re-orienting strategies for development and growth through knowledge dissemination, sharing,

including collaboration for technical. Having explored the disruptive pedagogies, the world has started with the narrative of sustainability to low carbon to net zero and climate change however traditional urbanism does have few silver bullets. The inter-disciplinary approach in Traditional Urbanism is inherent to the framework of development while the hedonistic approach of global economy model compartmentalized issues from an integrated to a disparate one driven by capitalism. Capitalism driven for financial gains departed from a culture of socio-economic of a geographical context to socio global financial context. The gap from contextual social to global economy lead to a paradigm shift wherein the inter-disciplinary cyclic process loop was complete, which was sustainable got disrupted with the sole agenda of numbers; so much so that the manner in which GDP is equated is just numbers and the qualitative aspects of living overlooked. "New pedagogies to have informed choices for what is valued gain currency with society and nature of heritage that will evolve beyond the synthetic biology, artificial intelligence" [7].

The discourse on pedagogies that explores cultural, political and economy intertwined within the discourse of environment and globalization underpinned with technology to be strategized. Urbanisms of Traditional cities need to be understood with tradition for urban areas, establishing varying thresholds aligned for the regional contexts' the thresholds of carbon emissions' relative to geo-context rather than absolute of the global norms. The synergy between local economies for the respective nature, pace and level of urbanization of the city may be determined such As the nations are at varying thresholds of growth with a common target the energy concerns need to be disparate until the recent past; the developing cloning the developed is endangering the environment and thus inappropriate, quite evident with the current state of affairs. Traditional Urbanism is productive cultural heritage connecting with people through local communities and place of historical value through traditional practices for place making. The new challenges brought about by rapid social and economic changes with the vulnerability of their attributes, the pressures of socio economic and their impact with fast pace of Urbanization in the Global south is a challenge whereas traditional urbanism especially is in fact our single most potent weapon against climate changes, rising energy consumption and environmental degradation, a common denominator, applicable in principle to the majority, if not all.

The focus of global economy looks for financial models and in-built environment sector global tourism; a huge potential for traditional urbanism, and the narrative spans beyond the historic buildings to traditional streets, precincts and the cities are influenced with the scope of their intervention, such transitions across all levels offers potential for experiences that are unusual. Tracing the path of such behavior pattern determines the energy use, consumption patterns and thresholds of comfort. In the recent past a large body of research based on meta studies on energy use have enumerated the role of occupant behavior and responses to energy use is strongly culturally determined. The baselines of thermal comfort of a traditional city were decided by the geo-contextual framework but the tourism sector follows the global that baseline that varies from 16+ to 25+ degrees. Simultaneously in UK and Europe the high temperatures happen to be the root cause for excessive summer deaths, while in some nations in Asia and Africa the very same high temperatures are acceptable and

with this backdrop the norm of thermal comfort temperature is a challenge for foreign tourist and related energy use too may be high. Occasionally when the interventions in the traditional heritage precincts are piecemeal the contextual framework is often overlooked for personal preferences for passive planning principles and systems, aesthetics and architectural styles. Based on the scale of intervention the impact is relative and most prominent of all is the infrastructure facilities and built form with passive systems in place the need to overlay with heating or cooling systems are responsible for carbon emissions that may vary from 20 to 30%; at the cost of the typology of urbanism and the microclimate in these compact cities with high densities gets altered manifold. The performance of buildings for climate change is often assessed on the basis of energy demand rather than carbon emissions the link between energy generations, energy demand and carbon emissions is not straightforward [8]. Also the building interfaces are such a profound part of the occupant experience and the corresponding occupant comfort and building energy performance; yet they've received relatively little research attention and outcome lacks the scientific credibility [9].

To attain carbon neutrality the agenda needs to be central for the new developments and applicable for large stock of existing through retrofit, as both types of interventions are inherent to traditional urbanism. The existing structures can be retrofitted: part or deep while implementing in the traditional urbanism has significance due to cultural heritage connotation with inherent passive systems in place, state of existing structures and intervention for continuing usage or for adaptive reuse. The role of traditional urbanism is integral for future development and as the approach shall be strongly contextual almost an extension of the framework of traditional cities incorporating contemporary needs. The distinct typology of each of the traditional urbanism got altered with layering of infrastructure facilities beginning with water and waste disposal but electricity, communication and information technology and continuing. Most of the transformations were based on assessment of social values often culturally driven. Interestingly, for same geographical location across the globe the traditional solutions are diverse and vary for thermal comfort thresholds as well. Currently immediate attention needs to be in place for climate change through strategies, planning, innovation, public participation, technology to inter-disciplinary multi-pronged approaches; while the time-tested traditional solutions that have delivered and continuing have their unique edge with the potential to be integrated with mainstream development.

Traditional urbanisms are largely comprehensive both conceptually as well as in development approach as the built and un-built have a complementary relationship with the built for habitation, landscapes from farmland to parks and gardens for public gatherings. The farming was indigenous, in line with the ecosystems thus sustainable and nurtured the bio-diversity with optimum use of natural resources especially water resulting as low on energy. This low carbon living was sustainable that evolved with the growth of the city, which was holistic, comprehensive, and inclusive in true sense for human comfort health and safety as well. This symbiotic relationship between local community and the climate smart agriculture was strongly embedded in the

socio-cultural connotation and local economy balancing it for the scale, which was key to the traditional urbanism.

The cultural and natural resources must be integrated in urban planning processes to strengthen cultural and environmental sustainability as that nurtures a sense of place and belonging. Translating the cultural and contextual dimensions in architectural and urban design cultivates sustainable development and applying human scale to built environments through compact urbanization curtails urban sprawl. Traditional urbanism realized effective management of population density and resource consumption, through methodologies and mechanisms that synergized with built environments that supported developing economies and prevented the destructive impacts of abrupt urbanization. These events witnessed by the traditional urbanism and their responses a testimony of scale was climate responsive.

Traditional urbanism is a universal resource, irrespective of their state of economy, typologies and often evolving constantly. The professional discourse driven by politico-economic agenda propagates the global development typology often in contrast to the attributes of traditional urbanism. This contrast vouches for global lifestyles that are high on energy. Although solution for climate change and energy challenges does not necessarily vary for core/inner versus city or suburbs rather an integrated approach dovetailed with mainstream development policies are required; is to re-integration into sustainable regional forms that may arise from respective traditional typologies. Tracing the tradition of economies, the contemporary lifestyle changes are impacting the traditional urbanism across all hierarchies of the built morphology from planning layout of the city down to the fenestration details. For example: technology has provided for thermal comfort for indoors with altering the microclimate into heat islands based on the spatial characteristics of the built morphology. But in case of traditional cities thermal comfort addressed across all hierarchies of built forms and therefore with the installations for conditioning of air (heating and cooling) affects the built form for microclimate adds pressure on infrastructure with gap in technologies, behaviour and performance evaluations with last but not the least the visual aspect a eye sore to the rich architectural detailing of the urbanism.

4.3 Energy Use in Traditional Urbanism

The Global building energy consumption has remained steady in the recent past but the CO_2 emissions increased to 9.95 GtCO$_2$ in 2019. This increase was due to a shift away from the direct use of coal, oil and traditional biomass that has relatively less carbon emissions. The building construction industry accounts for 38% of total global energy-related CO_2 emissions for operational emissions followed by embodied energy, construction among others [10]. There has been a lot of innovation in reducing the operational energy needed to heat and cool buildings however the need to reduce the 'embodied energy' of buildings, related to production, construction are yet to explored for full potential concurrently the

demolition and maintenance by the Construction companies takes away only about 1% of building materials from a demolition site for reuse, as the market isn't in place thus reuse of whole buildings with modifications emerges as a viable option that not only reduces embodied energy but consumes less energy as well [11]. Among other global initiatives in decarbonizing the energy sector from the RIBA 2030 plan for climate change targets two major issues that pertains to traditional urbanism is using locally available natural materials that minimizes the embodied energy and related carbon emission and impact on ecology. Globalization has encouraged natural building materials to travel across the nations for aesthesis of global office spaces and tourism sector that are alien to the contextual geographies and high on energy as well and often do not sustain as regular replenishing them is high on energy and impacts climate change too. Survey by EU for 2019 enumerates that 93% of EU citizens see climate change as a serious problem and the measures for mitigation to make the EU economy climate-neutral by 2050 [12]. However Europe rich for traditional architecture and planning models and attracts a large number of tourists both domestic and foreign. With sound economies in place they developed an equally stable scientific research base that enables them to safeguard the traditional heritage often static well-preserved in museums and recreated in the form of events as festivities, performing arts and translated as built form as village's of the said era; thus in cities they are isolated pockets well connected for tourism sector whereas other attributes of incidental to the city. International Energy Agency data estimates the energy demands for developed economies and developing economies at par or even twice in case of china and that is alarmingly i.e., UK-73.8 EJ; USA-88.8 EJ; India-79.6 EJ; China-159EJ with Africa at 54EJ and rising as China has invested heavily for funding and operating or for both escalated the energy demand [13].

Energy is the key issue responsible for climate change. Typically, each of the traditional urbanism demonstrates contextual energy efficient systems largely through passive systems for planning principles, building materials, construction technology among others. The standards of thermal comfort either for cooling or heating were indigenous and so were the solutions that were effective for the times and the thresholds were contextually guided and varied with geographical locations in sync with the DNA of the local community. The thresholds arrived at such varied from 16+ to 30+ degree centigrade; although it may appear grossly inappropriate but rationally speaking the comfort level were relative for the temperatures of their geographical location i.e. the excessive summer deaths in UK those occurred for about 35+ degrees whereas in few Asian nations people live with 45+ degrees. However, UN guidelines of standardizing temperature globally at 28 degrees and initiatives like cool biz allowing wearing causal clothes in offices; a social change that helped to reduce demand and consumption substantially. Although the narrative for global communities these standards is debatable, as they are applicable in global mega cities. With majority of the population living in urban areas, culture is significant to contribute for the threshold of thermal comfort. The development algorithms in cities using smart technologies enable to be energy efficient while the non-carbon passive traditional urbanism has the potential to reduce the energy demand cultural effectiveness and acceptance in place has the potential to continue. The traditional

urbanism has practices for places that influences places for people strongly under-pinned by culture; an effective way to deliver for social justice, where the community benefits as universal user that is unique as most of mega cities have hubs that are high on energy demands essentially due to disparate land-use planning system over mixed land use in traditional cities.

The pragmatic way to understand energy efficiency of traditional urbanism is through the energy systems beginning with embodied energy of building materials as they were procured locally or within close proximity and used in its natural form except for cutting it the shape and sizes that were managed manually, thus carbon footprint for either processing or transportation. The projects executed were utilized with indigenous construction technology which often relied on mechanical energy that was manually operated therefore limited fossil fuel used that too locally available. The daily working hours were governed by the natural daylight that limited the working hours with rest of the time utilized for social interactions, a fundamental attribute to nurture culture and cultural values. As electricity is invented barely over a century old until then traditional urbanism thrived with optimum use of natural daylight for centuries on; a balanced low carbon life style. The traditional practices designed, detailed and constructed their buildings so as to make the most of the natural resource for thermal comfort; was strongly contextually governed i.e., in desserts where temperatures are high the walls are made thick to address the time lag for heat transmission and increased wind movement through the built spaces examples that illustrates use of Bernoulli's theory translated in system of openings and fenestrations an inherent aspect of space syntax. When the built morphology evolved with such an approach based on grammar emerged an architectural vocabulary that provided not only for comfortable spaces but had rich architectural style as well. It's interesting to note how the natural resources rather than becoming a limitation proved to be an opportunity to be creative and innovative for limited locally available building materials and contextual indigenous construction technology. Scientific studies have validated the performance of such buildings but limited text is available on analyses of the principles and documentation of traditional practices as set of standards; a ready reckoner for all.

The local community is developed contextual practices for the respective context over a period of time and fine-tuned along the way to arrive at traditional practices that determined the energy use. The threshold of consumption of energy was determined by (a) 'lifestyles' that utilized maximum daylight thus reducing the energy required for lighting. Energy consumption in buildings was minimum as maximum use of daylight was the norm further the traditional knowledge of quality of daylight in place enabled them to exploit both quality and quality of daylight i.e. diffused light from the north facing spaces were allocated functions accordingly often related to the nature of work. Further the scale, proportions, areas' of the built spaces was such that they were well illuminated by daylight and based on geography and climate sun screen were designed and detailed that controlled the quality of life and such examples are omnipresent in traditional urbanism, (b) for 'thermal comfort' be it heating or cooling was taken care off through passive and traditional planning principles and systems using, a natural renewable resources i.e. timber etc. Whereas

the norms for thermal comfort were determined through passive and planning systems in place adapted by the local community through traditional practices i.e. food-spicy food has a tendency to counter impact of high temperatures, limited working hours for qualitative social life and so on. All sources of energy from nature were acknowledged, tapped through traditional practices for optimum use; likewise, wind too was explored in innovative ways for thermal comfort through traditional principles of spatial planning i.e. courtyard planning, design of spaces, and system of fenestrations among others all shaped up with rich architectural style that added value to the built environs. Thus, approach lead to utilize daylight and thermal comfort standards that not only determined the working hours and lifestyle' but added value for quality of life, health and well-being that assured harmony among the local people as they enjoyed security which facilitated social interaction's resulting in strong local community. Although the agenda may be understood from energy standpoint but the inter-disciplinary approach inherent to the local communities has related development indices; something that can be translated for the global community as well, (c) as the 'scale' of cities was compact and walk-able thus majority of the circulation was pedestrian movement with limited carriageways pulled by animals thus no fuel required for transportation. It may be logical to conclude that the energy requirement was reduced and minimum drawn from renewable natural resources.

The use of energy rose when infrastructure got institutionalized less than century ago except for water supply that used gravitational force as the fundamental principal translated as typology that was unique for the contextual architecture Considering the basic function was to transport water from source to the point of consumption but the translation of this function through aqueducts, water tanks, stepped wells etc., that were constructed in materials from stone to bricks exploring innovative structural systems from arches to walls with piers and so on thus no fuel used for transporting water; also it was viable as the scale of the traditional cities was limited and even the requirement was rational more so when compared to the global standards prevalent now Such an approach to translate the use of natural resource was archetypal in traditional urbanism and such an approach continued largely for other natural resources and infrastructures services too. The sewage and waste disposal was largely through manual labor and sometimes by carts that are low on energy if at all. When electricity was in place the impact was substantial as it aided the existing services of water supply and waste disposal and underpinned by technology facilitated heating and cooling for thermal comfort followed by communication technology that escalated the energy requirements even further. The infrastructure facilities boosted the local economies encouraging migration and re-densification occurred for which the infrastructure facilities had be augmented regularly. Additional built spaces were required for the migrant population for which technology and new building materials were often used due to ease of accessibility. The pace of building activity within traditional urbanism was gradual but with electricity and technologies, the pace has got accelerated further accentuated by global norms for tourism sector. This accelerated pace of urbanization had some inherent gaps that the migrant population were unable to be embedded within the local community, continuity of the local building materials and construction technology, super imposition of services, practices and

norms over laid in alignment with the global cultures that added pressure of energy use in most of the traditional cities.

Modes of transportation is one of the main contributors for carbon emission's and energy use in cities, especially the automobiles; while the traditional cities were walk able cities with mixed land use, pedestrian movement was the key. With re-densification the norm continued until the city grow outside the city walls or beyond its natural limits. As the immediate periphery was an extension of the existing and embracing technologies and infrastructure services two and four wheelers started plying but with limitation of streets' the various modes of transportation started encroaching onto the open spaces of the city. This impact on spaces limited the use of open spaces by the neighborhood communities; although the local community uses cars but they were parked on the periphery with limited access with in the city and that limited carbon emissions. Thus planning approach for built morphology by restricting cars and encouraging pedestrian movement is often applied in contemporary residential neighborhoods as that encourages social interactions and nurtures kinship. These condominiums aid in reducing energy consumption and emission's a traditional urbanism connotation evident in contemporary planning; among others of which some are explored while others have the potential. Globalization triggered major transformations underpinned by technology and patronized by governance that boosted the local economy. However, this was not the standard response but varied based on the economy of the cities, nations and geographical locations, where the living traditional cities had the framework firmly in place the transformations were in line with the existing ensuring the continuity of cultural heritage and thus the energy requirements were relatively low. While the nations with developed economies where the tourism sector took precedence and the energy consumption is manifold as they are guided by the global standards, often this traditional urbanism were a combination of frozen cultural heritage precincts.

Energy efficiency has been inherent for traditional urbanism at all stages from design, construction to operation of built environs. The selection of building material for its availability either in situ or close proximity from the region that ruled out the transportation costs and the material were processed using local skills and indigenous technology optimizing the embodied energy. Such an approach assured the economic activities for indigenous skill development that was distinct to the traditional city. The approach continued for construction technology adopted including the maintenance as well, limiting the operational costs. As the material procured was locally available thus the local community with their wisdom of knowledge including about the life cycle of the materials and knew weathering of the building materials and with local construction technology resulted in distinct architectural vocabulary that was fine-tuned with generations on as rich traditional typologies. With each generation and migrant population re-densification occurred for additions and alterations for which the building materials and construction was similar and continued till the globalization occurred.

However the global thermal comfort standards of 20+ centigrade unanimously accepted including BEE-India, when applied to the traditional buildings often not

aligned with the contextual norms and to interpret the performance of the buildings falling short needs to be reviewed with sensitivity for cultural heritage and thresholds. As with the said global standards, these existing structures are retrofitted, refurbished and upgraded for building performance and energy use and carbon emissions. The entire process and approach may be negotiated and adapted for sensitive refurbishment for maximum energy efficiency for contextual standards. Ample scientific studies globally demonstrated that the passive systems that exist and continuing contribute significantly for example: sky view factor contributing for urban heat island and thereby microclimate and thermal comfort at large for built morphology among the many studies. As mixed land use was the norm for the traditional urbanism and with daylight determined the working hours the energy use was minimum and with electricity in place the working hours extended and the energy consumption rose. With growth and urbanization of these traditional cities the mixed land use gave way to retail and production under pinned with technology further escalated the energy use.

The impacts of globalization on climate change and energy are evident and mitigation strategies and options are the norm now adequately supported by the government policies. At one hand technology gave mankind the option of cooling and heating at the cost of energy and at the same time providing options from renewable energy sources for energy efficiency validated through scientific studies and precision enabled again by technology. It's virtually completing the loop to deviate from low carbon living escalating the energy need to make them efficient. The fundamentals laid down in traditional urbanism wherein living with nature limiting contextual resources and managing optimum standards that are conventionally low and often logical for the context.

Governance plays a decisive role for carbon emission through its policy framework, however incentives and taxes vary with nations. Initiatives like congestion charges have been applied in limited number of cities worldwide to control road usage by private vehicles while some are designed to tax higher-emitting vehicles more heavily, like in London and Milan among others. Congestion charges have observed for reduction of GHG emissions from transport up to 19.5% in London, where receipts are used to finance public transport, thus combining global and local benefits very effectively [6]. Initiatives by Energy Services Companies, or ESCOs, generally finance their energy efficiency investments via direct borrowing or via loans to end-users, which may be covered via utility bills or property taxes. Municipal bonds can also be issued for raising capital for municipal energy efficiency programs. For instance, the city of Varna in Bulgaria issued municipal bonds to obtain financing to retrofit and modernize the city's street lighting system, a project that had a payback period less than three years. The bond raised three million Euros, had a 9% interest rate, and was repaid over a three-year period. Another significant example is of Global megacity Tokyo have managed energy demands and regularly improving being in sync with efficient technological innovations and Tokyo metro is almost a century old [14]. Also they planned that energy required for Olympics' 2020 to be totally from solar energy; an attempt to be self-sufficient contextually.

To address climate change at policy and norms of Global agenda emission trading system or carbon tax strategized through global economy while locally implemented i.e. carbon pricing USD 1–127$/tCoe2 (ton of carbon dioxide equivalent) of which about 51% pay 10 USD. Mitigation strategies by COP25, to reduce and avoid emission of GHG; storing and capturing carbon through plants and protecting forestry and increasing energy efficiency using green technology and renewable energies [15]. The Asian countries largely developing currently have threshold that are much lower but with rapid urbanization and with global norms with the scale it shall alarming situation in near future due to high use of building materials with related embodied energy, operational energy technologies and smart innovations. However, assigning a cost for emissions may be debated as the impacts are far-fetched and the stronger economies are in position to trade such with a considerable impact on environment. In such a narrative prevention is better than cure, as to facilitate a nature of development that is high on energy the policies and norms to ensure low carbon, even if at the cost of slow and low production may be worth exploring a system that was inherent in traditional urbanism a response of traditional urbanism that echoes in their take for climate change. Concurrently Europe too has a large reserve of traditional urbanism and have taken measures to commit for carbon neutrality by 2050. Survey of national governments to target increasing the amount of renewable energy; for which 93% of EU citizens saw climate change as a serious problem of which 79% see it as a very serious problem. 92% of respondents think and 89% believe governments should provide support for improving energy efficiency by 2030. Further for supporting more public financial aid to be given to the transition to clean energies, even if it means reducing subsidies to fossil fuels; 84% believed that should be in place. Next 92% of respondents and more than eight in ten in each Member State agreed that greenhouse gas emissions should be reduced to a minimum while offsetting the remaining emissions, in order to make the EU economy climate-neutral by 2050 [12]. The results show that the contemporary dwellings has the highest peak heating load with an amount of 9,571 (Watt), which is 50% higher than the triple-space vernacular dwelling even though they have the same area of inside spaces, while the peak heating load of the single-space dwelling is 2,109 (Watt) [16], Another global initiatives in decarbonizing the energy sector by RIBA 2030 plan for climate change targets focusing on to reduce embodied and operational energy, carbon emissions; portable water use and day lighting and address overheating, carbon level while the thrust for existing building stock to be whole life carbon, water use, indoor health, bio-diversity. Reducing embodied energy clearly suggests use of locally available building materials or locally produced and through use of technology and baselines of thermal comfort the operational energy can be minimized for which the indigenous solutions are a huge resource. Operational costs for energy efficiency are recurring costs' thus important for carbon emissions. Several Australian studies have shown that the embodied energy can account for a significant portion of the total life cycle energy consumption of a building [17]. The indigenous construction technologies impacted the life cycle of the building materials. While the other characteristics of the building materials like color, texture, natures that relates to honest aesthetic appeal unlike with processed building materials delivers tailor made aesthetics often coupled

with best of technology but may add to energy usage and related carbon emissions is a challenge when compared to the traditional building materials. Materials used in traditional buildings proved to be durable as they delivered subject to maintenance and often with minimum energy consumption. This was largely as the material was procured were locally available so inherently accustomed to the temperatures' and humidity both in their natural form and even after when used in construction of buildings, as the natural conditions continued therefore minimum maintenance required, while when any material is brought in from a different context the material needed to adapt to the environmental conditions that were often high on installation and operational costs for energy and maintenance. The passive systems in our heritage buildings have proven to be sustainable for reduced energy demand due to selection of building materials that had thermal capacity, heat conductivity, U-value, embodied energy and other characteristics' when coupled with local construction technologies, use of lime among others was standard for traditional buildings. As the system of construction was region and geographical specific resulted in rich architectural style with an identity of its own that was low on energy with equally low carbon emissions.

Studies indicate that 'sharing of indoor space can improve space and energy efficiency through flexible use of space; something that was typical in built form of traditional urbanism both for public and private spaces. Improving space efficiency (e.g. by sharing indoor space) is a key strategy to meet simultaneously the future demand for facilities in cities and fulfills environmental objectives such as a reduction of climate change impact in the building sector. According to the principle, the first priority should be to adjust activities to require less space (e.g. through digitization) the second to intensify the use of existing buildings, and the third to adapt buildings to new uses, constructing new buildings only as a last resort [16]. As the building sector is responsible for about one-third of global final energy use and between one-fifth and one-third of greenhouse gases (GHG) emissions.

Urbanization influenced the traditional urbanism especially the architecturally rich heritage precincts that are well conserved provided for tourism sector and when nominated as world heritage sites were developed to deliver for global standards and often substantiated with state of art technology. While for the living traditional cities the impact was complex as it brought about a paradigm shift from the contextual socio-economic thresholds of the respective urbanism; as each of the traditional urbanism is unique so are their responses, irrespective of the state of economies largely because of the social capitol being the key decisive factor. Either way, mitigation for climate change is a concern including carbon emissions to be minimized to target net zero emissions. An attitude that advocates acknowledging efficient use of natural resources with protecting and nurturing natural environment for climate changes in traditional urbanism to focus on the three R's reduce, reuse and recycle to contribute to continue for low carbon. With passive systems in place the energy demand gets reduced for the standard baselines. Adaptive reuse of existing buildings for contemporary needs for tourism or for local community is reuse of same space for different functions and reuse of materials and construction technology has the potential to be explored reviving the indigenous economic activity; a universal resource of traditional knowledge that is low carbon. Often, during additions and

alterations to the existing, buildings recycling and recovering the existing with merit to be retained and even upgraded with technology for energy efficiency is valuable as it ensures the continuity the very essence of any city. Broadly the three R's can be explored for all dimensions of traditional urbanism and contribute for climate change. With adaptive reuse of traditional buildings and precincts energy demand is reduced as only limited alterations and only the energy gap to be addressed.

Traditional cities are usually compact with well-defined open spaces while the immediate periphery of such cities had open spaces only but have been encroached with urbanization of core city expanding beyond the earlier defined limits; this default limitation was key for these cities to be sustainable. Studies have demonstrated that the green open spaces counter the carbon emissions which got disrupted with modes of transportation especially automobiles. "Increasing efforts to scale up adaptive capacities and mitigation efforts for exiting systems and focusing on energy resilience during urban planning, strategies are natural climate solutions such as trees storing carbon and forests acting as carbon sinks. Mature trees have limited growth capacity due to environmental factors such as space, soil nutrients, and root density" [18]. Urbanization and globalization present's risks for local economies affecting competitiveness and jobs and alongside worried for carbon emissions such a backdrop of disruptive development the global systems appear to be dysfunctional. However, concerns about climate change will drive a "fundamental reshaping of finance" [19] in the near future and sooner than most anticipated. There will be a significant perception of available resources and reallocation of capital, be it social, finance or environment catalyzed through cultural heritage leading to sustainability. Currently climate change is dealt with alongside the global economic agenda with vested political decisions to govern development to be sustainable both by government and non-government sector there is need to be prioritized and dovetailed the said agenda with the mainstream development with related environmental costs. An approach that assesses the environmental costs can provide for framework of development that is in sink with the context shall have least impact on nature and it's related systems is the need of the hour. Ironically saving the past for future holds true for both the nature that existed including the manmade that is continuing.

4.4 Thresholds of Traditional Thermal Comfort

Based on the geographies the set of resources vary thus the nature of traditional urbanism evolved while based on the state of economies the world is broadly subdivided as developed and developing nations and with nations themselves at varying thresholds are exposed to global urbanisation with its related connotations. This is a complex situation as the global economy has determined the baseline needed to deliver and simultaneously exploiting the low baseline of nations with poor and developing economies for larger profits. This inherent imbalance of social equity impacts the environment and gets reflected in nature of urbanism. This situation enumerates that the nations are at varying stages, which is its own advantage of bringing

the world together that embraces diversities of all kinds for economic activities, social, cultural and others. While the challenge is that these respective communities aren't strengthen in capacity building thus there shall be paradigm shift and when the shift is substantial so are the transitions that alters the urbanism for major modifications. The major modifications occur mainly for working spaces, office spaces and commercial spaces and they are built, operated and maintained with global standards irrespective of where they are located and who the users are and that is a major point of concern. Such a mathematical approach wherein the social narrative is ignored, cultural connotation overlooked takes a tool on the resources both man made and natural as well. One cannot negate the fact that globalisation is here and omnipresent and surly a sign of progress as well. But the issue is that conceptually speaking the varying thresholds has been put at par irrespective of its baselines.

On one hand, we have a case of traditional urbanism that is strongly rooted to its context which is essentially a bottoms up approach. On the other hand, we have the global economy driving urbanism is rather a top-down approach; this diverse approach is evident as climate change. In case of nations with developed and stable economies the gap was minimum, and the rest addressed with technology and timely planning intervention. While the nations where the gap is more and tools inadequate to address the gap implications are grave. This may be explained as the office spaces required for multi-nationals have a standard architectural vocabulary as its image and that is duplicated irrespective of local climatic conditions further the standards of thermal comfort too are defined for such a narrative energy is a huge issue right from selection of building materials of certain embodied energy to its nature and type of construction, to its interiors and eventually for operational costs. Setting such norms needs to be reviewed without compromising on the delivery. The thresholds can be insightful for lifestyles for example the temperatures that a set of people can live by varies as in case of UK due to rising temperatures there were excessive summer deaths in the recent past when mercury touched thirty degrees; while in some nations in Asia thirty degree's is comfortable [20]. However ironic the information is but important is to recognise, as when the lifestyles has the natural capability to deliver for certain temperatures therefore to redefine them in line with the global standards needs introspection. Next when such thresholds are in place the human body has the inherent capability to adapt to them along with related impacts like immunities getting altered and that is a permanent change. Like socio-cultural changes the human body too is wired to gradual changes and sudden changes impacts the system of system affecting the health and well-being of individuals and their ability to contribute to the progress and development reflected as performance index through studies. This area has a huge potential to contribute for climate change. The thresholds can be insightful for lifestyles for example the temperatures that a set of people can live by varies as in case of UK due to rising temperatures there were excessive summer deaths in the recent past when mercury touched thirty degrees; while in some nations in Asia thirty degree's is comfortable. However ironic the information is but important is to recognise, as when the lifestyles has the natural capability to deliver for certain temperatures therefore to redefine them in line with the global standards needs introspection. When such thresholds are in place the human body has the inherent

capability to adapt to them along with related impacts like immunities getting altered and that is a permanent change. Like socio-cultural changes the human body too is wired to gradual changes and sudden changes impacts the system of system affecting the health and well-being of individuals and their ability to contribute to the progress and development reflected as performance index through studies. This area has a huge potential to contribute for climate change.

Typically, air-conditioning costs are high both for installation and more so for operation as they are used at temperatures from 16 to 22 degrees considering the UN recommends air-conditioners to be operated at 28 degrees. This gap is a concern and multiplies when large quantities of such office spaces are constructed. Quite often the research in technologies is upgraded frequently but nations with poor economies lack the funds to undo the existing and replace with latest also the technology is getting upgraded quite frequently thus the impact is manifold. Apparently, each of the regions the local communities adapt them and are able to deliver such as by default of their DNA are wired to sustain temperatures their climatic conditions prevails; and to raise the bar of base line is both redundant and not required. As the DNA constitutionally have the inherent capacity to respond and exposing to specific temperatures made their bodies vulnerable and has the tendency to lower the immunity as well. This is evident in the generations that have been pampered by the parents are more prone to health issues and its on the rise especially in urban areas. Diseases like obesity, allergies and others are on the rise and they were virtually non-existent in traditional cities as the lifestyles were such to which nature of urbanism is innate.

Traditional cultures had a defined framework wherein all aspects were addressed and all abided by the conformity of it; making the local people a community with harmonious relationships that was their strength as well to face adversities if any. The social narrative within the framework had enough room for individual expressions as well that assured individual identities as well, interestingly one can draw a corollary such for the elevations of the buildings in traditional urbanism. All the buildings look similar due to the typical architectural style that maintained the harmony. Whilst the hierarchy in building detailing represented the status in the community. Often the size of plot, its location in the layout plan of the city, orientation and other related parameters reinforced it even more. Translation of social narrative is predominant in most of traditional urbanism. Diversity has been inherent to traditional communities for caste, colour, jobs undertaken and so on unlike the economic stratification prevalent now. In traditional communities the diversity was more of a symbiotic relationship that gave each their identity and an opportunity to excel as well and with generations each of the crafts grew, known for its place of production and regional distinctiveness and now for global world as well. Diversity proved to be strength rather than sub-division of the society. While with economic stratification the whole approach has had a paradigm shift wherein mutual respect for dignity of labour and work is getting missed out and replaced with buying capacity and does not nurture symbiotic across the other strata at large. Such an approach gets translated in the built morphology as isolated pockets very much self-contained and thus do not get woven to the city fabric and urbanism. Further these pockets with good buying capacity uses resources more for status rather than need and that overrides the rational thinking that

was inherent to traditional urbanisms; this gentrification has other related impacts as well jeopardising the inherent balance of the community diluting it, which is a permanent loss.

References

1. Climate Change 2014 Synthesis Report Summary for Policymakers (2014) Article 2 of the United Nations Framework Convention on Climate Change (NFCCC)
2. Faust E, Rauch E (2019) Climate Chang Series of hot years and more extreme weather, Climate change and its consequences. Munichre.com. https://www.munichre.com/topics-online/en/climate-change-and-natural-disasters/climate-change/climate-change-heat-records-and-extreme-weather.html
3. Recommendations from the Scientific Council Symposium; Cultural Heritage and Global Climate Change (GCC) ICOMOS Scientific Council, Pretoria, South Africa, 7 October 2007, March 2008. https://www.icomos.org/climatechange/pdf/Recommendations_GCC_Sympos ium_EN.pdf
4. 41st session of the World Heritage Committee Krakow, Poland 2–12 July 2017. https://whc. unesco.org/en/sessions/41COM
5. Elkin TM (1991) Reviving the city: towards sustainable urban development, friends of the earth. London
6. https://whc.unesco.org/en/newproperties/date=2019&mode=table
7. Francart N, Höjer M, Mjörnell K, Orahim AS, von Platten J, Malmqvist T (2020) Sharing indoor space: stakeholders' perspectives and energy metrics. Build Cities 1(1):70–85. https://doi.org/10.5334/bc.34
8. Conservation Principles, Policies and Guidance (2015) The sustainable management of the historic environment. https://historicengland.org.uk/images-books/publications/conservation-principles-sustainable-management-historicenvironment/conservationprinciplespoliciesand guidanceapril08web/
9. Judson EP (2012) Reconciling environmental performance and heritage significance. Australia ICOMOS Hist Environ 24(2), 2012; Built Heritage and Sustainability HE 24(2), 2012; Built Heritage and Sustainability
10. Mousa WAY, Lang IW (2014) Solar control in traditional architecture, potentials for passive design in hot and arid climate. PLEA 2014, 30th International Plea Conference CEPT University, India
11. (2021) https://www.bpie.eu/news/building-sector-emissions-hit-record-high-but-low-carbon-pandemic-recovery-can-help-transform-sector-un-report/. Accessed 3 Feb 2021
12. EU 2019 survey. https://ec.europa.eu/clima/citizens/support_en
13. IEA. https://www.iea.org/data-and-statistics
14. Bigio AG, Ochoa MC, Amirtahmasebi R (2014) Urban development series KNOWLEDGE PAPERS climate-resilient, climate-friendly world heritage cities [89635]. World Bank Group
15. UN-Habitat at COP25: Time for Action! (2019). https://unhabitat.org/story-UNH-at-COP25
16. Francart N, Höjer M, Mjörnell K, Orahim AS, von Platten J, Malmqvist T (2020) Sharing indoor space: stakeholders' perspectives and energy metrics. Build Cities 1(1):70–85. http://doi.org/10.5334/bc.34
17. Crawford RH, Treloar GJ (2004) Assessment of embodied energy analysis methods for the Australian construction industry. Conference: Australia and New Zealand Architectural Science Association. https://www.researchgate.net/publication/283347275_Assessment_of_emboied_energy_analysis_methods_for_the_Australian_construction_industry
18. Cambridge institute for sustainability leadership, sustainability horizons: what's coming into view? https://www.cisl.cam.ac.uk/resources/sustainability-horizons/april-2020/carbon-storage-in-mature-forests

19. Fink L (2020) https://www.bbc.com/news/business-51111727
20. Gupta R, Barnfield L, Gregg M (2016) Overheating in care settings: magnitude, causes, preparedness and remedies. https://doi.org/10.1080/09613218.2016.1227923

Chapter 5
Synergies Between Traditional Urbanism and Climate Responsive Design

5.1 Traditional Urbanism and Climate Change

The manner in which heritage is contextual to its region and geographies so is its perception and thus the contextual framework impacts the built morphology including its planning principles and design philosophies for its continuity, rationale for additions, alterations and related transformations with time, driven by political, economic or social circumstances. Largely it's evident that richer the cultural heritage, the stronger is the symbiotic relationship with nature thereby often sustainable with optimum utilization of resources for low energy. With ongoing climate changes contextually, risks of wildfires, thunderstorms, draughts, heat waves, cyclones, earthquakes, volcanic eruptions, floods, rising mean sea levels to global warming accelerated with the rate of urbanization underpinned by technologies, infrastructure facilities and tourism sector. Thus, to isolate heritage from its immediate habit shall prove to be skewed approach to address the risks posed by climate change. To achieve the one and half degree limit globally is each one's onus irrespective of heritage. However, the world mapped for resources, diversities of all kinds from social, economic, cultural is a pre-requisite for post natural calamities; rebuilding activity is the key and a significant milestone to intervene for climate change coupled with anthropogenic activities and use of technology. Impacts of Climate Change are occurring due to hydrological, Metrological, Climatological and Geophysical, these events triggered by societies variability.

The next ten years are crucial as that shall be the real game changer and having accepted that heritage has universal value the challenge is huge. Based on geographies and traditions their distribution in mapping is fairly uneven essentially because of availability of resources. Often availability of resources facilitates the structure for research, work culture and technological inputs. What is significant is that each of the traditional urbanism addresses the regional and local responses to climate thus these solutions have universal value that may be shared as best practices. Until date traditional urbanism continued due to sustainable practices wherein the local

communities were in sync with their natural environments. Need of the hour is to have universal access to the database and solutions that can be carried forward or adapted for the contemporary needs with required modifications if at all. The research and resources be disseminated for all. Considering the exhaustive mapping is far from complete, the lack of proper mapping and database being limited and may be inadequate to draft out policies. Therefore, when implemented globally the norms may be superfluous and may not deliver the intended targets outlined at the global level. Having accepted that the traditional urbanism is a huge resource that if integrated for norms at policy level to be in sync with the local communities.

The grammar of traditional urbanism being a universal resource needs to be place for it to be carried forward as a deliberate intent rising above geo-political and socio-economic conditions. Although with current pace of growth has had limited impact to control carbon emissions and Climate disruptions frequent and is becoming new normal. To address Climate change mitigation the economic opportunities, need to be critically evaluated with governance at the backdrop at regional and global level simultaneously while the responses for climate change is possible only through local planning interventions. It's interesting as globalization with technology has accelerated and enhanced a typology of growth that has amplified the climate change and this very global awareness mitigation initiatives supported by technology is providing the answers as well kind of completing the loop.

Spatial Planning and Infrastructure is key to model urban climate as a function of design for thermal comfort both indoors and outdoors, significant when rebuilding, adaptive reuse and interventions occurs in the traditional urbanism. Interventions even if isolated needs to acknowledge the existing grain of the urbanism that recognizes the synergy between the traditional urbanism and indigenous practices that are low on energy and delivers one for itself and as a part of larger whole. Considering urbanization challenges are inevitable but traditional urbanism offers opportunities for climate change mitigation that are socially ingrained within the cultural heritage. Typically, the settlement patterns and structures in traditional urbanism evolved for the geographical contextual framework in sync with the local communities that resulted in traditional societies. i.e., often for hot and dry climatic zones compact development is the norm with low rise high density and interesting examples exist for different cultures but in fine detailing they differ for example use of cul-de-sacs among others. Such built morphology has inherent limit to growth i.e., for density ground plus three is the maximum that growth has been limited over centuries. Largely the urbanism translated such in typologies are specific and often unique for the region. The same has been recognized and acknowledged at international forums i.e., ICOMOS resolution 19GA 2017/30 that the cultural heritage community can help to meet the challenge as much a dimension of climate change and heritage as preservation and communities to participate; just validates the synergies of cultural heritage between local communities and climate change and that the sustenance of typology for its character including the intrinsic concepts of perception and valuation and therefore people with the embedded values that contributed for the framework were responsible for the texture of urbanism that was typically acknowledged within the legitimate value of geographical context.

Having established the symbiotic relationships such mapping of environmental performance of traditional urbanism narrative spans across all scales of urbanism from planning of cities to urban design norms down to individual buildings. Often the documented body of work has been focused on all the said scales but the cross-references amongst them often limited. As traditions are rather holistic in nature therefore to have policies and strategies for the systems of traditional urbanism needs to perceive such [1] to build reference to the energy and resources embodied in heritage buildings with specific thrust on durability and performance of building materials and buildings in terms of the energy needed in production and in use; equips for individual buildings only, each of the building is a part of set of buildings and delivers as one and contributes to be part if systems at the city level as well. The negotiations between norms of traditional urbanism with the contemporary standards arrived at determines the type and nature of intervention for energy use, that itself needs introspection. The need for mapping of traditional urbanism and determining susceptibility for climate change one due to natures' weathering and other man made.

Heritage buildings capitalize on embodied energy and save on the energy use for the production processes, transportation including construction of the same and related carbon emissions rules out the quantity of waste that would go for either land-fill or waste processes something that too consumes energy with related carbon emissions and so on, significant for life cycle analysis of the building materials. The need to recognize the full range of values inherent in heritage buildings, historic precincts to historic cities it may be worthwhile to assess the environmental and ecological values valued while assessing the value of the building materials and construction technologies. In the narrative of lifecycle analysis and technologies energy is the significant beginning with demand, production supply through transportation and consumption at the use end with losses at each stage. In the purview of the global thrust to economize on energy use intervention in traditional urbanism be facilitated through adaptive reuse, technology up gradation and existing stock refurbished retrofitted preferably deep retrofit with up-gradated infrastructure for additions and alterations. The standard gauge to assess energy use is through norms and rating systems, often the narrative builds on there systems traditional urbanism neither put them at par nor can they be equated such. To assess environmental costs a more holistic approach needs to be place that refers to embodied energy of building materials' transportation costs, construction technologies including maintenance including users' behaviour. Thus existing rating tools are often of limited assistance when appraising environmental value of heritage buildings, as their focus is principally on operational energy performance of the building envelope, while other related environmental costs i.e. embodied energy of building materials' their transportation costs among others not considered. Assessment tools for environmental performance of traditional heritage buildings, precincts or even Cities needs to be a more holistic approach i.e., Life Cycle Assessment (LCA) method. Few limited comparative studies that explored the impact on the human thermal comfort and energy consumption between traditional houses with the modern houses concludes that traditional houses depend on passive design to control solar gains and decrease heating and cooling loads keeping

a good level of thermal comfort inside thus reducing energy demand and carbon footprint as well. The results show that the contemporary dwellings has the highest peak heating load with an amount of 9,571 (Watt), which is 50% higher than the triple-space vernacular dwelling even though they have the same area of inside spaces, while the peak heating load of the single-space dwelling is 2,109 (Watt), [2] While few scientific studies also validates important parameters such as sky view factor, floor area ratio, site coverage ratio and building stories impacts the urban morphology and determines the microclimate typically inherent to traditional urbanism [3].

Irrespective of the nature of urbanism a generic approach needs to be relooked at for the assumptions taking existing for granted rather than a to and fro dialogue wherein the learning's from the traditional urbanism coupled with deliberate technological interventions that may be studied, gauged and calculated specific to the context as each of the traditional urbanism is unique. The question that we need to ask ourselves that if wish to pass on the wisdom of tradition then any technological interventions should be reviewed closely with reference to the traditional contextual heritage and worked upon for the way forward for i.e., adaptive reuse as it is one of the key intervention on the rise especially with tourism sector facilitated for economic development. The economy boost propels both the rate and nature of urbanization and that has multiple impacts on urbanism predominantly being energy use for transportation and buildings, while energy use by buildings is more than twice that of transportation. Although urbanism aids economic development with traffic and transport contributing for substantial of carbon emissions and related footprint, which tends to worsen as income per capita increases (Fig. 5.1). Transport is not a technical, but political issues with cars are also a status symbol. Quality pedestrian space is a powerful symbol of respect for human dignity and its pervasiveness a mark of a civilized city, in more primitive and unequal underdeveloped societies these factors weigh even more heavily [4].

Weathering has been a concern to historic buildings and sites but the impact in traditional urbanism has been limited as the local building materials used in construction were accustomed to the climate and weathering limited to issues i.e. salt problem, humidity and moisture etc. But the anthropogenic induced climate changes threats, that intensified with frequency of anthropogenic changes that proved to be severe in nature and unsustainable i.e. depleting water tables and ground water levels, uneven humidity cycles; altering soil composition to changed freeze/thaw cycles in highland areas and coastal erosion events, soil instability leading to droughts and floods. It may be observed since anthropogenic gained momentum, the impacts are more pronounced thus the objective conclusion to limit the selection of materials to the geographical context. This largely reinforces the framework within which traditional urbanism operated. The contemporary urbanization trends and future cities; are developed in ideal conditions from construction viewpoint and financially viable solutions while the traditional urbanism that thrived belong to diverse geographical habitats. Likewise, the climate threats too are diverse stemming from hydrological, Geophysical, Metrological events to climatic events of extreme temperatures, droughts, Earthquakes, wildfires' and so on; of which the predominant is the hydrological event due to rising temperatures and rising mean sea levels. The global mapping enumerate that

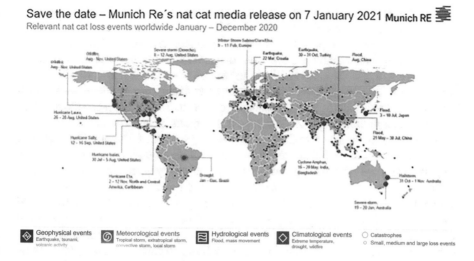

Save the date – Munich Re´s nat cat media release on 7 January 2021 Munich RE

Relevant nat cat loss events worldwide January – December 2020

Fig. 5.1 Natural catastrophes worldwide (*Source* [5])

Asia and African nations are affected the most ones characterized by weak economies but rich n vernacular and traditional urbanism (Fig. 5.2).

An approach to look at the same resource differently is a challenge with contemporary norms for their consumption. Further the operational logistics for disparate resource use vary and are community specific; implies that we have wide range of repository at our disposal, the diverse cultures contain knowledge that had an evolutionary value in the history of progress. Global economy shaped up globalization that impacted the environment resulting in climate change crisis. To address

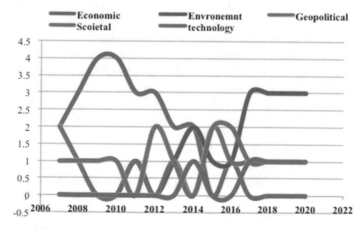

Fig. 5.2 Top 5 global impacts (*Source* [Author: 6])

climate change social, geo-political along with technology aligned to focus on environs with economy as supporting in future. These parallel lines need to be regaining the symbiotic relationship with an inherent balance. The shift of global to focus on regional the contextual urbanism establishes its strength more so through traditional urbanism to be able to contribute for environment. The narrative with global initiatives touched upon issues often in parts or isolated ones but documented such helped to lay the foundation for the whole over time as HUL recognized the relationships between precincts and the geographical context. While Nara charter referred to partial retrofits to deep retrofit to reduce energy and cut GHG and Burra charter focused on mitigation to reduce carbon emissions, also engaging traditional heritage for climate change by engaging heritage and archaeology with climate policy, adaptation planning, community engagement, and to climate and migration solutions' summed up to connect Climate Change and Heritage (CCH) this platform facilitated for professionals to discuss ways to translate fundamental archaeological research into actionable science to inform decision making as well as monitor climate change as it related various aspects from in situ modelling, sustainable strategies to transdisciplinary examples of engaging with climate change from research design to outreach for cities/buildings and the public domain. Global tourism contributed for the carbon footprint that increased substantially from 2009 to 2013 almost doubled contributing to 8% global GHG emissions and the growth continues at this rate the GHG emissions shall increase substantially [7]. Currently 40% of energy use accounts for destination-based accounting and residence-based accounting whereas the other operational logistics too are equally significant. Initiated in 2005 Vienna memorandum and declaration through numerous international conferences, case studies and workshops in 2010 drafted recommendation on HUL that concluded as New Urban Agenda that focused on bottoms up approach establishing the importance of contextual and regional connotations. 2011 HUL recommendation, adopted the New Urban Agenda completed with the Paris Agreement of the United Nations Framework Convention on Climate Change. Need of the bottom-up processes at the local level proved to be interdisciplinary developed through geo-cultural contexts prioritized by local communities through community engagement thereby bringing local wisdoms to the table to create alternative models for resilience and climate change. At the turn of the millennium a World Bank report endorsed that the local population is the ultimate guardian of the traditional built environs, is a reservoir of knowledge and experience of social and environmental interactions that can form improved sustainable approaches to using natural resources and protecting built heritage. Traditional Historic cities are the sole surviving engines of the cultural identity. The strong symbiotic relationship is relevant between the local communities and the local environments. Having recognized the gravity of synergies between traditional urbanism and climate change its apparent the way forward is to implement the said synergy in our future cities, as majority of the worlds' population shall be living in urban areas. Furthermore, with large scale urbanization in Asia and African nations offers us an opportunity to structure urbanism that can be climate responsive.

5.2 Traditional Urbanism Praxis for Climate Control

To understand the traditional practices the narrative stems from the process of urbanization and the role of an architect. The disparate traditional practices are evident across the traditional urbanism of the world adequately documented in the built fabric of the traditional urbanism and the buildings. Each one triggered urbanization driven by capitalism unlike the urbanization process in traditional urbanism. Rapid urbanization occurred with automobile and technologies, the scale escalated to mega cities to transit oriented development. The global cities, an agglomeration of people from various nationalities hailing from diverse ethnic groups, castes, creed and ethnicity among others are underpinned by their respective cultures. Each of the global cities displays the coexistence of different cultures virtually permeating with the global undertones and adapted to city urbanized thus. Often the transitions lack the authenticity of their roots and transformation to the global cultural milieu.

In the recent past Capitalism drove being the fundamental premise for urbanization rather mathematical i.e., workspaces required directly proportionate to the output that related to manpower to supplement that delivered. While the process of urbanization in traditional urbanism was based on the social their wisdom of knowledge of the geographical context economy designed with the set of locally available resources that resulted in disparate typology of urbanism. This basic difference to approach urbanization such of either economy driven or socially driven needs a relook. The traditional role of an architect was to coordinate all aspects for their receptive input in the design process and continuity. The global outlook with focused specialization recognized each aspect in isolation the thrust being focused in depth and specialized. Each of the architectural and planning aspects fine-tuned in the process the co-ordination amongst them had gaps. The socially driven approach of traditional urbanism was coherent and anchored the co-ordination and related decisions, such an approach ensured balance with no gaps. The scientific technological advancements upgraded regularly added more finesse however lacked the inherent co-ordination.

The hegemony of global urban spaces diluted the authority of socio-cultural connotation of the local population but could not rule from their lifestyles and behavior at large and the responses that are evident as anthropocene. The contemporary growth and further development, the gauge of global economy has generic distribution of the countries as developed and developing economies enumerates countries at varying thresholds planet as a whole that isn't sustainable. The current initiatives are based on cause and effect and as carbon footprint is the impact caused by excessive energy use the focus is specific for energy and its forms, its production, distribution to consumption. Renewable sources available in nature as energy from solar, wind, tidal, geo-thermal among other sources. Whereas even to tap energy from renewable sources energy is required in various forms but relatively less environmental impacts too. In traditional urbanism as the sources of energy from nature were used directly the energy for processing eliminated. The cities are for people and when they are the key to achieve the 1.5-degree Celsius target of climate change

seems achievable, as demonstrated in traditional urbanism. It is time to look at traditional urbanism beyond cultural heritage, architectural marvels but to decipher the planning framework with context traditional practices inherently in sync with nature. The presence of Traditional Urbanism has universal value and a rich resource for the mankind. The discourse needs to broaden the canvas for the world much beyond English heritage, European heritage, Chinese heritage and so on. The way forward needs to be a holistic approach wherein traditional urbanism with all its attributes are inherent for the framework of development as a whole rather than being parallel with traditional urbanism an integral part of mainstream policies, strategies and development framework i.e. school of thoughts on urban planning the identity of the history of the place consists of the values that should be strengthened in a rapidly developing world [New Athens Charter], New urbanism in 1990 to the notion of regional cities by Kenneth Frampton, to collage city by Colin Rowe echo the dimensions of traditional urbanism is some way or the other.

The narrative of traditional urbanism stems with socially networked people woven through local economy and contextual environment. The symbiotic relationship of production and consumption continued for centuries through contextual local practices. These traditional practices were resilient, flexible and drawing from nature and this adaptability connotation was sustainable. These practices initially vernacular to the locals over time became tradition of the place with key aspects as the core and accommodated to changes due to political, governance, social to environmental with rational approach. When the king and governance patronized the intent of health and well-being for all, the traditional culture and practices thrived. Traditional cultures were insightful for the thresholds of thermal comfort and use of natural resources i.e., land, daylight, water and air. The standards were culturally ingrained within the behavior pattern of the local communities, which addressed the building performance for satisfactory levels of occupants. However, traditions in history arose from the contextual framework nurtured by the wisdom of knowledge of the local population translated such in the built environs. The time span played a very significant role with growth; changes and transformation that occurred were responded by the respective cultures with their traditional environment knowledge that gave each one their unique identity as traditional urbanism. Each of the traditional urbanism displays the symbiotic relationship of tangible and the intangible of traditional practices. Each of the said practices was resilient to infinitesimal changes and rationale prevailed for the translation of each of them often not reflected in the built. The process of selection and deletion guided by traditions was deep-rooted as traditions shaped our buildings, public open spaces and cities. The traditional urbanism embraced the various layers from history that were important through the holistic understanding of the local community. Buildings were physical manifestations of traditional urbanism but not the whole and thus focusing on buildings for climate change may be limited as there are other aspects that were inherent to traditional urbanism that contributed for climate change as well. Beginning with orientation of the building, space syntax, design of space: dimensions, proportions, system of fenestrations, building materials, construction technologies, utilization of paces, services to behavior of people and user's perspective among others. Each building was a part of system of systems

and thus the scientific studies with parameters attending the thermal comfort may prove to be limited. The systems refer to social, cultural, traditional practices, buying capacity, access to technology, availability of resources, technology, knowledge etc. While in traditional urbanism a structure exited that attended the system of systems. The narrative of climate change needs to be placed in the broader framework the input when taken up at all scales, shall make significant change starting at building level, contributions when accounted for as system of systems then the initiatives were embedded such. The traditional urbanism as each aspect is a part of a system and that feeds the other systems of urbanism to act as an integral part of the whole; thus, when these built forms were adapted and retrofitted for reuse they delivered, considering the intervention was piecemeal thus being a part of the whole had limited impact. The nature of socio-culture is constantly responded to the changes rather pronounced in living traditional urbanisms', this transient nature assured necessary resilience that was a part of the people's behavior which has a direct repercussion on energy and resource consumption.

Cities are about people and traditions inherent to the traditional practices are the key. It is evident that economy drives urban areas have escalated the climate issue while the people driven in traditional urbanism have had limited carbon impact. Since the mid-twentieth century, the trend has been away from traditional forms and methods of construction, with a preference for deep plan forms and an increasing reliance on mechanical systems [8], which are driven in part by advances in technology i.e., for artificial lighting and air conditioning. Unlike many traditional buildings, the internal environment of modern buildings often relies on energy intensive mechanical heating and cooling systems to maintain tight temperature tolerances or fixed set points. In heated or air-conditioned buildings, this close control almost always implies higher energy use [8]. Global initiatives for climate change with rating systems that were developed typically addressed the issues emerging for a specific geo-context and that when implemented as a universal gauge, gaps surfaced. These gaps were mainly due the contextual variations due to geographies, climate, local communities etc. The global awareness encouraged each of the nations to contextualize the framework and in due course it became competitive rather than complementary however, a broad framework with a section of it addressing to the contextual connotation. Nations and continents at varying thresholds of development, the importance to have such a gauge needs introspection and in this purview traditional urbanism is insightful as each one is archetypal. Globally, cities are responding to climate change through local interventions by focusing on regional climatologies and role of traditional communities shall enhance to achieve climate change that has a continuing legacy of practices that are low carbon. The current mindset to address climate change mitigation as incentives benefits through governance have had limited impact to be attended by widening the canvas and traditional urbanism shall be beneficial.

Currently the Covid crisis are formatting the patterns of production and consumption wherein urbanism is the foundation and for a low carbon future that is cost effective may pick up lessons from our traditional heritage [9]. Traditional urbanism

demonstrates relational values, or values that people hold on the basis of their relationships and responsibilities to society and the nature. Environmental assessment processes designed to support infrastructure decisions should consider relational values explicitly. The strength of the traditional social capital is that it virtually acts as one entity for all the diversities. While the social diversities existed for centuries in the form of ethnicity, races, and castes among others but in traditional social capitol there existed an order or hierarchy that structured the community as one, and when such a communities cultivated a culture that drove people's behavior as part of system of systems. Currently, formal environmental assessment tools generally do not explicitly include societal values rather focused on instrumental, financial valuations. The environmental social sciences and humanities have produced substantial scholarship on relational values in communities experiencing environmental change, which can inform integration with environmental assessment [10]. The regressions analysis that explored the compact city concept through policy tools if it lead to low energy consumption and environmentally friendly urban areas demonstrated that local governments' socio-economic characteristics and their locations influence the implementation of compact city-related urban policy. These results indicate that urban planning for optimal city size, significant compact city characteristics and effective policies with sufficient financing can help reduce transport-related energy consumption and air pollution [4]. Thus traditional compact cities need to be relooked beyond conservation, climate change and balancing energy conservation through building conservation, sustainable heritage retrofit, connecting energy efficiency.

Fundamentals of Climate responsive practices in Traditional urbanism exists across all scale: beginning with planning of a city strategically to design with nature for the site and its surroundings, the landform, gradient, soil characteristics', availability of water for quality and quantity, ground water table, biodiversity and the natural features. Although initiatives i.e. Biophilic, Biomimicry, Nature based solutions, Eco-cities, Organic, Metabolic and others acknowledged the need to build with nature but often structured approach that had limited recognition of all contextual natural aspects. The scale of the traditional urbanism was limited with the symbiotic relationship with nature for production and consumption of food security and partly due to modes of transportation as well. The species of food grains were well suited for the soil type, ground water table, rainfall and native to the local ecosystem and biodiversity this approach assured food security and being in line with the local ecosystem was significant as agriculture too is cultured landscape. The local population mainly consumed the homegrown food grains and thus the carbon footprint contained within the local ecosystem. This attitude of the local community extended to water as well; irrespective of quality and quantity available the traditional lifestyles developed distinct solutions thus limiting consumption for the resource locally available. Thus, traditional urbanisms shaped up to limit the growth rather a necessity thereby sustainable. The open spaces were social spaces that fostered the bonding for the social capitol and duly complemented with the design and detailing of these public open spaces that varied in shape, sizes and location in the layout of the city were largely responsible for nurturing traditional practices. The varying nature of spaces encouraged interactions' across all scales and were used when thermally comfortable

i.e. streets, nodes and crossings during the day while the large open squares for public gatherings. The streets were designed for activities where people were valued which was conceptually intrinsic to the scale of the city. Utilization of spaces was innate for all spaces often with flexible usage generally governed by the level of thermal comfort. In fact, the traditional lifestyles mainly took cognizance of the climate and day lighting, and functioned such. With 'nature' as foundation acknowledged by people who designed an economy with low carbon footprint embedded sustainability. The climatic responsive traditional urbanism varied based on the climate from compact to dispersed built forms, the open spaces were significant, unlike the covered ones, as in contemporary. The traditional urbanism were essentially walkable cites and urbanized however the growth saturated as low rise high density and conventionally the living traditional cities grew outside the set limits of the original plan. The built environs followed the norm of locally available building materials while the construction technology was shaped up indigenous with the wisdom of knowledge of the local community and built morphology that evolved give a distinct identity with local architectural style. The resourcing of the building materials was limited to the site and the region that reduced the carbon footprint for embedded energy.

Infrastructure services proved to be task for the traditional cities, as each of the services was layered, regularly upgraded with latest technologies. The individual water and electricity connections in residences gave flexibility for working and living, facilitated by information and communication technologies, to integrate for the networking within the existing built fabric was challenging. Initially the services were superimposed thus visible with the architecturally rich heritage buildings. This conflicting visual experience diluted the traditional ambience of the public spaces, streets and so on mainly along the streets initially above the ground later below the ground level. Earlier on the electrical transformers were an eyesore but with technology the sizes got reduced with better efficacy. The tourism sector with foreign tourists was largely governed by the global baseline of thermal comfort the buildings were refurbished, the energy demand was reduced with passive systems in place.

Each traditional urbanism has a distinct typology not necessarily all the buildings had ideal orientation but the set of traditional practices that addressed at all scales delivered i.e., system of fenestration. The window openings varied for shapes and sizes, often multiple for the same floor or simply large narrow windows of specific proportions; all these were innate to the traditional architectural vocabulary for the respective typology and urbanism. Use of sun shading, recessing of windows and the other permutation and combinations for solar shading were typical for the disparate climatic zone. However, for the same climatic zones the typologies were fine tuned for respective socio-cultural connotations, such sensitivity of the traditional urbanism established their identity to create healthy environments with comfort levels in place. The strong symbiotic relationship resulted in a unique typology and for similar geographical location the typologies varied, as the physical fabric was a result of other systems as well triggered often by innovative approach coupled with the wisdom of knowledge of the communities.

Passive systems were key for any traditional urbanism typology. The fundamentals like symmetry, axis and orientation were the principle for planning. The passive systems were applied through all scales of the city from planning of the city to the block development to the building design and detailing. The layout of the blocks defined by street pattern, these linear public spaces were oriented and laid out keeping in mind the climate of the place either shaded or to let the sun in to keep them warm; either way to provide for thermal comfort for the pedestrians. Based on the activities to be housed access was designed such along the streets, nodes, crossing, street junctions and each of the entrances were celebrated, a social connotation. The inhabitants of each block generally had open space that was strategically located either one large space or more than one, a decision guided by the climate and socio-cultural connotation. The windows overlooking the public spaces were designed such that the privacy was assured for the families. Next the shape, size, proportions of the openings were determined by the climate and detailed by the traditional practices and cultures.

Positioning gender for climate change was direct as they were largely responsible for resource consumption, food security, energy use, health and well-being for the spatial planning to negotiations for mitigation, technology. The strength of gender connotation is more pronounced in traditional communities that were evident through their behavior and traditional practices while the contemporary societies too it's the women who are largely responsible for continuity of the cultural practices. The gap between contemporary and traditional practices in knowledge and data could be the key to work on mitigation strategies and type of technologies as a way forward to yield the desired results. The traditional urbanisms were disparate and so are the communities therefore the strategies, policies, norms need to be tailor made for the context specific for people, places and traditional practices. Considering traditional urbanism is of universal value, the broad framework may continue with flexibility to address the geo- political and aligned with governance agenda. The global mega cities have established their worth as economic engines of growth that are high on energy with equally large carbon footprint, although with mitigation strategies attempts are to curtail the climate impact but the learning's is the scale for built morphology in sync with context through traditional practices. These future cities may align with traditional urbanism the same volume, height and alignment with public spaces.

Summing up the traditional design solutions and the building details may be applicable for similar climatic zones as well, only for the cultural connotation as best practices to refer to. Standard typologies for residences as mixed land use, whereas the institutional, religious and the city palace were characterized with larger scale. With design planning principles in place the detailing of spaces for thermal comfort through space syntax, sections and building facades demonstrated the in-depth understanding.

5.3 Constructing Tradition of Climate Responsive Urbanism

The legacy of Traditions Urbanism has been recognized by the professionals both for their significance and relevance, for potential to contribute for climate change. The acknowledgement may have come about with varying terminologies but the essence of traditional urbanism prevails be it Passivhaus by RIBA, low carbon living, Traditional environmental knowledge for biodiversity, agriculture to vernacular indigenous systems to solutions to protecting nature and natural environments among others. Despite recognition there is dearth of literature and hands on research for all such typologies for all geographies; except for nations that are well equipped with resources focused on the said thrust. Carbon emission is the main concern for climate change and therefore to construct the continuation of traditional practices of traditional urbanism the backdrop of energy sector with related carbon footprint needs to be outlined to see things in correct perspective.

The high rate of urbanization in the global south especially nations like India and China with the *nature of development* is crucial and the continuing contemporary global typology needs to be reviewed for a paradigm shift back to traditional urbanism if the need be align with the SDG Goal 11—Sustainable Cities and Communities that outlines to strengthen efforts to protect and safeguard the world's cultural and natural heritage across all geographies, per capita spent on the preservation, protection and conservation of all cultural and natural heritage, by type of heritage. The key pillars of sustainability to be addressed along with the institutional organization within the regional purview of geo-political that shall govern both the *nature and pace* of growth and development. With the capitalist global economy, each pillar emerged as disparate and parallel to each other operating such in silos and with information technologies enlarged the canvas of global economy. Continuing such, has brought the world to critical position to relook at with the ongoing trend of development and with strategies in place the outcome to be inter-disciplinary nature translated as the concepts of livability, Inclusive development, integrated approach among others; something that was inherent to traditional urbanism. The comprehensive way to look at the symbiotic relationships translated in the built environs' successfully as unique as their cultures may be way forward even today with environ crisis.

The narrative of post-industrial revolution and global economy had two key learning's one that despite capitalism the being the key driver could not sustain as repercussions arose for both social and environment and that economy is no longer the sole driver for growth and development for the world. The global economy explored the poor nations for cheap labor for production and low costs purely for larger profits executed through respective regional governance setup wherein political will and intent was crucial. Typically, political intent supported global economy for mutual benefits exploited by nations with developing and poor economies often rich with natural resources i.e., African, Asian countries. The information technology sector facilitated the operational logistics and on the flip side the nations had access to technologies to begin with awareness, understanding and knowledge. This process

became game changer as the global mega cities located in developed and stable economy nations; were the base for the global ventures and the operational units located in nations with poor and developing economies' due to cheap labor and office spaces built in line with global standards with relatively low costs, irrespective of the contextual relevance adhered to global thermal baselines. Built spaces constructed such coupled with high rate of urbanization especially in China; India from Asia and Africa impacted the climate virtually aggravating the global climate crisis and unfortunately continuing is a huge concern. The lack of social equity and climate change observed across the globe become a pressing concern to relook and concepts like regenerative economy, circular economy among others and attempts integrated in developmental approaches aspired for sustainability regionally to achieve global targets of SDG to act locally and contribute globally. This approach orients the economy to be strongly contextual virtually an extension of local traditional socio-economies may be with transformations of technology and contemporary needs that largely completes the loop to be sustainable, rooted as circular economy. At this moment in time, we see finance playing a central role in the interconnected social, political, economic, and ecological crises now cascading out of our control. The ideology of finance is a threat to civilization itself. Often business decision must be made in such a way as to maximize shareholder value that optimizes considerations of values other than money is essential. The narrative builds for new way of thinking about economics—an approach aligned with the latest understanding of how the universe and its living systems actually work; defined as the application of nature's laws and patterns of systemic health, self-organization, and self-renewal to the vitality of socio-economic systems [11]. With UN bringing all nations under one umbrella; the sole vested interest of profits had to be negotiated and in that purview the role of local economies proved to be significant to achieve the targets for climate change. The balanced approach through governance wherein the traditional urbanism that delivered as integrated approach wherein the process the *values* reined over the *pricing* that purely added for profits. In global economy the price often limited to the goods while value of a good tends to include the workmanship, aesthetics, cultural identity, heritage and environmental among others rather holistic in line with the products manufactured in a traditional manner underpinned with strong social connotation. Both economy and geo-political are proving to be inadequate to sustain for their respective intents' and parallel with SDG the need to include socio-cultural aspect; typically each of the cultures' have a tradition that bonded generations on and translated such in all aspects of their lifestyles including their built environments; designed and detailed that reflected their threshold of natural ventilation, thermal comfort and related resource consumption thereby reducing energy demand, energy use etc. validated for built spaces through meta-studies and case study research across all scales of built environs'. The need to build anywhere and everywhere in the same manner and cloning built spaces such needs to be reviewed as the energy required to do so is very high and maybe even redundant as being the main cause for climate change. It may be logical to arrive at the baselines through negotiations between global and local socio-cultural connotation. Therefore, the design and detailing of the spaces

driven by the tradition of cultures' is evident in both private and public spaces of traditional urbanism.[1]

Land-use impacts carbon emissions through urban form and density, and property taxes infrastructure with adding pressure on land as a resource. In some countries, property taxes may be skewed in favor of single-family houses, discouraging compact city development; in the USA, for example, sub-national jurisdictions tax apartments more heavily than single-family homes, considering them commercial real estate. Elsewhere, like in Greater Copenhagen, the inverse is true, where housing coopera-tives are not subject to the municipal property tax. More compact development can be stimulated by introducing split-rate property taxes, as applied in Sydney, Hong Kong, Pittsburg and Harrisburg, and other cities in Denmark and Finland, where land value is taxed more heavily than the buildings on the land, thereby providing an incentive to densify. Many cities depend on land sales for a large part of their revenues that encourage urban sprawl. In the case of China, local governments have been motivated to generate revenues from land sale and leasing that they have gener-ated an oversupply of land for construction, which in turn has stimulated sprawled development [12].

Ownership in case of traditional urbanism with each generation was more than legal possession of the property but a sense of belonging; connect with the roots and so on and with each generations the number of stake holders increased that bonded the core community. Thus, interventions for weathering, conservation, preserva-tion, restoration, retrofitting, refurbishing, adaptive reuse, technology up gradation etc. proved to be challenging and more often limited retaining the built form with its climate responsive practices in place. Mixed land use was the key planning principle that gave the local people to use the space in multiple ways. Such flex-ibility to use both open and covered spaces responded to timely transformations from economic activities to socio-cultural activities those occurred seamlessly and continued for generations on until use of electricity, air-conditioners and others; largely the transformations were integrated that demonstrates the resilience char-acter of social and built morphology of the traditional cities that delivered social justice and with gentrification social equity inherent to SDG.

The three 3 R's (Reduce, Reuse and Recycle) reduce energy demand, carbon emissions, embodied energy with built spaces. Reuse of built spaces building mate-rials etc. traditional practices and recycle both tangible and intangible. It is well acknowledged that low carbon emissions are one of the key factors contributes for sustainable development and effectively tackling climate change. Adaptive reuse of buildings is a form of sustainable urban regeneration, as it extends the buildings' life and avoids demolition waste, encourages reuses of the embodied energy and also provides significant social and economic benefits to the society [13]. Contin-uing with the three R's the design principles of passive systems for thermal comfort,

[1] Currently too much importance is granted to scientific epistemology defined by numbers. However, there are inherent limitations of scientific problem-solving in social issues. Mathematics does not really hold up when the system gets complex with both qualitative and quantitate. When there are many variables the human experience is a much better approximater than any deep learning methods. hashtag#oxford, post from Arpan Kumar De.

natural ventilation, managing humidity, control heat gain through properties of selection building materials: U-value, insulation properties, thermal capacity and others to indigenous construction technologies directly or with adaptation or improvised to contextual design solutions, systems, planning principles to even shape of buildings to navigate winds. While the technology driven solutions of LEED bulbs, monitoring mitigation and research studies are insightful that provides feedback to technology to improve further on completing the loop. The said narrative sums up the key attributes of the hierarchies of built environs that respond for climate change.

Traditionally cities mushroomed along the trade routes as that was the requirement thus on land for within the country and along the sea, coastal edge for international for various geographical locations. The location of each of the city was determined by eco-political intent and the response was unique for the traditional urbanism wherein they build with nature aligned with the native ecosystem. This principle can be explored for the small and medium towns and cities, as they are the main bulk in urbanization process except for the mega cities as they are inevitable for the global economy. The climate and local ecosystem including all natural features as determinants integrated in the contemporary planning norms to include mixed land use, facilitate flexible use of institutional spaces recognizing the landform, water channels, indigenous biodiversity and limit the use alien species are they often are high on resource consumption be it water, soil nutrients, balance of natural systems. The planning principles of traditional urbanism were culturally driven of which, that are relevant even today is *compact planning with mixed land use*. The layout of the city echoed the structure of social order based on ethnicity, castes or economic strata in case of contemporary society; the strategic location for administration head, religious head with others surroundings it as per the social hierarchies. The *orientation of streets* provided for thermal comfort and facilitated pedestrian movement, as that was key mode of transportation may be promoted such. *Hierarchy of street* was standard mixed land use principally in primary streets with spilling over to secondary streets if so required while the tertiary streets basically for residential activities parallels may be drawn for future cities for design and usage. Studies have validated that the planning of streets when they are oriented north south with height: width as 1.5:1 and higher results in street shading between 40 and 80% of street area, whilst diagonal street orientations north-west to south-east and north-eat to south-west yields street shading between 30 and 50% of street area throughout the year. Thus, mutual shading with the said aspect ratio is one of the key salient features of passive systems [14]. The large public open spaces were strategically designed within the layout plan, conventionally in the heart of the city with main streets leading to the space. This deliberate intent to build the narrative to reach the public space accentuated the perception and thus the participation got heightened; an experience in its own rights from individual to community that bonded the people. The intersection of primary streets invariability leads to *large public open spaces* predominately used by the local community for cultural activities; often continuing now for tourism sector in the same space recreating the cultural milieu. These public open spaces have a history therefore any events organized have connotation of cultural heritage at the backdrop and connects with the roots of the place for sense of belonging. The public open

Fig. 5.3 Built morphology of traditional urbanism [author]

space was defined by important public buildings that may adapted for reuse for current needs for example from local council meeting room to museums. The design of public open spaces was bio-climatic responsive from streets patterns enjoyed comfort and delight by the users (Fig. 5.3).

The design and planning decisions were culturally guided i.e. street patterns with hierarchy of streets the tertiary either culminated as *cul-de-sac* in case of conservative communities for gender connotation and security as dead ends and sometimes the streets continued across connected to the street network of the city. The use of locally available building material's and the indigenous construction technology resulted in disparate *rich architectural style*, which evolved over a period of time as the *identity of place*, which became the *civic pride* for the people. Conceptually all design aspects mentioned above are relevant even today and has the potential to be incorporated with any modifications if required. Ample literature exists on compact planning, mixed land use but the nuances of architectural style that responded to the climate through system of fenestrations, solid and void proportions is limited. Additionally, the qualitative aspect of sense of belonging that connects people to nurture harmony that is inherent for the core community culture, behavior, responses surly an added advantage over impersonal neutral spaces of contemporary architecture however rather than exploring new building materials for our future cities; local building materials with indigenous technologies explored may be worthwhile as they are low on embodied energy with low carbon emissions.

Traditional urbanism thrived for centuries on thus observed growth and development for changing times of political, technology and economic activities. Migration and re-densification occurred within the existing built morphology; a sensitivity that was acknowledged but important is, that it delivered. Additional built spaces were required for expansion with pressure on infrastructure facilities but had minimal impact due to use of locally available building materials. However, with optimum baselines that were socio-culturally accepted, the energy demand was limited owing to the baselines lower than the global norms. The scale of the traditional urbanism

was essentially pedestrianized and the conceptually the pedestrian scale module is often duplicated in contemporary urban residential condominiums and encouraging mixed land use can further help to reduce travel both for time and energy including financial benefits too.

The urban morphology of Traditional Urbanism responded from macro to micro for re-densification and super imposition of infrastructure facilities with technology that was upgraded regularly while the core population continued along with room for tourism as well. With the said physical transformations of functional spaces delivered, with flexible use by the local community and tourists. The necessary interventions were accommodated within the built morphology largely retaining the typologies in place. The social consistency and physical interventions of infrastructure facilities demonstrated the resilience nature of both the built morphology and the strength of social capital. Densities reduces the transmission and distribution losses, manage balance of heat and power to be used optimally with energy demand be localized- mixed land-use, high density neighborhood; notion of decentralized concentration and high-density mixed land use reinforced by energy considerations [15]. The selected study demonstrates that doubling densities typically increases energy consumption by about 25% (Fig. 5.4).

The Cultural framework that embraced scared ancient texts, governed the traditional building design and detailing that connected the people to their roots and with *sense of belonging* practices instilled something that the hegemony of contemporary planning lacks. Each building was placed next to each other with no setbacks orientation was addressed by the mega block and the design detail addressed the daylight

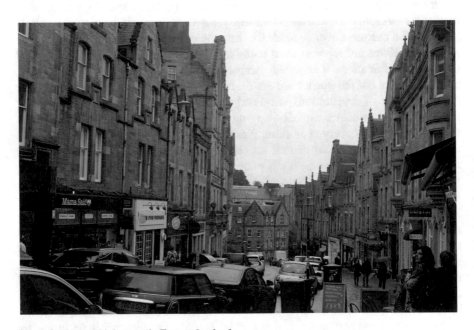

Fig. 5.4 Typical high street in Europe [author]

and natural ventilation; the building as a part of whole that contributed to build for the community as holistic. There was a deliberate design connect between the individual building to the adjacent buildings. All buildings on either side of the streets observed a grammar and detailed that was climate responsive. The street elevations delivered at the urban design scale the design practices and detailing in each building addressed the domestic functions. Typically, each building had an introvert character that ensured privacy with courtyard as his or her own personal space. Thus, each building was a part of system connected with the next hierarchy of urban scale eventually at the city level. This interdependence was inherent to the building typology. This learning's can be included in housing that has densities parallel to traditional urbanism. The juxtaposition of the buildings were configured such that it contributed for the character of the streets—a linear open space that addressed for optimum day light cutting down glare as much possible and facilitating natural wind movement due to tunnel effect and acted as a transition space as well that provided for the access to the buildings (Fig. 5.5).

The typology at the building level although culturally driven but were detailed out for functions both for economic activities and residences specific to the context. The key climatic attributes temperatures, humidity, wind speed and direction and precipitation were addressed for optimum thermal comfort along with daylight conditions. The built spaces therefore were efficient and facilitated flexible use of space; such multiple uses with thermal comfort for the occupants were important. Sunlight was taken maximum advantage of something that has limited application in contemporary

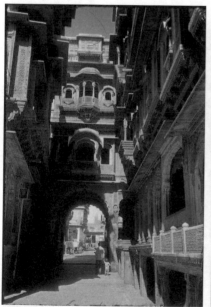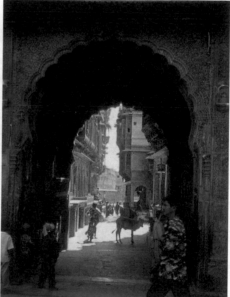

Fig. 5.5. Entrance gateway to residential street in India [author]

development due to ease of accessibility to electricity. Each of the building design is similar and often not identical as that left some room for individual expression for building types was the strength of the typology. Typically, the individual building design in the traditional urbanism is a part of the block or neighbourhood rather than delivering for oneself. Orientation was largely dealt with at the urban design scale and each building detailed for envelope optimisation for solid and void alongside the load bearing walls and roofs spans governed by local available materials. The building design had typical layout, that honoured the typology and cultural connotations i.e., entrance to the building from residence or institutional had a definite relationship with the street or the open space and often used for spill over of activities. The deliberate timings of synchronising the events with comfortable weather conditions and seasons reduced the energy demand with flexible use of space and encouraging community participation (Fig. 5.6).

The building typology existed a well-defined relationship of open to covered spaces and transition spaces i.e. entrances porches, balconies, terraces and other transition spaces were inherent to design of the buildings as they were airlock for the thermally comfortable indoor spaces that conserved the energy. Having outlined the spaces the architectural vocabulary that evolved essentially emerged through the ancient scriptures ensured uniformity and kind of semblance among the buildings within a typical block. The building facades both; internally overlooked the courtyards as personal open spaces while the external façade overlooked the street or public open spaces. The system of fenestrations, solid to void ratio, scale, shape, proportion hierarchy and elements were similar and often used with varying permutations and

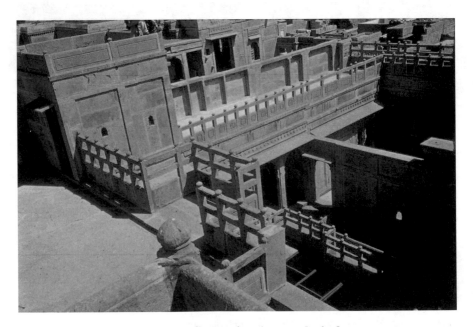

Fig. 5.6. Distribution of open spaces: Courtyards and terraces [author]

combination ensuring thermal comfort. The local population had an in-depth knowledge and understanding of the natural daylight for its quality, quantity and availability with respect to orientation translated in the design and detailing. The understanding determined the utilisation of spaces during the day that minimised the energy demand. Passive Design solutions are energy efficient with low carbon design with its related benefits is central to traditional urbanism and buildings. The baselines for the thermal comfort were in line with the respective local communities but with the global norms the gap existed for traditional urbanism. The locally available building materials were used therefore the spans of the built spaces were determined that got standardised for the built morphology; while the public buildings were a challenge for large spans and the indigenous practices to address them enabled to develop creative solutions with in-depth knowledge of the locally available building materials. The passive systems addressed most of the issues through design, construction and detailing, based on the local climatic conditions for wind and temperatures for example the design to let the wind in the habitable spaces was modulated through wind catchers- traditional bi-directional wind catcher, etc. Often the spaces were designed as basements that were cool spaces due to earth berming technique combined with the concept of wind tunnels; wherein the wind passes through pipes below the mother earth and then feed into the habitable spaces. This deliberate wind movement controlled the humidity as well for basic comfort. The movement of wind was manoeuvred for streets as well as continuous linear space with puncture at regular intervals and the hierarchy of spaces wherein the street width reduced from primary to tertiary propelled the wind movement. Reducing the street width ensured rapid wind movement due to varying pressures and the same principle continued from street to internal courtyards of residences. In cases of desserts the streets were designed to be narrower towards the top to cut down dust that assured quick wind movement. The manner in which wind was articulated so was the natural daylight. The system of fenestrations with respect to orientation were deliberate and wherever possible building elements i.e., light shafts, *Jallis* among others were designed to modulate the sunlight largely made of stone with intricate patterns to create interesting shadow patterns that changed through the day. While detailing the same, the fundamentals of deflecting sunrays, limiting the daylight, controlling the extent of the light among others; thus keeping in mind the basics the designs were created for aesthetic that augmented for the local rich architectural style. Standard sun protections for windows were built with stone structurally supported by brackets; often embellishments that enriched the architectural style (Fig. 5.7).

The passive systems evolved with traditional practices and indigenous design principles based on functions that delivered for the local community through the space syntax arrived at principles i.e., courtyards for stack effect, wind catchers for air circulation, light wells to modulate the quality of natural daylight that enhanced the comfort and delight for the work spaces; street section to articulate the wind as tunnel effect and ruled out urban heat islands and so on. The decisions of *passive systems* can be seen began with design stage through construction, detailing of building elements and delivered with socio-cultural connotations for building performance.

Fig. 5.7 Sun Protection over windows with stone brackets [author]

These set of passive systems are omnipresent, and time tested climatic responsive solutions appropriate to bridge the gap for building performance and thereby to reduce energy demand and related carbon emissions, the large scale urbanization in developing countries could build with these fundamental principles as basics with or without adaptation for contemporary needs. The passive system delivered for the respective contextual typology and by addressing them in contemporary development shall ensure the continuity and connect with the roots and enjoy an identity in the hegemony of the world today. The need of the hour is to build on our fundamentals that may be aided with latest technology to deliver so that mitigation options and practices shall be energy efficient and may be backed up with scientific research. The perspective on infrastructure may be drafted for Climate change with feedback and adaptation for technological, environmental and other risks and uncertainties including social acceptability.

The agenda to achieve globally, act locally, the local climate action plan that abides by national climate polices and regulations gets further aligned with the international climate networks is the key the role of passive systems have a huge potential to contribute and the relevance of passive systems is valid for both the developed nations for practices and knowledge base for same geographies and for developing nations for mitigation especially for new developments and future cities. However with thrust on technology for emerging ones and rate of incremental cost and performance improvements for mature technologies, improvements in technology and the availability and accessibility of advanced technologies. Developing economies need

to be flexible to respond to transformations as with information technology knowledge gaps are reduced and the economies largely are a system of systems across scales to be sustainable and climate responsive. Third world nations have challenges of technological, physical, financial, institutional, cultural, legal challenges including limited resources for access and implementation of latest technologies.

The holistic nature of traditional urbanism makes it inclusive through interdisciplinary relationships i.e., the three pillars of sustainability are intertwined as socio-economic; socio-cultural, traditions of the environmental knowledge, socially anchored with religion and all this strongly woven within the spatial configuration determined by social norms and standards in place. This network translated as typologies for varying geographical contexts for the respective social connotations. The principles of traditional urbanism as an approach shall be valuable for future cities as they will be global cities. An inter–disciplinary framework may acknowledge the local standards that are inherent to the typology to be the baseline along with global standards for reviewing the norms proposed for new developments. The manner in which the traditional urbanism was in sync with the local climate the global future cites need to cultivate nature-based solutions; the contrasts of traditional and modern to be addressed aesthetically through indigenous solutions may be with few changes as required. The traditional urbanism is more than historic layers rather an opportunity to building from nature and builds with nature. The stark difference between the traditional urbanism and future cities may be the scale; that is essentially responded by modes of transportation while the walk able blocks are and have been translated as condominiums, but such isolated walkable pockets are not necessarily woven within the city's' fabric for maximum output. The mode of transportation is a major source for carbon emissions both at intercity and intra city level across the globe as well i.e., typically a journey by train from Paris to Madrid 6 kg of carbon dioxide emissions while via flight its 150 kg of CO_2 emissions, except for time, as put forth by Amoxy Louise that each megawatt conserved is more cost effective than megawatt produced should be the mantra (Fig. 5.8).

Ironically despite the scale, the real estate and land values are very high for the traditional urbanism and often inaccessible. The land is limited with buildings adjacent to each other as compared to the buildings outside the traditional urbanism are isolated with adequate personal open spaces with larger areas. Any property in traditional urbanism is much more than a built space rather a built social space that is networked with the fabric of the neighbourhood and city at large and strongly in harmony and connects with the local community, which is a significant aspect. The issues of real estate in traditional urbanism are related to social capitol and security as with this pre-requisite other related aspects like acknowledging the contextual architectural style including the continuity of the existing systems in place ensures that the occupants and the users to contribute for the socio-cultural connotation of the low carbon local community.

The developed nations have managed refurbishment of about one percent of the building stock; with state of art technology and knowledge base with this state of affairs clearly. It is a tall order for nations with developing economies. The time to achieve two-degree limit is a challenge and with current rate is difficult and with

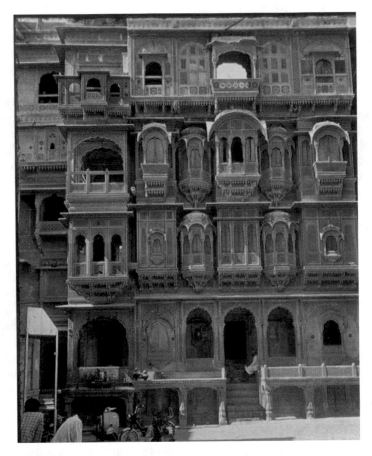

Fig. 5.8 Use of Jallis for fenestrations in hot and dry climate [author]

this ground realities traditional urbanism guarantees to be promising. Technology has proven to be insightful for knowledge base, gauge building performances and the data, which is the key for future strategies, policies and norms and way forward from refurbish to new developments. Digitization can aid to compile data at global level with universal access shall be significant to strategize and achieve targets has challenges (a) access to digital technology including internet (b) regular updates (c) resources to sustain (d) geo-political climate to facilitate data sharing (e) operational and maintenance logistics (f) data security and data sharing. To put all these together is a herculean task both for the time, money and energy with climate emergency we need to act fast with a realistic approach that is inclusive, ease of logistics and in that purview traditional urbanism has time tested contextual practices. Each of the disparate traditional urbanism typologies is unique and strongly contextual and in sync with the local climate. But the climate change has a standard impact on each of the diverse typologies while the response varied based on either social or

economy. The developed nations with stable economy managed the said typologies in their pristine state often virtually frozen in time. While the ones with growing economies the response for buildings were driven by ownership status and often altered to cater to the revised needs for economic activities but socially governed with social order in place, the value systems, the behavior pattern for usage of spaces, resources, energy and services etc. were guided by traditional practices. Although the physical space if altered was within limits but the traditional ambience continued i.e., construction with locally available materials and executed through local craftsmen. Such transformations are legible through historical layers in city mapping.

The future cities need to be prepared for pandemics as well especially with Covid and others that may follow in future; the key learning has been that the economic growth is not directly related to the bulk of commercial and office spaces. This understanding for the current typologies are being relooked at; as they are high on energy with high embodied energy of building materials and construction technologies followed by opulent interiors including operational costs, related energy demand for use and consumption by infrastructure facilities, safety and security and last but not the least energy required for travel often the energy may be more especially when people need to travel greater distances in mega cities, as most of the multinational brands are strategically located such. All put together for the global norms leads is a challenge for increased carbon emissions. Invariably such developments reduce carbon sinks, as they are advantageously located with large open spaces that have limited accessibility and constructing, as isolated sustainable pockets do not make the cities sustainable at large. The global pandemic has demonstrated that it is possible to run the economies with out such built spaces, with wider accessibility across the globe. Few of the global top firms are reviewing the need of swanky office spaces and limiting them to a selected few the mega cities of the world. Also the online technology enables to give opportunities to all irrespective of state of nations making it more inclusive reinforcing social justice and facilitating a balance work and home lives something that has been inherent in our traditional urbanism as mixed land use. Drivers of urban justice along side trends of urbanization post Covid are pushing professional to review the global framework and to focus on safe and healthy spaces for communities. Scale matters and megacities with its own challenges and general observation across the world have observed a decline in the population of mega cities and thus current trends of urbanization both pace and nature is under scanner with professionals and planners are taking this as an opportunity to look at the future cities in a more holistic manner that shall address climate change and design with social justice to bring in necessary equity among people globally.

5.4 Traditional Urbanism Matters for Future Cities

The narrative on sustainability that began with environmental decay with environmentalists taking the lead soon to realize the role of social sciences, economists, anthropologists, and professionals from creative disciplines as well felt the need to

act together to yield the desired results. Although the large amount of texts available is insightful but largely each discipline pursuing with fundamentals of their respective grammar, has limitations.

Whereas the traditional urbanism where an inherent balance of the three pillars of sustainability that was determined by the contextual natural resources for its geographical location and functioned by the local culture of socio-economic setup; wherein the values were upheld over pricing. However when each of the dimensions acknowledged for their strengths and weightages of their sub-aspects leads to a complex matrix. The strength of traditional urbanism lies with its resilience to accept changes in the name of progress and development and the transformations imbibed by urbanism at large and continuing. The response to the pillars of sustainability by traditional urbanism—economy experienced the maximum with a virtual paradigm shift from contextual to global only to realize that the transition isn't healthy either for the traditional urbanism or for the global cities. Soon enough conceptual ideas got floated i.e., circular economy, regenerative economy, doughnut economy and others all stressing on the fact of completing the loop. However, the whole narrative the prices were addressed but the values remained incidental for social and environmental connotation. Typically the environmental impacts are assessed for rising temperatures, carbon footprints and so on while at the backend of ecological balance for example pollination contributed by the forests and green cover is crucial for ecology but the contribution and value of such natural processes is not priced as economy focuses only on financial calculations of the human capital and processing products priced such; in fact the GDP calculations at the global level too are numbers that gauges the financial quotient and thereby stability of the nation based on per capita. Engines that drive focus on profits are the basic financial models designed and delivered such and the results are evident with carbon emissions highest ever altering the climate change. Need to change the way we evaluate the performances at large and, in this context, traditional urbanism emerges as a time-tested best practice. However, the fundamental principles of traditional urbanism have the strength that can be carried forward due to its inherent resilience nature that they have demonstrated in the past limited to the contextual environmental limits. Interestingly this take is evident in the global megacities wherein there are isolated sustainable pockets self-sufficient within themselves with quality of life but often not woven within the city's fabric; or in other words we may refer to them as mini cities within the larger global megacities. Typically, the gaps are condominiums with limited resources but contribute for the city's economy and by default low on energy consumption but at the cost of poor living conditions. Each of the isolated pockets have the potential to carry forward the principles of traditional urbanism with or without the intervention, either by the people or local municipal bodies. Living with nature is the new norm, the key basic principle of traditional urbanism that establishes the relevance and validates their authenticity.

Cities are financial hubs encouraging urbanization and their economic activities are operational at global level i.e. IT hubs, corporates and others alongside economic activities catering to the needs of the city dwellers and floating population as well. Such an economic setup was strongly underpinned for profits, per capita, GDP that

lead to money power and authority for decision-making. Such a process was diverse to account for social and ecology resources. This deviation from the convention wherein all pillars of sustainability were inclusive, which the global economy devited from. It may be logical to conclude that the cities that continue to grow within the contextual geographical environmental limits shall largely be sustainable. In the name of rapid urbanization continuing with unprecedented growth of the city in the name of development needs a relook and the contemporary spatial requirements initiated by the global economy be located in geographical context those that can sustain their needs with room for growth as well. Often the locations are geo-politically decided but the back-end planning has the potential needs to be identified, understood and implemented such; lesson of our traditional cities.

Environment decay for rising temperatures, carbon footprint seem to be our immediate concern something that was laid out by traditional urbanism, the framework derived from the regional ecology wherein the natural cycles of the ecosystem including food web, biodiversity, pollination and others was intervened by agriculture but the selection of food grains was in sink with the soil characteristics at large. Global lifestyles increased the awareness of the uniqueness of places across the world and the buying capacity priced the product and one they were transported for miles across the world adding to carbon footprint and emissions; while very often the products were grown in different ecosystem disturbing the symbiotic relationship of the food grains and the soil, further the pollination and intervened with the local solutions. Noteworthy is that the traditional cities operated within the local natural resources, a holistic approach extremely comprehensive for the archetypal character. While globalization has facilitated such mass intervention in the ecological cycles disturbing and gradually a permanent change that is neither sustainable and jeopardizes the social balance of the local community. Thus, behavioral change of a strata of city's population increased the gap and the cultural driven social capital had a paradigm shift to monetary driven cities' population that is all about numbers a gauge of price over value; something that is integral to traditional urbanism. Such a paradigm shift has related implications as well on health and well-being due to dilution of social equity and transforms the nature of growth at large. This shift accelerated the climate change whereas Covid pandemic in the recent past when the world has come to a standstill has given a necessary pause wherein the traditional lifestyles, cultures are proving their merit and emerging as a sustainable way forward, and however limited the cities from consumers are turning to producers as well. People are not just numbers but bonded through cultures be it traditional or global each one with its repercussions and to be sustainable we need cohesive harmonious communities that were the key strength of traditional urbanism. The socio- economic equation when translated to economic—socio one the population got perceived as economic class corresponding to their buying capacities and that was in sync with the per capita and GDP at large; and the environment issues arose resulting in onset of climate changes. When GDP of nations were looked at the political will too had a shift from leadership administration to geo-political decisions through policies, norms and legislative frameworks for stronger financial position rather than stable economies unlike in

traditional urbanism where socio-cultural communities were underpinned by local or regional economy.

'Scale' is crucial for cities to be sustainable, in traditional urbanism that is determined with the contextual environmental framework and climate governed by the nature of development. While the global cities facilitated with automobiles and technology are expanding with virtually no limits that needs to be taken into consideration both at planning level including all decision-making authorities. Such a framework encourages all types of developments and that may not be in sync with the context; thus, could be high on energy for both embodied and operational energies. Indigenous typologies are strength of traditional urbanism as the architectural vocabulary is archetypal and relates to the identity of the place. While to global typologies are standard thus sterile and often not relate to the people i.e., typical land use planning has zones that are commercial, institutional residential and so on and the operational hours in each of the zone are fixed thus after working hours the spaces become dead and are not used. However mixed land use in traditional cities facilitates flexible use of spaces, optimum utilization of open and covered spaces that reduces the figure ground and carbon footprint. Thus, standards and norms for space allocation for functions may not be flexible and that limits the multiple uses of spaces' i.e., with global uncertainties resilience needs to be inherent to planning of our cities; wherein sharing of spaces advocates for cultural connotation as well an important dimension of traditional urbanism. Rapid pace of urbanization across the globe is implemented with standard global urban practices with an equally standard typology that is high of energy that makes the cities largely consumers; soon to realize the gravity of the situation measures are on. SDG and initiatives for climate change are universally accepted and locally implemented and interestingly the global standards and norms when implemented universally and the traditional building stock too comes under the said purview. Retrofitting be it deep or partial for historic buildings or for adaptive reuse buildings, al such negotiations may be relooked at keeping in mind the thresholds of the local communities more a bottom-up approach rather than top-down approach from administration viewpoint. Further it may be limited for public buildings; the tradeoff between the standard and the cost of whole retrofit against socio-culturally acceptable norms. The universal acceptance of culture as the fourth pillar of sustainability puts forth democratic planning approach. The whole narrative of heritage management exist for the traditional cities; considering culture heritage is synonym to the local population and instead of managing culture and people facilitating them, as bottoms up approach with moderation may be more effective. Also, when the historic buildings are evaluated for performance and energy efficiency through scientific studies issue of behavior is foremost which is related to the culture. Also, the residential blocks in their pristine state shall be an added USP for tourism sector. Cultural heritage is strong driver for development and sustainability, thus needs to be acknowledged as framework for the context as key dimension and strategies and approaches worked out such. It's well acknowledged that traditional urbanism vouches for low carbon emissions, one of the key factors contributing to sustainable urban development and effectively tackling climate change. Adaptive reuse of buildings is a form of sustainable urban regeneration, as it extends

the building's life and avoids demolition waste, encourages reuses of the embodied energy and also provides significant social and economic benefits to the society [16].

In the wake of concern for climate change and carbon emissions the global cities being the drivers of innovation and productivity, governance and administration are stepping up for the said global challenges of the twenty-first century. The strategic planning initiatives across all levels for nation, to regional to local are taken up through implementation and review and feedback to complete the loop for effective modifications for the subsequent cycle. The focus is to reduce carbon footprint, scale-up renewable energy resources' solutions and harness technology to absorb and protect migrant populations and reduce inequality. In this whole narrative the design and planning approaches are neither mentioned nor tabled as the traditional urbanism solutions have time tested strength and have the potential for innovative intervention for contemporary needs; this body of work exists but during the implementation one observes a gap that is worth exploring. i.e. global pandemic has taught us that living by the fundamental was and is sustainable; also the need to follow lifestyles' in future. Significant is to understand and be aware of the deviation from traditional urbanism as each decision has impact on energy, energy related issue, sustainability and related dimensions of built environs.

The traditional urbanism is the fundamental and roots to, from modern to global urbanism. Diverse cultures of various traditional urbanisms have varying perceptions of understanding of resources and such an approach to look at the same resource differently is a challenge as the consumption is strongly contextual. The way each of the communities responds is ingrained in their cultures' lessons that have sustained through the times. Of which the key learning's for response to resources that impact climate change is significant.

The issue of Climate change goes much beyond the evidence of natural disasters and rising temperatures. It largely touches upon all aspects of lifestyles and thus integral to a more holistic way of living. Contemporary urban lifestyles dictated by the socio-cultural limited by the economic aspect but driven by the global standards have inherent conflicts. Although the impacts of climate change are evident as environmental decay but ongoing urban way of living is accelerating the change in all possible manner. Thus, to have a holistic understanding, each of the aspects related for sustainable lifestyles need to be put together, for which the traditional cultures are insightful and have the potential to contribute as well.

Climate change is the key issue for the survival of the mankind today. Despite the best of Information technology and scientific innovation that are constantly being upgraded globally and addressed such for climate change initiatives but the threat continues. In the fast-changing times wherein change is a constant and therefore the dimensions of this constant for climate change needs to be closely monitored, studied, understood and a rationale way forward to be the need of the hour. Climate change has gained proportions beyond the weather changes as it is impacting our livelihood systems with chemical and biological changes i.e. rising sea levels to food securities to quality of air with pollution crossing the political boundaries and reaching the earth's atmospheric layers an outcome of the way mankind has decided to live and continuing. Such is the footprint that life is at stake with loss of biodiversity

with species already becoming extinct a price too much to surmise. The nature of natural resources puts the climate change at the global map and the international climate agenda requires inter-disciplinary approach on all levels; wherein the local governments have a bigger role to play for carbon emissions that has universal value.

Climate change beyond 2100 shall reach a point of irreversibility and abrupt changes shall become the norm and recognized as national security by big nations just reinforces the concern. Many aspects of climate change and associated impacts will continue for centuries, even if anthropogenic emissions of greenhouse gases are stopped. The risks of abrupt or irreversible changes increase, as the magnitudes with temperatures are increasing [17]. In recent past, changes in climate have caused impacts on natural and human systems on all continents and across the oceans. Impacts due to climate change, irrespective of its multiple causes indicate the vulnerability of natural and human systems to changing climate. The ongoing efforts to achieve sustainability have fallen short; as the scale and nature of natural disasters are challenging, impacting the world today. Cost of delay to address climate change is increasing manifold with each passing day; that needs immediate focus especially in cities, as they are largely responsible for contributing for carbon emissions for both small and long-term action. Further due to resource constraint only a handful of nations are applying a "climate change lens" to the implementation of regional spatial or economic development policy framework often regional development policies are typically applied independently of national sectorial strategies to address climate change and such an inherent dichotomy approach exposes the contextually rich traditional urbanism to be vulnerable.

Climate change is bringing more energy into the atmosphere influence on weather hazards, and the vulnerability of buildings and infrastructure to natural events as well. The development of preventative structures and regulation also have a major effect on the scale of registered losses; i.e. studies have revealed that the probability of severe flooding events in certain regions across the coastline has increased significantly compared with a world without climate change. Of 131 extreme events in different parts of the world investigated in peer-reviewed studies by one scientific journal, 68% revealed an influence of climate change on altered exceeds probabilities [18].

The concerns for sustainability have been on the horizon for a while but the pace with which it has and continuing to deliver is falling short, as the consequences of climatic impacts are loud and clear with natural disasters on the rise. The anthropogenic activities are influencing the development processes such that the GHG gases and carbon emissions are rising and continuing, aggravating the continued carbon emission is causing further warming and long-lasting changes from increasing the likelihood of severe, pervasive and irreversible impacts for people and ecosystems. The issue of climate change got accelerated due to frequent natural disasters; environmental decay and initiative of two-degree limits brought the globe under one umbrella for the need to achieve the common goal. Although the events are direct repercussion of carbon footprint, environmental decay and others, however a closer understanding of the issue with respect to sustainability the narrative appears to be rather holistic as apparent in the earlier section. Broadly there may be two approaches to address the issue; one that addresses directly and other one that challenges the root

cause, which is strongly woven in our anthropogenic influences. Further the implementation of two degree limit needs to be implemented contextually with bottoms up approach and may be as percentage rather than absolute values i.e. as the data base available is essentially from nations with stable and developed economies and the thresholds have been arrived such; whereas the poor and the developing economies are not there yet; at the said threshold thus with the gap that puts the nations developing economies on a back foot and also with the scale and shear volume especially from Asian countries' China and India even a marginal increase can jeopardize the said thresholds'. Therefore, at whatever level each of regions may be; a generic reduction in percentage or stabilized at certain level may help to achieve the target; significant is the perception of the two-degree limit at global level and contribution by all nations.

Limiting climate change would require substantial and sustained reductions in greenhouse gas emissions, which, together with adaptation, can limit climate change risks [19]. Cumulative emissions of CO_2 largely determine global mean surface warming by the late twenty-first century and beyond. Projections of greenhouse gas emissions vary over a wide range, depending on both socio-economic development and climate policy [19]. Latest UN COP25 reports that an estimated USD 93 trillion worth of infrastructure will be built by 2030, over 70% of which will be built in urban areas. The buildings and construction sector alone accounts for over 20% of global greenhouse gases emissions. Buildings operations account for 23% of energy related CO_2 emissions globally, making them among the largest contributors to climate change. USA is one of the top contributors for carbon emissions despite stable and developed economy.

Constructing on the broader narrative of the global south particularly Asian countries were inhabited earliest and for centuries on celebrated civilisations that went down in history, however with global economy these very countries are facing the highest rate of urbanisation coupled with a global vocabulary of development and continuing and that is contributing to climate change in multiple ways. With lack of social equity, it is established that the biggest risk is to the urban poor; people from nations who are the least responsible for the consequences of carbon pollution, are expected to be faced with severe impacts. In addition to being the victims of the climate crisis and exposed to environmental repercussions of Climate change. This puts Climate change on the centre stage with the regions directly impacting the renewable resources from social, technical and cultural standpoint for acceptance, awareness and implementation. Thus, Climate action is the game changer in virtually every country, city and community and therefore it may be appropriate to declare it as climate emergency for all lives on this planet.

Documenting the narrative of anthropogenic development through United Nations Development Program has summarized five types of human society that have spread worldwide as hunter-gatherer, agriculturalist, mercantile capitalist, industrial capitalist and followed by the consumer capitalist while the current; sixth type of society will require both greater energy and improved ways, to communicate knowledge and manage information essentially intensified due to anthropogenic factors over time. However, each typology in chronological order is inversely proportionate to

duration of time in history becoming more complex with each type. The initial three stages of societies cultivated a symbiotic relationship with geographical location and natural resources consumed but industrial revolution initiated drastic changes and impacted the operational framework of the societies virtually with a paradigm shift resulted as the current one. The anthropogenic influences that intervened transforming landscapes driven through biological and natural systems related to the physical changes to our planet Earth. In this realm the contextual traditional solutions evident in traditional urbanism are worthwhile to look at. Largely the traditional urbanism is omnipresent among important global metropolitan cities; that reinforces their significance and establishes their recognition such. Traditional urbanism as a universal resource irrespective of their state of economy, typologies and often constantly evolving that has been fundamental to shaping the future. The professional discourse driven by politico-economic agenda propagates the global development typology typically in contrast to the attributes of traditional urbanism. This contrast vouches for global lifestyles are high on energy. Although solution for climate change and energy challenges does not necessarily vary for core/inner versus city or suburbs rather an approach required; is to re-integration into sustainable regional forms arising from existing traditional typologies.

Global lifestyles are predominant in urban areas and metropolitan cities where over half of the world's population is expected to reside by 2030 and is largely responsible for high energy use and carbon emissions leading to climate change; a socio-cultural issue endorsed by capitalist global agenda is in contrast to the sustainable traditional lifestyles The global economy driven by capitalism focuses on financial models, that's quite diverse from social equity with related environmental costs, parallel to the existing local economies that were in sync with the social and regional environmental framework. Therefore, initiatives like circular economy, regenerative economy and others an attempt to acknowledge local cultures' and often revive or continue with the traditional socio-economies. Tracing the tradition of economies, the contemporary lifestyle changes are impacting the traditional urbanism across all hierarchies of the built morphology from planning layout of the city down to the fenestration details. For example: technology has provided for thermal comfort for indoors with altering the microclimate into heat islands based on the spatial characteristics of the built morphology. But in case of traditional cities thermal comfort addressed across all hierarchies of built forms and therefore with the installations for conditioning of air [heating and cooling] affects the built form for microclimate adds pressure on infrastructure with gap in technologies, behaviour and performance evaluations with last but not the east the visual aspect a eye sore to the rich architectural detailing of the urbanism. The global lifestyles coupled with the high rate of urbanisation determining the nature of development are the root cause of climate change. The large concentration of people and greater densities infused microclimate changes resulting in increased energy consumption with high carbon emissions. Ironically the negotiation between the financial gains over the social construct underpinned by cultural issues happens to be typical for each geographies and regions and that is in sync with the global economy. The regional urbanism of traditions responded the local geographies for their respective cultural framework i.e., the soil characteristics-

indigenous food production to usage of water and other natural resources for centuries and the traditional understanding of environment that addressed human comfort, safety, health and well-being. Typically, the microclimate focused on such heritage climatologies and responses that were inherent to the traditional urbanism.

The large-scale urbanisation propelled due to globalisation; global societies are emerging that are assorted with kinds of diversities introduced due to migration across nations, continents and the world. The traditional social tissue was rather balanced homogenous with its inherent stratification nuances whereas the global societies is grouping of diverse fragments of traditional social tissue that are geo-region specific thus though the social tissue is richer for its characteristics and then the number that contributes for urban densities. Currently the population numbers are equated such but the social tissue needs to be understood for its numerous typological fabric as communities for their respective cultures, each one contributing for economies and resource consumption. Cultural matters are inherent to the lives of the people and therefore as development is directly related to quality of life cultural aspect is significant in its own right, ironically ratified only at Habitat-III by UNESCO; now recognized as a key component of strategic urban planning and a key innovation for the New Urban Agenda. Also the fourth dimension of sustainability accepted unanimously. Further even the cultures and sub-cultures reflected such in broader and sub-communities are insightful for decision making across the scales from global to local. And therefore the translation of the world population as communities is crucial, as that needs to be acknowledged for its inclusive representation and contextual participation for sustainable development goals agenda. The 19th General Assembly of ICOMOS acknowledged the climate change agenda with narrative build through meta studies and recognized the role of cultural heritage solutions to climate change adaptation and heritage's potential to contribute to the global climate change built on the Scientific Council Symposium [20] and The World Heritage Committee [21] stated that all countries needed to secure the full implementation of the Paris Agreement that emphasized that cultural heritage is impacted by climate change and is a source of resilience for the local communities; that heritage sites as well as local communities' intangible heritage, knowledge and practices' that constituted an invaluable repository of information and strategies to address climate change, even while those resources are themselves at risk from climate impacts and that the value of cultural heritage-based solutions to climate change mitigation and adaptation are significant as the way forward. The Intergovernmental Panel on Climate Change comprehensive assessment have documented drastic impact of fossil fuel emissions especially since the turn of the century and that has affected the earth systems at large. Additionally impacts of urbanisation and globalisation, the GHG affecting the earth's atmosphere layers, polluting the air and deteriorating the quality resulting in rise in temperatures. The climate change is highlighted across all hierarchies from the GHG gases, depleting ozone layer, atmospheric layers, rising temperature to build environs to existing building structures, heritage buildings including an intermediate scale that of streets, public open spaces, precincts and traditional urbanism has its own challenges.

However, all the hierarchies are inter-connected and therefore only inter-disciplinary approach is required and including Cultural heritage beyond preservation, conservation of heritage management projects at large. Initiatives by the countries to limit the global warming to less than two degrees brought most of the countries at a common political platform but due to varying thresholds of the various countries the required target is proving to be a tall order. It is evident that even when countries with strong economies and political will have had limited success with climate change and its related issues. While poor economies are struggling even harder and lacking in latest technological inputs the impacts get amplified for their stages of urbanization, development that economies need to attend. Considering weathering, atmospheric changes, rising temperatures, aging and others taking a toll on traditional heritage although fair amount of work has been done among the developed and stable economies and continuing. With input correction measures to adept the repository to meet the global norms and standards. In the process of retrofitting and adapting the comprehensive and through understanding and documentation needs to be place of the existing structures that has layers of information addressing all dimensions of built environs for systems that are in place.

References

1. Conservation Principles, Policies and Guidance (2015) The sustainable management of the historic environment. https://historicengland.org.uk/images-books/publications/conservation-principles-sustainable-management-historicenvironment/conservationprinciplespoliciesand guidanceapril08web/
2. Alzoubi HH, Malkawi AT (2019) A comparative study for the traditional and modern houses in terms of thermal comfort and energy consumption in Umm Qais city, Jordan. 20(5):14–22. https://doi.org/10.12911/22998993/105324
3. Ruihan W, Song, D, Wong NH, Martin M (2016) Impact of urban morphology parameters on microclimate. 4th International Conference on Countermeasures to Urban Heat Island (UHI) 2016. http://creativeeconomices.org/licenses/by.nc.nd/4.0/
4. Anthony GB, Ochoa MC, Amirtahmasebi R (2014) Urban development series knowledge papers climate-resilient. Climate-friendly World Heritage Cities. [89635]. World Bank group
5. (2019) Münchener Rückversicherungs-Gesellschaft, NatCatSERVICE 1. https://www.mun ichre.com/en/company/media-relations/media-information-and-corporate-news/mediainfo rmation/2020/causing-billions-in-losses-dominate-nat-cat-picture-2019.html
6. (2020) https://www.weforum.org/agenda/2020/01/15-years-risk-economic-collapse-planet ary-devastation/. Accessed 29 April 2021
7. Manfred L, Sun Y-Y, Faturay F, Ting Y-P, Geschke A, Malik A (2018) The carbon footprint of global tourism. https://doi.org/10.1038/s41558-018-0141-x
8. Susan R, Nicol F, Humphreys M, Tuohy P, Boerstra A (2010) Twentieth century standards for thermal comfort: Promoting high energy buildings. Architectural Sci Rev. 53(1): 65–77. ISSN: 0003-8628
9. LCA (2019) Net Zero carbon commitment—reducing embodied carbon at early design stages. Recorded webinar. https://www.oneclicklca.com/webinar-net-zero-carbon-commitment/
10. General assembly ICOMOS (2017) Francesca Leder, Valentina Torelli ICOA1063: Heritage led-development by shared recovering of urbanized historic rural landscapes in the Veneto Region, Italy Subtheme 01: Integrating Heritage and Sustainable Urban Development by

engaging diverse Communities for Heritage Management Session 1: Sustainable Development and Community Engagement

11. Catherine De W (2021) We need to reduce the 'embodied energy' of buildings. 5 January 2021. Horizon magazine by Alex Whiting. Available on https://sciencex.com/wire-news/371293285/qa-we-need-to-reduce-the-embodied-energy-of-buildings.html

12. EU 2019 survey. https://ec.europa.eu/clima/citizens/support_en

13. John F (2019) Regenerative economy. http://captalinstitute.org

14. The New York City Local Law 84 Benchmarking Report (2012) The greenest building: quantifying the environmental value of building reuse. National Trust for Historic Preservation. Washington, DC. http://www.nyc.gov/html/gbee/downloads/pdf/nyc_ll84

15. Yousef Mousa WA, Lang W (2014) Solar control in traditional architecture, potentials for passive design in hot and arid climate. PLEA 2014, 30th International Plea Conference CEPT University, India

16. The New York City Local Law 84 Benchmarking Report (2012) The greenest building: quantifying the environmental value of building reuse. National Trust for Historic Preservation. Washington, DC. 2012. http://www.nyc.gov/html/gbee/downloads/pdf/nyc_ll84

17. 2007 Newman and Kenworthy (1989) Atlas Environnement du Monde Diplomatique

18. Gambardella. Carmine UNESCO CHAIR… Le Vie Dei Mercanti International forum. http://www.leviedeimercanti.it/

19. Yung EHK, Chan EHW (2012). Implementation challenges to the adaptive reuse of heritage buildings: Towards the goals of sustainable, low carbon cities. Hab Inter 36:352–361

20. (2007) Recommendations from the Scientific Council Symposium; Cultural Heritage and Global Climate Change (GCC), ICOMOS Scientific Council, Pretoria, South Africa. https://www.icomos.org/climatechange/pdf/Recommendations_GCC_Symposium_EN.pdf

21. (2017) 41st session of the World Heritage Committee; Krakow, Poland, 2–12 July 2017. https://whc.unesco.org/en/sessions/41COM

Chapter 6
Designing Traditional Urbanism of Jaipur

6.1 Context of Jaipur

The walled city of Jaipur one of many examples across the globe was one of the typical traditional cities that mushroomed along the trade routes and the strategic geographical locations incidental either along the coastal edge or at convenient natural travel routes that were easy to navigate with security as the key. The location of these cities was determined by geographies and the mode of transportation, which then was carts driven by animals i.e., regionally determined through horses, bulls, camels, and ponies among others. The geo-climatic framework, often not necessarily ideal but the local communities, with their indigenous wisdom of knowledge-developed systems to build the cities resulting in traditional practices that were low on energy manually or mechanically driven to provide for thermal comfort for the built spaces. The wisdom of knowledge spanned across from design detailing to selection of building materials, construction technologies to the utilization of spaces too. The deliberate holistic approach from layout of the city down to buildings and thus the macro to micro was in sync and delivered such; that sustained for centuries through indigenous planning and passive systems. The systems need to be understood as a system of systems including the users' behaviour that was culturally governed.

The walled city of Jaipur is one of the planned cities in India. Currently the Asian cities are experiencing highest rate of urbanization with fastest rate of growth, especially among small and medium class cities and Jaipur falls in this category thus experiencing rapid growth. The City Development Plan Jaipur has recognized that the city as a fast-growing city, ranking 11th in the list of Indian mega cities with a population of 2.3 million and annual growth rate of 4.5%. Jaipur, the capital for the state of Rajasthan, constitutes for the urban core with million plus city in the state. It is the primate city of the state acting as the Centre for education and employment opportunities. The city attracts migration from all parts of the state with 70% of migrants coming from within the state and offers jobs in commerce, services and the

© The Author(s), under exclusive license to Springer Nature Singapore Pte Ltd. 2022
A. K. Sharma, *Traditional Urbanism Response to Climate Change*,
Advances in 21st Century Human Settlements,
https://doi.org/10.1007/978-981-19-4089-7_6

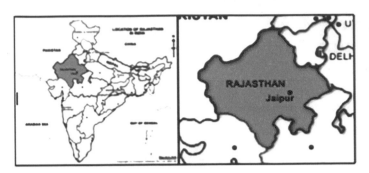

Fig. 6.1 Map of India with location of Jaipur in state of Rajasthan [2: 90]

informal sector, depicting a high economic growth compared to several other Indian cities [1] (Fig. 6.1).

The main economic drivers in the city are trading, administration, tourism activities and local handicrafts industries. Trade and commerce accounts for 24% of the workforce followed by household industries with 22%. Jaipur, also known, as the pink city part of the golden triangle for the tourism sector most sought after tourist destinations in the world with about 3000 tourists visiting the city everyday equally popular with both home and foreign tourists [3]. Jaipur is located between 26° 45' 00" to 27° 02' 30" N latitude and 75° 40' 00" to 75° 55' 00" E longitude and is 427–457 m above mean sea level, is about 270 km from Delhi. A considerable part of Jaipur geographical area is covered by alluvium northern and eastern occupied by schist; belonging to the Aravalli system resting on genesis and overlaid by quartzite. Hills on the south have exposure of white sand; nearly devoid of vegetation except natural spring. Area of Jaipur is 467 sq km; 4.11% of the state while the area of the walled city is only 8.63 sq km [0.11%]. Jaipur region falls under the Tropical steppe as Hot and semi-arid hot region, with temperatures ranging from 3 to 46 degrees; average rainfall of 556 mm with an average of 32 rainy days; July to August receives about 85% of PET for Jaipur district is 1744.7 mm; average humidity is 60% with dry air and lowest humidity being 15–20% and winds movement is generally light to moderate with annual mean wind speed: 12.4 km/Hr; soil type: sand and sandy clay loam [2]. The walled city continues to be the central business district for the city with large-scale exports of local handicrafts ranked as one of the top in the country. The population of the workforce is 51841 [46.42%] of which the share of population of the walled city is 32.67%. Nearly 30% of people inherited family trade and nearly 47% walked to the place of work [4] (Fig. 6.2).

Jaipur was the vision of king Sawai Jaisingh's to build the city within his lifetime. The city was designed based on concepts derived from ancient Hindu texts, strategically implemented with a set of migrant population that evolved as the local community, cemented by religion. The economic activities were handicrafts made from the locally available materials with indigenous technology that adapted as each of the craftsmen were invited to migrate and settle in Jaipur that evolved and improvised while responded to changes over time. Jaipur demonstrates a strong social

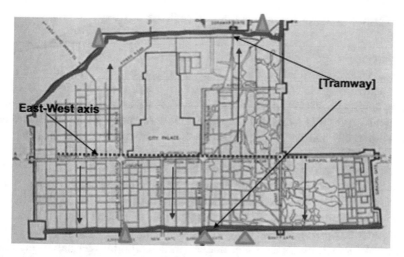

Fig. 6.2 Layout plan of Walled city of Jaipur [2: 112]

capitol with a set of traditional practices that were integrated through a series of rational decisions; which responded to events that occurred due to changing political, economic for sustainability of the walled city. The innate relationship between the social and the economy nurtured an archetypal culture, typical for Jaipur; this cultural heritage for centuries fostered the traditional knowledge cementing the social capital strongly translated in built morphology of Jaipur. The pace of growth for Jaipur is the key for the city to have sustained, as the changes irrespective of social, lifestyle, educational, technological and others were distinct and spread over a period of time, which with time got imbibed by the local people demonstrated the resilient nature of the local population. Although Jaipur faced both drastic and nominal changes but the response for each one was deliberate and sensitively handled. The narrative of traditional urbanism of Jaipur enables one to deduce that the practices to achieve sustainability for a city are case specific and are rather a *state* than a fixed goal to be achieved once for all. The process of adapting a set of available resources translated into a lifestyle for generations that enriched as the local culture. The key negotiations that occurred with infrastructure facilities were when they were layered on the compact built morphology and regularly upgraded for technology. In this process the design and detailing of building and typologies with heritage connotation proved to be a challenge including ownership/property rights, intervention that occurred in parts for rebuilding, addition alterations etc. impacted the decision also the sense of belonging to the community influenced the impact too.

The municipal limit for Jaipur city has grown almost fifty-five times whereas the population of the historic city has stabilized with a density of 240 persons/acre since the last four decades with the city urbanized beyond the city walls. The historic city continues to be the nucleus for Jaipur. The strategic location of the historic city reinforces the hierarchy and the authority enjoyed both for socio-economic and socio-cultural reasons and the identity of Jaipur now reinforced more so with the World heritage status [4].

6.2 Geo-Political Framework—Birth of Jaipur

The strategic geo-political location was key for selection to build the city of Jaipur; with Delhi the political administration at one end, also close proximity with Agra, center of handicrafts. While Surat, the port city was the trade link that enabled for handicrafts products produced and shipped to other parts of the world. Jaipur provided security and facilitated the trade routes such that with regular invasions from both north and southern political powers Jaipur developed alternate trade routes as well for security reasons. The geographical location was rather political and despite the limited natural resources Jaipur's unique response for the available natural resources of site and its surroundings with their efficient utilization of available natural resources assured growth of the city. Aravalli's the natural mountain ranges towards north provided for security while the southern side had city walls. The climate condition being hot and dry with limited rains thus availability of water was augmented through manmade water bodies, wells and rainwater harvesting [1883] and traditional practices that ensured agricultural produce which assured food security for the local population. The geographical ecosystem was the contextual framework for the walled city of Jaipur and the design and detailing across all scales of built environment responded such vouched for low carbon living of the local community. The social capitol comprised of migrant population a distinctive feature of the walled city that emerged as strong pillar of sustainability. The structure of the society was a balance of business communities to finance, money lending to craftsmen to develop the local economy and religious heads to anchor them. The craftsmen were invited from northern part of India i.e., Delhi, Agra, Jodhpur who were constantly exposed to political unrest due to raids of Marathas and Pindari in these cities; for them an option of a city where security was prime concern was very tempting to settle down. The incentives offered by the king for the business community were quite lucrative and ended up becoming an ideal destination for them to settle down. Security was the basic premise on which the city grew and flourished. Timely measures were taken up to ensure security i.e., officially gate passes were issued for the movement of goods as a security measure by the king when railways were introduced by the British [2] (Figs. 6.3 and 6.4).

The plan of Vastupurusha mandala as nine squares were placed on the selected site in such a way so as to keep the backdrop of Aravalli's for the city and palace complex strategically placed in the center. With the site constraints and positions of the existing structures resulted in repositioning of one of the nine squares from northwest corner to the east to encompass the Aravalli range and the plan was rotated by fifteen degrees to the east. This response for slight deviation from the cardinal axis for the orientation of the city demonstrates adaptability of the planning principles for the geographical context upholding the nature, natural features and resources giving identity to the city, even though they were derived from the planning principles. Such contextualization for planning of the city that recognized the local ecosystem and were in sync with the local climatic condition and gave enough room for individual creative expression that gave unique identity to Jaipur. The city when laid out used

Fig. 6.3 Context of walled city of Jaipur with Aravalli hills [5]

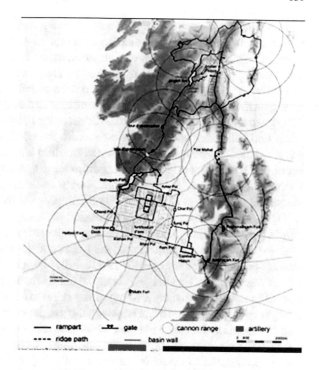

Fig. 6.4 Sources of water for walled city of Jaipur [2: 110]

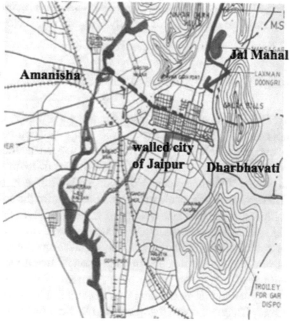

natural slopes that were recognized with primary street along east–west axis along the ridge while secondary streets perpendicular to it; as that facilitated the overall drainage of the city. A twenty feet high stone masonry wall surrounded the city with seven gateways: one on the north; two on the east, three on the south and one in the west. The layout plan of the city placed palace chowkri in the center nestled at the base of Aravalli's, surrounded by the other blocks that provided additional layer of security to the king. Immediately to the north of the palace, area there was a lake with water tank built exclusively for the palace. To the north east of the palace existed a rivulet named *Darbhavati* (1735) opened out into a manmade lake *Jal-mahal* [109 hectares]. To the west existed another perennial stream named *Amanisha*, which was source of water since the city came into being and continuing, although meets only the partial requirement of the city's water supply now [6].

Once the location of the city was decided the king Sawai Jai Singh facilitated to build the city of Jaipur in his lifetime only, considering it takes generations for cities to shape up. The implementation of the plan on site chosen was one of the favorite hunting grounds; surrounded by Aravalli hills. Jaipur tehsil records the site of the city-covered parts of six villages namely: Nahargarh, Talkatora, Santosh Nagar, Moti Katla, Galtaji and Kishanpole. Some of the religious structures are remains of these villages were retained and often appear in the middle of the road networks even today. The city therefore had to be planned with these existing structures. The laying of the foundation for new construction, be it a building or a city, is a ritual duly performed by the religious heads and executed pragmatically as per Vedas, with precise date, time arrived at; thus fairly an auspicious ordeal an inherent part of the cultural heritage and thus the foundation of the city was laid on 29 November 1728 [6].

6.3 Building Socio-economic Structure of Jaipur

With the fundamentals in place for the walled city of Jaipur to flourish, a holistic approach to build a socio-economic setup was outlined and translated in the layout plan of the city. With agriculture as basic to feed the local population the southern end with plains was allocated for cultivation of land also the natural slope of water towards it proved to be beneficial. However, with limited rains the deliberate selections of food grains so as to yield maximum produce for the soil type and limited availability with continued brackish quality of water; parallely the handicrafts were facilitated. The site of Jaipur city had few existing villages that constituted only a small portion of the population added to build the social setup along with major migrant population of craftsmen related economic activities of handicrafts were invited and facilitated with seed money for which business community and the Hindu priests invited to strengthen them. As the king was a staunch Hindu, he encouraged a society with a strong Hindutava base that proved to be beneficial at the time of building of Jaipur, Islam was predominant across the country and there was political unrest. As a result, the Hindu business community was insecure. The building of Jaipur provided them with security and shelter wherein they could utilise their resources for building lavish

residences. To reinforce the Hindu base, a large number of temples were built at strategic locations although such an approach was entirely due to king's own faith in the religion while the related practices became the norm for the local population to acknowledge the king and with time became an integral part of the local culture. Thus, a strong Hindu social setup which was inclusive to the planning of Jaipur: the chowkri opposite the city palace were allocated to the businessmen and higher officials of the kings interspersed with temples at strategic locations such as along the main streets, corners, next to the entrance gateways, at intersection of primary streets. Basically, craftsmen migrated from Delhi, Agra and mainly from northern parts of the country i.e., block printers from Sangner, brassware workers from Mirzapur, inlay workers from Agra, lacquer workers from Jodhpur among others also blue potters from Bengal. Numerous incentives were given by the king in the form of free plots with financial aid with very low interest rate and extended repayment plans for construction of residences. Gradually the serving class, workers moved in for job opportunities and settled in other chowkri's allocated based on their castes, as often the caste was associated with a specific task as accepted in the Vedic texts'. This deliberate socio-economic setup was nurtured that shaped up as the core population. The socio-economic base was resilient and often responded to changing needs of the people, political decisions including for natural resources. Originally, only four chowkri's were developed with the rest planned as the next phase. The city palace occupied two of the nine squares at the base of the Aravalli hills planned with rest of the chowkri's, surrounding the city palace.

The king laid the foundation of Hinduism, as the religious base and the broad classification of Hindu for sub-castes was reflected in the layout of the city with higher castes the think-tank was located closer to the king. 1901 census of India the number of sub-castes reduced from 78 to 16; this dilution of sub caste exhibits the adaptive nature of the local community to continue that was vital, a transformative response due to diversification of jobs, education and changing lifestyles. In the meantime, other religions too were embraced and embedded within the socio-economic setup and lived in harmony as one social entity, exhibits the resilience nature of the local community. The reduction in number of sub castes implied a progressive approach that stabilized the social order which responded to changing economic conditions. However, the Hindu religious base continued to grow its roots deepening and continuing their status till date. Their residences were built in an elaborate manner and maintained such for generations on and hardly any property resold thus built morphology largely in place. The core social capital of Jaipur is known for its distinct traditional lifestyle: identity they pride even today and globally recognized by tourism as well. Traditional urbanism of Jaipur is a reservoir of knowledge and practices of socio-economic and environmental interactions for the contextual framework. Handicrafts from Jaipur are key to the economy that thrived and continuing due to wide range of systems from vernacular to indigenous to gender inclusivity. The production process was regularly upgraded with technology and design as well as value addition is and has been one of the unique selling points of Jaipur handicrafts.

The Hindu's were culturally rooted to the ancient scriptures i.e., Vedas that was reinforced due to political patronage. Joint Family was and is the basic socio-economic unit continuing even now with a common kitchen. The social and the religious aspects ensured the continuity of the traditional practices, values and lifestyles. The central courtyard was the space for social interaction housing common functions and facilities like drinking water, kids play area, washing with spill over of kitchen activities to drying of clothes. Although with changing times the activities in the courtyard varied but the open to sky space continued to deliver for thermal comfort with stack effect. The traditional lifestyle of the local population was largely vegetarian, eating locally grown food grains with drinking being a taboo proved to be healthy; often reinforced with religion and continuing. Limited availability of brackish quality of water but waterborne diseases was never the major cause of epidemic. Indigenous trained medical practitioners in alternate therapies i.e., Ayurveda, Homeopathy, Unani, among others were acknowledged for curing health problems and continuing parallel with allopath. The healthy lifestyle assured the economy to prosper. Women and culture are almost synonym in the tradition; women were primarily responsible to inculcate values, traditional practices, lifestyles that are directly related to resource consumption which vouched for low carbon living and thereby low carbon footprint. The compact built morphology encouraged community living and social interactions that nurtured harmony and reinforced and continued security, which enabled them to combat setbacks both natural and manmade.

With layout of city in place water had to be facilitated and that was done gradually as each of the chowkris were inhabited. At an initial stage water was carried from Amanisha, Dharbhavati and Jal-Mahal about a century later common water tanks were built at two chauper's each 70'0 × 70'0 [1840]. Later a water channel was constructed connecting the two water tanks as well for ease of collecting water by utilizing the natural slope of the east west axis was from west end that continued till 1876 thirty-six public standalone pumps [PSP] were installed in secondary streets within each chowkri. 1887 saw city water supply extended to private houses; water connection for individual houses [28 number] owner paid for the fittings and connections one rupee for the first tap and Rs. 0.48. Comparing the costs with other city Agra with Rs. 3–7/1000 gallons while Jaipur had Rs. 2/1000 gallons; textile workers benefited as they got water supply at the rate of Rs. 85/month as compared to Rs. 179/month they had to pay to carry the water manually [2]. Despite the limited availability of water the administration facilitated and that nurtured the growth of the city and economy. With re-densification the demand for the block printed textile rose and with limited supply of water within the walled city the textile workers moved on the outskirts of the city. Publication sector replaced the said chowkri as the water requirement was much less and the demand by the education institutions the economy continued to be stable. As early as in 1883 rainwater harvesting initiated was initiated. In 1916 the strata of ill-defined and irregular riverbeds were layered with sand so as to terminate the sinking of water courses and levelled covered with 6″ layer of harder soil and planted thatch grass along with Seesham, Neem, Pipal, Mangoes tree plantation to increase the water retention a mitigation strategy in place to ensure limited but regular supply of water (Fig. 6.5).

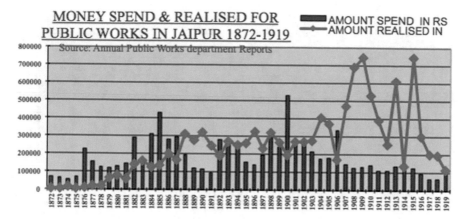

Fig. 6.5 Economy stabilized with Agriculture [2: 148]

The thrust on economy was such that even agriculture, which feed the local population, proved to be profitable with measures taken up by the local administration. The food security measures continued along with till the handicrafts got stabilized. The tourism sector aided the continuity of traditional foods, a delicacy sought for, also an identity of the walled city. The strength of the socio-culture that stabilized economy; is evident in the timely policy decisions that were taken that ensured growth and expansion in businesses, demonstrated the ability to adapt to limit the growth with available natural resources. Capacity to value addition and adapt to the changing market forces has been the strength of the economy in addition to ensuring the continuity of the traditional economic activities of Banking and traditional handicrafts of semi-precious stone cutting, block printing, carpet weaving, blue pottery among others; example of semi-precious stones is unique to Jaipur as the raw materials is procured form Africa and other foreign nations processed in Jaipur and exported to other developed nations. Such vale addition to hand crafted products is the unique selling point of Jaipur and the export of semi-precious stones has been top five handicrafts product now for over decades.

The socio-cultural community was the backbone of the economy and continuing is resourceful and due to their traditional practices and lifestyles continuing with low carbon living. The gap with traditional practices and systems in place standard thermal comforts base lines are contextualized that are climatic responsive. Numerous scientific studies have highlighted that the behaviour pattern of users' is significant for resource consumption and in that respect when the local population adheres to baselines that are context specific reduces energy demand. Each contextual examples of traditional urbanism has the potential to contribute for climate change with their respective baselines and thresholds; for example the national building code suggest water supply at 215 lpcd while the walled city has a water supply of 100 lpcd and the local population managing and living such, largely with traditional practices and systems and parallels may be drawn for energy as well [2].

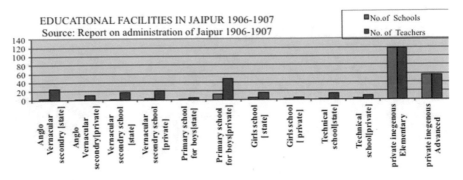

Fig. 6.6 Diversity in Educational facilities in Jaipur [2: 158]

Educational system in Jaipur was one of its kind as it nurtured diversity aligned with social diversity ensuring access for all including education for girl child and such diversity continued for almost two centuries irrespective of governances. With handicrafts the backbone of economy, system of apprenticeship with master craftsmen was recognized at par and thus reinforced the eco-cultural roots. This education system proved to be inclusive that enabled to establish social equity as well (Fig. 6.6).

Jaipur being a planned city was conceptualized, designed and detailed with a grammar as foundation, that evolved with transition of socio-economic to socio-cultural. The traditional practices of Jaipur from lifestyles, handicrafts to architectural heritage, each of these aspects evolved and got fine-tuned with the strong socio-cultural backdrop when adequately supported by good health, safety and well-being, the growth was but natural. The framework of building construction despite being regimental had ample room for individual expression, thus the resourceful business community exhibited their wealth through finely embellished building elements from flooring to walls, jallis, brackets, fenestrations to building facades especially the entrances and within the courtyard. The socio-cultural aspect was evident with various ethnicity and religion as the city thrived as people from all communities were absorbed and with years on few of the crafts were strongly associated with specific communities as well i.e., craftsmen related to brass work, lacquer ornaments were predominately Muslim women constituted a large part of the workforce and handled retail as well as women were the main buyers. Islam has inherent limitation only to use flowers, petals, motifs from nature including geometrical patterns, and which they used for their handicrafts to their residences and excelled in geometrical patterns especially for screens as jalli; a building element that defined spaces; these screens were visually appealing and often created interesting shadow patterns through the day on to the floors, walls and ceilings and the changing quality of light facilitated varying functions through the day such. Whereas among Hindu's images of God and Goddesses at the entrances, their worship areas and sometimes in kitchens and included motifs from nature. The translation of traditional urbanism was reflected across all scales, each of the chowkri's in the city were allocated a specific craft and with particular community inhabiting it with specific aesthetics that was

consistent within the chowkri. Although the grid iron patterns of streets were the norm but within the chowkri the inhabitants often deviated i.e., use of cul-de-sacs was standard in areas where Muslim communities resided as culturally the women and children have well defined spaces with limited access and thus streets with dead ends although altered the typology at urban design scale while at the building level the detail of design continued and thus response to climate honored with courtyard planning. An individual expressions gave identity to the similar looking buildings and assured harmony for example the use of pink color for which the city is known for was introduced only about a century ago considering the city is almost three centuries old.

The political change with British had selected impact, as the local community was strong with its traditional practices in place. The British intervention in Jaipur exposed the local cultures to colonial; although western culture wasn't new to the city as Sawai Jai Singh was a keen astronomer and had built a state of art observatory with technical precision in place such that the accuracy is acclaimed even today. Astronomers were invited from Europe and other countries for exchange of knowledge and were entertained for their respective cuisines; vegetables consumed by the Europeans, were specially imported and locally grown; a gesture to welcome visitors continues till date a cultural connotation now enjoyed by the tourists. Given that the local population was exposed to western cultures they continued with their very own strong contextual socio-culture and contributed significantly for the city building.

6.4 Grounded Theory of Walled City of Jaipur

It's noteworthy from Jaipur's experience that an individual's vision to build a city in his lifetime; derived from ancient Indian texts and systematically executed through strategically designed socio-economic structure based on the locally available materials and indigenous technologies that evolved, developed and improvised with time to respond to changes. Interestingly the local population was largely migrants from the region with few from Bengal as well. Based on the case study of Jaipur; a theoretical formulation that spells out the grammar as a set of concepts that were integrated through a series of relational statements experienced by persons or organizations or communities and responded to events that occurred with the changing political and economic scenario to attain sustainability of Jaipur, the Grounded Theory developed such is as follows:

Sawai Jai Singh's absolute conviction to build the city within in his lifetime; was the key. For a city to flourish socio-economic setup was outlined, as he was a staunch Hindu he encouraged a society with a strong Hindu base and a balance of Brahmins, Business community, craftsmen, cobbler etc. all belonging to the various hierarchy of Hinduism. He invited them especially from northern part of the country; essentially crafts men i.e., blue potters from Bengal, block printers from Sangner, brassware workers from Mirzapur, inlay workers from Agra, lacquer workers from Jodhpur etc. To reinforce the 'Hindutava' a large number of temples were built and plots strategically located adjacent to the entrance gateways, at the chauper's, along

the primary streets etc. Although this decision was an extension of his own belief in the religion and the related practices which became the norm for the local people to emulate as king's verdict, which with time became an integral part of the local culture. The socio-economic base was critical for the city to flourish with time the local population turned into a 'community' later known as Jaipurians.

Initially the city had agriculture base, to feed the local population and gradually developing it as a trading centre for handicrafts for which finances were made available by the businessmen, moneylenders and facilitated by the administration. The process was gradual so that it become an inherent part of the local community and with time the socio-economic base of the local population got nurtured [PhD]. As lifestyles encompass all facets of living thus the handicrafts too got merged with the socio-cultural organization of the local population. All these layers were sensitively super imposed so as to act as one with time (Figs. 6.7, 6.8, 6.9, 6.10, 6.11, and 6.12).

Sawai Jai Singh used the unstable political scenario in Agra, Delhi etc. that ensured quick migration of the wealthy traders as they were assured security. Over a period of time, a kinship nurtured among the inhabitants in the respective chowkri's; reinforced by caste as each of the chowkri's usually hailed from the same caste. The invitation for the migrant population (1728) was facilitated with incentive such as:

Fig. 6.7 East–West axis [2: 271]

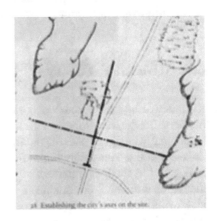

Fig. 6.8 North–South axis [2: 271]

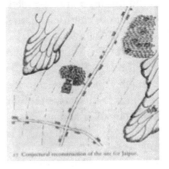

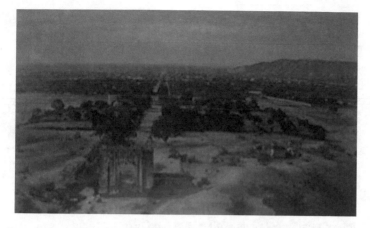

Fig. 6.9 Demarcation of East-West axis of Jaipur laied out at site [2: 271]

Fig. 6.10 Grid-iron pattern for Jaipur

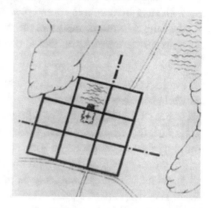

Fig. 6.11 Vatupurisha mandala—the conceptual planning principle of Jaipur

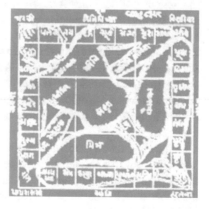

Fig. 6.12 Locations of
gateways with layout of
primary streets [2: 271]

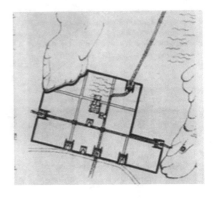

- allocation of residential plots with mixed land use.
- financial assistance for the craftsmen to build their houses facilitating soft loans with easy instalments spread over a larger period of time etc.
- the king assured to facilitate the products to be sold either in the local market or to export them to Agra, Delhi, or even outside the country via sea through Surat etc.

Archetypally, the construction activity was monitored from religious perspective as well as in line with the planning principles laid down by Vidyadhar who was the architect of Jaipur. As the building activity was firmly supervised, a strong character fostered which eventually became its strength. Despite the rigid framework of building there was adequate room for personal expression, which turned out to be another dimension of the rich architectural style of the pink city (Fig. 6.13).

Road networking connecting Jaipur to Agra, Delhi and through Ajmer to port in Surat for international trade were build, maintained and security looked into; and in cases of political unrest alternative route too was build, maintained and security offered. This facility encouraged the local craftsmen to expand and improvise, evolve and adapt the handicraft's product responding the market forces. Conventionally the traditional handicrafts had a set sense of aesthetics but the attitude to evolve; put the traditional crafts of Jaipur a class apart till date such that they are preferred over other similar traditional crafts because of their innovative approach. This art of value addition eventually got integrated within the attitude of the master craftsmen, which proved to be a huge asset of these craftsmen to sustain and continuing (Figs. 6.14 and 6.15).

Jaipur had its own railways around 1920's that helped easy movement of people and goods and facilitated to develop stable economy early. For a social capital to develop, an appropriate mix of communities: religious, business, craftsmen etc. is desirable which was administered as the city grew rapidly. Typically the pace of growth occurs when peace and harmony is the order in the society and Jaipur provided that. As the local population comprised of a range of migrants along with, came the diversity of education system too including other aspects as well. Once the city was settled a range of schools co-existed i.e., Anglo-vernacular secondary, primary,

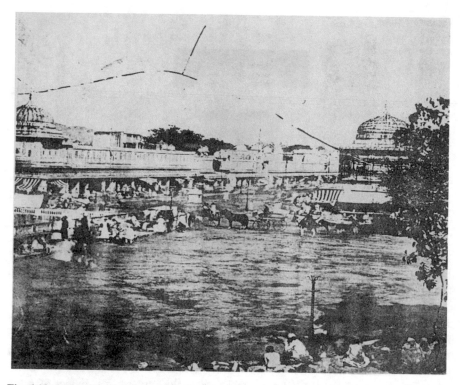

Fig. 6.13 View of Badi chauper, 1872 [2: 272]

Fig. 6.14 Alternate trade
route to export Jaipur
Handicrafts [2: 273]

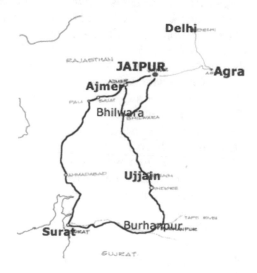

Fig. 6.15 Alternative trade
routes to ensure
uninterrupted trade [2: 273]

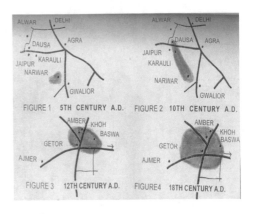

private, state, indigenous, etc. for both boys and girls separately or in combination. This system of education almost a century earlier, suggests initiatives taken up both by the British as well as the king. It gave flexibility to pursue future of their choice with dignity of labour.

The local population of Jaipur was open minded and therefore responded to all kinds of exposures and responded with sensitivity; such transformations over a period of time became an inherent part of the socio-cultural system. This attitude supported them to sustain various circumstances for centuries on for example Vishweshvarji ki chowkri essentially houses trading community with time few of the wealthy families have moved out of the walled city giving away the property to traders of other religion or caste which is a deviation from the principles laid down by Vidyadhar. They continuity of the values of the core population such exhibits the resilient nature of the local population. The hierarchy laid down for the social setup continues even today as unsaid code of conduct: an intrinsic part of the cultural heritage. Other than amalgamation of various communities, exposure to international cultures was a regular feature with Europeans astronomers visiting, as Sawai JaiSingh himself was a keen astronomer and later due to British administration. It is worth mentioning that earlier influences never filtered down to the common man as the kings. On the contrary the Global lifestyles came at a time when structural changes occurred within the centuries old socio-cultural aspects, with ease accessibility for all the global impact was embraced with open arms as a gesture of progress. Nonetheless both Europeans and British contributed for sustainability of the city. Europeans enriched the knowledge base on astronomy resulting in building of sundial of high precision even as per today's standards and as a part of hospitality different species of vegetables alien to the locals were grown; introducing biodiversity to the locals (Fig. 6.16).

The British encouraged education for girls, improved quality of water, networking of water supply to individual connection, rainwater harvesting, solid waste management among others that supported the growth and sustainability of the city. Initially the city had common source of water supply and manually collected waste disposal networking, with technology electricity and individual connections of water supply sewerage/waste disposal occurred, thus overlaying these infrastructure facilities

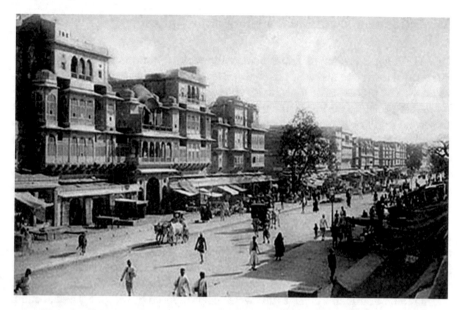

Fig. 6.16 Facade of the main North South axis (1915) Jauhri bazaar [2: 274]

within existing built fabric was a delicate issue. Therefore provision of building services management needed to be dealt with sensitively and with technology improving by the day one had options to choose from.

The role of women was significant to contribute for the socio-cultural capital; strongly depicted in the values system, joint family type, religion, cultural practices endorsed such by continuity of the cultural heritage. Despite urbanization outside the walled city the land prices within the walled city are constantly on rise. Although the price rise is not uniform through the various chowkri's: for example Topkhana Hazuri, Ramchanderji-ki-chowkri and Ghatgate where majority of the migrant labourer's are staying the property prices are low, further these chowkri's house both Hindu's and Muslim's a strong pointer that sustained the demand of labour required for the small scale industries within the historic city, also vouching for social equity too. While Vishweshvarji ki chowkri houses Hindu traders where the trading community has been living for generations, such chowkri's has relatively high property prices; but they are continuing to live within the same premises for centuries mainly for socio-economic reasons thus ensuring continuity of the socio-cultural capital. Despite the high real estate the core population of traders and religious base is going strong that encouraged development activities related to tourism and making more space available for trading and business. Historic city of Jaipur has enjoyed a stable economy rising at a consistent pace, grew strong since its inception till date. The resilient socio-cultural capital continuing is the key for sustainability of walled city of Jaipur for centuries on and shall continue to do so even in future as well.

6.5 Mapping Traditional Urbanism of Jaipur

The traditional urbanism of Jaipur demonstrates the optimum use of locally available natural resources that were adapted and responded to that enriched the urbanism regularly. The process of adapting to natural resources turned into a habit with generations that enhanced the local culture translated in traditions. Jaipur demonstrates the archetypal traditional environmental knowledge, which is unique and un-paralleled. Jaipur nurtured a socio-economic culture within its regional context where the city urbanized the traditional cultural heritage proved to be the key for its continuity for centuries. The pace of growth for the pink city is the key as the changes from social, lifestyle, educational, technological etc. all distinct but spread over time and that with age got imbibed by the traditional community displays their resilient nature. Jaipur faced from rapid to structural changes but the responses' for each one was deliberate and sensitively handled. The narrative also goes on to validate that solutions to achieve sustainability for a city is typical for that city and is more a state than a fixed goal to be achieved once for all. Globalization re-addressed the contextual ecological resources for unlimited global opportunities driven by global economy and introduced structural changes that were super imposed by the global architectural vocabulary quite alien to the contextual ecological characteristics. Thus contemporary approach driven by globalization and reinforced by technology has mathematical approach and typically overlooks the local and regional connotations with an interpretation as capacity to build anything everywhere virtually disregarding nature in every sense. The narrative of traditional urbanism of Jaipur begins with building with nature rather holistic, evident from approach to design, planning strategies, planning policies translated such in lifestyles of Jaipur from social, environment, to economy with cultural heritage as its anchor for centuries on.

Summing-up the contribution of selected indicators: Environmental: Water and waste; Physical: Land, Transportation; Social and Economy [2] for traditional urbanism of Jaipur is as follows:

6.5.1 Environmental Indicator: WATER

The historic city laid down as per the original master plan; with the east–west axis the natural ridgeline for the site. The grid–iron street pattern was designed that ensured rainwater to be drained with gravitational force from tertiary to secondary to the primary. The water was drained on either side of the east–west axis; in the northern direction channelized to Jal Mahal Lake whereas the water drained in the southern direction was utilized for irrigation purposes later Ram Niwas gardens. The Chauper's and the streets were the key open spaces in addition to the internal courtyards within the chowkri's. The rainwater from the courtyard was drained for recharging the wells in large haveli's while for small residences water was drained off on to the street. With laying of building services of water supply, waste disposal, electricity supply

to communication network has been challenging for secondary and tertiary streets being narrow.

Jaipur developed and grew despite the limited availability and brackish quality of water. Among the contemporary water supply the original sources of water are continuing i.e., Amanisha with land alongside to be developed as green area and recreational zone is acknowledged for action [4]; Ramgarh lake and other sources augmented such. The quality and demand were and are jointly worked on by Public Health Engineering Department and Jaipur Municipal Corporation for improvement of infrastructure and reinforced by programs from the central government i.e., Atal Mission for Rejuvenation and Urban Transformation (AMRUT), Jawahar lal Nehru urban renewal mission and so on [ref: Appendix 1].

The narrative for limited water availability began with the initial period from Amanisha and wells but after Ramgarh dam the availability of water improved substantially during early nineteenth century responded to the urbanizing city. While the original source of water from Amanisha continues till today and is being supplemented by water from Ramgarh, which with time got reinforced from other sources i.e., Ramgarh lake and other contemporary sources of water supply by PHED. During the initial time period the ground water was tapped, as management of water was high priority, as they wanted the city to be established at the earliest. Kund's were built e.g., Saraswati kund at the western edged chandpol; additionally Kund's were built at the Chauper's connected through an aqua duct; this entire network was the source of water for the city, water from these Kund's was manually carried to their respective houses. British initiated individual water supply network and maintained of the quality of water that continued about 125 years, whilst the system was upgraded, additionally with re-densification and migration the demand increased. In the recent past the residential constituent decreasing, with workshops, commercial activities mushrooming along all hierarchy of streets has impacted the water requirement. Further the width of the streets is a challenge for installation and maintenance of the pipes affecting the efficiency of the networking.

The quality of water was and continues to be brackish till date [2, 7]. Ironically the quality of water being brackish never deterred the growth and development of the city; as no major health problems were registered except once [1905–1917] in time span of 279 years. Although the attempts were insufficient to take care of the quality of water but typically addressed by the traditional food habits for example: regular consumption of red chilies in every day meals counters the impact of brackish water; while new technologies by PHED, RUIDP, JMC, etc. are in place. Production of indigenous crops by the local population was an integral part of the traditional food habits and the norm continuing, as with limited water the yield is manifold. Noteworthy is that during the economy getting stabilized the agriculture produce despite the brackish quality rose with adequate management inputs and also turned out to be financially lucrative as well. Both the ground water and rainwater was tapped to augment the required demand. Since the inception of the city rainwater harvesting was recognized [Talkatora in the Sarhad chowkri and Jal Mahal] that was sustained by British [1883] and continuing. Drainage of rainwater from Aravalli's to Jal Mahal

Lake was and is uninterrupted with rainwater harvesting continuing facilitated by the master plan prohibiting stone quarrying and any type of construction in the Aravalli's.

Per Capita Consumption was low due to limited availability of water which was altered when the land use started changing especially around from 1840's onwards the commercial activity saturated along the primary streets, in addition to the four initially designed. Once the main streets along the east–west axis and the north–south axis thrived; that the spillover started happening on the secondary streets and so on. The independent India observed a paradigm shift in land-use such that the crafts consuming greater quantities of water moved out of the historic city making way for other commercial ventures that required less water i.e. textile printers replaced by publishers as Jaipur grew as an educational hub, a change in land use that proved to be sustainable. The city has sustained with regular water supply @ 110 lpcd, which was augmented 180 lpcd to be increased to 215 lpcd to align with the national building code; norms that are nationally implemented considering with varying geographies' and climate the water demand varies and Jaipur responded till the norms are in place. A significant learning is that its time to relook at the standards and norms and need to be context specific and with traditional urbanism the thresholds may be arrived at such.

Thus optimum consumption of water as a resource by the local population was essentially propagated by the traditional lifestyles strongly reinforced by religion. They lived on locally produced food grains and vegetables. Vegetarianism was key word; although exclusive vegetables were specially grown for the European astrologers visiting the king but the farming continued on, for the British; as a gesture of Indian hospitality. The traditional lifestyles charted for optimum usage of water largely due to limited availability. The migrant population has adapted themselves to the traditional culture, evolving and continuing it for centuries known as Jaipurians.

6.5.2 Environmental Indicator: WASTE

The local population due to strong religious were basically vegetarianism thus the waste produced was less in quantity and mostly biodegradable. The streets were regularly cleaned for dead animals, other wastes regularly by the local adminis-tration. The use of plastic bags is a major cause for choking the drains for which the local administration took stern action [8]. The quantity of waste produced has doubled in the past hundred years gradually increased from 0.36 kg/person/day to 0.45 kg/person/day to 0.60 kg/person/day [9]. Despite the type of waste the quantity of waste produced hasn't increased that much when one compares with the cities of the same scale.

Initially the waste was collected manually typically by the lower caste of the society. With the city urbanizing the quantity of waste increased while the British introduced tramway that plied along the city wall with wagons that carried the waste that was eventually dumped on the periphery of the city [Sodala]. The independent India observed transformations in land use and re-densification and with that both

the quality and quantity of waste increased but timely SWM measures were taken up [10]. Narrow streets are a major limitation for the modern vehicles to pick up the waste. Conventionally the waste is dumped on to the edge of the streets or at the intersection of the streets and picked up at the wee hours such that the space can be used for other activities during the day. Construction of public toilets at the Chauper's' facilitates the all especially the tourists'.

Impact of urbanization is resulting in increasing commercialization, reducing the residential component within the chowkri's for example in Vishweshvarji ki chowkri: creating Gaddi's the workspaces equipped with technology that are consuming high energy and producing waste much faster than the traditional ways of production. Urbanization, when reinforced with technology, lifestyles changes and densities have multiple impacts on both quantity and quality of waste produced. This impacts the air quality, visual experience, social capital, and rich architectural heritage among others.

6.5.3 The Physical Indicator: LAND

Mixed land use is inherent to Jaipur and with urbanization the chowkri's grew consistently. The nature of commercial activity was largely local handicrafts; daily needs of the locals and for the tourism sector. Incidentally home tourists are more than the international. The concentration of tourists is more pronounced on Jauhri bazaar, Bapu market, Badi chauper Chaura rasta including Hawa Mahal, Janter-manter and the city palace. Conventionally the traditional handicrafts are spilling over to the secondary streets along with daily needs, as primary streets catering for tourism. The main streets also have multiple use of the space for example the Jauhri Bazaar Street at the early morning hours is also used for whole sale trading of jewels/stones or for wholesale flower market on another street as so on. With the world heritage status strategies and decisions for conserving the traditional urbanism is central. The elevational control by municipal authorities along the main streets for the rebuilding activity; thrust on colour, building material to acknowledge the rich architectural heritage. The social hierarchy of the chowkri's is the determent for the real estate prices. i.e. business and Brahmin community fetch higher prices for their real estate as compared to other groups. Further there has been uneven distribution of amenities within chowkri's conventionally governed by the social group that it inhabits [11]. Real estate value have a direct impact of ownership, mostly the ownership has family lineage; reinforcing the social homogeneity for generations. If at all it changed hands the migrant group too belonged to the same social caste. Further due to multiple ownerships the rebuilding activity is a challenge a blessing in disguise for the built morphology continuing are often self occupied as well. The continuity has been the order for centuries; a note worthy aspect is that the four chowkri's which were developed initially observe the order even today. As the city grew the commercial activity within the historic city expanded with only shops built along the city wall without residences and retail activity formalized by municipal authority.

This shops were leased out to the migrant population of 1947 partition essentially Hindus, Sikhs, Muslims etc.; a dimension of migrant population integrated with the local community. Transforming the city walls for such developments within and outside the city walls ensured a seamless transition integrating the city as a whole thereby reduced the pressure within the historic city.

During the various time periods till liberalization policy by government of India (1991); the process of re-densification was gradual which helped in integrating the transformations and changes such that they became an integral part of the historic city. This pace of development was the essence for the city to sustain itself for years and statured with an average density within the historic city is about 240–300 persons/acre. Interestingly, exposure of western values was a regular feature with Sawai Jai Singh keens interest in astronomy and frequently invited renowned astronomers from Europe; followed by the British and currently the Global culture. During those times exposure was more for exchange of intellectual ideas limited to the king and his think tank.

The distribution of densities among various chowkri's as per Census data indicated consistent growth within each of the chowkri over the years, reinforcing the settlement pattern of the city. Majority of the houses are in livable condition as they regularly refurbished with locally available materials. The number of individuals per household was higher than the national standard within the cities as that is lifestyle of traditional community. Corresponding to the growth of the city, the city's infrastructure also grew for community facilities like education, health initially supported by the religion, gradually emerged as centre of repute for institutions. These institutions acted as catalyst for re-densification. To facilitate tourism sector some government offices are relocated outside so as to reduce the pressure within the city [4]. Work areas are within the walkable distance continues to be advantage of the historic city. Continuity of the commercial and business activity within the walled city; especially along the city wall a gradual transition is a significant as it integrates with the rest of city outside the city walls.

Jaipur was designed as a compact city with streets and courtyards as open spaces with Chauper's as large public open space. The king's and his clan enjoyed large open spaces located in Sarhad chowkri that housed the palace complex. The courtyards largely contributed as interaction spaces for the family members as the space was thermally comfortable due to stack effect. Although the transformers installed in the open spaces affected the usage of open spaces i.e. pedestrian movement etc. Chaupers are the only large open spaces located strategically at the intersection of primary streets, for large gatherings for festivities at the city level. These originally designed open spaces responded with time from congregation of people for celebrations and festivities to location of water tanks to a landmark space with facilities for tourists including as a roundabout for hybrid and pedestrian movement as well. Chauper's houses temples, institutions and informal bazaars etc. such functions adds value to the space making it lively and contributes for place making for the local population Most of the infrastructure facilities were upgraded regularly with latest technologies. The layering of services was done both above and below the streets; affecting the

visual experience of these streets considering the original street pattern of the historic city has continued to be consistent [12].

The major environmental impact has been for deforestation towards east thus soil erosion and mining of building stones and salination of water in west and south west: where majority of the Jaipur is developing. However the walled city workforce 51,841 [46.42%] share of population of the walled city is 32.67%; major contributor to the city's economy, nearly 30% people inherited family trade nearly 47% walk to the place of work Further recommendations to decongest walled city by relocating wholesale activities outside city walls and land along Amanisha to be developed as green area/recreational zone. The world heritage status of Jaipur (2019) has reinforced the strength of the pink city, despite urbanization the natural landform and the gradient continuing as per the original plan of the city. Aravallis, a natural feature has continued since its inception; a picturesque hilly backdrop that adds to the visual experience from the streets of Jaipur.

6.5.4 The Physical Indicator: CIRCULATION

The road network has been integral for the growth of the city since its inception at intra-city level and intercity as well as that facilitated the transportation of traditional handicrafts to other parts of the country including sending them overseas [12]. Road building was on the agenda by the administration be it the king's or the British, such that alternative routes were proposed to ensure continued trade despite political instability. Tourism sector encouraged with better connectivity with Delhi and Agra often referred as the golden triangle of northern India must for the foreign tourists. Until independence, the national highway passed through the historic city (through Badi chauper) which in the recent past has been diverted through a bypass and acknowledging the tourism potential of the historic city. The grid-iron pattern of the streets continues as designed and constructed with stone thus largely maintenance free. The booming economic activity spilled over commercial activity in the secondary and tertiary streets. The servicing of the workshops and shops are largely done by manually or by cycle rickshaws that has slow pace and carbon free.

Hybrid mode of transportation existed and continuing; interestingly the mix of modes varied for the various time periods. Despite the hybrid modes the speed was similar whereas the contemporary modes the vehicles may be better equipped for speed but quantum of traffic being so large that the speed is quite slow. Two wheelers and automobile mode of transportation created parking problem and reduced the street widths and often walking proves to the fastest way to travel across the city. Due to practical problems the system of navigation within and outside the city is dealt with differently. Tourists' cars and buses have parking lots outside the city gates [13]. Further the experience of walking through the streets the perception of the rich architectural style of the compact city with the natural backdrop of Aravalli's and culminating the journey at chauper with Hawa Mahal is a joy. Cycle rickshaws are an important mode of transportation for easy accessibility, offers employment to lower

section of the society and environment friendly too. Two wheelers are extensively by the local population, while LMV/MMV is used for trading, services for handicrafts. The scale of the walled city was designed as walkable city with pedestrian movement as the key mode of circulation and continuing. Covered walkways were provided to cut out the summer Sun so as to provide thermal comfort to the pedestrians. The slow pace of pedestrian movement ensures the passer-by to cherish the rich experience of traditional urbanism (Figs. 6.17 and 6.18).

Tourism pedestrian movement added to the local pedestrian movement but has been responded through allocation of retail activities. Typically the tourists walk along the primary street entering through the ceremonious gateways along the shops of the city walls and primary streets to the Chaupers; mainly due to the sale of traditional crafts and ethnic products along the route. The scale of the historic city is such that pedestrian movement is the key and is the fastest way to navigate through the busy bazaars.

Fig. 6.17 Circulation of tourits in streets of a chowkri (thickness proportionate to the intensity of circulation)

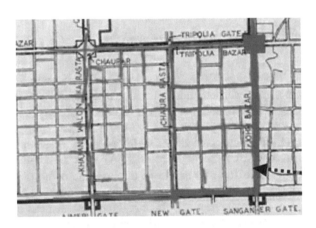

Fig. 6.18 Mapping of key tourist circulation in walled city of Jaipur [2: 168]

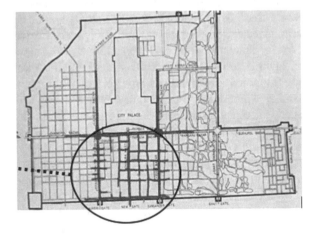

6.5.5 The Physical Indicator: TRADITIONAL URBANISM

The buildings in the city observed a framework outlined by architect planner: Vidhyadhar derived from ancient Indian planning texts. Prior approval of building plans was a pre-requisite thus basic dimensions relating to streets, plinths, entrances, system of fenestration, etc. were standardized including building materials and construction technologies as well. Mixed land use standard for all chowkri's often as low-rise high-density. The detailing of the buildings typically reflected the caste inhabiting the chowkri. All buildings were courtyard houses, built with red sandstone in lime mortar. The cultural heritage of Jaipur pivots around the socio-economic structure that was responsible for growth and development and stabilized such. Public buildings i.e. religious, administration and institutional buildings are strategically located and contributed to enrich the traditional urbanism, often acted as landmark too. The indigenous technology and the locally available material was the order for centuries initially it was a code to be abided, with time got integrated as a part of the lives of the local population. As the city was built over a period of time the individual expressions did get reflected but the overall uniformity continued. The consistency was more pronounced along the main streets compared to the secondary and the tertiary streets but the common building material ensured the development of rich architectural heritage, which was and is the strength of the city with visual coherence making it a unique experience. The uniform look continued earlier as a way of life and currently through legislation especially with world heritage status.

The journey of Jaipur to pink city is about a century old but currently the civic pride of Jaipur. Prior to the pink colour Jaipur had already established its reputation as a well-designed city with passing by travelers eager to have a look at the meticulously designed streets. The pink colour reinforced the image and got recognized for this unique feature. Jaipur grew as a centre of trade and learning with a strong religious and political setup, so over two centuries a large body of literature in the form of manuscripts, documents etc. has been collected in the temples as those were the initial centre of learning [2].

6.5.6 The Social Indicator

Jaipur celebrates the distinction of building a social capital with migrant population that continued at the time of partition and independent India. Initially Brahmin, Business community, craftsmen and others were invited to settle here which with time evolved its own culture in harmony with the context. The Brahmins cemented the religious base, the business community facilitated the finances for the craftsmen to build their businesses constituted the majority of the population and there were other required for the services typically manual labour. The core population continuing till the saturation occurred (about 240 persons/acre) within the mixed land use residential chowkri's and at the time of partition the migrants hailed were Sikhs, Muslims

etc. broadly non-Hindu but were facilitated for retail and commercial activities but resided outside the city walls. The key observation is continuity of optimum resource consumption, behavior response for energy use, culturally driven lifestyles among others inherent to traditional urbanism; significant social connotation that impacts carbon footprint. In the recent past the migrants basically comprises of workers for the craftsmen from the neighbouring villages for job opportunities. They often stay in close proximity to work place and therefore settle in the respective chowkri's. This deliberate socio-economic connect is the strength of the city and even with economy booming the social aspect was equally important. With time the socio-economic capital reinforced by 'religion' nurtured the traditional lifestyle for Jaipur. The 'Social capital' owes its attributes to the core resident population that sustained the traditional lifestyles by continuing to live there; indirectly limiting the commercialization in various chowkri's. Traditional urbanism of Jaipur is a reservoir of knowledge and experiences of socio-economic and environmental interactions that are sustainable and may not appropriate to acknowledge them as best practices for the context as well. Historic city of Jaipur is a true surviving engine of the rich cultural heritage. The local population is the basic denominator to achieve sustainability for the historic city. The socio-economic aspect of Jaipur was and continues to be its core strength with tourism sector augmenting the economy for Jaipur city at large. The upholding of traditional lifestyles by the local population is extended to the tourism sector as well. Ironically the traditional lifestyle has become a product to be capitalized on and introduced to the tourists such. So long as it is in vogue the continuity of the traditional cultures is assured but vulnerable if the core population gets diluted. Value addition is one of the main reasons for consistent demand of Jaipur handicrafts both by the home and foreign tourists; as the craftsmen and business houses patronize through technologies and market responses (Fig. 6.19).

The social composition of Jaipur began with few villages that existed on the selected site but that constituted only a small portion of the population, with majority of the local population migrated from the neighbouring areas i.e. Jodhpur, Agra, Delhi etc. As directed by the king Jai Singh, most of them were businessmen and lesser number of Brahmins. They were essentially Hindu with few Muslim who had been loyal to the king, but no Muslim population was invited to settle unlike the Hindu's. Thus a strong Hindu social setup was inclusive to the planning of Jaipur: the chowkri's opposite the Sarhad chowkri [Vishweshvarji ki chowkri and Modikhana] were allotted to the businessmen and higher officials of the kings interspersed with temples at strategic locations such as along the main streets, corners, next to the entrance gateways, at the Chauper's etc. Gradually the serving class, workers moved in for job opportunities and settled in Topkhana Desh and Purani basti. The religious structures were evenly distributed among these chowkris too. Thus the Hindu religious base was omnipresent, provided a strong framework for the local population. The Hindu community's broad classifications with their sub-castes were predominant to migrate; the profile is similar for other castes too. With time, a wide range of castes and sub-castes saw a reduction in the number of the castes. This reduction implies stable social order responding to changing economic conditions but the consistent religious base continued to grow its roots deeper with time. The Hindu's

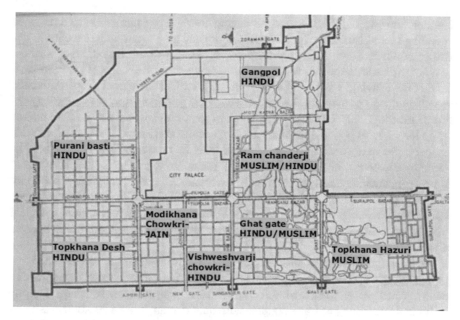

Fig. 6.19 Distribution of communities' chowkriwise [2: 130]

were well exposed to the ancient Hindu scriptures, literature etc. due to the political patronage coupled with the strong religious base. Joint Family was and is the basic socio-economic unit housed within a haveli the conventional habitat, with a common kitchen. The central courtyard was the space for social interaction housing common functions and facilities like drinking water, kids play area, washing and drying of clothes. The social and the religious aspects ensured the continuity of the traditional values and lifestyles. Currently the social composition is a mix of original migrants and people from various ethnic groups: Muslim, Sikhs, Christians etc. Of which some of the wealthy business families have moved out for better infrastructure facilities, open spaces, parking space but have retained their ownership status for identity, sense of belonging and sometimes for real estate as well. It is significant to note that the Hindu religion is continuing its dominance since the inception of the city. Jaipur was exposed to other religions and ethnic communities with time but the Hinduism continues to dominate. Additionally Jainism: a Hindu faction, though in minority were/are held in high esteem, as they are the think tank for the city.

 The king encouraged scholars and learned in his courts. He had a keen interest in Astronomy thus he built a sundial of high precision an invention of par excellence that many scholars from Europe came down to Jaipur to exchange notes on the same. Education was close to the Jain community and took up initiative to introduce formal learning. With temples, as the centre of learning considerable emphasis was on the ancient Hindu scriptures with Sanskrit as the main language for the learned. Gradually the schools were built, strategically located on the main streets and at the chauper's. Initially children belonging to the higher castes came forward for formal

learning however with castes system diluting children from other castes too started attending school, initiated with Jain community and king's patronage education. The British continued the thrust on education, as they were the first to start a school only for girls with lady faculty especially to teach English. Parallely the traditional handicrafts thriving; a wide range of learning institutes developed from vernacular to indigenous to accounting for gender etc.; that genuinely spread the message of formal learning. This diversity in education system proved ideal for socio-economic set up for the local population then. After independence Gandhi's effort to formalize standard system of education at the national level Jaipur too aligned such. While the economy driven by the local crafts needed hands on experience, over the type of formal education that was imparted at the schools. After taking primary/secondary education [learning the 3R's] they took to apprenticeship with the master craftsman while some branched out to be independent entrepreneur. This system is prevalent even today; whereas the students seeking higher education move out of the historic city.

Health and well-being is directly related to the life style of the people. The local population of Jaipur was largely vegetarian with drinking being a taboo and eating locally grown proved to be healthy, reinforced with religion [Vaishanvism]. Despite the limited availability of water coupled with quality being brackish; water was never the major cause of epidemic in Jaipur, deaths occurred due to Malaria, Cholera: 2296 deaths in 1900, Plague: 3459 deaths in 1908; 4822 deaths in 1910; 3620 deaths in 1912; 4417 and 1191 in the year 1917 and 1918 respectively; smallpox taking its toll as 1367 in the year 1877 and 1451 in the year 1880 being the worst. The time period 1875–1920 when Jaipur was affected the maximum till date nothing of that order has been registered. Vaids and Hakims were accredited for curing health problems. As per Boileau reports in 1835 the number was fairly large and the trend still continuing unless and until the disease is beyond control then conventional Allopathic are resorted to. 1844 saw first medical dispensary built by the regency council attached to the British administration, which played an important role then. Jaipur was one of the first one to build an Ayurveda institute followed by others in the state. Currently the historic city has centers of treatment from Ayurveda, Allopath, Homeopath, Unani etc. giving the local population the flexibility to opt for [12].

Women and culture are almost synonym words in a traditional Hindu family. Such is the reverence that a girl child is acknowledged as an avatar of a mother. The queen had a major role to play to lead the women folk of the city; looked upon as a symbol of motherhood, even today the 'Rajmata' is looked up to and followed by. Women primarily responsible to inculcate family values, customs at an early age through rituals, practices, arts, performing arts to day to day living and extends in all aspects of their lives adequately supported by men and elders in the family. The worth of the values has been recognized by generations and continuing and with exposure to education and technology a rational attitude has emerged that has helped to appreciate their culture and its strength even more. Jaipur has been a centre for Hindustani classical dance i.e. kathak and music known as the Jaipur gharana style which has evolved over centuries. The tourism industry like the traditional food has patronized the arts too and showcased through annual festivals during the peak

tourism season. This display of intangible cultural heritage is an integral part of the local population. The Muslim women specialized in fine detailing for lacquer works; minakari etc. these traditional handicrafts products were worn by women thus the making and selling too was done by them, a typical Islamic connotation that restricts women to interact in public but when limited to women was acceptable; this gave the Muslim women to participate in economic activities and contribute as well a trend continuing. Conventionally with men folk exploring better job opportunities outside the city they take charge and manage the business. They get introduced to the craft at an early age so they are at par with the skilled labour.

Security has contributed for building of Jaipur and continues to deliver such. When the city was set up business communities were invited from Delhi, Agra, Jodhpur, etc. who were constantly exposed to political unrest due to raids of Marathas and Pindari in these cities. For them an option of a city where security was assured proved to be welcoming. Also the incentives offered at that point in time by the king for the business community were lucrative thus ended up becoming an ideal destination for them to settle down. The security of the women was well cared for and was the basic premise on which the city grew and flourished. Timely measures were taken up to ensure security i.e. officially gate passes were issued for the movement of goods as a security measures by the king when railways was introduced by the British. The social setup strongly dovetailed with the religious backdrop; guarded the behaviour pattern of the locals and ensured security at large. Besides the supremacy of Hindu's over other ethnic groups ensured that they dominated the rest, this deliberate hierarchy assured of the peace within the city thereby security. The shear strength of the local population that despite communal riots and bomb blasts in the contemporary time period recuperated from such set backs.

6.5.7 The Economic Indicator

Jaipur's economy grew consistently and stabilized. A significant feature of Jaipur's economy is it's strong socio-cultural base through traditional handicrafts key for the economy. The Jaipur traditional handicrafts rank high for country's export due to their uniqueness and regular value addition being their unique selling point. Economy, one of the key pillars of sustainability becomes crucial with capitalist approach especially with globalization propelling societies for consumerism, often quantitative as the gauge of progress. The economic sustainability has been one of the major contributions for the city to thrive for centuries and serves as the CBD for Jaipur and the state of Rajasthan. The initial time period for economy and trade to flourish, finances are required which was made available at low rate of interest by the king. Trading and Banking was formally delineated along the main streets and the Chauper's that ensued the mushrooming of commercial activities and this combination encouraged the growth of the city's economy. Each sub-caste of the community was allocated plots with in a specific neighborhood of their caste, divided as per the chowkri's. The funds were made available, usually at minimal rates for them to build their houses

and workshops. Whereas in cases of functions related to religious and social concerns the interest was waived on principal amount. The Royal tax each year gave promotional incentive for example if they built earlier, the tax reduced etc. Other option which the traders had was as per an official order that informed that houses would be built for them and they should pay for the buildings in installments by sending 10% of their annual income to Vidhyadhar: the architect for the city. Therefore, the way the city evolved is quite unconventional and thus the city was built within the lifetime of Sawai Jai Singh; his dream vision. This initial period saw lots of building activity with production of local food grains to feed on that provided security for the volatile political conditions that existed then. The king supported banks until they became self-sustaining. The moneylenders and the banks supplied funds to Jaipur and the towns close by; such was the rate of transactions that it was compared with the Lombard Street of London [12]. With easy access to finances, the production of handicrafts grew into a small-scale industry initially catering for the local markets and gradually with increased production was exported as well. To assure continued trade of the traditional crafts alternative trade routes were worked on so that in case of political unrest optional routes could carry on the trade uninterrupted. This deliberate planning helped the traders to expand their businesses and as an expression of reverence they build lavish haveli's that exhibited their status and money power. Thus dynamics of money was well integrated with the design of the city adequately patronized by the king and indulged by the traders. Most of the handicrafts were borrowed from parts of northern India. When craftsmen were invited from their native places, once settled, they became popularly known as the traditional handicrafts of Jaipur. These craftsmen worked on the original craft evolved it to adapt for the context of Jaipur. However, the process of adapting stills continuing responding to both the national and international markets.

The inquisitiveness to see a city with a uniform look, rich in temples was unique. When Marathas were frequently raiding the city having parked on the outskirts of the city, the warriors expressed the desire to see the city, which was well planned with uniform bazaars. Also the kings invited people from other states to visit Jaipur on festive occasions, puja celebrations etc. to showcase the beautiful city. Although Jaipur was/is recognized as the pink city only a closer look at the city, the onlooker perceives the joy of the city beyond the pink colour; the total ambience and the experience of being a part of such environ was exhilarating and unique "I have seen Jaipur, now I can die.........one of the three most beautiful cities in the World; others being Venice & Paris." ["The filigree city" by Max Lerner, published in New York post; 1960]; just demonstrates the strength of the traditional urbanism of Jaipur.

The growing economy transformed the land use within chowkri's reducing the residential component thereby affecting the social capital of the historic city, evident in Vishweshvarji ki chowkri. Simultaneously proved convenient for the buyers, exporters to explore within the same chowkri that resulted in real estate prices escalating as highest in the walled city when compared to the real estate prices outside the city walls. The change in land use increased with liberalization policy by government of India boosting the local and national economies. However, the transition from residential to commercial with added pressure of population growth

through re-densification and migration. Except for Vishweshvarji ki chowkri, the other chowkri's spill over of the commercial activity curtailed for few secondary streets and most of the tertiary streets continue to nurture for residential activities.

6.6 Continuity of Traditional Urbanism of Jaipur

The historic city of Jaipur has sustained and with world heritage status now mapped at the global level too. Traditional urbanism of Jaipur is an integrated inclusive approach to build a city. Cities are for people by people about people and these very people that build societies' with cultures. In this broad canvas the foremost is the context where the city is to be built as that delineates the set of natural resources accessible, available and the climate. In this dynamic the aspect of economy just weaves the city's tapestry evolves with the depth of detailing; implying the number of dimensions explored such. Significant is that nothing is viewed in isolation and it is this very premise that traditional urbanism differs from the contemporary approach now decades old; that is in place with global economy the sole driver for growth and development across the world. Global economy paved the way for parallel approaches; each one focused and typically under pinned by technology often lacked the comprehensive intent at large. However technically sound the focuses has been for the respective pillars of sustainability but fell short to deliver. Environmental decay probably the early sign that alarmed the mankind and measures to mitigate the same were in place by respective nation based on their stage of development and resources available from financial to technologies. However the initiatives created isolated sustainable pockets for the sustainable whole planet earth. Anthropocene highlighted the domino effect wherein the linkages with each of the pillars of sustainability and their sub aspects concluded with people. Environment, Economy and Social soon address for Culture i.e. energy use related to energy demand to sources of energy parallel to contemporary lifestyles that are high on energy through gentrification percolated to societies and based on their respective cultural that determines their behaviour impacted the energy use thus source of energy may be technical but social connotation determines the demand and so on. Traditional urbanism outlines a structure typically govern by culture that is created, evolved and nurtured by people that aligns with the lifestyle of the societies. These very societies over time evolve as communities rich in cultural heritage inherent for all the living traditional urbanism.

Jaipur has a unique disposition for a set of initiatives that have stood the test of the time and exclusive as well; as to build the city was the vision of a king to do so in his lifetime considering it takes decades for city's to be built. The intent was executed within a framework designed and outlined as a deliberate initiative for the geographical context. The strength of Jaipur has been that the development was monitored for structured growth of the city. Thus traditional urbanism evolves as a holistic in nature and therefore resilience is inherent for the changes and transitions that occurs with time i.e. in case of Jaipur when economy was to be shaped up agro based society took the lead and with handicrafts sector adequately facilitated by the local administration

the social equity got drafted. Further the culture underpinned by religion cemented the socio-economic value system. This inherent balancing act is typical for traditional urbanism and each of the solutions are geo-context specific for the respective cultural vocabulary. It is interesting to note that for similar geo-context the solutions opted for vary which is the strength of traditional urbanism as the behaviour and responses are culturally driven, something that numbers scientific studies are concluding as building performance evaluation, post occupancy evaluation among others. In Jaipur the socio-economy base has strengthen over years despite the spill over of the city expanding outside the city walls with walled city continuing to be the CBD of the city. The framework of development responded to both transitions due to political, economical, and environmental or technologies reflected as changing needs of the local core population. The political conditions were quite diverse from aristocracy to colonial to independent nations and all through the urbanism continued with the designed developmental framework. So is with economy as well the traditional handicrafts' have evolved with time responding to market forces, technologies for communication to processing of products within the built spaces. Similar was the response to environment largely integrated in the lifestyles of the people that consumed locally grown food grains that required much less water with a better yield; earlier on was a norm now inherent for tourism as well ensures continuity. It's interesting to observe that city sustained through the transitions from economic to social and back to economic such seamless way to address the transitions' was possible due to traditional urbanism of Jaipur.

These layers of growth and development are legible in its built morphology strength of the traditional urbanism. Each of the layers adds to the identity enriching through cultural heritage however diverse they have been for building services to other infrastructure facilities an input for its continuity through globalization. The high rate of urbanization has seen the growth of the city outside the city walls but the walled city continuing to be drive the economy of the city at large. Therefore the continuity of the Traditional urbanism cannot be looked upon in isolation, as it is now a part of the Jaipur city and mutually complementing each other. The layers of growth of the city expanding outside the city walls are legible and adaptability of the designed framework responding to the transformations of all nature are responded such. Research studies have proven the merit of traditional urbanism of Jaipur for selected sustainability indicators in Fig. 6.20.

The polygon highlights the contribution of land and social indicator for the city to sustain. The land indicator stands for the traditional urbanism for its resilience for transformations and changes of all kind. Globalization and technologies propelled a nature of development across the globe dis-regarding the geographies and regional contexts'. Simultaneously the pandemic that is compelling us to relook at the urbanism typologies and how people shall live in future. Exploring the options the traditional urbanism emerges as a probability with immense potential; as it has geo-specific solutions that are time tested and can be carried forward. The key feature of mixed land use combing the work and residences reducing travel developing condominiums that are eco-friendly and sustainable; as the nature of development shall be in sync with the carrying capacity of the geographical context. Its been documented

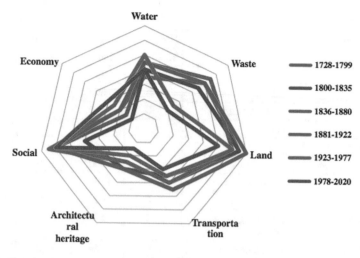

Fig. 6.20 Sustainability indicators for walled city of Jaipur [2: 279]

that the world has a large repository of traditionally rich heritage cities and happen to be located in Asia where the rate of urbanization is high. Therefore it is a huge opportunity to explore these time-tested solutions that may be incorporated with the mainstream development. The built morphology of traditional urbanism with embedded climate responsive solutions as passive systems, practices, traditional knowledge of the respective context, are surly an asset to be explored with global pressures. The term development needs to put in correct perspective and perceived such by all considering developing nations are characterized as less developed may be argued upon with the huge resource of traditional Urbanism, environmental knowledge, culturally rich practices; but the gauge may be difficult to be determined by the statistical figures, considering it's the qualitative aspect the socio-cultural connotation drives the way of living and typologies.

Appendix 1: T1 Professions and Castes as in 1835

Name of caste	Profession	Number of houses		Population	
		Muslim	Hindu	Muslim	Hindu
Aheree	Watchman	0	600	0	3000
Vaid	Physician	0	250	0	1250
Bhet	Poets	0	200	0	1000
Bheel	Bowman	0	80	0	400
Bhangee	Sweepers	0	700	0	3500

(continued)

(continued)

Name of caste	Profession	Number of houses		Population	
		Muslim	Hindu	Muslim	Hindu
Bhura	Pimps	0	250	0	1250
Bhutiara	Cooks	0	600	0	3000
Biloch	Camel men	150	0	750	0
Brahmin	Priests				
Brahmin-Boora	Undertakers	0	80	0	400
Brahmin-Puleewal	Merchants	0	500	0	2500
Brahmin-Dakot	Sextons	0	1100	0	5500
Brahmin-Gor		0	17,000	0	85,000
Brahmin-Kapree	Who beg from Buniya	0	500	0	2500
Brahmin-Keertunia	Musicians and Dancers	0	40	0	200
Brahmin-Khandelwal		0	300	0	1500
Brahmin-Pokhurna		0	300	0	1500
Brahmin-Purohit	Family priests	0	0	0	0
Brahmin-Pourohit	Chaplins of state	0	200	0	1000
Khutria-Pareek	Private chaplains	0	350	0	1750
Khurtia-Sreewunt	Private chaplains	0	250	0	1250
Khurtia-Sunawad	Private chaplains	0	1100	0	5500
Baniya-Beejaburjee	Merchants and shopkeepers	0	1100	0	5500
Baniya-Dusan	Merchants and shopkeepers	0	100	0	500
Baniya-Munshree	Merchants and shopkeepers	0	4000	0	20,000
Baniya-Oswal	Merchants and shopkeepers	0	900	0	4500
Baniya-Siraogee	Merchants and shopkeepers	0	5500	0	27,500
Baniya-Ugarwal	Merchants and shopkeepers	0	5000	0	25,000
Burwa	Geneologists	0	100	0	500
Chakar	Servants	0	450	0	2250
Chapayi	Printers	0	3000	0	15,000
Chejara	Masons	1100	0	5500	0
Chitramee	House painter	0	200	0	1000
Choonput	Lime burners	0	450	0	2250
Chureegur-Ivory	Bracelet maker	100	0	500	0

(continued)

(continued)

Name of caste	Profession	Number of houses		Population	
		Muslim	Hindu	Muslim	Hindu
Chureegur-Lacquer	Munihars	200	0	1000	0
Chamars	Cobblers	0	500	0	2500
Dhoondee	Religious devotees	0	125	0	625
Dom	Horn blowers and Drummers	0	200	0	1000
Durzee	Tailers	0	1200	0	6000
Fakir	Mendicants	500	0	2500	0
Ghasiara	Grass cutters	0	350	0	1750
Goojar	Cow herds	0	500	0	2500
Hizaras	Eunuchs	0	80	0	400
Hakim	Physicians	900	0	4500	0
Jat	Cultivators	0	1000	0	5000
Jogee	Religious devotees	0	350	0	1750
Julaha	Weaver	700	0	3500	
Joshee punchrangs	Religious devotees	0	100	0	500
Jureea	Lapidaries	0	125	0	625
Jutti makers	Tanners	0	300	0	1500
Kaith	Writers	0	2500	0	12,500
Kahar	Bearer of Bagghi	0	250	0	1250
Kahar-Muhra	Bearer of Palki	0	550	0	2750
Kathee	Carpenters	0	300	0	1500
Keer	Basket makers	0	200	0	1000
Khalpeea	Tanners of goat skins	0	125	0	625
Khuteek	Parchment maker	0	250	0	1250
Kumhar	Potters	0	500	0	2500
Kunjora	Green grocers	550	0	2750	0
Kuleegur	White washers	200	0	1000	0
Kulwara	Distillers	0	1100	0	5500
Kushbee-Pathur	Prostitute	0	1300	0	6500
Kusara	Braziers	0	1000	0	5000
Kasai	Butchers	250	0	1250	0
Kuthawa	Woodmen	0	225	0	1125
Lohar	Iron smiths	0	200	0	1000
Mali	Gardener	0	2000	0	10,000
Meena	Thieves	0	200	0	1000
Mirasi	Mendicants	0	150	0	750

(continued)

(continued)

Name of caste	Profession	Number of houses		Population	
		Muslim	Hindu	Muslim	Hindu
Mousalman	Muhumadans	3000	0	15,000	0
Mochee	Shoe maker	150	300	750	1500
Muhawat	Elephant drivers	125	0	625	0
Munihars	Lac workers	200	0	1000	0
Nai	Barbers	0	500	0	2500
Naichagar	Makers of pipe-snakes	50	0	250	0
Balbund	Farriers	200	0	1000	0
Nairia	Refiners and Assayers	0	350	0	1750
Numdia	Felt Ajers	200	0	1000	0
Ogur	Devotees	0	140	0	700
Pewandee	Fruiterers	0	900	0	4500
Puthurphor	Stone cutters	600	0	3000	0
Raegur	Tanners of sheep	0	200	0	1000
Rambaree	Camel men	0	103	0	515
Rajput	Thakurs	0	2000	0	10,000
Ruma	Musicians of state	0	125	0	625
RunaRungrez	Dyers	250	0	1250	0
Salotree	Horse doctors	350	0	1750	0
Shamee	devotees who marry	0	1500	0	7500
Sonar	Goldsmiths	0	900	0	4500
Suka	Water carriers	400	0	2000	0
Tutgur	Canvas makers	100	0	500	0
Topchee	Game killers	0	200	0	1000
Tumolee	Pan sellers	0	300	0	1500
Tuthera	Brass smiths	0	500	0	2500
	Grand total	10,075	68,798	50,375	343,990

Source For SI and ST:I Boileau, Personal Narrative of a tour through the western states of Rajwara in 1835, pp. 232–235

Appendix 2: Interventions for Heritage in Walled City of Jaipur

Organisations involved—year	Interventions in Walled City of Jaipur
The Municipal Council; Jaipur—1970	Ensure continuity of traditional urbanism character-Specific recommendations outlined streetwise so as to maintain the architectural character especially the primary streets through legislation with accountability for quality of workmanship
Master plan for Jaipur—1972	Master plan was prepared with thrust on: • Traditional architecture to be preserved and protected • Reconstruction to be under taken to cater to the local community
Jaipur Municipal Corporation—1977	Public participation for inclusive approach through Seminar on Jaipur's Development "developing the walled city"
Ford Foundation and JDA—1985	Study of Heritage Buildings within walled city and identified 300 buildings for conservation as due to lack of legislation, some of them have totally changed or are demolished
Master plan for Jaipur—1991	Thrust areas for walled city: Government offices to be relocated in and around the walled city to facilitate extension of commercial activity and To stop the stone quarrying activity on Aravalli's
Deptt of Tourism—1995	Conservation and Restoration works on heritage structures Proposals made
INTACH: Jaipur chapter and CTP—1997	Jaipur: urban heritage documentation and project identification study-A comprehensive report on historic city of Jaipur Developing institutional framework for interventions. Public sector interventions, Private sector interventions, perceptions of stakeholders, recommendation for demonstration n project
Master plan for Jaipur—2011	Master Plan addressing needs of the walled city Major thrust on • Environmental balance: both for manmade and Natural resources, Sewerage system, and • Guidelines for Urban renewal plan for the historic city • Preparation of Data base and Conservation
INTACH and JVF—2001	Heritage walk in the Chowkri Modi Khana • Walks are still continued by JVF but infrastructure conditions in the walk area have become worse
ADB and JMC—2001	The Asian Development Bank project of infrastructure—Reuse of wells and repair work in the walled city/installation of sewage pipes • Some works were executed but not very effective

(continued)

(continued)

Organisations involved—year	Interventions in Walled City of Jaipur
JMC and JDA—2002	Multi-storeyed parking options within walled city • Have not been implemented as yet
RUIDP—2002	Thrust for improving infrastructure facilities • Solid waste management for the whole city • Traffic and transportation system and • Environmental: Air, noise pollution
JVF—2002	Jaipur Heritage International Festival Successfully continuing and now has UNESCO endorsement
Asia Urbs—2003	A revitalization proposal for Chowkri Modikhana • Well researched and documented but not executed
INTACH and JVF—2004	Heritage walk in the Chowkri Modi Khana • Walks are still continued but infrastructure conditions in the walk area have not been maintained
JNNURM—2005	Development of an Integrated approach accounting for all stakeholders from governing, beneficiaries, NGO's etc. • Tourism, Trade and Commerce and Traditional crafts • Investment on Infrastructure: SWM, Traffic, Urban Heritage, Conservation
Heritage Management plan—2006–07	Conservation projects in Amber fort and Hawa Mahal and 1096 listed structures
Heritage Management plan—2007–08	Conservation projects in Jaleb chowk, Janter Manter and Gaht-ki-kuni
Architectural control guidelines initiated—2009–10	For Primary streets and Janter Manter as World heritage site
2011–13 Jaipur master plan—2025	Heritage management plan included in Jaipur master plan 2025; Conservation of 3 main streets, Janter manter buffer zone Amber fort inscribed as World Heritage Site—part of 6 serial hill forts of Rajasthan
Jaipur Smart city plan—2014–20	Heritage walks Janter manter interpretation centre, conservation of remaining bazaar streets. 2015 tentative UNSECO creative city and 2019 Jaipur inscribed as World Heritage site. Jaipur Smart city plan includes walled city Heritage management plan 9 best practices 20,150 and conservation of primary streets

References

1. CDP Jnurm 2006
2. Sharma AK (2012) Sustainability of living Historic cities in India; case study walled city of Jaipur, doctoral study, School of Planning and Architecture, Delhi
3. Dennis R (2015) Conservation and sustainability in Historic cities by Dennis Rodwell 2015. Available on https://www.researchgate.net/publication/296183497_Conservation_and_Sustai nability_in_Historic_Cities
4. Jaipur master plan 2011/2025
5. July 2020 JAIPUR, A planned City of Rajasthan by Alain Borie, Françoise Cataláa and Rémi Papillault, altrim publishers India. ISBN 978-84-949330-1-1
6. Roy AK (1978) History of the Jaipur City, published by Manohar Publications, New Delhi; printed at S. P. printers, New Delhi
7. (1730) An ancient Indian text; Ishwaravilasa Mahakavya
8. Gulabi Nagar (2001) Rajasthan Patrika; Daily Newspaper from Jaipur Weekly Articles: Series of 20 Articles
9. (2002) Rajasthan Human Development report, Government of Rajasthan
10. JMC: 1977, ADB and JMC: 2001, JNNURM: 2006 and Master plan 2011, 2025
11. Survey by University of Rajasthan & JDA 1965 & 1985; Rajasthan development report by the UNDP: 2002
12. Annual PWD reports of Jaipur :1868; 1878; 1871; 1872; 1873; 1874; 1875; 1876; 1877; 1878; 1884; 1896; 1899; 1902; 1905; 1916 & 1919
13. Rajasthan Urban Infrastructure Development Program. https://urbanslbruidp.rajasthan.gov.in/

Chapter 7
Climate Responsive Traditional Urbanism of Jaipur

7.1 Building Climate Responsive Typology

The climate responsive typology of Jaipur was shaped up by the political situation then that determined the location of Jaipur patronized by the king for the local climate. The geo-political contextual base with the socio-economic framework that was designed developed and translated in the built morphology constructed with locally available building materials and indigenous technology that was largely labor intensive. The walled city of Jaipur has unique distinction nationally and now globally as well. The continuing robust tourism status with the World Heritage Status 'acknowledged the outstanding universal value of traditional urbanism with cultural heritage for the walled city of Jaipur.

In the recent past Europe built the narrative on culture and sustainable development which was strengthened by evidence-based research and indicators but only 6% of case studies have conceived as holistic study covering economy, social, cultural, environmental and translated such for the physical fabric of built environs. However even these limited scientific studies are insightful for traditional urbanism of varying geographical contexts for their sustainable practices and systems in place. There exists a large number of traditional historic cities and towns globally and all nurtured by their respective local communities for the local ecosystem and thus strongly contextual. The database till date exists for the ones that are listed as world heritage sites, considering there exists a large repository of the same especially in Asia, Europe and few other nations.

To understand the strength of the walled city of Jaipur the narrative needs to be traced since its inception and continuing for centuries on. The original master plan designed by Vidyadhar outlined in detailed as a dossier with the key salient features as:

Figure 7.4, 7.5, 7.6, 7.19, 7.20, 7.21, 7.22 and 7.24 were drafted by Sonia Pradhan for the Author exclusively for the publication of this Chapter.

© The Author(s), under exclusive license to Springer Nature Singapore Pte Ltd. 2022 195
A. K. Sharma, *Traditional Urbanism Response to Climate Change*,
Advances in 21st Century Human Settlements,
https://doi.org/10.1007/978-981-19-4089-7_7

- Compact layout planning with natural backdrop of Aravalli hills in the layout of Grid–iron pattern for streets with mixed land use.
- The social hierarchy was translated in the layout plan of the city with higher castes and higher administration officials adjacent to the king followed by the other castes and so on.
- Open spaces within the compact planning were courtyards, streets and the intersections of main streets that were designated as the large public open spaces for cultural, religious gatherings including circulation with open spaces between the city walls and the chowkris.
- Approval from Vidyadhar the architect was a prerequisite for construction of residences; framework of architectural control was in place with stipulations i.e. quantification of building elements: plinth, entrances, fenestrations, heights etc. [1: 270–274].

Compact planning layout based on Ancient Indian texts of Veda: Vastupurusha mandala the sacred square. The hot and dry climate was important that was attended for the city to thrive the ease of movement with thermal comfort was important; for which the walled city addressed them efficiently through the scale, passive systems and traditional typology of Jaipur. Beginning with conceptually based on Vedic ancient scriptures adapted to contextual environmental conditions of the site executed through a designed developmental framework. Jaipur was laid out as a compact city with gridiron pattern with mixed land use with primary streets for retail activities. Jaipur with its hot and semi-arid hot region was envisioned as trading center implied that movement of local craftsmen and visitors had to be facilitated; the streets irrespective of their orientation were provided with covered corridors that was uninterrupted through the streets and chaupers: the intersection of streets and continuing; an architectural feature that is inherent to Jaipur city. The natural slope of land used for naturally drain through gravitational force, governed the layout of the streets. However, limited most of the rainwater was tapped for natural and manmade water tanks and for agriculture and rainwater harvesting initiated as early as the nineteenth century.

The cardinal axes were key for orientation of the streets so as to facilitate thermal comfort for pedestrian movement through the day. While each of the chowkri had dwelling units that were oriented with hierarchy of streets as primary, secondary and tertiary therefore the orientation varied. Such enclosed planning reduced the surfaces exposed to sun thereby reducing heat gain. Mixed land use reduced movement with most of the function's under one roof. The traditional urbanism of Jaipur developed, grew, urbanized, stabilized and continuing. As a living heritage city, Jaipur is globally recognized for its rich handicrafts and culture heritage. The holistic approach of traditional urbanism had inherent resilience to changing times, aptly demonstrated through traditional practices in the city. The pillars of sustainability contributed for sustenance, growth and responses to the changing times be it political, governance or lifestyle for optimum resource consumption and energy use. The holistic framework of traditional urbanism thrived with inputs through education, health and gender as well.

However limited, the transitions in the fabric of the city occurred overtime but the core typology continued. The nature of transitions varied with the social groups for scale and type. Tracing the building of socio-economic to 'culture of socio-economic' for walled city of Jaipur is insightful from diversity of education to health i.e. despite the brackish quality of water the mortality rate in the city wasn't due to water considering with the said climatic zone water borne diseases are a major cause. This coupled with the traditional lifestyle and tradition of economy continued that to be nurtured by the core local population has been the strength of the living historic city of Jaipur. The infrastructure facilities i.e. electricity, water supply, sewage, waste disposal to communication network once laid in the traditional urbanism delivered along with other facets contributing for the holistic nature. The services provided for flexibility of working hours and that coupled with tourism increased energy demand. While the behavior pattern of the people, their responses, the work cultures and related economic activities continued with traditional practices and therefore energy consumption was/is socio-technical issue. When focused on a built environment for mitigation for climate change often yielded limited desired results as energy consumption proved to be culturally governed thus socio-culture is significant that governed the baselines for thermal comfort.

In nature diverse climatic zones exist and therefore the responses too need to be contextualized for respective climatic zones and with each of the traditional cities that demonstrate such design solutions; are an opportunity that may be acknowledged as best practices for the respective climatic zones. The world shrinking with global economies are in place, the paradigm shift is inevitable and therefore to focus on contextual responses make sense. However to gauge development with respect to global standards needs to be redefined such wherein the local contextual framework that delivers' and inline to address climate change needs to be on the forefront. The measures for mitigation of climate change may be largely focused on building through understanding of socio-culture that enables to be effective for decisions and output. The traditional urbanism of the walled city of Jaipur flourished as it ensured security of all kinds from food, education, and health, physical to employment opportunities.

7.2 Constructing Urbanism with Tradition Planning Principles and Context

The concept to design the walled city of Jaipur was based on Vastupurusha mandala derived from Prastara plan from ancient Vedic texts[1] by Kautalya's Arthashastra wherein a section on Shilpshatra has its complete detail. The Vastupurusha mandala planning principle outlined as defined gridiron street pattern, essentially a square further sub-divided into nine squares. The plan was laid out for the specific selected site beginning with the palace to be centrally located followed by the social hierarchy occupying the rest of squares determined by the caste and status. The city had streets with gridiron pattern, intersecting at right angles, rather uncommon for Indian cities,

unlike the typical Indian traditional cities that were organic in nature and grew need based while Jaipur was well planned. Vastupurusha Mandala Square in plan, the city was divided into nine squares, corresponding to the nine treasures of Kubera: the lord of wealth aptly so, as it was developed as a trading and banking center for that region. Prastara is basically a square or rectangular in shape. Space was left in between the city walls and the buildings by a road that went all around the town [2].

Nine and multiple of nine is evident across the city from street widths to dimensions of chaupers to shop widths down to the system of fenestrations in elevations and parapets as well. Odd numbers are sacred as per the Vedic texts. The broad dimensions were sacred but adapted to the site conditions i.e. each of the chowkri's were about 900 m by 900 m approximately and thus the east west axis length measuring up to 3.6 km. The width of the primary street was 108 feet again as the said number refers to abundance and very sacred. The hierarchy of streets too honored the said number the secondary street was half of the primary 54 feet and tertiary one fourth as 27 feet and when one adds the said numbers add up to number nine (Fig. 7.1).

The fundamentals of Jaipur traditional typology responded for climate change and addressed from macro to microclimate with ideal response to natural resources through orientation, wind movement use of daylight and open spaces. The Geo-Political framework was primarily responsible for the site selection of Jaipur and climate determined the design decisions executed through planning principles that were culturally rooted while the architectural vocabulary was derived from the locally available building materials with indigenous construction technology. Attributes of traditional building typology of Jaipur was a holistic response from macroclimate at city scale to microclimate at building level through design beginning with the layout for the city—land use, zoning, orientations, street pattern, open spaces, pedestrian

Fig. 7.1
Vastupurusha-Mandala—the
sacred square [1: 117]

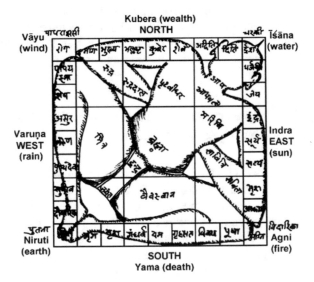

Fig. 7.2 Layout of Jaipur with palace centrally located [4]

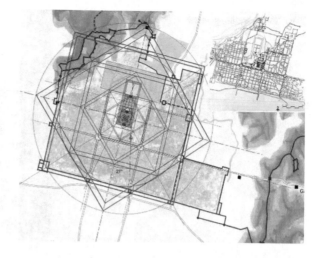

movement, modes of transportation and landscape that addressed temperature, heat gain and thermal comfort, wind movement, rain, dust storms etc. (Fig. 7.2).

The city was laid out keeping in mind the existing landform. The location of the Aravallis range dictated the layout of the 'Prastara' plan that had to be tilted by 15 degrees on the east; such that the plan could be laid out. Furthermore, one of the squares had to be relocated towards the east to get the magical number nine, thus the plan emerged. The tilting of plan and shifting of a square in response to the existing ridge of Aravalli's highlights the sensitivity of the architect to respond to natural features, slope of land and to build with nature was remarkable for decision considering the plan of the city was derived from Vedas to adapt to the contextual connotations.

The ridge of the site was ear marked as the east–west axis about 3.6 km with streets perpendicular to it sloping on either side towards north and south. This layout of the streets ensured that rainwater was easily drained. Besides the secondary and the tertiary streets with in each chowkri were made to slope towards the main street as the internal by lanes were designed to be at higher level. At entrance gateways of the city and chaupers and other strategic open spaces including courtyards of institutional and public buildings. Indigenous species of trees were planted that provided shade and reduced heat gain. However, the courtyard in residences was the personal open spaces for the inhabitants. Hot and dry climatic conditions required both indoor and open spaces to be addressed sensitively for thermal comfort (Figs. 7.3 and 7.4).

The entrance to the walled city was through nine defined gateways each one with a grand scale to provide security and visually block the built environs within the whole experience was designed such as it unfolded from the entrance and through the streets within the city and the whole narrative proved to be an enriching experience walking though the city. The design of the city limited the harsh climate outside the city walls, as within the city walls as the built morphology was climate responsive thus as one entered through the gateways there was a transition, a reference often

Fig. 7.3 Entrance gateway
[1]

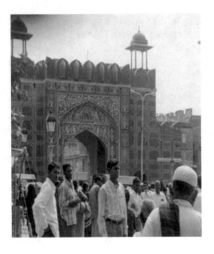

Fig. 7.4 Entry to house
along the shopping corridor
(Author)

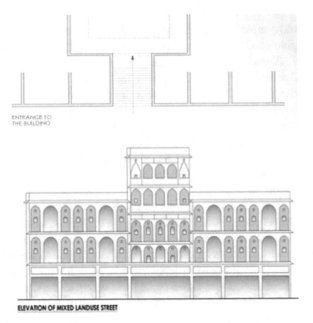

a celebration. Conventionally each of the entrance gateways led to primary streets. As one entered the city, the intersection of entrance gate and the primary street, the buildings on either side were public buildings i.e. temples or institutional with large trees to provide shade and drinking water facilities for people to pause and rest the harsh climate outside the city walls and inside such a resting space acted more like an anti-space to adapt to the transition. The transition enabled the individuals to be thermally comfortable and the further travel was through the covered corridors through the city. Most of the intersections large trees provided shade leading to

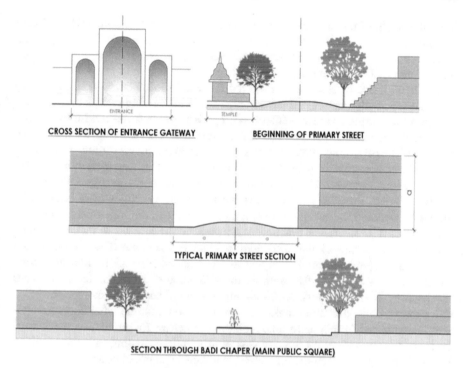

CROSS SECTION OF ENTRANCE GATEWAY BEGINNING OF PRIMARY STREET

TYPICAL PRIMARY STREET SECTION

SECTION THROUGH BADI CHAPER (MAIN PUBLIC SQUARE)

Fig. 7.5 Cross sections of primary street from entrance to chauper (Author)

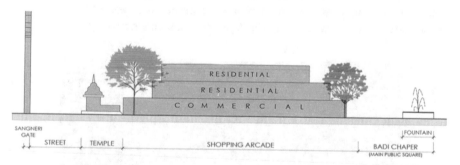

Fig. 7.6 Section along the primary street from gateway to chauper (Author)

pedestrianized covered corridors. This holistic experience was designed so cherish the experience of the streets and city designed through the set of cross sections from entrance gateway till the chauper the intersections of primary streets were the only large public open spaces for the walled city. The primary streets defining the nine chowkris were the arteries of the city as these linear spaces were bazaars with all kind of economic, social to cultural activities. The gridiron dictated the street pattern with streets intersecting at right angles and each of the intersections was widened to design as large open spaces; the space was square shaped. The chauper was three

times the width of the primary street about three hundred feet both ways and area amounting to nine hundred square feet in area. There was a clear hierarchy, both functional and visual with each street generating different activities that changed with the order of the street (Figs. 7.5 and 7.6).

The open space of chauper's navigated the wind movement into linear spaces of streets and with hierarchy of streets each one with varying widths and sections designed such ensured wind movement. With grid–iron pattern the continuity of wind movement was assured but in few chowkri's with cul-de-sacs the wind movement got restricted. The pedestrian movement was facilitated in the streets through orientation that cut out direct sun and ensured wind movement; with the said measures in place, the thermal comfort was in place. Although the baselines of thermal comfort were/are relatively higher than the global norms but these said baselines were acceptable, culturally governed and socially implemented. The role of the core local community was significant for traditional practices and translated in acknowledging the designed developmental framework that responded to changes with time. The strength of the city's built morphology timely adapted and responded for social, cultural, infrastructure services decisions for example the utilization of large public open spaces i.e. chaupers' observed transition from congregation of people an interactions space with public buildings to water tanks—a common source for the inhabitants to fountains that changed from time to time including to deliver for circulation for various modes of transportation. As the city was built with few existing villages of which the religious structures mainly temples were retained and often seen in middle of the streets with circulation occurring seamlessly around it. In addition to the chaupers the open spaces within the city were the streets and internal courtyards. The compact built form was structured and consistent through the city that was climate responsive and delivered as system of systems through traditional practices (Fig. 7.7).

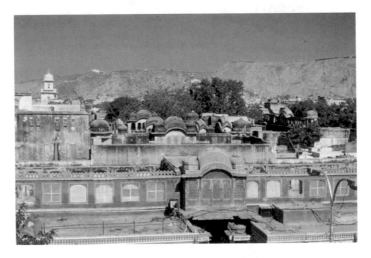

Fig. 7.7 City palace with Aravalli hills in the backdrop (Author)

The backdrop of Aravalli hills contributed for the imageability of the walled city, an identity that was visible from all primary streets of Jaipur. This natural feature is an inherent part of the visual imageability of Jaipur contributing for its rich architectural heritage most of the buildings along the main streets maintained the covered corridor and consistency of the elevation that was inbuilt in the developmental framework by the architect of the walled city is still intact. The key traditional principle for the city was the compact urban form appropriate for the hot and semi-arid hot region as it reduced number of surfaces of built form exposed to sun thereby reduced heat gain and ensured that the indoor temperatures were low. Shading of walls, roofs and fenestrations and the external walls towards the secondary and tertiary streets were mutually shaded. The street sections were designed in such a way that largely reduced heat gain; extremely significant for the climate typology. Additionally ensured wind movement and avoided dust storms. The compact form has the advantage of low-rise high-density with optimum use of land and limiting the impact on local environment. This urban form is sustainable as it had inherent strength to limit the growth and saturated at 240 persons per acre for the walled city of Jaipur [3] and beyond that the city expanded outside the city walls. This saturation of density was socio-culturally governed with legislation rather incidental. This concentration of population nurtured social interactions that bonded people for a sense of community; a perception that assured security and place making of the built space. Therefore, it may be fair to conclude that the compact development is sustainable socially, physically and environmentally as well; this symbiotic relationship is holistic in nature making the traditional urbanism inclusive in true sense and in contemporary term a suitable example of eco-city as well.

Mixed land use was typical for traditional urbanism. Having work and residence under single roof one had the flexibility to use the spaces such as when the work pressure was more the workspace could extend in courtyards, verandahs and vice versa. As the spaces were used all the time the infrastructure facilities were common and shared thus economical. Segregation of land uses creates non-functional voids except work hours whereas with mixed land use the city is lively 24×7, which reinforces the socio-economic and cultural strength of the local community. Such vibrancies of a city add value for tourism sector with maximum utilization of the spaces for both built and open. This arrangement is environment friendly as with maximum functions located under one roof so that the thermal loading and hot air could be minimized especially with passive systems and design of spaces delivered for light and ventilation inherent in design and detailing. With global pandemic the significance of work and home space is becoming the new norm kind of synonym to mixed land use that are climate responsive while the energy intensive commercial and office spaces are being relooked at coming a full circle.

Transportation in cities is high energy consuming also with time invested whilst in case of Jaipur, the travel time is virtually negligible minimum mainly due to mixed land use and that has dual advantage of one zero energy required for travel as the city is walkable and the time otherwise would have been utilized for travel is used for family and kinship reinforcing the social capitol. The traditional lifestyles revolved around the daylight but with electricity and other infrastructure facilities brought in a

paradigm shift of extending working hours for greater income; an option available to the local community but in case of Jaipur they continued largely with the traditional lifestyles with spillover of additional businesses outside the city walls, a deliberate decision by the business and craftsmen. This standpoint ensured the traditional built environments to operate with less energy use. The infrastructure facilities are energy consuming but when the built form is compact the time, money and energy required to supply was largely economical and has ease of servicing as well. The scale of the city was walkable, circulation was basically a pedestrian and covered corridor provided along the main streets, which ensured uninterrupted economic activities irrespective of weather conditions and attended thermal comfort. Other modes of transportation were driven either manually or by animals thus carbon free. The east–west axis was the ridge of city with maximum length as 3.6 km the scale had advantage that minimized urban heat islands as well. The majority of the local population walking; the popular mode of transportation is the cycle rickshaw. As it is manually pedaled thus low on energy, provides job opportunities to more and the most appealing part is that due to slow pace of movement the tourists have an opportunity to observe the city closely for details and appreciate the city's aesthetics in a structured manner, a memory that each one builds and carry's home.

Originally when Vidyadhar designed the city a framework of architectural controls compiled as a dossier was in place, which was adhered to and responsible for the uniform look of the city especially the visual experience that got reinforced about a century ago with pink color. The framework of construction governed from use of locally available materials and indigenous technology to height of the plinths of the residences, system of fenestrations, and sunshade protections among others. The use of locally available materials ruled out the embedded energy while the indigenous technology exploited the local resources and traditional environmental knowledge and wisdom and was labour intensive thus provided jobs. Services i.e., waste and sewage, disposal was manually dumped on the outskirts of the city. The toilets were provided in each of the residences; for which the network of pipelines was laid down along the streets by the municipal authorities. The hierarchy of streets was designed to drain off rainwater thus the required slopes were already in place that facilitated the draining of sewage as well. Super imposing services on the built morphology did not have any major impact on the utilization of spaces both open and covered the individual water supply to common pumps were located in secondary streets those exists even today. Over centuries the city got super imposed with infrastructure facilities beginning with water supply, solid waste, sewage disposal, electricity supply to information and communication technologies and continuing the fundamentals of thermal comfort as passive systems and design of spaces delivered with light and ventilation inherent in design. However, with economic activities increasing the use of energy rose but with design and passive systems in place the energy demand was much less.

British acknowledged the traditional urbanism of Jaipur and enhanced with i.e. built dam and reservoirs to store water, removed silt from the river beds, introduced rain water harvesting and measures to attend the brackish quality of water to individual water connections; electricity including solid waste management. These

measures facilitated re-densification of the residences and a couple of storeys were added on the existing buildings and stabilized with three to four storeys with further expansion extended beyond the city walls. In 1920s Railway connectivity was set up that facilitated the growing economic activities, expanding the business to other parts of the country. The city expanded city outside the city walls, which began with Albert Hall museum built along the axis of city palace followed by an allopath hospital, additional residences' and institutions. The layering of infrastructure facilities in the walled city absorbed these transitions till Jaipur became the state capital for Rajasthan; large-scale urbanization occurred with growing economy and tourism sector become predominant. Further with liberalization policy at the national level and information technology accelerated the pace of development that proved to be a challenge. Jaipur being a living historic city responded to the transformations imbibed changes adapted them for their socio-cultural context and embedded as a part of traditional culture; such has been the resilient nature of the core community. Thus heritage hasn't been static for them but evolving, responding and maturing and unique is that most of the layers of history legible within the texture of the walled city with core strength of the walled city of Jaipur intact. This puts Jaipur high on the mapping for best practices for traditions and others for climate change for indigenous solutions. The transformations were peripheral to the core and key planning principles and social capitol continuing largely as designed and detailed.

The master plan [3] has designated the area of Jaipur about fifty-five times that of the walled city while the walled city continues to be the Central Business District for the urbanized city. Jaipur almost three centuries old now, is one the fastest urbanizing city in the country. The walled city has its distinct identity for traditional handicrafts that are constantly responding to vogue thus sought for by both domestic and international markets however the chowkris catering to specific handicraft continues till date. This distinction has put pressure for increased retail spaces but the real estate and ownership status has limited the expansion within the walled city while growth started mushrooming outside the city walls. This understanding has saturated the growth within the city walls with transformations wherever possible. The open space along the city walls was utilized for expansion of the retail activity an extension for tourism sector. The major expansion of the city was construction of Albert Hall museum the axis of city palace aligned with large open spaces that was used for agriculture and now accommodated for the spill over activities of the core population and for tourism sector too i.e. zoo is located here. The city walls continue their presence as a backdrop for a major road parallel to it, connecting the walled city through transition in modes of transportation as para-transit system for the walled city. 1991 saw the 74th amendment by the Constitution of India, which introduced the liberalization policy that encouraged multinational, and Foreign Direct Investment across all sectors including tourism industry. Despite urbanization and city expanding beyond the city walls the core community continued it's influence for decision making for interventions within the walled city.

The prosperous socio-economic capacity of the business community and higher kings officials enabled them to construct architecturally rich buildings in their respective chowkri's. The legacy of traditional families continuing through ownership for

generations on, now has multiple stakeholders thus resale of property virtually limited often the lineage continuing with the residential use (Figs. 7.8 and 7.9).

The population growth among various chowkris' was consistent despite political changes as state of Rajasthan was formed in 1948 and 1991 saw the liberalization policy the core community enjoyed the power to influence the decisions within

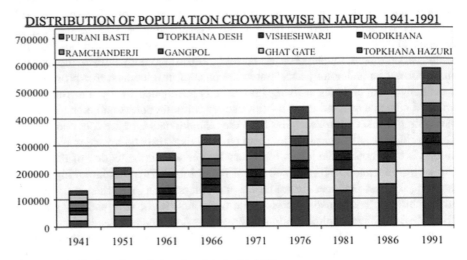

Fig. 7.8 Distribution of population chowkriwise [3: 182]

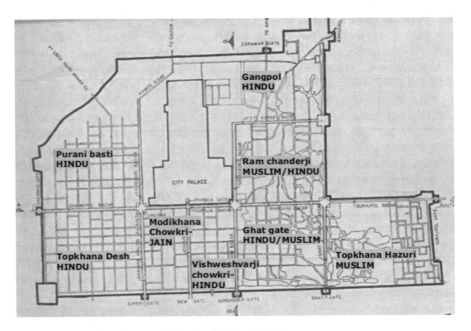

Fig. 7.9 Distribution of communities chowkriwise [3: 130]

the walled city. All of the eight chowkris' [as city palace occupied two chowkri's] observed consistent growth in all chowkris' while the Ramchanderji ki chowkri wherein both Hindu and Muslim live together depicted a steep growth. The traditional practices of Jaipur were foremost for the local community with religions' co-existing that ensured harmony and healthy living. The ethnic connotation was translated in the built morphology mainly for the chowkris that were developed in addition to the original four chowkris for example with organic street pattern and cul-de-sacs parallel to the orthogonal planning of original design. While the courtyard continued with internal layout with balconies and terraces. However with basic design decisions for the climate responsive strategies were in place and continued. Typically each of the ethnic groups for generations on excelled in a specific handicraft and often cherished a symbiotic relationship for work i.e. brassware the basic mould often made by Muslim's while the fine carvings done by the Hindus while ornaments from lacquer were essentially made by Muslim women and often retailed as well and continuing. The consistency of the social capitol contributed by the respective caste and ethnic groups followed the traditional practices that continued, thus virtually no gentrification occurred within the walled city. Although there have been families moving out of the walled city for certain quality of life but the core community continued with no structural changes for the social capital. The socio-cultural aspect permeated beyond the city for the rest of Jaipur a culture omnipresent families observing the legacy of Jaipur traditional lifestyles continued with awareness of varying cultures i.e. aware of European followed by colonial and in the recent past with the global culture coupled with technology; the local community layered with the awareness of varied cultures but the core traditional practices continuing cherish a sense of belonging as the civic pride for the pink city. The advantage of technologies for improved productivity and efficiency got integrated within the local work cultures, demonstrates their resilience for change and adaptability for growth and progress. These changes are reflected in the handicrafts' as well that are constantly innovating to be in line with the global markets; a unique selling point that they pride themselves with. This is one of the main reasons for consistent demand of Jaipur handicrafts both by the home and foreign tourists thus reinforcing the economy of the city.

The densification process required addition, alterations and sometimes re-building of the buildings. The infrastructure facilities added to the challenge of rebuilding within traditional urbanism. Nonetheless it was an opportunity to acknowledge and incorporate the climate responsive fundamentals i.e. courtyard planning and building with locally available building materials although with transportation a range of building materials were but the locally available building materials were selected for least embodied energy and for construction technology that was indigenous and labour intensive. The technologies constantly upgraded that were energy efficient along with retaining the passive systems as much as possible i.e., orientation, shading of fenestrations among others. The majority existing building stock with passive systems in place, when refurbished with technological innovations were low on energy demand. The production of handicrafts extended outside the city walls with walled city continuing for the retail of handicrafts and thus pressure for the walled city

to mobilize for additional space for commercial activities. The symbiotic relationship of economic activity coupled with high real estate prices and ownership /property rights limited the construction activity within the walled city and curtailed the land use for commercial.

Summing up the salient features for climate responsive planning of the city began with layout limiting the city as walkable, strategically placed with access to water and security a key concern with city walls. The pedestrian movement was facilitated through orientation of street pattern both for economic and social reasons. The city sub-divided into chowkris with each one engaged in a specific craft thus sharing infrastructures and facilitating the buyers and peer learning with healthy competition as well. Each craft produced by specific caste was in sync with the social stratification and their common lifestyles that were directly related to resource consumption, energy use and low carbon living. These traditional practices was passed at urban design scale as well and later at each building level as well to complete the loop for resource consumption and energy use.

7.3 Contextual Planning Practices for Climate Control

The synergy between the city and urban design gives meaning as place making that derives from both spatial and socio-cultural practices. The residences with mixed land use as compact built form with occasionally open spaces, including the streets that were common community space while the courtyard was internal personal open space. The economic activity continued along all the primary streets in the city thus each of the chowkri was delineated with specific retail activity with hierarchy of secondary and tertiary streets within each chowkri. The economic nodes often housed the socio-economic functions as religious, institutional merged through the primary streets especially at the chaupers and entrance gateways and others. This deliberate transition at strategic location within the layout of the chowkri gave identity and facilitated the social activities within small walking distances i.e. schools, temples etc. The streets were active 24×7 with multiple activities merged which assured security for the inhabitants especially for women and children. The streets being the key community spaces, nurtured social interactions that bonded the local community. Due to increasing demand and growth the socio-economic activities typically extended to secondary streets as well. Each chowkri known for specific handicraft enabled the buyers to see all the products at one place that encouraged healthy competition and often peer learning with consumers getting the very best (Fig. 7.10).

Typically each of the chowkri was sub-divided by smaller squares while the squares along the primary street and city walls were in the ratio of 1:1.25–1.5. The one and one quarter had a cultural significance for Jaipur as the prefix of the king was *sawai* means one and one quarter times; as the perceived their king more than other kings thus that ratio as a mark of reverence for the king. The street pattern has been adhered even with transformations the structure is largely in place translated in built environs too. The retail activities on primary streets with covered corridor ended up

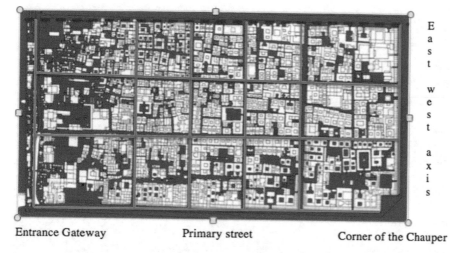

Entrance Gateway Primary street Corner of the Chauper

Fig. 7.10 Figure ground of a typical chowkri (one half) Red line is center half (Author)

with a linear space open to sky, as roof of the continuous shops, an architectural feature consistent throughout the city. This was rather a public open space accessible by the residences living at first floor and above typically to view the processions that were occasionally held for religious, political, festivities among others; originally designed and continuing. While the superstructure building facades observed the architectural controls from maintaining the floor lines, number of bays, system of fenestrations, shape and size of openings, traditional sunshade: chajjas to the parapet details typically referred in the dossier. Such a framework has ensured the consistency and harmony of elevation control, as the system of fenestrations and chajjas were designed for reduced direct solar gain with adequate ventilation thus climate responsive. The grammar for building facades abided by till the last detail for residences, institutional to religious buildings as well often limited to primary streets (Fig. 7.11).

The hierarchy of streets reflected the proportions as 1:2 to 1:3 for secondary and tertiary streets respectively. The secondary streets often had an entrance porch as an extended plinth narrow about 3 feet to 3 feet 6 inches and was a flexible space either for economic activity or social interaction often open to sky and sometimes covered with jalli panels when the residences belong to wealthy families typically these platforms were thermally comfortable spaces thus encouraged social interactions. These permutations and combinations of individual expressions added character to the uniform streets; the expression for elevations with set of systems of fenestrations were pre-determined in the dossier. Each of the buildings had their own built vocabulary for example even to define edges emulating the geometry and proportions in their own way enriched the street sections especially the secondary street. The nodes and edges were explored and designed within the framework of the architectural elements and features; especially when the transition from primary

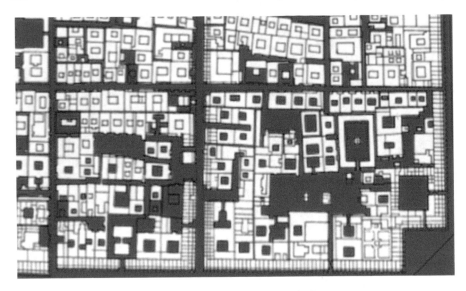

Fig. 7.11 Figure ground part of chowkri with courtyards (Author)

Fig. 7.12 Tertiary (left) and
secondary (right) streets with
projections above (Author)

to secondary streets occurred i.e. sharp edges were wither rounded off or chamfered
with square shape with various permutation and combinations. Each of such detailing
rendered identity to the street, building and so on. These architectural expressions
added uniqueness and often an identity for the respective street too. Further the
super structure projected on to the street provided shade at the ground floor facili-
tating pedestrian movement and reduced the direct sun except overhead. However
the tertiary streets were the narrowest with no extended plinths (Fig. 7.12).

The secondary streets and the tertiary streets were less celebrated for building
facades but more for community activities. As secondary was next in hierarchy the

transition accommodated the spill over economic activities of the primary streets or for community activities. The scale of street section was appropriate for the set of mixed activities and observed the continuity of architectural features i.e. the floors above were projected that provided shade at the ground floor for pedestrian movement and for buyers as well. Sometimes each of the subsequent floors was projected further on to the streets that cut down the direct sun and created a space that nurtured social interactions. While the tertiary street was purely for inhabitants of the residences with the scale modulated such. The pedestrian covered corridors along the primary streets were constant that accommodated the spill over of retail activities and mushrooming of informal vendors was acknowledged. The informal retail gave opportunities for the migrants to contribute for local economy and were strategically placed at chaupers and incidental open spaces that added value to the local handicrafts and these small shops were placed below large trees with roof extensions to provide shade to the buyers continuing till date. At the intersection of primary streets, the corners had a square of the chowkri with dimension equal to the width of the primary street that was added to the chauper resulting in a larger square. Each chowkri, the inhabitants had their own version of edge design detail a response, which added character to the streets explored various combinations (Fig. 7.13).

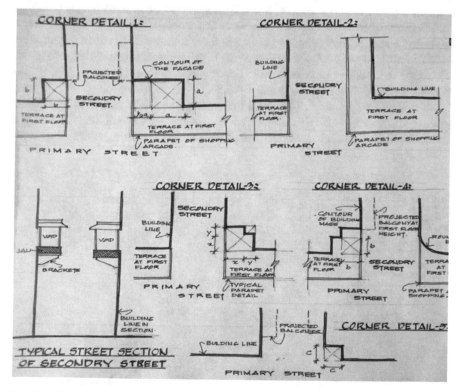

Fig. 7.13 Edge details of building (Author)

As the production of handicrafts occurred in respective chowkri's, the services required too were concentrated, shared that nurtured bonding among the craftsmen and often the chowkri was known by the craft that ended up being their identity as well. Such an arrangement ensured the worked spaces with defined plinths were similar that created uniformity in the visual experience for the visitors. The handicrafts were allocated chowkri, based on their activities i.e. block printing textiles were placed with one end the city wall as there was open space adjacent to it, all along the city wall that was used for drying of clothes, washing and related activities while the secondary and tertiary streets were narrow thus thermally comfortable thus often used for any spill over activities of handicrafts as primary streets were basically for retail and commercial activities. Initially 162 shops were constructed by the state on either side of the primary streets. All these shops were of uniform size and shape and gave the city a uniform look that continued along for the rest of the primary streets in the city. Most of the chowkris' once inhabited by the said crafts the continuity maintained by the future generations both as an identity, sense of belonging and matter of pride for the ongoing traditional handicrafts and built morphology too (Fig. 7.14).

The Chaupers were the only large public open spaces that catered for the needs of the local population. The space was intersection of primary streets the retail activity continued along the covered corridor with the first-floor housed public buildings i.e. libraries, institutions, temples that were accessible with single flight of steps. Typically, a single flight of steps leading to the public buildings at first floor were wide and often at the base; the informal retail activity mushroomed that sold goods related to the function of the said public buildings i.e. flowers for temples, books for libraries among others. Conventionally the access to public buildings is at ground floor but in Jaipur the first floor was an extension for public activities and access rather a celebration to emphasize the function of the public building. This design detail was normally at chaupers and sometimes at the entrance gateways' as well.

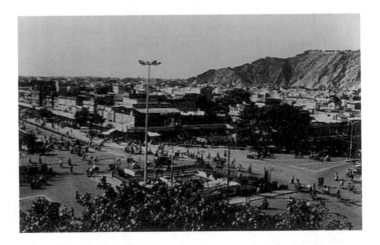

Fig. 7.14 View of chauper 1750 [3: 270]

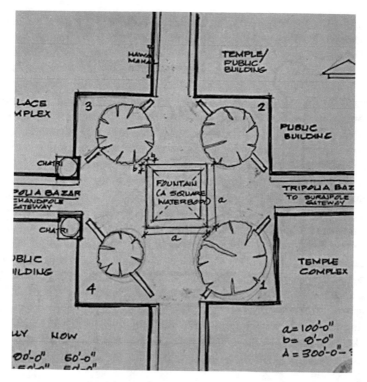

Fig. 7.15 Typical plan of a chauper (Author)

This building typology ensured the pedestrian movement from the chaupers for retail activity including for tourists; while the movement of locals directly accessed the public buildings at first floor thus well synchronized with the pedestrian movement of the city (Fig. 7.15).

When the city was built the number of shops was limited that grew with time while the chaupers facilitated the economic activities. The recognition of acknowledging and providing specifically for informal sector was a deliberate design decision. The informal economic activity thus mushroomed at the chaupers and with city expanding beyond city walls the space between the city walls and chowkris were utilized retaining the limits of figure ground. Jaipur with its economic activities growing created job opportunities and the city got re-densified with additions and alterations to the existing structures saturated to about four storied. Most of the re-building activity responded to the changing work culture. Noteworthy is that the transformations in the chowkri were governed by social framework of the chowkris, especially the original chowkris that were inhabited since the beginning i.e. Vishwerji-ki-chowkru; Modikhana chowkri belonged to business community and the higher officials of the administration respectively Thus resourceful and aware these transformations were in sync with the framework with contemporary requirements incorporated aesthetically. While the chowkris that developed later transformed more frequently due to

many reasons i.e. property rights that changed hands and only a limited continuing for generations. Re-densification as addition, alterations sometimes re-building too but all the construction activity was contained for the same figure ground within the chowkri abiding by the architectural controls in place either socio-culturally and through legislation as well. Ownership played a significant role to monitor transformations and regulate the real estate as well; as even today the real estate prices are highest within the walled city often not accessible to all. Jaipur just reinforces that of the pillars of sustainability the economy isn't the sole determinant that drives the city but the socio-cultural traditional framework that vouched for low carbon living and practices is significant (Figs. 7.16 and 7.17).

Jaipur also known as pink city as the buildings along the primary streets are painted such. All the shops had a well-defined slot for the name of the shop that along the corridor ensured the consistency through out the walled city, an urban feature that added to the identity of Jaipur. However the trend started only about a century ago considering the strength of elevation control existed for a while that demonstrated the strength of the traditional practices. The tradition of urban design practices continued as designed with street patterns, visual order of building facades, chaupers and open spaces within each chowkri. Although the utilization of spaces attended the changing needs that were made efficient with use of technology and services. Despite the varying responses based on the crafts and others the built morphology among all chowkri remained consistent. The figure ground was maintained with the mode of transportation two wheelers, cycle rickshaws for the majority of the population including the tourists.

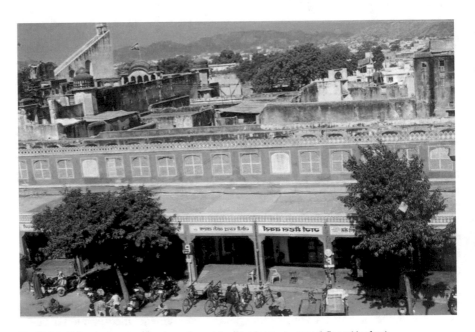

Fig. 7.16 Primary street with covered corridor for shops at ground floor (Author)

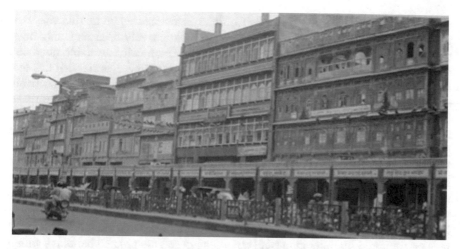

Fig. 7.17 Primary street with covered corridor at ground floor (Author)

7.4 Low Carbon Traditional Building Practices

The geo-contextual framework was fundamental for any traditional urbanisms that were typically low carbon solutions were designed and detailed for respective climate from macro to micro across all scales of development traditional practices. Beginning with layout of the city to urban design down to the detailing of the windows. The passive systems were standard in these traditional built environments and as they were contextual specific for the natural resources and the climate was the key framework within which the local communities were innovative to design the solutions. Studies demonstrate that energy demand in traditional buildings is relatively less with due to passive system and other related design decisions in place. This framework of traditional practices in traditional urbanism that is as important for the building design and detailing. Often the empirical studies are when conducted the observations are limited to the space while the other related aspects that contributed for the set of observations often not addressed. In traditional urbanism each building is not a stand-alone but a part of the group of buildings and that further part of the zone and so on. Therefore, a holistic perception is a pre-requisite for understanding the application of the passive systems. Each system is a part of the system next in hierarchy for scale from building to city, geographical region and climate. Thus, to have an accurate assessment of energy use, building performance evaluation, post occupancy evaluation and related studies needs to have indicators that refer across all scales for related information and data, may be used in combination for compatible of characteristics for each building as a unit in compact built form.

Jaipur was laid out such that it was relatively cool and prevented urban heat islands set adjacent to Aravallis and water bodies on three sides. The city was built with local quartzite for rubble masonry of dressed stone construction coated with thick lime plaster along with red sandstone that was locally available often the frames

of doors and windows too were made from the sandstone; while marble was used for special structures. *Araish* and *Khamira* were extensively used including inlay work in stone with extensive use of stuccowork. The locally available quartzite, red sandstone along with lime plaster was the basic building material that had low thermal capacity and had similar conductivity 1.295 and 1.53 kw/m.C respectively and thus the time lag was consistent the durability of sandstone wasn't determined by hardness or chemical stability but by the cementing agent that binded them: lime in case of Jaipur. The large diurnal temperature variations consisted of large thermal capacity for both walls and roofs constructed with said building materials. The heat stored in the daytime dissipated at night times kept that the habitable spaces thermally comfortable. Embodied energy a major concern was minimum in case of traditional buildings and thus with rapid urbanization the selection of building materials when procured indigenously reduced the carbon footprint too. The norms in place suggests to continue with same building materials that are locally procured be used for additions, alterations and rebuilding of the dilapidated buildings within the walled city sometimes legally enforced. The new construction was executed in the same piece of land often the typologies got adhered to, as that is the only design solution that addresses the light and ventilation for the residence with courtyard planning: a typology adhered to due to the built morphology in place However, with elevation control enforced along the primary streets ensured the consistency and continuity (Fig. 7.18).

Courtyards were the center for all domestic activities and occasionally facilitated the spill over of economic activities as well. When the buildings were large there were

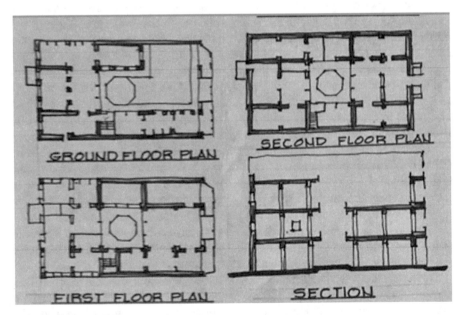

Fig. 7.18 Typical residence cum work courtyard dwelling unit (Author)

more than one courtyard and if so, the one next to the entrance was used for economic and retail activities while the internal courtyard utilized for domestic and personal use including cultural and religious events provided thermal comfort through stack effect. Courtyards were flexible spaces with multiple uses as and when required and such flexibility ensured maximum use of the space. In a study on 'what building forms make the best use of land' addressed by Leslie Martin in 1960, through selected six urban archetypal building forms and analyzed and compared the archetypes in terms of built potential and day lighting criteria, eventually reaching the conclusion that courtyard performs best [2]. Although courtyards were standard for all houses often the entrances had socio-religious connotations that determined i.e. east facing for Hindu for rising sun and west facing for the Muslim oriented towards Mecca the abode of Prophet Mohamed. The standard sizes of available sandstone slabs ranges from 10 to 12' feet that determined structural span of habitable spaces and thereby dimensions of the courtyard. Each house had an internal courtyard and if more than one all were aligned along the central axis line of symmetry extended from the entrance. The courtyards were surrounded by a verandah- an anti-space that acted as transition space between the open courtyard and the internal covered habitable space.

Jaipur falls in semi-arid hot region and thus both covered and open spaces were equally important, as during evenings in summers and winter for daytime and afternoons, terraces were important habitable spaces for a range of cultural activities that were traditionally rooted. The terraces at various levels; beginning with the roof of the covered corridor along the primary streets attended for traditional lifestyles. It was an interesting space and unique for Jaipur as a common public space open to sky at first floor level, often used to watch royal processions including cultural and traditional ones and continuing. Further the roofs within each of the residences were their personal open spaces but with buildings sharing walls and virtually adjacent to each other resulted in compact form that reduced the heat gain from vertical surfaces. The roofs often had double roofs in the form of chattris' typically a square pavilion propped up on stone columns and open on all sides that ensured air movement and reduced direct heat gain. The chattris were located at the corner of the buildings defining the extent of the residence a standard architectural feature. Each of the chattris was decorated with patterns that were used in elevations as well. Depending on the orientation the *Jaali*, perforated panels, were used that monitored daylight and ensured air movement for ventilation. Jaali as perforated panels were made in sandstone with geometrical patterns to let the sunlight in and reduce the dust as well. The roofs were typically shaded with pavilions built on the edges or symmetrically along the axis and were open on all sides that ensured the wind movement and thereby reducing the direct heat gain from overhead sun. The jalli patterns were based on geometry and the thickness of the stone explored to add the depth for the pattern, often they were champhered along the perimeter of the geometrical forms to cut out the direct sun and let the wind in. The deliberate cutting of stone jalli created interesting shadow patterns on to the internal vertical surfaces and floors those were dynamic and would change through the day. Verandah around the courtyard was standard for all building types; a prelude for the living room, was a flexible space

to accommodate the spill over of either the living room or courtyard activities and served as an anti-space for the covered habitable living space to address the transition of temperatures. The verandah next to the main living room space was wider a standard norm. Occasionally the large buildings had verandahs all around the courtyard. Bay window was another typical architectural element built largely for internal courtyards and in front elevation as well in public buildings.

A dossier was prepared that laid out the regulations for all aspects of building and urban design guidelines for chowkris, chaupers and closely monitored the construction of the buildings. The basic principles of zoning and layout responding to both natural and manmade, hierarchy for spaces, fenestrations, streets among others with mixed land use, low rise high density, courtyard planning etc. evolved an architectural vocabulary that was specific for Jaipur; which got reinforced with pink colour over time. However with the said document in place, there was provision for individual expression as well from house design of single courtyard to set of courtyards when the residences were large. The locally available building material was red sandstone, quartzite among others were used extensively with indigenous construction technology. The freedom of expression continued for system of fenestration although standard while the numbers varied conventionally odd as 3, 5, 7, 9 and so on. The large residences had more number of bays and each opening rather celebrated with exquisite jalli patterns and sometimes as bay window too. The basic grammar of play of rhythm of solid and voids, decorative elements, detailing ensured similar facades but not identical often established harmony in the visual order of the streets (Fig. 7.19).

The system of fenestrations in building elevations both internal and external was defined with room for individual expression's as well that explored the rhythm and order of openings for shape and sizes. The combination of hierarchy of openings ensured wind movement and reduced dust, often the opening on primary streets were small often odd number as three or five that was auspicious. The openings in an ascending order were rectangle to square to circular for each floor all aligned along with vertical axis for each set. The rectangular was for visual connect with the streets and ensured privacy due to small sizes, followed by square ones that ensured wind movement and reduce heat gain and the shape square well in alignment with the sacred Vastupurusha mandala and the circular smallest opening on the top as circle with minimum perimeter for same area thus hot air from indoors could escape the fastest creating negative pressure to ensure wind movement through the system of openings. The fenestrations followed an order; the openings at the lower floors were relatively bigger while the subsequent floors smaller. Based on the orientation use of jaali was articulated used for the standard form, shapes and proportions that ensured consistency in elevations. Whereas based on the orientation the same forms translated as solid, void or jaali panel or as bay windows as well that brought about consistency and elevation syntax of fenestrations while the larger residences had the set of openings that nestled in arches from simple to elaborate ones, again that gave opportunity for individuals to celebrate and build in harmony with the rest. The visual perception of buildings elevations along any of the primary streets appeared similar but no building elevations are identical. One the key principles followed

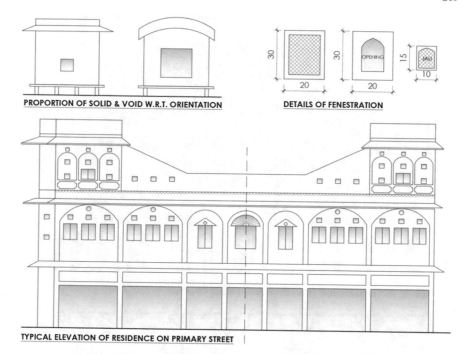

PROPORTION OF SOLID & VOID W.R.T. ORIENTATION DETAILS OF FENESTRATION

TYPICAL ELEVATION OF RESIDENCE ON PRIMARY STREET

Fig. 7.19 Order and type of fenestrations (Author)

was symmetry with the odd number of bays. The floor-to-floor heights were defined consistent along the primary streets. The detailing of elevation was often insightful for the function of the building as administration that governed had a greater number of bays with embellishments and detailing too. The administration buildings were located strategically in the layout of the city with access at ground floor while the institutional buildings varied with entrances at ground or first floor (Figs. 7.20, 7.21, and 7.22).

The roof of the shopping arcade corridor acted as the plinth for the building elevations. Each of the building was set back from the primary street by the width of the corridor that enabled the view of the buildings across the street, widened

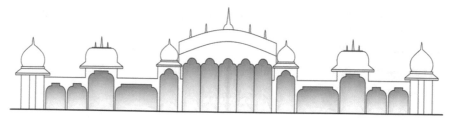

Fig. 7.20 Silhouette of a public building (Author)

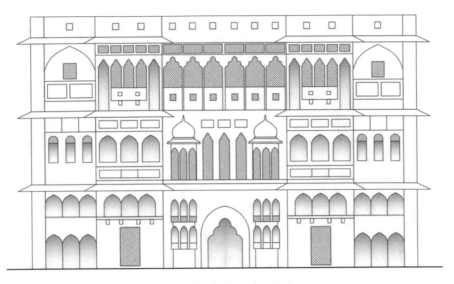

Fig. 7.21 Typical elevation of administration building (Author)

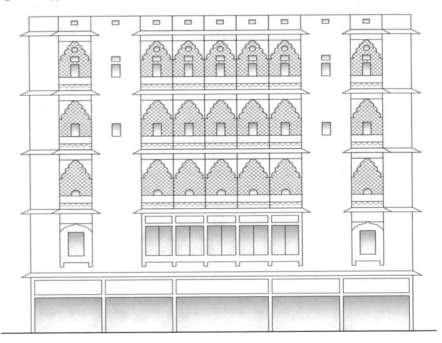

Fig. 7.22 Typical elevation of an institutional building (Author)

the section towards the sky giving a sense of grandeur and ensured privacy for the residences above. Conventionally each floor was well defined with an overhang of the shading about 3"0"–3'–6" feet. The structured framework wherein the shapes, sizes, proportion, floor heights among others standardized that ensured the grammar in place, which extended even to parapet details. The standard length of available building material determined the standard building height about ten feet.

Shading of walls, roofs and fenestrations enabled to reduce the heat gain. In the streets walls were protected through mutually shading as the subsequent floors projected that reduced the heat gain. The courtyard planning with ground floor had verandahs while the floors above had circulation corridor overlooking the court-yard and based on the orientation bay windows with jaali's were provided to cut down direct sun and heat enabling visual connect. An architectural element that adorned the internal facades and finesse of the jaali was directly related with status of the inhabitants. Thus irrespective of the orientation of the residences' within each chowkri, thermal comfort was addressed through detailing of facades with respect to orientation (Fig. 7.23).

The system of fenestration was governed by orientation, its immediate surround-ings of the house with respect to street, access, height of the building and of its adjacent buildings within the chowkri. When the buildings were ground plus one, the courtyard edges were shaded by the cantilevered circulation corridor of the first floor, which was further shaded by chajjas for subsequent floor circulation. In case of larger courtyard that was defined with three to five bays that repeated on all

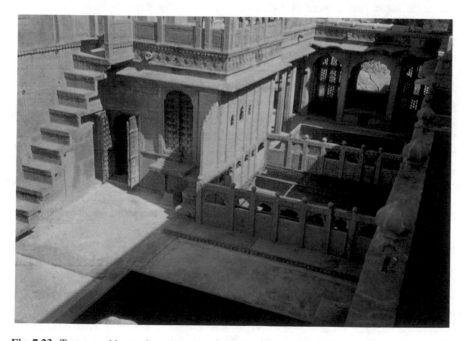

Fig. 7.23 Terraces with set of courtyards and open pavilions—the double roof (Author)

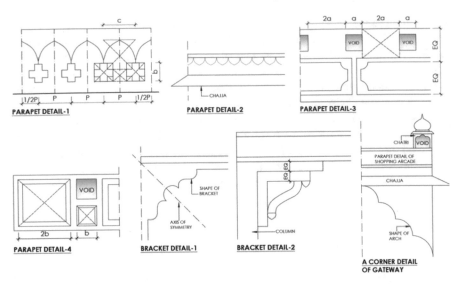

Fig. 7.24 Permutations and combinations of parapet details using standard forms (Author)

floors, while the detailing of the fenestrations was guided by the traditional practices although jaalis were used for all orientation often specifically for west facing corridors generally had jaali panels that reduced heat gain. The addition of subsequent floors the jaalis panels were provided for all sides. The logic to have openings at lower floors with jaali panels with a combination of jalli and stone walls reduced the heat gain simultaneously allowing day light i.e. lower floors with larger openings and upper floors with lesser and smaller openings was the norm.

Balconies were provided both on the external and internal elevation overlooking the courtyard either aligned with the parapet, elevation or projected out like a bay window with seating space and jaali on the projected sides. Additionally, an architectural feature, proved to be an anti-space as transition for thermal comfort. These windows provided privacy and reduced heat gain for the circulation corridor, often had seating space a design element to pause, connect with activities of the courtyard (Fig. 7.24).

The socio-culture aspect played a significant role in anchoring syntax of aesthetics and architecture. The legislation laid down the broad framework but the cultural connotation ensured alignment for usage of spaces and behaviour pattern that directly impacted the resource consumption and energy use. The passive climatic design practices nurtured by the wisdom of the local communities for their respective climatic regions for energy efficiency. The traditional lifestyles were responsible for low carbon living responded timely for adapting to changing needs for multiple uses of spaces. This inherent characteristic mainly contributed for their resilience nature for transformations to adapting to technologies (Fig. 7.25).

Re-densification observed addition, alteration and re-building activity with the chowkris. Additions have been largely with floors added with a maximum of ground

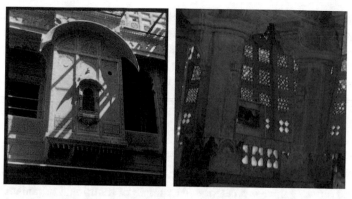

Fig. 7.25 Chattris in internal courtyard and Jalli in verandah (Author)

plus three storeys. The installation of various infrastructures facilities was spread over a period of time; the process was gradual thus integrated with the existing built morphology. Access to electricity and communication extended the working hours and the same space was used for extended hours to cater to the increasing demand as the business grew. With extended hours the comfort required for work efficiency and with existing passive systems in place the energy demand was relatively less, validated such through numerous scientific studies concluded that the contemporary dwelling had the highest peak heating load with an amount of 9,571 [Watt], which is 50% higher than the triple-space vernacular dwelling even though they had the same area of inside spaces, while the peak heating load of the single-space dwelling was 2,109 [Watt] [3]. The energy use was governed by the socio-cultural behavior pattern coupled with their DNA that responded to the comfort thresholds that bridged the performance gap, optimizing the energy use and related greenhouse impacts. The rebuilding activity occurred within the space of compact form and with high real estate prices each centimeter counted and thus often in line with the existing built framework due to traditional practices and partly due to building byelaws. The court-yard planning was the only logical design option that assured light and ventilation thus virtually no deviation from the existing built morphology. The newly built was often in sync with the existing fabric that sustained the aesthetic and design of the chowkris' and the city as well. Despite the piecemeal interventions the historic city continues to perpetuate the traditional urbanism at large. Thus traditional urbanism of Jaipur demonstrated the amalgamation of systems of systems that timely responded for the natural resources and contribution of social pillar of sustainability established the significance of climate responsive building typology relevant even in now.

The quantification for energy demand of a building needs to address the orienta-tion, adjacent buildings, access and availability of services including wind movement among others. As all the buildings may not have ideal orientation for daylight but in design and detail of building; elevations and sections are modulated that deliver with in framework of elevation control. Generally, the scientific studies conducted for Building Performance Evaluation, Post Occupancy Evaluation and others addressed

parameters limited to the building alone while in case of traditional urbanism the low carbon living was tackled across all scales beginning with city, chowkris to urban design and the building level as well. This approach of hierarchical understanding from macro to microclimate too needs to be looked at for a holistic study even though to be conducted for a building, it is important to include relevant parameters at all scales to arrive at precise data.

7.5 Ontology of Traditional Urbanism of Jaipur

The walled city of Jaipur is a celebrated example of traditional urbanism now with world heritage status recognized for the traditional practices, rich cultural heritage that is strongly embedded in the local community for the four pillars of sustainability. The conventional three pillars nurtured and facilitated for rich cultural heritage underpinned by single religion. Therefore the merit of traditional urbanism of Jaipur lies in the comprehensive approach where a deliberate balance was designed, nurtured and achieved to sustain.

The traditional urbanism of Jaipur has unique dimensions largely in place and continuing till date (a) to design and develop a city within a lifetime possibly a rare example achieved successfully (b) the city evolved through a deliberate town planning design derived for gird-iron pattern from the ancient Indian texts thus inherently rich with heritage connotation (c) a strong contextual framework that explored the natural resources available at site and region (d) the zoning was designed with the kings palace as sarhad chowkri in the centre for security reasons and immediately next to the Aravalli backdrop; with other chowkri's surrounding it. (e) The chowkri opposite the entry to the palace complex housed higher administration officials and think tank of the city (f) a tailor made socio-economic setup with a deliberate mix of sections of society that was stable and evolved with time (g) to develop a community from migrant population (h) the city conceived with Hindu religion base that vouched for vegetarianism (i) an architectural vocabulary in place with a well-defined framework for all building typologies but with a room for individual expression as well thus the buildings were in harmony but not identical (j) courtyard planning concept universally implemented for all buildings (k) the architectural vocabulary was designed to be climate responsive and was implemented in all buildings through administration and standard building material and construction technologies (l) despite the broad framework of architectural heritage there was room for individuals to have their signature motifs, detailing and embellishments' etc. The city when saturated among the chowkri's at ground plus three storey's the city expanded outside the city walls; however the layers of history are legible in the city's fabric. This limit to growth was inherent to the socio-economic context of traditional urbanism of Jaipur. Such an approach that facilitated growth to a certain limit through a built morphology that was rich with climate control measures as passive systems had low carbon footprint and thus climate responsive.

Often the layering of infrastructure services was a challenge that led to transformations nevertheless the core continued to demonstrate the flexible nature of the built form. Traditional urbanism of Jaipur has questioned the myth that economy drives the city but it's the socio-cultural aided with services that governs the economic activities, which sustains the city. In the narrative of sustenance of the city issues like flexibility with mixed land-use, adaptability for the changing needs irrespective of cause were inherent. The continuity of traditional urbanism gave an identity that became the civic pride for the local community as they cherished a strong sense of belonging for the pink city.

Traditional urbanism has shared values of the local community to have a common ground reflected as the local traditions. The culture of Jaipur responded timely to changes from geo-political, social, religious, economic, environmental and others. Considering each of the influencing indicators was diverse but the core population responded through their socio-cultural framework of traditional practices for the typology and heritage. Often with the world heritage status discourse draws on said status and the interest of the local communities but the enterprising temperament of the core population always adapted for their advantage i.e. each of the Jaipur traditional products have upgraded with technology and accessed the global markets with their presence so much so that the world cup for cricket and other games are made here. Such a product is neither traditional nor has any history in Jaipur but this example illustrates the innovative nature of the craftsmen to make a mark in the global competitive markets. This innovative temperament goes down in history, as Jaipur is known for semi-precious stones procured from African nations processed here and exported across the world but known for something that isn't indigenous to Jaipur. This trait to add value to the product is strongly inherent to the Jaipur traditional crafts and thus has been top exported handicrafts for decades on. The progressive approach to sustain their position in the global markets demonstrates their skills and professionalism while their personal lives are celebration of traditional socio-cultural practices and they pride themselves; an extension of their identity and sense of belonging. With such a framework that is embedded among the local community the built spaces and environments echo's the patronage. This showcasing of culture through practices comes in handy for the tourism sector. The fact that Jaipur is popular equally among home and foreign tourist demonstrates the strength of Jaipur traditions and that the experience isn't veneer deep but truly authentic as a holistic experience. The outstanding universal value for local identity is pivotal for sustenance of Jaipur traditional practices and traditional handicrafts.

The socio-cultural context is the key that anchors all aspects for traditional urbanism for it to sustain. The practice, beliefs influence the decisions that are directly related to the resources consumption from energy demand to baselines of thermal comfort to maintenance of the buildings and for alterations, additions and even re-building. Jaipur has been abreast with the transitions from technologies, global economy to communication skills and have rationally integrated as a part of their lifestyles. The conventional approach for heritage urban areas is for conservation while the strength is to sustain an ambience that orients the mind to appreciate the then aesthetics of traditional practices, people and places. As each generation

evolves and has a fine-tuned sensibility and thus enriching the bond with traditional heritage that becomes a unique experience for each one while any static built environment shall deliver an equally static perception that is same for all. Ownership has been instrumental in sustaining the transformations; the approach to uphold the wellbeing of the community over personal interest was and is key for the sustenance of practices. Traditional practices that respond evolve and connect such with each generations reinforces the social capital which has the stability of walled city of Jaipur.

The strength of Jaipur lies in its indigenous definitions, baselines and thresholds for all aspects from system of diversity of education, alternative health practices, gender connotation, resource consumption, energy use, energy demand, thresholds of thermal comfort to construction sector. Such an approach exists even for the building sector wherein the need to reduce carbon footprint through retrofitting, refurbishing, deep retrofit and digitizing for precise scientific results. Each building does not exist as standalone but as a part of built morphology wherein the principles and practices too contribute for continuity of traditional practices; to baselines for resource consumption etc. This contemporary approach to view aspects in silos may appear to be focused but addresses the other aspects in a rather incidental manner. In traditional urbanism each of the systems is a part of a larger web of systems i.e. passive systems in place deliver when users operate within the thresholds etc.

Jaipur has the unique distinction to design a social capital totally with migrant population, a rare instance in history from its composition, inherent balance of the various ethnic caste groups among others. The political patronage and religion contributed to cement the designed social fabric. Often the caste system were classified for being stringent for the structure, while in case of Jaipur the inter dependence among the various groups and their layout within the city's planning gave them an opportunity to establish themselves and grow, developing a symbiotic relationship amongst others. The city being walkable nurtured kinship within the chowkri and harmony at the city level. The recent pandemic has propelled us to relook at urbanism for human scale in which the mixed land use as flexible spaces are being reviewed for future urbanism and other aspects of traditional urbanism too shall be insightful.

Summing up the responses by traditional urbanism for climate from control, to planning strategies to design solutions that sustained for centuries through culture for environmental, physical, social and economy indicators. The points of alignment with traditional urbanism for continuity are as follows:

Environmental Indicator—Water and Waste: Rainwater harvesting was in place since 1880s due to limited availability of water. Original storm water drainage system has continued with regular maintenance. Limited but regular water supply @ 100 lpcd although much less as per National building code but the rationale decision of norm that is sync with the context is the strength for Jaipur and continuing. Thus, the need to re-examine the standards especially with varying geographies, access to technologies, social connotation and so on is learning from traditional urbanism of Jaipur. All the traditional handicrafts were recognized equally and their contribution for the economy of Jaipur. Textile/block printing requires large quantities of water were moved out of the city to be replaced by a set of publishers as the water demand

got reduced and the urbanising city stabilized such. The strategic decision taken timely, was solely driven for water demand.

Brackish quality of water was a concern since its inception; addressed either through traditional food habits to use of technologies by British to timely upgrading the water supply for both quality and quantity as well. Ironically no epidemic or water borne diseases was never the cause of deaths in the city considering for the said climatic zone the susceptibility if high.

The quantity of garbage produced has been relatively less, mainly biodegradable owing to the food habits and lifestyles. With urbanization stabilized the waste produced too got stabilized. The networks of municipal mains laid are maintained regularly with technology up gradation as well. Cleaning of streets and garbage collection done before the shops open.

The Physical Indicators: Built morphology and movement: Optimum use of land in sync with the socio-economic activities set up has been consistent for Jaipur. Residential chowkri's have densified, adapting to timely services over laid within the chowkri's. While the open spaces delivered for their flexible use that catered to the needs of the users and continuing. The city was designed for compact development and as a walkable city. The built morphology of four storeyed structures punctured with courtyards with mixed land use while the open spaces in the form of streets and Chauper's facilitated multiple use thus maximum utilization of space. The visual backdrop of natural feature of Aravallis: synonym to the pink city is intact and now is vital for the tourism industry is protected through legislation as of today. Although along the main streets the architectural features for elevation were adhered to as a sense of belonging and civic pride while currently ensured through legislation. With re-densification at various time periods residential density saturated at 240 persons per acre stabilized such till date; mainly due to ownership and socio-cultural connotation. The traditional built morphology within the chowkri's is fundamental as the architectural character along the main roads and within the chowkri's is distinct especially along the primary streets it is rather celebrated whereas within the chowkri's the essence of traditional urbanism prevails for the socio-cultural characteristics the authentic strength of the historic city.

The historic city was designed for pedestrian movement and even today walking is the fastest way to navigate through the city. The covered corridor designed for walking is thermally comfortable thus an enjoyable experience both for locals and tourists as well. Walking is still the fastest way to commute within the historic city majority of the workforce within the walled city walk to work.

Jaipur has varying modes of transportation with cycle rickshaws quite popular; as it is economical, provides jobs, as manually driven thus the pace slow for the travellers to enjoy the experience of the streets that are architecturally rich streets and the significant of all carbon free better worded as net zero thereby climate responsive. Vehicles are an essential part of living in cities while in Jaipur the vehicular movement restricted till the parking lots strategically located for locals and tourists. Although vehicular movement isn't legislatively implemented but people out of choice select either walking or cycle rickshaws.

Both home and international tourists cherish the rich architectural heritage of Jaipur acknowledged with world heritage status. Interestingly the home tourist contributes for large percentage mainly for handicrafts and traditional food. The experience of the rich architectural heritage along the main streets with backdrop of Aravalli's is a visual treat; crucial for the civic pride of Jaipur [2].

The Social Indicator: The Social composition has been fundamental for the growth and stability of the city for centuries. The continuity of the respective castes within the chowkri's as designed has been the key. Natural surveillance was inherent within the chowkri's that helped in bonding the community and developing harmonious relationships that reinforced the social capital. Often the caste system is perceived as being rigid but had its own strength for the symbiotic relationship that it nourished amongst them. With growth and urbanization in Jaipur the number of castes reduced over a period of time from 78 in 1835 to 17 in 1901 such dilution of castes depicted the adaptability with time and demonstrates the rationale attitude of the local community. Next Hindu religion followed by the king cemented the core population while other religions too were integrated displays their resilience to adaptability. System of joint families was the norm and continuing signifies the depth of cultural roots and practices thereby. Nearly 30% people have inherited family trade, 46.42% of the workforce hails from the historic city is a strong pointer of the stable socio-economic capital of Jaipur. Exposure to foreign cultures has been the norm since the city came into being, with astronomer visiting from Europe and king as a good host served them vegetables of western origin grown only for them. During the colonial rule the exposure was for building services, education etc. while globalization brought in technologies; the response for each one was deliberate and the local communities thrived as their responses to resources, energy, lifestyles among others that contributed for rich traditional urbanism continued. The global economy impacted the world, but the traditional urbanism upheld the socio-economic synergies as the way forward.

The growth of economy has been consistent since its inception and continuing considering the city has expanded beyond the city walls the walled city is the nucleus of the city. The Banking and trading that facilitated the handicrafts sector with king's patronage stabilized early with tourism sector reinforced it. Traditional handicrafts have been vital for the growth and economy of the city for centuries and central to Jaipur's economy even today. The city came into being with an economy that contributed for the development of the city. However with the global-techno economy has had a paradigm shift for one point agenda of large profits even if it meant marginalizing social equity. But in case of the strong Socio-Cultural backdrop of the local community continued to thrive, interestingly the attitude of value addition ensured that they explored innovative solutions for their advantage to boost their economy.

Capacity to adapt to the changing market forces is the strength of the local economy ensuring the continuity of the traditional economic backdrop of Banking and traditional handicrafts: semi-precious stone cutting, block printing, carpet weaving, blue pottery etc. Jaipur despite limited natural resources back but their artistic skills of handicrafts with value addition are recognized as handicrafts from Jaipur. The continuing family business have nurtured these crafts to such an extent that

textiles, metalwork's, semi-precious stone cutting etc. have been highest exported for decades now. Cultural heritage of Jaipur is fundamental for tourism industry. Since its inception, the curiosity of visitors to see a city with uniform bazaar streets and disciplined visual facades continues till date attracting home and foreign tourists. Jaipur enjoys a unique position in contributing to nation's economy both from export and tourism.

Traditional Urbanism of Jaipur has been resilient for climate for almost three centuries for climate control through appropriate climate mitigation strategies in place timely executed through planning strategies, contextual design solutions adequately underpinned by technology regularly by the culturally rich local communities upholding the identity of Jaipur.

References

1. Roy AK (1978) History of the Jaipur City, published by Manohar Publications, New Delhi; printed at S. P. Printers, New Delhi
2. Sharma AK (2012) Sustainability of living historic cities in India; case study walled city of Jaipur. Department of Environmental Planning, School of Planning and Architecture, Delhi
3. Master Plan of Jaipur 2011 & 2025
4. July 2020 JAIPUR, A planned City of Rajasthan by Alain Borie, Françoise Cataláa and Rémi Papillault, altrim publishers India ISBN 978-84-949330-1-1

Printed in the United States
by Baker & Taylor Publisher Services